PRAISE FOR
HEALING TRAUMA WITH GUIDED DRAWING

"A profound journey from an intuitive, 'felt sense' experience, giving rise to a lifelong exploration of theoretical constructs involving the integration of sensorimotor approaches and bilateral body mapping. This integrative practice transcends anecdotal findings from creative arts therapies by bridging neurobiological considerations with foundational art therapy theory and practice."

—ELIZABETH WARSON, PhD, ATR-BC, LPC, NCC, EMDR

"Cornelia Elbrecht's book draws the reader's attention to an understanding of how line, shape, form, color, and movement in artmaking can have a dynamic impact on the client who has experienced trauma. The creation of archetypal visual forms is explored for visceral and embodied effects in the art maker. Her model of art therapy is informed by key authorities in the trauma field, including the seminal work of Peter Levine. Elbrecht conveys her method of art therapy visually as well as descriptively with the generous inclusion of many illustrations. This text contributes a unique perspective to the literature on art, healing, and trauma."

—PATRICIA FENNER, PhD, senior lecturer and coordinator of the master of art therapy program at the School of Psychology and Public Health at La Trobe University, Melbourne

"It is revitalizing to read this contemporary and provocative text that sensitively addresses the complexity of trauma and trauma healing. Sophistically articulated from her life's work and experience, Cornelia Elbrecht provides a body-focused framework for therapists to navigate difficult terrain in ways that are meaningful, straightforward, life-changing, and applicable in contexts from which an arts-informed perspective is maximized. She acknowledges the inherent resiliency of the body and how it can be used for transformative and healing purposes within the therapeutic encounter. This pivotal text is an essential must-have as it will most certainly progress the discipline and discourse on trauma healing in profound ways."

—RONALD PMH LAY, MA, AThR, ATR-BC, registered and credentialed art therapist and supervisor and program leader of masters in art therapy program at the LASALLE College of the Arts, Singapore

"To read this book is to watch a master at work. As in *Trauma Healing at the Clay Field*, Cornelia Elbrecht charts new territory in neurobiologically informed trauma treatment. Her decades of experience as a sensorimotor art therapist are rooted in the understanding that no psychological process can be experienced separately from the body. Blending extensive knowledge of current science with years of mastery in ancient and modern body-based movement meditation and healing, the author presents guided drawing activities for application with clients. Those of us working with bilateral drawing, writing, and body mapping owe Elbrecht a special debt. She greatly deepens our intuitive understanding of how and why these whole-brain, whole-body methods are so effective while expanding our repertoire of tools. Illumined by deeply moving case studies, this handbook is a must-read for expressive therapists, trauma treatment specialists, and holistic practitioners. The author's wisdom, experience, and inspiration shine through on every page."

—LUCIA CAPACCHIONE, PhD, ATR, REAT, author of *The Power of Your Other Hand and Recovery of Your Inner Child* and director of the Creative Journal Expressive Arts Certification Training Program

"This wonderfully useful and inspiring book takes as its foundation the idea that guided drawing can be curative and that an understanding of the body, mark making, rhythm of movement, and archetypal forms can underpin this. Can it be so simple that by using repetitive shapes with eyes closed and with a concentration on movement, rhythm, and repetition one can find within themselves a way forward? This is the question that formed as I read this book. It offers a unique combination of explanatory discourse, personal experience, and practical examples concerning guided drawing."

—JEAN BENNETT, lecturer on creative expressive therapies and art therapy at the University of Derby, UK

"In *Healing Trauma with Guided Drawing*, Cornelia Elbrecht manages to weave in her lifelong professional experience and trainings with emerging research evidence on trauma and the body. Neuroscience has opened a new horizon for trauma work, deepening our understanding of the relationship between body, brain, and emotions. Elbrecht's book is a much welcome and significant contribution to this field as it introduces an art therapy-specific approach. She generously shares her wealth of experience. Theory and descriptions of practical exercises are well integrated, and case examples make the book lively and engaging. Elbrecht's life experience underpins the richness of her work and her caring and compassionate approach toward clients who have experienced trauma."

—DR. VAL HUET, PhD, chief executive officer of the British Association of Art Therapists

HEALING TRAUMA

with

GUIDED DRAWING

HEALING TRAUMA
with
GUIDED DRAWING

A Sensorimotor Art Therapy Approach
to Bilateral Body Mapping

~~~~~~

## CORNELIA ELBRECHT

Foreword by Cathy A. Malchiodi

North Atlantic Books
Berkeley, California

Published by
North Atlantic Books
Huichin, unceded Ohlone land
*aka* Berkeley, California

Cover design by Howie Severson
Book design by Happenstance Type-O-Rama

Printed in the United States of America

*Healing Trauma with Guided Drawing: A Sensorimotor Art Therapy Approach to Bilateral Body Mapping* is sponsored and published by North Atlantic Books, an educational nonprofit based in the unceded Ohlone land Huichin (*aka* Berkeley, CA) that collaborates with partners to develop cross-cultural perspectives; nurture holistic views of art, science, the humanities, and healing; and seed personal and global transformation by publishing work on the relationship of body, spirit, and nature.

North Atlantic Books' publications are distributed to the US trade and internationally by Penguin Random House Publisher Services. For further information, visit our website at www.northatlanticbooks.com.

Institute for Sensorimotor Art Therapy, Claerwen Retreat, PO Box 174, Apollo Bay 3233, Victoria, Australia.

MEDICAL DISCLAIMER: The following information is intended for general information purposes only. Individuals should always see their health care provider before administering any suggestions made in this book. Any application of the material set forth in the following pages is at the reader's discretion and is their sole responsibility.

Library of Congress Cataloging-in-Publication Data

Names: Elbrecht, Cornelia, author.
Title: Healing trauma with guided drawing : a sensorimotor art therapy
   approach to bilateral body mapping / Cornelia Elbrecht ; foreword by Cathy
   A. Malchiodi.
Description: Berkeley, California : North Atlantic Books, [2018] | Includes
   bibliographical references.
Identifiers: LCCN 2018031622 (print) | LCCN 2018034699 (ebook) | ISBN
   9781623172770 (E-book) | ISBN 9781623172763 (pbk.)
Subjects: | MESH: Art Therapy—methods | Psychological Trauma—therapy
Classification: LCC RC489.A7 (ebook) | LCC RC489.A7 (print) | NLM WM 450.5.A8
   | DDC 616.89/1656—dc23
LC record available at https://lccn.loc.gov/2018031622

4  5  6  7  8  9  Versa  26  25  24  23  22

North Atlantic Books is committed to the protection of our environment. We print on recycled paper whenever possible and partner with printers who strive to use environmentally responsible practices.

With love and gratitude

to the many parents who have nurtured me

and to my children and grandchildren,

who are the future

*Awake, my dear.*

*Be kind to your sleeping heart.*

*Take it out into the vast field of Light*

*And let it breathe.*

—HAFIZ[1]

# CONTENTS

# FOREWORD

*Healing Trauma with Guided Drawing: A Sensorimotor Art Therapy Approach to Bilateral Body Mapping* is a groundbreaking volume by an accomplished therapist and teacher whose wisdom and clinical experience span more than forty years. A brilliant addition not only to art therapy literature, it also captures what every trauma-informed art therapist now knows about how expressive arts repair and heal—the key to recovery is found in the body's rhythms, movements, and memories. Elbrecht's visionary work introduces a set of principles and practices not only in a user-friendly format, but also through an impressive overarching paradigm that integrates sensory integration, contemporary neurobiology, and a fundamental healing practice—bilateral drawing.

While there are many clinical treasures and practical applications throughout this book, Elbrecht emphasizes an essential concept in each chapter—that therapists meet individuals where they are in their reparation and recovery, responding with both insight (knowing what one feels) and empathy (knowing what others feel). Siegel refers to this as "mindsight"[1] while others refer to it as *attunement*, the capacity to recognize the nonverbal communications, rhythms, and responses of others. It is the capacity to be able to read the nonverbal communication and rhythms of others. In other words, it is perceiving not only what individuals say, but also attending to eye signals, facial gestures, tone of voice, posture, and even breathing rate. It is an embodied response because we actually feel a connection to other individuals in our physiology. Attunement operates from "bottom up" because how we perceive feelings in others is part of the more ancient parts of the brain—the amygdala, hippocampus, and structures underlying the cortex. Therapeutic relationships that resonate these experiences enhance overall functioning and truly create new adaptive response.

For readers unfamiliar with art therapy as a form of psychotherapy, its transformative factor is the unique sensory nature of the art psychotherapeutic relationship. This is what makes it different in its impact and role in trauma-informed intervention than strictly verbal approaches. Art expression embodies the senses, feelings, and nonverbal communication; art therapy establishes a type of attunement between the practitioner and the individual or group that is less dependent on words. Additionally, specific relational dynamics are present. In art therapy, a therapist is a provider of materials (nurturer), facilitator of the creative process, and active participant in helping the individual manifest visual self-expressions. These are experiences that emphasize interaction through experiential, tactile, and visual exchanges, not just verbal communication, between the client and therapist.

Like the author, decades ago I was impressed by one simple art-based technique that involves working with both hands through creating large rhythmic drawings on paper or with paint on canvas. It was presented as a way of "loosening up" through gestural responses as a prelude to creating "serious art." Now commonly referred to as *bilateral drawing*, my first exposure to it as an art therapist was through the writings of Florence Cane,[2] an art therapist, educator, and artist. Cane is one of many early art therapy practitioners in the United States who observed an important connection between free-form kinesthetic qualities of gestural drawing on paper and the embodied qualities of the experience. In her work with children and adults in the mid-twentieth century, Cane hypothesizes that it is important to engage individuals through movements that go beyond the use of the hands to engage the whole body in natural rhythms. In particular, she refers to large swinging gestures that come from the shoulder, elbow, or wrist not only to liberate creative expression, but also to act in a restorative capacity to support healthy rhythms in the body and mind. In other words, these rhythmic movements can be practiced in the air and then later be transferred to paper with drawing materials.

Sensory integration is often associated with similar bilateral techniques found in occupational therapy and other experiences that assist individuals in organizing specific sensations. In the process of reparation from psychological trauma, we have now seen a variety of forms of bilateral stimulation or movement that seem to be used effectively to stimulate cross-hemisphere activity, an assumption that, because both hands are engaged, both hemispheres of the brain are stimulated. This belief is reflective of Shapiro's model

of eye movement desensitization and reprocessing (EMDR) treatment[3] that involves dual attention stimulation and consists of a practitioner facilitating bilateral eye movements, taps, and sounds as sensory cues with an individual. Sensorimotor therapy,[4] Somatic Experiencing,[5] and other forms of body-based trauma intervention also include bilateral principles and practices. In applications of art therapy to trauma-informed work, bilateral work may be, in part, what reconnects "thinking" and "feeling" via the sensory-based processes involved in art-making.[6] These applications potentially impact on recovery from traumatic events because, for many individuals, the limbic system and right hemisphere of the brain are activated by actual experiences or memories of trauma.

I believe that bilateral drawing is effective not only as a method of self-regulation and a grounding technique, but also to initiate the literal process of "moving" the body and mind forward, post-trauma. Individuals who are reexperiencing trauma memories and particularly those whose dominant response is to freeze often need experiences that involve movement in order to reduce their hyperarousal or decrease sensations of feeling trapped, with-drawn, or dissociated. Making marks or gestures on paper with both hands communicates the body's sense of distress, but also creates an attention shift from the distressing sensations in the body to an action-oriented and self-empowered focus. Within a psychotherapeutic relationship, this shift con-tains the possibilities for the body to begin and eventually to resolve even the deepest long-held sensory-based memories of trauma.

Like the author, in a parallel time on another part of the planet, I too was disillusioned with my art therapy graduate training that taught psychody-namics and archetypal theory; the potential of art-making as a sensory-based experience resonating rhythm and movement was not on the menu and was even discouraged as a key concept in treatment. As Elbrecht observes, the recent practice of art therapy has been "too long in the shadow of various cognitive behavioral approaches" and similar top-down theories of psycho-therapy. While these therapeutic strategies can address certain disorders or challenges, in many cases, until the body resolves its distress in some way, experiences of anxiety, panic, depression, or dissociation often continue. As we continue to explore and understand the underlying principles of neurobi-ology in trauma-informed intervention, the body-focused concepts found in the pages of this book will certainly become an essential part of our collective arsenal in treating both acute and complex trauma.

In closing, I want to express my good fortune in not only having the privilege of writing this foreword, but also in being able to call Cornelia Elbrecht both a colleague and a friend. She is a true pioneer in expanding the depth and breadth of the art therapy theory, methodology, and practice; body-based approaches to health and well-being; and trauma-informed work. She has continually inspired my psychotherapeutic work as well as my excitement about the power of art to repair and transform the lives of our clients. Most importantly, how fortunate it is for all the readers of this volume who will be able to apply the inspiration, insights, and intelligence found in the pages of this volume.

CATHY MALCHIODI, PhD, LPCC, LPAT, ATR-BC, REAT,
founder and sirector of the Trauma-Informed Practices
and Expressive Arts Therapy Institute

# PREFACE

A strange coincidence brought me to art therapy. I was a young fine arts student in the first semester and had lost the key to my apartment. It was a cold, rainy November night and I was searching the glistening cobblestones in the dark. I was wet and miserable and grateful when a woman took pity and invited me in to get warm. The moment I stepped into her room I gasped. From floor to ceiling her walls were covered in large black-and-white drawings. The lines were raw with emotion, and I was instantly captured. She shared that she had just returned from a six-week retreat in the Black Forest in Germany, where she had practiced Zen meditation, hatha yoga, and this

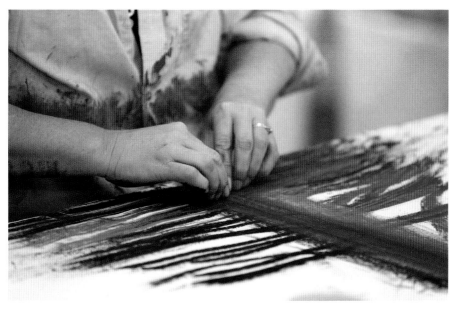

Drawing in rhythmic repetition with both hands.

kind of drawing that I saw on her walls, called Guided Drawing. To no surprise, we are still friends almost fifty years later.

I guess that was the key I was looking for. Having initially enrolled for psychology and sociology in the hub of the student rebellion at Frankfurt University in 1969, my overwhelming experience among the chaos was one of utter disappointment. The lectures—if there were lectures—were still all about rats and mice and did not answer any of the existential questions I had about the meaning of life.

Being a child of the sixties, I was a hippie; I took drugs. I lived in the community around Timothy Leary, the famous Harvard professor who promoted LSD to "drop out and tune in" during his so-called "exile" in Switzerland.[1] In the context of these transpersonal experiences, the Freudian-based talking therapies did not touch the heart of my concerns even remotely.

And while I loved the arts, I wanted neither to become a schoolteacher nor work in an advertising agency, nor did I have the confidence to be a freelance artist. Yet, here in this small room in the middle of a rainy night, I saw walls covered in an art therapy process I understood intuitively—even though the term *art therapy* did not even exist then. Eventually I went to the center in the Black Forest myself and stayed for eighteen years.

My teachers, Maria Hippius and Karlfried Graf Dürckheim, were pioneers in their field. Dürckheim, a professor of psychology and philosophy, had lived for ten years in postwar Japan studying Zen Buddhism under the guidance of D. T. Suzuki.[2] Dürckheim became known for his books bridging the knowledge of the East with the West,[3] and he introduced Zen meditation into Europe along with the importance of body awareness as a spiritual exercise, which was simply unheard of in the 1950s. One of his key teachings was to "stop having a body" like an object, but to "be the body that I am," to integrate body, mind, and spirit. For Dürckheim, the body was the container for our spiritual existence. Instead of "ecstasy," where spirituality is an out-of-body experience, he promoted "instancy," a state of being where our spiritual practice will increasingly "sound-through" the body (taken from Latin, *personare*) and gradually transcend our physical existence. He often used the image of the Hindu god Krishna playing the flute, the individual being this flute through which the divine breath sounds.

At their center, called Rütte, Dürckheim taught meditation and Transpersonal Bodywork,[4] and Hippius worked as a psychologist and Jungian depth analyst with Guided Drawing. She had gradually developed this form of

bilateral drawing from the origins of her doctoral thesis in the 1930s concerning the effect emotions were having on individuals' handwriting. When I met her, she had begun to relate particular shapes to archetypal patterns as C. G. Jung describes them, primarily in his books on psychology and alchemy.[5] Her personal encounter with Erich Neumann,[6] Jung's most renowned disciple, had confirmed that such shapes could evoke the collective unconscious. For example, Hippius would relate a large rhythmically repeated drawn circle to the Great Mother archetype.

My studies with Maria Hippius were apprentice-style. They were initially informal and interwoven with my own gradual development from client to student to coworker. Over time I added additional studies, most importantly to become a Gestalt therapist. For fifteen years I financed all my training as a shiatsu bodyworker in the context of psychotherapy, which taught me invaluable lessons on how trauma is held in the muscles and connective tissue, and how it obstructs the flow of energy in the subtle body, specifically the flow of qi in the meridians.

In this context, my training in bioenergetics with Stanley Keleman and Wolf Büntig was eye-opening. Here I found a body-focused form of psychotherapy that I could instantly translate into my practice with Guided Drawing. Over the next forty years, this approach became instrumental for my work. I moved away from the emphasis on archetypes and paid more attention to how this form of bilateral drawing could mirror the inner body on a sheet of paper. How muscle tension could be made visible; how the flow or the blockage of energy was reflected in rhythmic repetition of certain shapes and the pressure the crayons exerted on the paper. Guided Drawing became a form of bodywork. It allowed my clients to find an instant connection between their experiences of physical discomfort and their biographical story encapsulated in this pain. To release the tension held in the body in a self-directed way proved to be empowering.

I stayed with this modality for forty years of practice simply because it was so effective. Only in recent years and thanks to my encounters and additional training with Peter Levine, Bessel van der Kolk, and Babette Rothschild[7] have I been able to understand this approach as the trauma-informed sensorimotor modality it truly is.

This modality of Guided Drawing, from its beginnings in the 1930s as psychology doctoral research into graphology via a form of mail-order writing therapy in postwar Germany anchored in Jungian archetypes, has evolved

into a body-focused Sensorimotor Art Therapy approach of significance. My first book on Guided Drawing, *The Transformation Journey,*[8] still strongly emphasizes the Jungian paradigms. In just ten years, however, the new disciplines of neuroscience, developmental psychopathology, and interpersonal neurobiology have profoundly changed the therapeutic landscape. My recent training in Somatic Experiencing has informed my understanding of trauma. This new understanding has prompted me to rewrite *The Transformation Journey* with a renewed focus on the sensorimotor approach.

My motivation is particularly fueled by the fact that the more I have read and trained in recent years, the more I have become aware how almost all the new sciences around neurobiology and complex developmental trauma promote therapies that have a body focus, are bilateral and movement based, and allow sensory integration. And yet there is a scarcity of therapies that can actually facilitate such an approach. Art therapy is also still primarily focused on image-making and the cognitive processing of such creations. These prefrontal cortex therapies, however, do not address the brain stem, where trauma is held. The top-down modalities have their place, but they are not capable to lastingly settle the involuntary fear-responses triggered in the autonomic nervous system.

Some parts of my first book will reemerge in this version. My aim, however, is to introduce this bilateral scribble drawing approach in the context of the neurosciences, and as an applied body-focused trauma therapy. Guided Drawing as a Sensorimotor Art Therapy approach is not necessarily concerned with an image-making process, but supports the growing awareness of implicit body memories. While these memories are always biographical, the therapy itself is not symptom-oriented. It actually tries to draw attention to body sensations in the present moment rather than being drawn into traumatic past events or future fear-based expectations. The specific problem or crisis does not become the focal point, but central to the approach is to find new options to life. These solutions are not cognitive and cannot be found through understanding the problem, but they are answers that are embedded in the body's felt sense.[9] Once we have discovered, explored, and practiced these body-based learning steps, they become sensorimotor achievements that are remembered, similar to learning how to swim or ride a bike. They become lasting procedural memories that are able to transform even early childhood developmental setbacks; they assist in finding an active response to traumatic experiences. Such steps are able to restore empowering action.

Our brain is malleable; it can change. Neuroplasticity has discovered that through creating new experiences, we can help the brain recalibrate itself toward responding adequately to the current reality, interrupting destructive habits and negative belief systems from the past.[10] Such a process allows clients to rewrite their biography toward a more authentic, alive sense of self.

Neurobiology has made a breakthrough in recent years to further our understanding of trauma. We know so much more about how adverse childhood experiences shape the brain, how such neurological disasters can have a lifelong impact on individuals and manifest later in life as emotional dysregulation, eating disorders, immune system breakdown, chronic illnesses, drug and alcohol addiction, and many more.[11] There is also growing insight into the difference between complex (formative early childhood) trauma and the experience of a single traumatic event an otherwise well-adjusted individual suffers. Ultimately, trauma is part of life. We all are exposed to it more than once. How we recover from it, however, makes all the difference, depending on our resilience and the support we can receive from family, friends, and experts.

For too long, art therapy has been in the shadow of various cognitive behavioral approaches. However, while these therapeutic traditions can address certain dysfunctions, they are unable to reach its primal core. There are body-focused art therapies that can be very effective in combination with trauma-informed conduct of a session. While we certainly need further training as art therapists in neurobiology in order to effectively treat clients with complex trauma, we also need to treasure the tools the art therapies are able to offer these neurological approaches. The psychiatric medical model still struggles to take art therapies seriously. Bessel van der Kolk, in his groundbreaking book *The Body Keeps the Score,* is a lonely voice in his research of dance, drama therapy, yoga, meditation, and bodywork for clients suffering from complex trauma:

> One of the clearest lessons from contemporary neuroscience is that our sense of ourselves is anchored in a vital connection with our bodies. We do not truly know ourselves unless we can feel and interpret our physical sensations; we need to register and act on these sensations to navigate safely through life. While numbing (or compensatory sensation seeking) make life tolerable, the price you pay is that you lose awareness of what is going on inside your body and, with that, the sense of being fully, sensually alive.[12]

Guided Drawing does not so much address the story—the conscious memory of an event—but has its focus firmly on the *implicit* body sensations. Implicit

memories arise as a collage of sensations, emotions, and behaviors. They are primarily organized around the emotions and action patterns we have learned in early childhood; they usually appear and disappear far outside the bounds of our conscious awareness.[13] Through tracing these implicit body sensations with crayons on paper, it is possible to address physical discomforts, emotional distress, and pain—and then transform them. Clients may, for example, experience muscle tension in the shoulders. They will then draw this tension just as it *feels,* using both hands and simple scribble movements such as tight up and down strokes applied with lots of pressure. A lump of nausea in the stomach might emerge like a knotted mess of wound-up curly whirls. There might be stabbing pain externalized as stabbing the paper with the crayons. To focus on, track, and express such body sensations can already bring relief. More importantly, though, at this point almost all clients begin to notice what they really want or need in order to find relief. This is the *guidance* in Guided Drawing. We are not talking instructions or interventions from the therapist, but rather the client's increasing reliance on an inner knowing that provides body-based solutions from deep within.

Hence on the next sheet of paper clients will "channel" their inner massage therapist or martial arts warrior and respond with movements that will ease the symptoms. Movements, like in a massage, are rhythmic and repetitive. Tension is released into arrows flying off the page. A boundary breach is repaired with firm lines all around the sheet, creating a safe place. Rocking back and forth in a large bowl shape becomes soothing and comforting. Jammed contractions may need gentle caressing strokes with a flat crayon to softly ease pent-up emotions. What clients experience in its immediacy is that they can do something to help themselves, and that their actions have a tangible impact on their felt sense.

The approach counteracts clients' sense of helplessness, which often triggers hopelessness as a consequence. Passive suffering is turned into active responses that are in alignment with deeply felt inner needs. In this way, clients can move from survival to gradually feeling alive.

Guided Drawing is suitable for a wide range of client groups. While I have worked all my life primarily with adults, children also respond well to this approach. For example, I once supervised a speech therapist; she used this technique with children between three and six years of age. She helped them to express the sounds they found difficult to pronounce with bilateral drawing movements. She had worked out a direct correlation between certain

sounds, such as "f," "t," "h," and "s," and shapes of Guided Drawing. Instead of practicing tongue exercises, she encouraged the children to draw the related shape with a crayon in each hand. It was surprising how initially these movements were clearly blocked; children could not draw them, or they appeared as fractured lines. Pressure was applied with the crayons to the extent that the paper tore. Intense emotions were expressed. What gradually emerged, however, was that without words, without a story, and without imagery, the children could express in a sensorimotor way what had happened to them, what caused them to stutter or had tied their tongues. Within only a few sessions, many could clear the inner obstacle—and the speech impairment disappeared, in most cases lastingly.

Guided Drawing requires mindfulness, sensory awareness, and trust; the body focus does not initially suit everybody. Many of my clients begin with traditional art therapy exercises where they create images of biographical or symbolic events: they assemble collages or sculpt figures. This is more in line with their expectations of a session, and it is often necessary to build resources. Once they have gained trust in the setting, in the therapeutic dyad, and in their inner process, we may continue with Guided Drawing.

# PART I

Body-Focused Art Therapy:
The Building Blocks of a
Trauma-Informed Approach

# 1

# Getting Started

When you come into a session for Guided Drawing, you will sit in front of a stack of several large A2-size sheets of paper. Colored chalk and oil pastels as well as finger paints are available nearby.

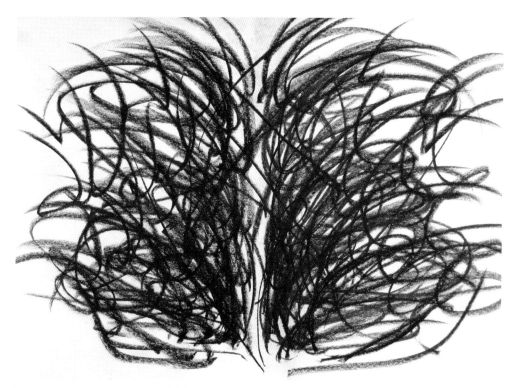

FIGURE 1.1. Typical bilateral scribble drawing expressing the release of inner tension. A2 size, approximately 23 by 31 inches.

Once we have made contact, and sufficient trust in the setting has been gained, I explain that it might be easier to imagine having a bodywork session rather than the idea of making art. If need be, I take some time to explain that all emotions have a physiological expression. Fear might make your heart race, your palms sweat, and your stomach churn. Excitement wells up. Joy usually flows with ease. Anger is hot and intense and always rises. Grounding moves down, putting roots into the earth like a tree. Inspiration is closely linked to inhaling, taking in spirit. You might sense blocked motion, such as a lump in the stomach or a stiff neck. Even a tumor is a movement.

Rather than translating the experience of, say, "fluttering in the stomach" into an image in the head, which will then be projected onto the paper, I will encourage you to use repetition to test and try out this inner sensation. Hence you will directly translate an internal movement into a drawn movement on the paper. You can flutter with the crayons just as "it" flutters in your stomach.

Once you are ready to go, I will ask you to close your eyes or leave them in an unfocused gaze. In order to build sensory perception, I may begin with guiding your awareness through the body, such as asking you to exhale and "sit down" inside into your pelvis, to feel the contact of your feet to the ground, to become aware of the uprightness of your spine, and to listen to the rhythm of your breath. This focusing exercise is designed to make you notice inner movements, maybe one that attracts your attention in particular, be it physical pain or discomfort, or the movement of emotion.

I will explicitly encourage you to rely on your body perception at all times. It is the simplest and most direct way to come into contact with your self.

Now you may start drawing, a crayon in each hand, preferably eyes still closed, in contact with these inner sensations. Drawing in this case can be the simplest, smallest repeated movement. Repetition, especially rhythmic repetition, is used to carefully test which drawn movement feels most like the sensation inside. The drawn shape can be arranged and rearranged according to these sensations, or be changed altogether until it feels right. This does not happen by thinking up shapes. Instead, you will need to find a rhythm and a shape that allows you to safely let go of cognitive control. Your head does not know the needed outcome. Rhythmic repetition gradually allows you to connect with implicit memory, your embodied biography rather than the conscious stories of your past. Similar to learning how to dance, you will not *dance* as long as you count steps. Once you can trust the rhythm to carry you, allow yourself to settle into any shape that emerges.

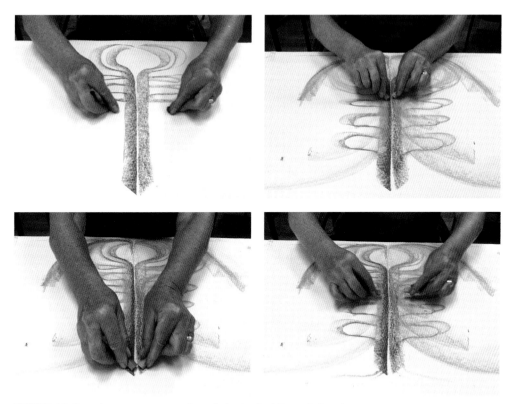

FIGURE 1.2. Step-by-step progression of rhythmic, bilateral drawing.

Let's say you settle into a circular shape. As you repeat the movement, however, your body might signal to you that the circles you have been drawing are too small, or too big, or that the rhythm is too fast or too slow. Follow these "instructions" from within until the drawing movement feels right and in line with your experience on the inside. The paper is changed whenever one impulse is sufficiently explored.

In the following, you may move from the question of *How do I feel?* to inquiring into *What do I need?* What movement do you need in order to resolve this tension? What could help to ease the pain? Do you need soothing, circular, "massaging" motions, or straight, sharp, even forceful lines to release pressure? Do you need to push something or someone away? Or do you need containment to be held?

What movement can make you possibly feel better? If you could have a massage now, what would you like your inner body therapist to do? If you practice martial arts, what defensive action would you need right now? And you will try out movements, again in rhythmic repetition on the paper, until

you can sense a clear shift in your body. Is there less tension? Less pain? Less numbness? Less fear? Is there more energy? More uprightness? More grounding? More hope? More courage? This is not a cognitive process; this is not thinking up things to draw, but about finding that inner guidance that will bring release and transformation. A newly drawn and enlarged circle or other figure may change not only your body awareness, but also your mental and emotional attitude.

Guided Drawing differs from well-known scribble drawing exercises in that it encourages the alignment with body sensations and rhythmic repetition. Both the emerging shapes and their rhythmic repetition have the purpose of building trust and inner structure. This is important especially for clients who are afraid of their inside. Many traumatized individuals are actually terrified of their body sensations and experience them as a threat.

This approach allows clients to gradually discover their own shapes borne out of a deepening contact with themselves. Motion and emotion can be expressed, as well as blocked motion and the way it is hindered. This new form of body language makes increasing sense as related emotions and thought forms become apparent, along with the way they constitute the body posture. For example, the feeling that "the circle I've drawn is too small" starts to correlate to a mind-set of self-limitation such as: "I need to be really small in order to be safe," or "I can hardly breathe; I need to get out of this," or the circling motions feel like running in a circle, or like a vicious cycle.

My training in bioenergetics has taught me that the way I experience my body, especially how my muscles contract or relax, is closely linked to emotional and mental states. Guided Drawing is a form of body therapy. All sensations, emotions, and feelings are connected to thought patterns and body postures. All are subtly interrelated. All influence each other. Psychosomatic medicine has shown that one can die of a broken heart. Our language reflects how some people can hold their ground, are down to earth, carry the world on their shoulders, or have a stiff upper lip. Looks can kill. Transformative healing work will always include the somatic factor.

For example, anger is tense, hot, and always has a rising motion. But instead of being able to follow this rising motion with the crayons on the paper, the client may detect another impulse such as "I should not show how angry I am," "To be angry is bad," a learned behavior that will cause downward movement. These two movements, the rising anger and the control of this anger, will then create a collision somewhere in the stomach or the

chest or the throat. To make these movements visible on paper can be most enlightening.

The following questions could then focus on: How do I deal with my anger? What does my anger have to say? Is it constructive to just suppress it and walk around like a pressure-cooker? Or will this attitude give me an ulcer in ten years' time? What ways are there to release the anger without hurting a close friend or myself? How does it feel to release the anger on the paper? How much of this anger is older than the present cause?

The drawn movement reflects an internal flow of energy. This flow can be destructive or constructive, conscious or not. It tells the client's life story, where certain thoughts, feelings, emotions, and actions were allowed to flow and others had to be forbidden and blocked. In this way "your body speaks its mind,"[1] as Keleman put it. Both therapist and client need to question and decode these patterns. Clients can learn to understand, redirect, transform, integrate, and thus heal and increase their flow of energy.

To draw with the eyes closed using both hands simultaneously is not for acrobatic reasons. The closed eyes, or an unfocused gaze, help to focus within and avoid any urge to control the artistic outcome on the paper. Once the mind ceases to interfere in a controlling, evaluating way, it is unimportant whether eyes are open or closed. Of course, there are exceptions, especially if clients become overwhelmed by images as soon as they close their eyes, or when it is important to direct energy as consciously as possible.

The bilateral use of both hands supports the holistic approach of Guided Drawing, which involves the whole person, including the untrained and often neglected side; it stimulates synchronicity between the two brain hemispheres, the intuitive and the rational.

Throughout, no images are drawn, at least not intentionally. Whatever the dominating urge, it is traced on the paper through repeated motor impulses. In this way, clients create layers of predominantly abstract shapes. The art is then to learn how to read and understand this visual language, which depicts muscular tension, emotions, and mind-sets. The meaning of the drawn shapes will vary with every client.

The therapist has the option to suggest particular shapes as intervention tools. Clients will then draw these shapes in rhythmic repetition and investigate the sensory response they evoke in their felt sense. These shapes relate to the body's structure, such as a vertical can assist to align the spine or the bowl shape may support grounding in the pelvis. Clients can apply these

interventions as a way to massage tense muscles effectively, or release anger safely, or to soothe themselves. In this way, clients are empowered to build somatic resources that give them structure, containment, or whatever it is they need to feel better.

# 2

# Setting and Materials

Guided Drawing is a mindfulness exercise. Hippius called it a form of "active meditation." Sessions require a setting that supports a calm and concentrated atmosphere. Since clients draw with their eyes closed, the room where they

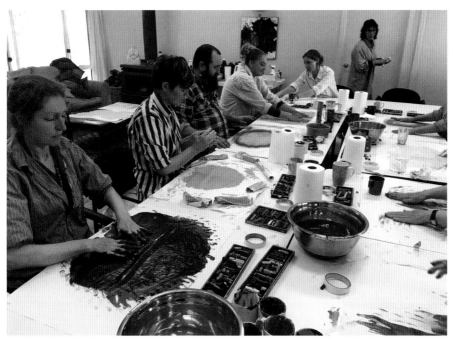

FIGURE 2.1.

work must be safe enough, as otherwise individuals will not be sufficiently able to relax and open up.

Guided Drawing can take place in individual sessions, as well as in groups. Individual sessions follow a rhythm of drawing in silence, then a brief or in-depth verbal sharing of the sensory experience, followed by more silence and drawing, and finally cognitive processing. In groups, after an initial introduction, there is a period of about forty to fifty minutes of silent drawing. Afterward the pictures are laid out in sequence on the floor and are shared with other participants in small groups. The aim then is to observe how the sequence evolved, and learning to read the story the drawings tell along with the explanations the client gives. How do drawn motor impulses resonate with the sensory perceptions of the client? Such sensory awareness can then be fine-tuned and linked to cognitive insights.

Tables and chairs are needed. The height of the table should ideally be approximately one inch below the navel of the client. Chairs should be high enough that the knees are slightly lower than the pelvis, and the feet touch the ground. It is important that one sits comfortably upright while drawing, as it is a meditative exercise of body awareness. This does not, of course, suggest that everybody has to sit in motionless silence. There are quite a few who will draw standing up. Movements can be forceful and noisy. But a starting position that allows a relaxed upright body posture is important, and it is not possible when crouched on the floor.

In individual sessions and groups, it is important that each participant have all the required materials at hand. Each client needs a supply of about ten large A2 sheets of bulky newsprint paper (about 24 by 32 inches) per

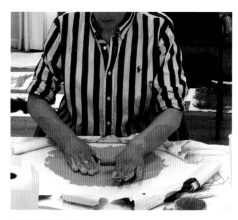
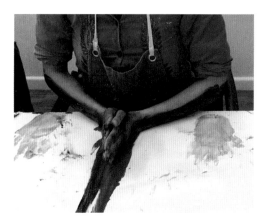

FIGURE 2.2. Finger-painting.

session, a role of tape to affix the sheets to the table so they can't slide, and a set of color chalk crayons and oil-pastels.

**Chalk pastels** are highly sensitive to subtle changes in the pressure. Especially when used flat, they allow multiple layers of transparent lines to appear on the paper. They appeal to clients with a transpersonal or a meditative approach to the drawing process or those who feel delicate and hypersensitive. The texture of the pastels is dry, and the dust can be rubbed into the paper with flat hands, which increases contact. This allows even unskilled clients to mix colors in a satisfying way. However, the dryness does not suit all; some even have allergic itching reactions to it. They are also expensive. There have been times when I sat with a certain amount of resentment observing a client going through two pastels per drawing, and at the end of the session a twenty-dollar box had been ground to dust. Chalk pastels break easily when pressure is applied, which can be frustrating for clients. In that case it is better to choose oil crayons.

**Oil crayons** come in different qualities and thicknesses and are much more affordable because of their application in schools and kindergartens. If they are too hard, they will feel scratchy on the paper and easily tear it without making satisfying marks. However, they do not need to be artist quality in order to be effective. It is good to have at least a few really thick oil crayons at hand, the ones on offer for preschoolers, as they withstand pressure and can be used for drawing with the fists.

**Finger paints** come in large bottles as school supplies. These acrylics are usually affordable and wash out of fabric, which can otherwise be an issue; painting with both hands can get very messy. There needs to be enough space to dry the pictures afterward. In most sessions, I supply the paints on demand. Sometimes only one color is needed to emphasize a particular emotion or to mix a balm that can be applied to a wound on the paper. Many clients with attachment trauma "never got enough." The therapist pouring paint into their hands while they have their eyes closed can be a nurturing gesture to assist them moving toward fulfillment of their needs. Handfuls of paint contribute a distinctly more tactile and sensual dimension that may prove invaluable in certain cases. The smearing, mixing, scratching, and mucking around, as well as the direct contact with thick layers of paint, can evoke early childhood memories and may satisfy a desire that was never granted. Sometimes finger paints are a more appropriate material than crayons. The vivid strength of the colors appeals to emotional expression. The fluidity of

the paints also encourages the idea of giving oneself a massage. However, clients who have been traumatized by touch, in particular those who have suffered sexual abuse, may get severely triggered by contact with the paints. In this case it is important to have access to plenty of paper towels and water for washing rituals, which may offer a countervortex to pivot to. The haptic dimension of touch has enormous healing potential, which I have explored in detail when working with clay.[1]

Crayons and paintbrushes allow distancing from the paper and thus from direct contact with the self, whereas finger paints are "full-on." Yet clients can also distance themselves from overwhelming contact by, for example, just touching the paint with the fingertips. Full contact of the hands with the paint and the paper indicates full sensory body contact also on the inside. Haptic perception, perception through touch, allows a score of diagnostic insights about how a client's hands have learned to orient in the world. How they reach out for contact externally reflects on how they are in contact with themselves internally.[2] Haptic perception relates the base of the hands to the pelvis and inner grounding, the middle of the hand to the chest and to feelings, and the fingers, especially the fingertips, to cognitive processing.[3] Relaxed hands allow diagnostic conclusions toward a relaxed felt sense, whereas tension, inflexibility, white knuckles, and the inability to fully touch the paint are indicators for fear and point toward a trauma history involving interpersonal abuse.

**Color:** I encourage clients to honor color in so far as to choose it according to the felt sense. If something feels blue inside, draw it blue; if it feels neutral, use a neutral color such as black or brown. Such choices make the drawings more meaningful.

Experience has taught me to attach no interpretation and meaning to specific colors. The impact a color has on someone is highly individual and depends on a momentary physical and emotional state, as well as spiritual and cultural aspects. In a study we conducted at university, the same color was perceived as "warm" in one setting and "cold" in another, even by the same person.

There are plenty of color theories around, and they can be found on the Internet. Joan Kellogg developed one for the MARI mandala assessment scheme.[4] Goethe wrote his theory of color between 1790 and 1808.[5] Werner Arnet, with whom I studied Gestalt therapy, had based his entire psychological color concept of Eidos (Greek for "perception" and the name of his

school) on the teachings of Johannes Itten,[6] who was part of the Bauhaus school in the 1920s. Verena Kast has written in depth about the interpretation of color in the Jungian context.[7] Theosophical teachings have a particular meaning attached to the colors of the seven rays of creation. The Hindus have a color system for the chakras, and Catholics another with instructions for gowns and altar decorations according to the church calendar. There are significant cultural differences in how color is perceived. In China, the color for mourning is white; in the West it is black. In a multicultural society, clients have not necessarily been exposed to the same archetypal values as the therapist and will likely associate differently.

There are universal perceptions attached to color, such as: the sky is blue, grass is green, blood is red. But ultimately there is always the individual experience. The red of blood will evoke certain sensations in a woman with menstrual cramps and others in someone who has just witnessed an accident. A doctor may associate medical details with blood, while for a voodoo shaman, it is a sacred substance. The green of vegetation will have different significance for a community living in the rain forest of Papua New Guinea compared to people living in the Australian desert or to those in a metropolitan area. Accordingly, I listen to clients' perception of the colors they have chosen and the meaning they attach to them. Colors enhance emotions, and they can act like a gateway to deeper insights.

With these external requirements in place, the inner journey can begin.

# 3

# The Guidance in Guided Drawing

*The spontaneous movement in all of us is toward connection, health, and aliveness. No matter how withdrawn and isolated we have become or how serious the trauma we have experienced, on the deepest level, just as a plant spontaneously moves toward sunlight, there is in each of us an impulse moving toward connection and healing.[1]*

Similar to this statement by Daniel Heller and Aline LaPierre, Guided Drawing does not mean guided by directions and instructions from the therapist but rather guided by an inner force that is clearly present, even though hard to pinpoint. C. G. Jung would call this internal agent the intuitive Self of the individual, which he describes as the immortal spiritual core in every human being.[2] Sensorimotor therapies would probably refer to this ordering principle as "instinct" located in the brain stem, which, if we look at nature, is unerringly only interested in healing and repair. Others might refer to inner guidance as qi, the life force that flows through our energy body according to Eastern philosophies. Ayurvedic medicine might refer to the kundalini as the healing power that rises through the chakras in the spine. Whichever way we name this inner guidance, and wherever in the body we locate it, it clearly is at work, and it can be witnessed. My personal attitude could be called a belief system that human nature at its core is "good," that as a life force it is

interested only in growth and healing. How otherwise can humanity and our planet move on from war, violence, and destruction and yet over and over again bring forth beauty, love, and the healing of wounds? Many times I have sat in sessions just as clueless and confused as my client with the only difference that I could trust that, if called upon, this inner guidance would wake up and lead the individual to whatever solution was appropriate.[3] I believe shamans do something quite similar by evoking the trust in their adepts and patients—trust that healing is possible. Then individuals can heal themselves. It takes, however, someone to confirm that they can trust, or someone to help them build this trust.

Intuition, instinct, or inner guidance can be viewed like a higher form of consciousness. It communicates through a myriad of impulses, inklings, body sensations, feelings, urges, flashes, dreams, images, and memories. We are almost continually guided by our intuition, but at the same time have difficulty in explaining it, and therefore tend to deny it in day-to-day life. Our senses, and what colloquially is referred to as a sixth sense, offer spontaneous guidance in innumerable life situations. Once clients have become comfortable in taking their sensory prompts seriously, inner guidance has set in; and once this stage is achieved in the therapeutic process, the therapist takes on the role of supporting midwife. The therapist will assist with the process of birthing, but only the client is the one who can give birth, when the conditions are right and ready for the arrival of something new. As therapists we cannot provoke changes in clients, if they have not organically evolved inside them.

This process is not ego-driven. Both client and therapist have to let go of expectations in order to allow something new and surprising to emerge. Originally, Guided Drawing was practiced as an active meditation, the crayons making the inner events visible. Just like in body-focused Zen meditation, the attitude is one of mindfully witnessing what is and accepting it unconditionally. Rhythmic repetition helps to stay with this "what is" rather than wanting things to be otherwise. Suzuki called the necessary attitude for meditation "loving awareness" to be observing of the inner movements and events with kindness rather than rushing instantly to fix things.[4] This state of acceptance is different from our usual sense of striving to be liked, respected, or admired. The nature of loving kindness is universal and all-encompassing. Clients are not even *making* art, but are tracking body sensations with bilateral scribble drawings. This allowing of sensations to arise and to respond to

them with motor impulses on the paper needs space for surprises. Anger and grief can flow; they do not need to be managed.

So much resentment and pain are held in the body, often for decades. We "can't move on," we are "stuck." Rhythmic repetition can track the patterns of contraction and holding on tight. With loving awareness and an attitude of gentleness and kindness, which has to be role-modeled by the therapist, our instinct, our intuition, our life force will find a way out. Be this into less pain, into forgiveness, or until the rhythm of life can find a new pulse.

At the beginning of therapy, the therapist often needs to intervene quite frequently, suggesting particular shapes or to modify the rhythm. Most importantly, the therapist needs to encourage rhythmic repetition in order to assist clients to connect with their inner flow rather than focus on the story of what happened. Many clients have the expectation that talking about their biography will be the focus of the psychotherapy sessions. While cognitive processing of explicit memories is certainly part of any session, it is not the main goal in the context of Sensorimotor Art Therapy. Yet to connect with implicit body memories requires an approach that is initially experienced as quite unusual—if not unsettling—by most individuals, such as drawing with eyes closed and both hands. The therapist has to find ways to ease clients into this unfamiliar approach at the beginning of the therapy and at the beginning of each session. This might involve some psycho-education explaining the reason for bilaterally drawing with closed eyes, or a body-focusing exercise or short meditation.

Clients at the beginning of therapy are usually stuck. That is the reason why they are seeking assistance. Once clients begin to draw and the blockages become apparent, the therapist often needs to become quite directive and encourage moves that will unblock them and assist them to step out of fixed and unproductive attitudes. If the therapist sits back too much at this stage, clients will feel unsupported. Encouraging experimentation with opposites or unfamiliar motor impulses on the paper provokes new sensory qualities and body perceptions. It promotes flexibility and reflection. It introduces the possibility that there is more than one fixed identity, more than one position, a variety of avenues. Clients can then choose particular shapes and test and try them through repetition.

Once clients have gained trust into their own voice, the role of the therapist changes significantly. The therapist will now need to adapt to a nondirective style, hold back with suggesting interventions, and instead support clients'

perception of their inner sensations. The therapist now becomes a mindful, nonjudgmental witness, or a companion on the path; someone who encourages and protects if necessary, and who follows the lead of the client. At this deeper stage of the therapy, directive suggestions from the therapist that were necessary at the beginning now easily become irritating and distracting.

The ensuing process happens as a creative paradox in the tension between active motor impulses and passive sensory perception. The client is active and creative, and at the same time passive and receptive, listening inside. The drawing process is not about senselessly acting out; it is not about some cathartic release without sensory awareness. The effectiveness of this approach comes from a deepening interchange between sensory body perceptions and the expression of these perceptions though rhythmic motor impulses, which will in return reinform the internal sensory experience. As clients progress in this manner, they get to know a deeper nonverbal aspect of themselves, which feels authentic in its immediate presence. The biographical stories we tend to tell all deal with the past, something that happened yesterday or years ago. Our body, however, responds to the here and now. Clients draw what is happening inside their body in the present moment and as they perceive it in this moment. To the extent that they gain trust into their inner abilities of perception, they may become aware of embodied identifications and belief systems; and they may become aware that these identifications are not fixed identities, but that they can actively change them into different felt sensations. As limiting self-images disappear, clients will be able to move from survival to feeling more alive, and even if not all the answers can be found, it is always possible to improve someone's quality of life, as Babette Rothschild once stated in one of her seminars.

Depending on a client's needs and the stage of the therapy, Guided Drawing can be facilitated in a directive and nondirective way.[5] The particular round and linear shapes offer nonverbal intervention tools. The majority of directives given by the therapist may suggest one or more of these options. These interventions are designed to modulate the client's motor impulses to

- draw a particular shape
- alter the rhythm to slower or faster
- release tension through letting go at the end of each line
- contain with round, flowing shapes
- draw sharp corners in order to provoke conscious decision-making

Once sensory awareness becomes accessible, the interventions become less directive, and the therapist uses questions and a more passive language. Questions are designed to assist clients tracking body sensations, and to support trusting them:

- How does this resonate in your body?

- Where do you feel this?

- Does this feeling have a color, a texture, a weight?

- Have you felt like this before? Do you know this sensation?

- How is the movement inside this …?

The answers may come as a churning feeling in the stomach, as a deep breath, as a letting-go of the thigh muscles, and physical states in which clients experience themselves shifting from a tense, closed, blocked state to a more open, relaxed, and flowing posture. They may have a sudden idea, a memory popping into their head, which shows them how they were hurt and how they bent themselves from then on in order to prevent pain. And through this process, they will get a glimpse of the one they were before they feared. The answer may be the impulse to take red paint and splash it onto the paper and to beat and pound it until it gives way to whatever was hidden underneath the crusted surface. It can mean to try out what it feels like when both hands move together and dance on the sheet rather than fighting with each other. I have seen finger paint applied like an ointment on "wounds" that were scratched into the paper with a black crayon, and the wound healed.

It is the therapist's task to create a setting where clients feel safe enough to try out and experiment with their internal impulses, until they receive proof: proof through an immediate response while drawing, or through inner and outer events, proof that "I am on the right track."

Below I share two case histories. In the first one, I had hardly any input, whereas in the second one, I was very directive.

## Nondirective Guidance

I would like to illustrate inner guidance with the following case history. It represents the drawings of a middle-aged woman. She attended a workshop with sixteen participants. We had one group session of three hours. The workshop was structured in a way that after a brief introduction, participants

would draw and paint for up to fifty minutes in silence. Later some individuals would spread out their drawings on the floor and share their experience with the group. My role would be highlighting, questioning, or assisting along the way.

The following pictures are a complete record of the third group session. All of them are about 24 by 32 inches in size. All six drawings were created in one group session, entirely self-directed; there was no intervention from a therapist during the period of creating her paintings. I shall call her Maryann.

At this stage Maryann had experienced two prior workshops of a similar format with Guided Drawing. She had developed a basic trust in the group process and in her own. She had understood the focus on the body

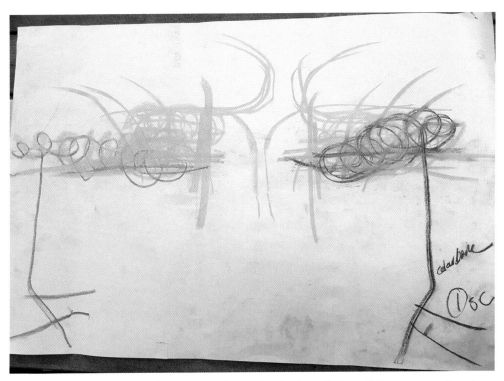

FIGURE 3.1. At first, Maryann focuses on a "sensation in the collarbone." Her arms are hanging down at her sides with her fingers emphasized in a childlike manner. It is a fragmented, dissociated body image. There is no inner ground and no spine. She is literally up in the air and just holding herself together in the shoulders.

Such dissociated body images appear frequently when clients have experienced complex trauma. The inner ground, as the pelvis and abdomen, is not experienced as something trustworthy or even "there." Instead this instability deriving from lack of internal grounding is overcompensated by holding oneself up and together in the shoulders. It is a survival attitude that allows us to function in the world. It is, however, a lifeless construct that lacks the juiciness and fullness of life.

and the idea of applying a massage. She had also learned a couple of basic movements, such as flicking strokes to release tension, or tender circulating movement to contain. I tend to support the body focus of each session with a brief meditation exercise at the beginning, where I encourage participants to pay particular attention to any bracing and tension in the body, and to notice where they experience flow and relaxation.

In order to understand Maryann's process, I will add a few details about her biography. She is in her fifties. Her mother was sixteen when she gave birth to her, temporarily hidden away in a convent. Both biological parents were from upper-class families, and this pregnancy was considered a shameful accident. Maryann was then given up for adoption and raised in a farming family. Maryann has spent much of her life trying to find information about her birth parents. Being adopted is a traumatic way to begin one's life journey. Her mother would have been highly stressed and

FIGURE 3.2. She applies a massage to ease her physical state according to the instructions for the group. "Bringing the fingers up, sending sensation to the hands." She focuses on her hands, and they seem to come alive, even though it is with an undecided, reluctant scrubbing movement that oscillates between impulse and inhibition. From there, she draws up along her spine and releases the tension in the shoulders. She repeats this several times. The group has been shown this motor impulse as an option.

unhappy during the pregnancy. After birth, Maryann was held in hospital for several months, in case her mother changed her mind. Such attachment trauma makes for a fragile connection to the inner ground. Maryann is shy and sensitive, and tends to make herself invisible; she is easily overlooked in the group.

I always like to look at the starting point of a drawing process. She has moved from dissociation into vibrant embodiment, all within fifty minutes of self-directed massages.

Maryann's drawings are an account of the ordering forces of inner guidance. She began with a diffuse sense of self, where she is dissociated from her body and lacked a sense of vitality. Just her arms and shoulders appear like a lifeless construct. As she applies her massage movements with a focus on what she needs, increasingly her lower body becomes alive; libido begins to flow, and a sense of wholeness emerges.

FIGURE 3.3. The tale of the Handless Maiden illustrates the archetype of the disempowered feminine.[6] Here, Maryann's hands quite literally gain their ability to handle life situations. This is empowering. "Fingers are spreading energy." Her focus is still on her hands. She can now actively respond to her needs. The tracking of sensations, evoked in the previous drawing, is pictured as horizontal vibrating lines. Their location is in the middle of the sheet and thus suggests the middle of her body. Her diaphragm comes to life. She then draws upright tentative verticals, many of them, to "spread the energy."

FIGURE 3.4. Maryann now takes finger paints and becomes bolder in her massaging: "Spreading energy with paint. Feeling whole." It is visible how much body she has gained. The top part of her body is still stronger than the base, but there is a base now. The inner emptiness apparent in her first drawing is filled with vivid liquid movements that make her feel whole.

FIGURE 3.5. Maryann begins with retracing the structure she has gained in the previous drawing with yellow crayon. With two blue circles, she brings in movement, fullness, and connection. She calls it "Spreading the energy, feel movement." There is rhythm now, and flow. She connects top and bottom, and at the end adds two little wings where her collarbones have been paining her before. They feel light now.

Her process illustrates what these days is called the bottom-up approach, where she initially draws tentative motor impulses, related to her felt body-sense, that reflect her diminished sense of self. By listening to her needs and following these inner sensory prompts, she can increasingly counteract what drove her out of her body in the first place. She reclaims her hands and with them her power, which in turn enables her to draw and paint an active response to her inner needs. At the end of her session her autonomic nervous system discharges long-held tension from the brain stem, where incomplete stress responses can be held for decades. It is discharged as a vibrating flow from the base of her spine. Such a release has a lasting effect; it resets the balance in the autonomic nervous system. You will hear a lot more about this in the following chapters. This is how we move from survival to living. Toward the end of the session, Maryann arrives at clarity, blossoming vitality, and embodied meaning.

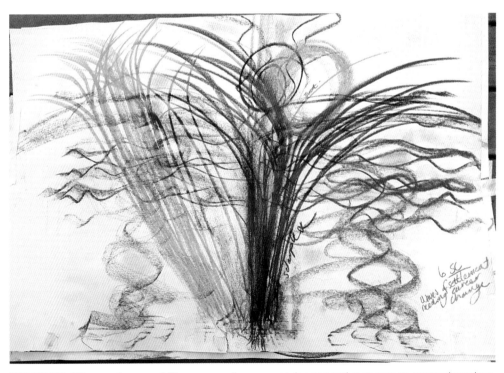

FIGURE 3.6. "Waves of energy." These wavy lines are no longer active massage motor impulses, but they picture the vibrating flow from the involuntary motor division arising from the autonomic nervous system, which appears when deep healing occurs. From there she stands erect in the full glorious flow of her energy.

# Directive Guidance

The following six drawings represent one individual session with a middle-aged woman. She had driven close to three hours to come to the session. She arrived crying, expressed suicidal ideation, and mentioned marital problems and trouble with her teenage children. She was overly emotional and lacked self-esteem. She would have needed long-term therapy if we wanted to address all the issues she shared within the first few minutes. However, it was also clear that she lacked the financial and logistic resources to do so.

For clients in such a state of being overwhelmed, a nondirective style can lead to even more overload. So I quickly decided to strengthen the structural ability within her and not focus on the trauma story she was troubled by. I wanted to assist her in building resources and not open up even more wounds.

One way of facilitating this approach is to pick a particular shape that will provoke structure and confidence in the client. I explained to Julie (not her real name) that she could only draw verticals, as a symbol of her spine, her backbone, and her uprightness. And in addition, that she could release to the sides in horizontal strokes whatever weighed upon her, whatever was crushing her. In this case she would have to draw with both hands up her spine, and where she met with inner tension or pain, she would have to draw a corner and release the troublesome issue to the sides. Drawing corners provokes decision-making; corners do not happen, they have to be consciously and intentionally executed. In Guided Drawing, the vertical is related to the spine in the body, and associated with it are the ego, self-esteem, and our sense of identity. The vertical represents our backbone, our ability to be upright, to stand up for ourselves, to be visible. It develops as we move as infants from crawling to walking. This is simultaneously the stage when children begin to emerge from the oneness with their mothers and begin to discover a separate identity: me.

My suggestion to draw verticals and corners inspired Julie to a series that gave her increasing confidence. She only needed to see me one more time for a second session to "recharge." The six pictured drawings were all created in the first session. Again, the paper size is A2, approximately 24 by 32 inches in size.

After every drawing, I asked her how the drawn shapes resonated in her body. I then supported her to frame the body sensations she had discovered in the process as affirmations starting with "I am …," which is a Gestalt therapy technique. In this way, she could perceive each sequence of drawn motor impulses as a renewing sensory experience and then integrate these felt sense experiences through forming cognitive meaningful insights.

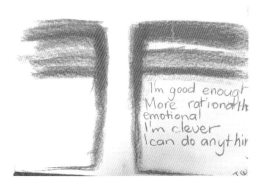

FIGURE 3.7. "I'm good enough; more rational than emotional; I'm clever; I can do anything."

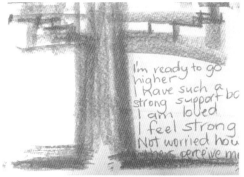

FIGURE 3.8. "I'm ready to go higher; I have such a strong support base; I am loved; I feel strong; not worried how others perceive me."

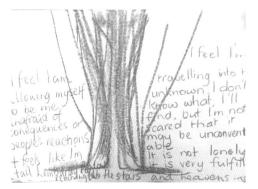

FIGURE 3.9. "I feel I'm allowing myself to be me, unafraid of consequences of people's reactions. It feels like I'm tall, a poplar reaching to the stars and heavens; I feel I'm travelling into the unknown; I don't know what I'll find, but I'm not scared that it will be unconventionable; It is not lonely; It is very fulfilling."

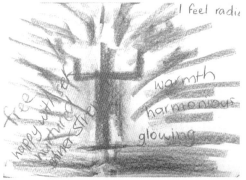

FIGURE 3.10. "I feel radiant; free, happy with myself, nurtured, inner strength, warmth, harmony, glowing."

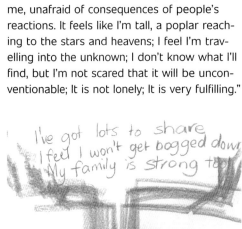

FIGURE 3.11. "I've got lots to share; I feel I won't get bogged down; My family is strong."

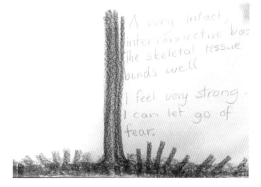

FIGURE 3.12. "A very intact interconnective base. The skeletal tissue binds well. I feel very strong; I can let go of fear."

All her affirmations, off course, suggest the tendency in her life to be fearful, to get bogged down, to not be good enough, and that it might be concerning what others think about her. Her ability to draw the vertical with such strength and clarity, though, indicates that she is capable of facing and handling her difficulties. She picked the same bright orange crayons for all drawings. My initial invitation to draw her spine resonated through both sessions. There are variations, but basically, she embraced the given structure. Her motor impulses are clear; her sensory perception is accurate and helps her modulate her emotions; she finds meaning and hope. Again, it is bottom-up from body-based motor impulses to sensory perception and cognitive integration. How beautiful is that last drawing? She stands her ground and the entire space around her has become available; nothing weighs her down anymore. It took just sixty minutes.

# 4

# Instincts Made
# Visible through
# Archetypal Shapes

The therapist has the option of structuring the Guided Drawing experience through interventions that may suggest the drawing of certain shapes based on the knowledge of their archetypal and body-related qualities. Different to the quite common assumption that an archetype represents an image, Jung defines *archetype* as an instinct. He linked origins of the human mind to the biological, prehistoric, and unconscious development of our archaic ancestors, whose psyche was still close to that of the animal: "This immensely old psyche forms the basis of our mind; just as much as the structure of our body is based on the general anatomical pattern of the mammal."[1]

According to Jung, who coined the term *archetype,* the imagery is secondary, each culture illustrating this instinct in a certain way.

> The term "archetype" is often misunderstood as meaning certain definite mythological images or motifs. But these are nothing more than conscious representations; it would be absurd to assume that such variable representations could be inherited.... Man's unconscious archetypal images are as instinctive as the ability of geese to migrate (in formation); as ants forming organized societies; as bees' tail-wagging dance that communicates to the hive the exact location of a food source.... Here I must clarify the relation between instinct and archetypes: What we properly call instincts are

physiological urges, and are perceived by the senses. But at the same time, they also manifest themselves in fantasies and often reveal their presence only by symbolic images. These manifestations are what I call the archetypes.[2]

This quote is not only interesting in the context of how Jung himself understood archetypes. His definition clearly states that archetypes are not primarily images in the way many then and today like to interpret them. Such imagery could be viewed as culturally specific interpretations of the underlying urge, which is instinctual. Erich Neumann, for example, wrote specifically about the many facets of the Great Mother archetype, taking on over three thousand years of art history.[3] Our ancestors prayed for their survival to life-giving fertility goddesses with multiple breasts and tried to appease their devouring blood-hungry death aspect with sacrifices. Jung tries to express something in his text that we today would call impulses arising from the brain stem, which stores our survival patterns and our limbic system, which is the seat of our emotions; these are the physiological impulses concerning our instinctual response to life and death. In order to understand these brain stem-based physiological urges, and in order to cope with the challenges of life and death, we have translated these impulses into our prefrontal cortex as symbolic imagery. Every culture over the last five thousand years would have found its own specific translation of our instincts into a language of collectively understood symbols. Seventy years ago, there was no neurological link to psychology. I also had to transition to these new paradigms. The core then and now, however, is the same; it is working with instinct, with embodied responses that reside at the core of our being, especially so, when we work with trauma, because trauma triggers brain stem–based instinctual survival responses. For me, it is also the reason why, over the decades, Guided Drawing has proved to be so effective and timeless.

The rhythmic bilateral approach to Guided Drawing is able to connect with our instinctual physiological urges. The drawn repeated movements manifest as primordial patterns, such as the circle and the spiral, the vertical, the rectangle, and the cross. These shapes are archetypal patterns underlying all existence, and all can be found throughout nature. All can be filled with life, with symbolic meaning. All have been used in the intertwined history of religion and art, reaching back to prehistoric times. As a drawing language, it taps into an underlying order in the human psyche that we have universally embodied: we are all born from a womb, the circle; we are all designed to walk upright, the vertical. However distorting and damaging our biography

may have been, connecting to these archetypes with a noncontrolling mindful presence can restore inner order.

For example, once someone starts drawing a large circle on a big sheet of paper, going around and around and around and around, this client is likely to experience that such a movement can evoke feelings ranging from pleasure to panic. One individual might experience the roundness as a securely engulfing, loving, and nurturing womb (or hug, or nest, or egg); for another it may be enclosing, restricting imprisonment, even an inescapable threat. Both are facets of "the round" as a symbol of the Great Mother archetype. Both are also an expression of implicit early attachment patterns, should we take the developmental psychology perspective. Or, in the context of complex trauma, they will illustrate a client's core experience of safety or threat. Other movements evoke other patterns, with, again, different emotional qualities attached to them.

Guided Drawing can be perceived as purely body-focused, or as an outlet for emotional charge, or as a medium to create images—whatever offers individuals access to their inner world. As clients progress, body sensations, emotions, and their mind and spirit begin to connect, forming an integrated narrative.

In Guided Drawing, the archetypal shapes are divided into two categories:

- *Round,* rhythmic and flowing with a female or yin connotation; such shapes are associated with both

  - the unconscious impulses of an unaware, sleeping state of mind, or

  - the being states of meditative, transpersonal experiences that are characterized by a noncontrolling, witnessing presence.

- *Linear and angular* shapes with a male or yang connotation; these are more associated with intention and a conscious impulse. For example, in order to draw a corner, one has to make a decision to change direction, which requires conscious, intentional execution.

Neither category is gender based; they are relevant for both men and women alike. In Buddhism, these two categories would be called yin and yang, the passive and the active principle. All shapes have their embodied equivalent. For example, the circle is the primary female form in this context. It endlessly flows around and around. Images associated with it can range from being contained inside an embrace or an egg; being stuck in a vicious cycle, a merry-go-round, or a tunnel; sucked into a malicious vortex; to an explosive bomb of emotions.

FIGURE 4.1. The circle as love and hugs.

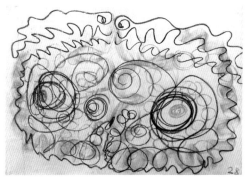

FIGURE 4.2. The circle as emotional turmoil.

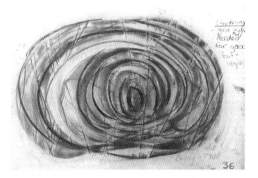

FIGURE 4.3. Circles as composting shit.

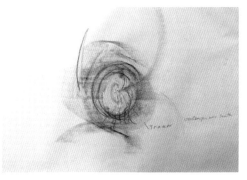

FIGURE 4.4. The circle as "womb."

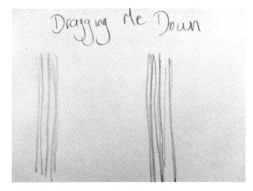

FIGURE 4.5. The vertical dragging me down.

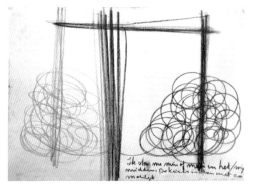

FIGURE 4.6. The vertical weighed down.

At the other end of the spectrum, the circle is perceived as a mandala, as wholeness, completion, unification, and all-oneness. In the body, the circle is primarily associated with the belly and the pelvis, but also being fully contained inside an aura or womb. The circle is closely associated with the Great

Mother archetype in all her multitudinous manifestations.[4] Circular movements reflect attachment styles—our sense of being held, of being safe and connected to loved ones; they are also linked to the flow of emotions and their modulation. Other shapes with a female-yin connotation are the bowl, the arch, the spiral, the figure eight, the infinity symbol, and the wave.

In contrast, the vertical is associated with the hero archetype.[5] In the vertical, our struggle with identity becomes manifest. It is considered the primary male yang shape, reflected most notably in the body as the spine. We experience it in our uprightness, as phallic power, and as our ability to act with an intention, to focus on a goal. Identity, what we stand for, what lifts us up, and what upsets us will show up in the way a vertical is drawn. Can ideas and decisions confidently fly off into the distance as arrows, or are such impulses thwarted, oppressed, cut down, crushed, and shamed? Low self-esteem inevitably manifests as a lack or even inability to create an upright line. Many verticals are drawn in a continuous up and down scrubbing movement, making an eternal "yes, but ..." struggle visible: "I want to, but ..." Anger can be released in lightning strikes; one can use boxing or punching

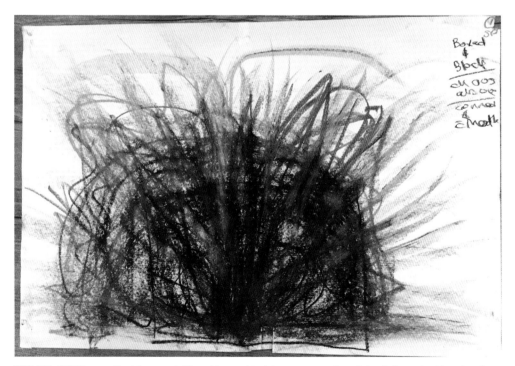

FIGURE 4.7. The vertical trapped: Here the vertical is oppressed, weighed down by the shoulders as an arching movement. The client experienced herself as boxed in and unable to express herself. Her frustration is clearly visible in the charged line quality.

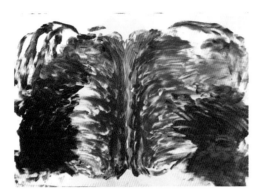

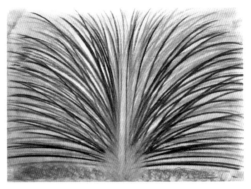

FIGURE 4.8. Liberating the vertical.         FIGURE 4.9. The vertical released.

movements with fistfuls of crayons releasing a fight impulse, or run on the paper in flight mode. Other shapes with a male-yang connotation are horizontal, lightning bolt, cross, triangle, rectangle, and the dot.

All these shapes are drawn in rhythmic repetition and with the focus on the inner experience of related body sensations. The closed eyes have the purpose of discouraging a visual focus of making art, getting it right, and looking beautiful. The therapist can enhance or clarify the client's focus by suggesting certain shapes to draw. Such interventions might propose to release pent-up muscle tension and the encapsulated emotion through letting go rather than holding on at the end of a line. They might suggest finding a rocking bowl-shaped movement in order to soothe emotions and to calm down. Each time, such interventions need to be tested and modified through repetition until they feel right for the client and bring relief.

One of the core benefits of Guided Drawing is that any of the above-mentioned primary shapes can be used as nonverbal body-focused intervention tools. The therapist has the option to suggest particular shapes to counteract destructive habits. Many clients suffering from complex childhood trauma have actually never felt good about themselves. They may not know the body sensation of walking confidently upright. Rather than repeating and thus emphasizing a destructive internalized behavioral pattern, it might be beneficial if the therapist offers a new option to life. In her pilot study on sensorimotor interventions with children who have experienced complex trauma, Lauren Hansen emphasizes that such interventions must be repetitive in order to compensate for the incorrect development of the neural pathways; only repetitive stimulation is capable of redirecting neural development.[6] Sometimes just a single alteration in the direction of the movement

can bring change, for example where clients have a tendency to direct their anger against themselves. In drawing, this is usually expressed as lines pointing inward or downward. Acted out with force, this can be utterly destructive, similar to knives being stabbed into his or her own abdomen. Thus, the therapist may suggest reversing the movement so that motor impulses start at the bottom of the page and go up and out. This simple change of direction can encourage a distinctly different felt sense. A "sup-pressed" issue might come alive. Old "im-pressions" can be "ex-pressed." "De-pressed" vitality might erupt in anger, but also as abundant, unstructured energy that needs to find direction in a constructive way.

At the core of Guided Drawing's effectiveness is the feedback loop between sensory perception and motor impulses that respond actively to these sensory experiences. Such motor impulses then create new sensory impressions, which again can find expression in drawn action patterns. Similar to children's learning patterns, repetition serves to integrate solutions. Children will repeat certain motor impulses, such as learning to walk or sorting building blocks, for weeks until they have integrated the desired step forward. In Guided Drawing, this feedback loop serves to find a way from "dis-ease" to healing, from pain to relief. Clients oscillate between a place of discomfort in their body and then endeavor to find, guided by their felt sense, an adequate response in their movements on the paper. The focus is not on "What happened?" but on "What do I need?" It is on finding embodied solutions. Each drawing reflects this inner dialogue. Each drawing mirrors inner body sensations. Drawings mirror the impact certain life events have had on individuals. They picture the motor impulses we needed to brace against adverse encounters. On paper we can trace how they shaped us and then sense how to undo them. Since there is usually a series of drawings, a visible process is created that reflects the progress. This establishes a continuum of increasing depth of self-experience.

Some clients even like to continue on their own afterward at home. Thus it happens that after a few weeks easily more than one hundred drawings document the inner proceedings, which can be encouraging and revealing.

The process is not unlike any other therapeutic encounter, except that an important part of the procedure becomes and remains visible. Especially with subtle changes, or issues one finds unbelievable, unacceptable, or unspeakable, this visibility can be helpful, as the drawings "prove" and document the event. They reflect the journey; they can inspire and provide enormous support.

# 5

# Body Perception

I frequently refer to Guided Drawing as a form of body therapy. Crayons or finger paints can be used to massage the back, to relieve tension in the stomach, to help grounding oneself. In later chapters I shall relate the primary shapes closely to aspects of the physical body. The shape of the bowl, for example, relates to the shape of the pelvis, and the arch relates to the shoulders, the vertical to the spine. Guided Drawing supports the drawing of motor impulses and just as much the sensory perception of these as they change and cause shifts in the felt sense. How do these action patterns resonate in the body? Healing arises from the feedback loop of perception and expression. It involves sensing and expressing the inner movements of the muscles, the breath, and also the motion of the emotions, and then witnessing the associated thought forms in a nonjudgmental way.

In accordance with many different schools of thought, I relate the physical body to an individual's mind and spirit. All three are closely interconnected and continuously influence each other. Even colloquially we refer to someone with a broken heart, having a gut-wrenching experience, being scared shitless, or that something happened that made one's skin crawl. We scan others' body language for clues of approval or rejection. Eyes can smile, but looks can also kill. Our sense of smell and taste is hardwired to attraction or disgust. Self-esteem or its lack is communicated to the world through body postures; we proudly beat our chest or are hunched over trying to be invisible. Many of these behaviors are a reminder of our evolutionary heritage: we

are at the core human animals. Instinct plays a much bigger role in our lives than our sophisticated minds are comfortable to admit.

Psychosomatic medicine was the forerunner to what has become an increasingly accepted paradigm in recent years, that there is a close link between the brain and the body. Trauma experts such as Bessel van der Kolk, Bruce Perry, Peter Levine, Steven Porges, Babette Rothschild, Robin Karr-Morse, Meredith Wiley, Laurence Heller, Pat Ogden, and many others from the medical, psychiatric, psychological, and neurophysiological field have done groundbreaking research or developed new healing modalities in order to address post–traumatic stress disorder (PTSD) and the link between childhood trauma and behavioral and learning difficulties.[1] We understand with greater clarity how these stressors in the long term cause physical and mental illnesses. They have proved what we have intuitively known all along: that destructive mind-sets and emotional stress make us sick; how false self-images cause false body postures. At least neuroscientists and developmental psychologists no longer believe that "bad genes" make bad people; there are, however, most certainly bad life-experiences, which shape our brain to the extent that they eventually become our biology.

The neurosciences have helped us to understand how the brain is wired from the moment of conception onward to assure our survival as much as possible under the given circumstances. Karr-Morse and Wiley state:

> While it is almost impossible to imagine, there is growing belief that even before the fertilized egg becomes an embryo, critical decisions have been made that will forever influence adult physical health. Long before it lies suspended in its liquid chamber of the mother's womb, the prefetus[2] is engaged in a dynamic, chemical conversation with the mother.[3]

This conversation takes place when most women don't even know yet that they are pregnant. Epigenetics have found a correlation between malnutrition of the mother's mother and diabetes and heart disease later in life in her child.[4] Maternal stress during pregnancy profoundly affects babies. Anxious, chronically stressed, or depressed mothers give birth to anxious and overly stressed babies.[5] What then follows is the dance of the mirror neurons that shapes the attachment patterns between mother and child. Infants and toddlers are totally dependent on their caregivers for their physical and emotional survival. They need their caregivers to regulate their tiny and fragile nervous systems through rocking and holding them, to calm them when they are upset. Babies will adapt to any pattern of behavior their caregivers

model for them, unquestioned. If there is love, they will learn love. If there is neglect, they will learn neglect. They do not know any different. Caretaker abuse has repeatedly been described as the worst option for life. When the most loved human being in your life is also the most feared, unbearable emotional dilemmas ensue. And children do not understand that their mothers or fathers have problems, and that what happens to them is not their fault. When children feel bad, they think they are bad. Nervous system dysregulation in young children due to their dysregulated caregivers creates the formation of fixed identifications that become confused with identity. We embody patterns of behavior from the onset of our development. The vast majority of these patterns remain unquestioned; they are not conscious.

> Securely attached children learn what makes them feel good; they discover what makes them (and others) feel bad, and they acquire a sense of agency that their actions can change how they feel and how others respond. Securely attached children learn the difference between situations they can control and situations where they need help. They learn that they can play an active role when faced with difficult situations. In contrast, children with a history of abuse and neglect learn that their terror, pleading, and crying do not register with their caregiver. Nothing they can do or say stops the beating or brings attention and help. In effect, they are being conditioned to give up when they face challenges later in life.[6]

There is an interesting documentary by two French filmmakers called *Babies,* in which they follow four infants from birth to their first unassisted steps.[7] There is no commentary or dialogue in the movie; it is the nonjudgmental observation of an American, a Japanese, a Mongolian, and a Namibian baby and how they learn to be in the world. How does the little Tokyo girl adapt to a megalopolis full of beeping colorful electronics, and how does the deserted Mongolian steppe, with a very different kind of vastness, shape the young boy, who spends hours on his own in a yurt, with just the company of some chickens and a goat. It is fascinating, in particular knowing that we have all grown up in our own unique way, internalizing without questioning the paradigms that surrounded us, learning patterns of behavior we now call identity.

Perry speaks about sequential development of the brain, which organizes itself from the bottom up.[8] Infants learn brain-stem survival first; in utero, for example, their cardiovascular and respiratory systems need to become fully functional. In the first year of life, their survival depends on food, warmth, and affect regulation, for which they are totally dependent on an external

caregiver. Gradually the limbic and cortical areas come online, each within the framework of a particular neurological developmental stage.

Early childhood events happen at a time when we are preverbal and our capacity to orient is still undeveloped. Especially when dealing with complex childhood trauma, we have realized that talk therapies have little ability to touch on these internalized, embodied patterns of identity, even though they have shaped how we feel and think, how we communicate, how we choose partners, how we nourish ourselves, and which diseases and addictions we will develop. When such patterns are dysfunctional, they can only be undone through offering new patterns that are as body-based and attuned as the old ones. Only these sensorimotor approaches can reach the brain stem and the limbic system, where such learned behavior is stored.

Over decades of empirical research of work at the Clay Field, we observed three core stages in preverbal sensorimotor development in children:[9]

1. **Sense Skin,** which develops from birth until twelve months of age; it encompasses the whole complex of secure attachment with the primary caregiver. Safety, love, and soothing are communicated through being touched. Skin-to-skin contact while being held, rocked, nursed, and cooed to is essential. Without it, babies actually die. When the mother is dysregulated herself, infants suffer serious developmental setbacks and develop insecure or avoidant attachment styles. The babies' perception is global: they primarily perceive through the skin, as it contains their entire body. Initially, touch has to come from the outside in order to wake up a rudimentary sense of self internally. Perry's research revealed that the sensitive brain area that develops during the first nine months of age is the brain stem, where we learn how to regulate arousal, sleep, and fear states.[10]

   In Guided Drawing, attachment needs in adults and older children can be satiated through finger paints. Insecurely attached clients often cannot touch the paint with the full hand, but rather just use one finger. It can make a difference if the therapist pours paint into the clients' hands with the assumption that babies need to receive; they are too little to take anything by themselves. To then simply move in full contact with the paint on the paper, to cream the hands and underarms, brings sensory delight and deeply satiates this early need for contact. There will be no imagery here, no deliberate movement, but a rhythmic, often rocking self-soothing, slow-moving discovery of

safe contact. Another age-specific option is the patting and splashing of the paint, similar to a six-month-old infant left with mashed potatoes. Essential is to have lots: lots of paint, lots of time, lots of attention and care from the therapist. This will satiate a vital need of *being,* being alive, being safe and welcome in the world.

Maryann's drawings in the previous chapter are an example of how finger paints can fulfill early infancy needs. Janina was the sixth child out of seven, and was primarily raised by her sister, who was nine years older. This left her with a lifelong sense that others always had more, that she was not good enough, and she had a fundamentally insecure sense of self. In her session, she mixes an abundant amount of pink paint, which she then applies with slow rhythmic rocking movements on the paper. The ensuing inner sensation leaves her dreamy and "happy for days."

2. **Balance** develops between the ages of one to two. Toddlers are now able to walk and move away from the mother. They are curious about the world around them, but still have limited ability to orient and overview their surroundings. Events can easily become very scary. As toddlers walk, they use their arms for balance. Their core discovery at this developmental stage is the spine as an inner axis of their own, which separates them from others. The spine is associated with an embodied sense of identity. Children are now aware of their name, for example, and have tantrums over certain wants that differ from those of their caregivers. They need to integrate multiple sensory inputs and begin to develop fine motor control skills. The limbic system begins to come online and needs the caregiver's support for the regulation of emotional states. Parental union manifests in children as an inner sense of balance. Divorce or the absence of a parent, either through death or departure, as well as constant quarreling and fighting between the parents, creates imbalance in children. As a result of such stressors, they often cannot coordinate hand movements, or use only one hand; both affect the coordination between the brain hemispheres and the communication of neurons across the corpus callosum. Bilateral rhythmic drawing exercises help to stimulate the brain to reorganize itself, and they are able to strengthen the spine in its uprightness.

Cath, a middle-aged female client of mine, suffered from type 1 diabetes, which she developed at eighteen months of age. From then

on, her mother had to administer injections several times per day in order to stabilize her insulin level. Otherwise she would fall into a life-threatening coma. Her food intake was severely regulated, which affected her social contacts, because she always had to be supervised during lunch break at school or while attending friends' birthday parties. She was deeply traumatized and shut down when I met her. She had no idea what she wanted and needed outside her still rigidly monitored daily routines. She could not feel her body at all. During her therapy, she invented a deeply satisfying way of drawing bilaterally, while sitting on a swivel chair. As she swung on the chair from left to right, she held fistfuls of crayons and marked her swinging movements on the paper. This playful rotation around her spinal axis in a rhythmic fashion enabled her to finally emerge out of tonic immobility; it satiated the developmental need of the eighteen-month-old toddler in her. It also enabled her to have temper tantrums with the crayons, which finally brought her into contact with what she wanted and needed.

3. **Depth Sensibility** develops between the ages of two to four in children. It involves developmentally the skeletal and muscular organization in the body, so we can have an impact on things. At the Clay Field, children learn this through pressing their hands down, pushing the material away or pulling it toward them, and making imprints. In order to do so, they have to coordinate their muscles and joints from the neck down into the feet. Children learn these motor skills naturally through, for example, play fights with their fathers, siblings, and friends. To be able to organize the body in a way so it can make an impact in the world gives kids a sense of power and competence. They can now *do* things. If traumatic events interrupt this developmental stage, it leaves children with puffy, easily collapsed joints and a frustratingly disempowered sense of self. This incompetence impacts significantly on their self-esteem. We have found that the behavior of children diagnosed with attention-deficit hyperactivity disorder (ADHD) improved noticeably when they were shown motor skills that involved the organization of the skeletal and muscular system of their entire body while they were encouraged to move several pounds of clay in the Clay Field. The development of these motor skills and the praise for being "so strong" and capable made an enormous

difference; it helped them to gain an embodied sense of power and capability. These motor skills are the prerequisite foundation, so children can later actually build and make things.

In Guided Drawing, this can be encouraged through standing up and making handprints on the paper using paint. Attention is paid to the outstretched arms, strength in the wrists, the alignment of the elbows with the shoulders, then down the spine into the hips, knees, ankles, and feet. Clients, adults and children alike, are encouraged to use the entire body to make an impact. In a similar fashion the base of the hands can be used to push paint away, honing defensive action skills.

These three core stages of early childhood development shape our implicit memory in the brain stem and the limbic system. They determine unquestioned how we feel and which felt sense we associate with "identity." The neglected infant or the abused toddler will have no story to tell when they start school or as adults in therapy; they will simply feel bad, stupid, weird, and unlucky or undeserving. Because their right brain is disorganized, they will frequently experience emotions hijacking their thinking and left brain good-behavior strategies.[11] Their nervous system will be dysregulated to the extent that they will feel either shut down or jumpy and easily triggered. Because they feel bad about themselves, they will attract further bad life experiences, which compound on the earlier trauma until a complex web of dysfunction makes them physically sick, or mentally ill, addicted, or delinquent and antisocial. Because the neglect and irregular development of the brain occurred at a young age, the growth of more complex regions will continue to be abnormal.[12]

From around three to four years of age, the left brain comes online, and with it the cognitive skills of the cortex. Only from now on will children engage in rudimentary image-making and commence being able to create meaningful symbolic representations. From now on, they have words and can tell their story. If this sensorimotor base—developed through skin sense, balance, and depth sensibility—remains incomplete, it makes for a fragile base for all further development. In that case, clients lack the vitality of an embodied self and instead feel that they never get enough, or they are not wanted in the world (skin sense) or they can't coordinate opposites within and in relationships and have fragile self-esteem (balance) or they lack the skills to make things happen (depth sense). Much is then compensated

through fantasies, but the vital realization of such ideas is compromised. Most art therapy activities have their emphasis on the image-making process. When working with complex trauma, however, it is crucial to address the underlying sensorimotor issues in order to reach the developmental needs of clients' early childhood. All approaches that allow for rhythmic, bilateral, body-focused action patterns, such as bilateral drawing, but also drumming and dancing, martial arts, and bodywork, are able to repair and reorganize implicit memory in the brain stem.

The ancient traditions in India and China have always known this and have developed body-focused therapies such as yoga and martial arts, which are emerging with renewed appreciation as effective trauma therapies thanks to Van der Kolk and others, who are not worried about the "alternative" label. Dancing and chanting and drumming are part of all indigenous peoples' healing rituals. These are events where the community with others is strengthened, which gives safety and rebuilds trust. Trauma is isolating, so to be welcomed into a group rather than feeling ostracized is healing in itself. African drumming circles, Hindu chanting groups, Aboriginal dancing cor- roborees—all these rituals celebrate repeated bilateral rhythmic patterns that connect individuals to ancient healing traditions. The shaman will "call back the spirit" that has taken flight in terror, rather than treat a dissociated patient with drugs or through cognitive processing, which would be our Western clinical approach.

There are many body therapies, such as Feldenkrais, Rolfing, bioenerget- ics, the neurosequential model of therapeutics (NMT) by Perry,[13] Somatic Experiencing, and the recently developed neuroaffective relational model (NARM)[14] to treat dysregulated attachment styles. All these have little in common with a resort spa-style muscular massage, but they implicitly include the psyche of a client; they foster sensory and somatic awareness around psychological issues. Just like no serious body therapy can treat the body separately from the individual that lives in it, no deep psychological process can be experienced separate from the body.

The body is not a thing; it is not an object. Living is about *being* in my body, not about *having* one. My teacher Dürckheim used to express this as: "The body I am."[15] He defined *Leib* as an entity of body, soul, and spirit. It is not a functioning mechanism that can be treated like a car—filled up with fuel, cleansed, and occasionally repaired—though many drive themselves in that fashion. Instead, this *Leib* has sense; it gives meaning as an organ of

perception. Sensory awareness "makes sense" of things; it gives life meaning in holistic structures that go beyond the intellect. Deep awareness of the senses creates a body consciousness, which sees individuals as incorporated spirit.

Deep sensory awareness is capable of opening up multilayered perceptions of our selves. There is the outwardly perceivable body we can look at in the mirror. There are the physiological states we can perceive on the inside, such as our heart rate or feeling hungry. Closely connected to these inner perceptions are our emotions, and some schools speak of an emotional body.[16] We also all know how we can walk and act in our dreams, while the physical body lies motionless and asleep. This dream body is no less real than the one we inhabit. It can be experienced in waking states as well. Houston calls it the kinesthetic body (from the Greek *kinema,* "motion," and *esthesia,* "sensing").[17] It is the body image encoded in the motor cortex of the brain, but which is experienced as the felt body of muscular imagination. Athletes and musicians, for example, know the experience of the kinesthetic body well. They are able to rehearse inwardly their respective skills when they are not actually performing. They are often able to experience this kinesthetic rehearsal as vivid as the actual physical engagement. We do the same when we watch sports events, movies, or theatrical performances; if we are engaged, we will feel kinesthetically that we are actually participating in the event. Thus, a football game or an adventure movie can leave us physically elated or exhausted. In the same way, good actors have the ability to stimulate our mirror neuron system to the extent that we can be moved to tears, or shake in terror, or laugh out loud while we watch a movie. We live their dramas vicariously, while we sit motionless in our cinema seat.[18]

Then there is the whole area of body memories. I once participated in an interesting workshop at a conference where the facilitator guided the group through childhood memories entirely based on remembering the touch and texture of particular clothes: How did your first bathing suit feel? The first bra? The first sanitary pad? Everybody knows how vivid such memories can be, how some experiences can be fully recalled: one's changed size, or younger age, the smell of certain places, and the emotions and sensory perceptions attached to such events. I have had a number of adult clients over the years who recalled sensory memories such as being a baby in a high chair wearing nappies. I have witnessed over the years two male clients who experienced and drew themselves as being pregnant. For them it was a very

real body sensation, but at the same time it could not possibly be a memory. Sometimes such memories are welcome, when a song on the radio triggers a romantic scenario from the past. Flashbacks, however, can be deeply distressing and confusing memories over which we have no control.

Yet, the body remembers, "keeps the score," even when we are anesthetized. In our Somatic Experiencing training, I have witnessed therapy sessions in which clients processed step-by-step surgical procedures in order to recover from invasive operations. I have worked with rape victims who were drugged but whose bodies clearly remembered the events. Such therapy sessions do not have a cognitive story to tell but are a collage of sensory impressions that arise from the inside. Levine states that in order to move out of tonic immobility and dissociation, clients need to find an active response to what has happened to them.[19] These responses are deeply embedded in the sensory imprints. If we can listen to the subtle shifts within and take them seriously without judging them, motor impulses will arise that show us the way. Only then can we "re-member" what was split off. The frozen shoulder will begin to flow with life again. The numbness in the pelvis will lift. Such re-membering of our somatic biography does not necessarily have a story, and Levine emphasizes that at times it is futile to attempt getting the story right, because when we were terrified and overwhelmed, our perception was too confused to get the full picture. We need to find, however, the motor impulses within that get us out of being scared stiff. Many rooms in our body are scarcely lived in because of the terrors locked inside them. We shut up the fears and never again dare to enter those rooms. Similar to the girl in the tale of Bluebeard, we have to open the forbidden door, encounter the pain and fear behind it, and deal with it if we want to become fully alive.

Ayurvedic medicine works with a system of ten senses: five outer and five internal ones. Each outer sense has its equivalent on the inside. These inner senses are subtle and traditionally require yogic training to develop them as conscious skills. In this way, we can, for example, come to the so-called opening of the third eye and become clairvoyant. These inner senses are designed to perceive a "subtle body"—some will use the term *astral body* or what in the Christian context is called "soul." Eastern traditions that date back thousands of years have based many of their healing modalities on this subtle body. Life energy, which in China, Japan, and Korea is called qi, flows through the meridians, an elaborate system of energy pathways similar to the vascular system or the network of neural pathways in the physical body. The medical

manipulation of the flow of qi for healing purposes is called acupuncture. The activation of the flow of qi is practiced with martial arts such as aikido, kendo, judo, karate, or as a movement meditation in taiji. Bodywork modalities such as shiatsu or acupressure use pressure points along the meridians to regulate the flow of qi.

Yoga focuses on the awareness of the flow of the kundalini energy through the chakras, which are located along the spine and relate to the vagus nerve and the glandular system in the physical body, but are not identical with these. The five inner senses are trained to perceive a light-body and the chakras as movement, light, colors, and shapes. This knowledge is five thousand years old and has been instrumental in ayurvedic medicine to treat imbalances in the physical body. It also has a long tradition in Hinduism and Buddhism as spiritual meditation practice in order to become more aware. Meditative control over one's breath, for example, has proven to effectively down-regulate a stressed nervous system.

In the Bible, the aura is called the "body of light." Theosophy, anthroposophy, Hinduism, Buddhism, Jainism, the Kabbalah, and Zoroastrianism all depict it as a rainbow-colored body of light surrounding every living being. The aura can muddy and darken, depending on our feelings and emotions. A depressed individual's aura will be predominantly gray, for example. The aura can also contract or expand up to three feet or more around the physical body, depending on the situation we are in. There is a perceptible physical sensation of stepping into someone's aura, which can be comfortable or uncomfortable. I notice it distinctly when I find myself sitting down in an airplane seat and instantly am reminded that I have to tuck my aura in. There is now evidence through Kirlian photography that even plants react with fear or well-being through contracting or expanding their aura, and that they express it through the vividness or dullness of its colors. Of course, in the scientific world, such spiritual insights are dismissed as fantasy and hallucinations, having frequently failed evidence-based research.

In heightened states of consciousness, abstract shapes gradually replace physical body perception; these shapes are perceived as color and light. These structures of the subtle body relate deeply to the shapes used in Guided Drawing. Some meditation practices, bodywork schools such as Barbara Brennan's Hands of Light,[20] Healing Touch, and also Jungian analyst Phyllis Krystal in Cutting the Ties that Bind[21] use similar shapes when the subtle body is visualized. We can, for example, picture a beam of light rising

up our spine, and instantly will sit straighter. Clients can visualize a circle of light surrounding them on the ground at arm's length for protection, or erect a tepee of light around them for the same reason. Such imagery usually has a positive sensory impact on clients, and I offer such exercises as a resource where appropriate.

The limitation of what we take to be our personal identity is addressed in many esoteric traditions. While rightfully the majority of psychotherapies must focus on strengthening the ego and building a solid sense of embodied identity, we also have to honor the multitude of spiritual practices as a resource and a way to open up to the spaciousness, fluidity, and fullness of our essential nature. When clients emerge from their trauma history and their nervous system has finally settled, they often naturally experience a state of deep mediation. Everything seems to have slowed down, all activation and upset has settled, and they perceive from deep within a mysterious healing process that manifests as tingling light, waves of warmth, gentle vibrations, feelings of expansive love and gratitude, of being held and being safe. I could describe this process as the subtle repair of the involuntary motor division arising from the autonomic nervous system, but the sensory experience clients have is one of spiritual wonder, as this healing experience is usually so utterly surprising, arriving like a quietly powerful gift—and it leaves clients with a profound sense of being whole and fully present. They can lastingly sense in their bodies that they are no longer just surviving, but are alive.

# 6

# Bottom Up—Top Down

I was fortunate in learning a body-focused approach from the very beginning in the 1970s. A significant proportion of my personal therapy sessions were bodywork therapies, facilitated by a psychologist or by Dürckheim himself. There was my three-year training in bioenergetics, but also yoga, daily meditation, and an annual five-day meditation retreat with a Japanese Zen master who would come and stay in Rütte in the Black Forest. I practiced martial arts, such as aikido, for five years, and kendo, Japanese sword fighting, for three. Both were viewed as psychotherapy. During the years of my kendo practice, for example, not once did I fight with a partner. My teacher laconically said, "You've only got one enemy, and that is yourself." Only decades later did I discover how fortunate I had been and how pioneering Dürckheim and Hippius's approach was.

I worked with Guided Drawing for forty years before I could adequately verbalize why it was so effective. My encounter with Peter Levine and subsequent training in Somatic Experiencing was life-changing; it finally gave me a language. This is why I am writing this book. I consider Guided Drawing to be a valuable art therapy contribution to the bottom-up approach.

> Bottom-up therapeutic approaches focus on the body, the felt sense, and the instinctive responses as they are mediated through the brain stem and move upward to impact the limbic and cortical areas of the brain. Continuous loops of information travel from the body to the brain and from the brain to the body.[1]

This language, based on neuroscience research, did not exist in the 1970s, so, in a way, as a therapist my learning has been bottom-up as well. I trusted the rhythmic bilateral approach to drawing. I learned to structure the body focus and the experience of the associated emotions, but I had to wait for forty years to cognitively integrate the technique.

In Guided Drawing, the role of the art therapist is to encourage the bottom-up approach through supporting trust into the emerging motor impulses and their rhythm, as well as through tracking the sensory impact these motor impulses have in the body. More than perceiving the shapes as images, one deals with the movements it took to create them. I will encourage my clients not so much to look for possible images that may have appeared—a circle can be seen for example as "nest," "egg," "belly," "universe"—as this focus will invite a top-down reflection of symbolic meaning and biographical memories. Instead, the therapist will encourage awareness of the sensory perception of the movements that created a particular shape. This might be simple encouragement to keep moving in repetition, if this movement feels good or exactly reflects an inner state of being. Or to ask questions such as: "How was it to direct your energy in this way?" "How do you know it needed to find this particular direction?" "How does it feel to create this flow?" "I wonder, how does this movement resonate in your body?" This attitude will help clients to stay in contact with their body sensations. Emotions and feelings may emerge. However, looking too soon for images and interpretations will activate the mind and cut off from instinct. Images will become significant at a later stage. As a therapist, I can then be sure that they are connected to the client's depth.

In this manner, the drawings "happen" more than they are "done" in accordance with a sense of inner guidance beyond rational control. The repetition settles the mind and allows deeper "in-formations" and "trans-formations" to surface. The resulting process will reflect biographical and archetypical life patterns as they are stored in the body-memory of the client. To reexperience these memories, to question them, suffer them, and remodel them, can assist clients to move from survival to living.

The bottom-up approach is initially kinesthetic, mostly nonverbal, and dominated by motor impulses. Then we move "up" in the body toward sensing, toward sensory awareness. A session will oscillate between drawn motor impulses and sensing the effect they have on the inside. However, toward the end of the session, cognitive integration is crucial. Even if words do not

express the full story, it is important to formulate some of what happened, and thus tie the sensorimotor events to a conscious thought pattern. I often ask clients to write a few words underneath the finished drawings. This helps make the process more conscious and leaves a trigger to remember the process later on. Guided Drawing is not a substitute for the therapeutic dialogue. This is necessary, but it can add significant nonverbal depth, body-focus, and sensory awareness to the therapeutic process.

Van der Kolk mentions three accepted trauma treatment methods:

- *top down,* which describes most known talk therapies designed to connect with others, understand what is going on, and process memories.

- *taking medication* to shut down inappropriate alarm reactions and to manage overwhelming overload. Other technologies can be applied to change the way the brain organizes information.

- *bottom up* allows the body to have experiences that deeply and viscerally contradict the helplessness, rage, or collapse that result from trauma.[2]

While I will refer some clients to a psychiatrist for medication, all Guided Drawing sessions are a mixture of top-down and bottom-up approaches. The past hundred years of psychology have developed a multitude of top-down models; they are a relevant component in all therapeutic encounters. However, the body-based bottom-up model is relatively new in the Western landscape of psychology and psychiatry. While we now understand that it is not possible to counteract internalized stress patterns and settle the alarm systems in the brain stem through cognitive "understanding," we lack body-based therapeutic techniques to facilitate such physiological change. Heller and LaPierre view the mindful bottom-up experience of the body as the foundation of the healing process.[3] The more we are in touch with our body, the greater our capacity for self-regulation is. Perry is clear that we can only influence higher functions such a speech, language, and socioemotional communication if the lower neural networks are intact and regulated. "Patterned, repetitive somatosensory activities" are necessary, if a poorly organized brain stem needs a reset.[4]

The bottom-up approach encourages the awareness of innate motor impulses in the muscles and viscera. The perception of these motor impulses will make clients aware of the flow, relaxation or contraction, tension, or

collapse in the body. Such patterns are then made visible through drawing these mostly involuntary physiological phenomena. Clients draw with both hands and eyes closed on large sheets of paper, and their actions mirror inner physiological states. The drawing process is not image-oriented, but simply pays attention to how the muscles, the gut, or the breath move on the inside. Such rhythmic scribbled repetition makes felt body sensations visible. Increasingly, the associated emotions emerge as well. This seemingly simple process of sensory perception and rhythmic expression of motor impulses allows a unique way of communicating with the autonomic nervous system. Feeling safe and present, individuals are being encouraged to rekindle the flow of life energy that contracted and froze due to past trauma. Over time, well-being palpably improves, and gradually wholeness can be restored.

The focus is on the internal body sensations, such as muscle tension, physical pain, or blockages, as well as the movement of emotions such as grief and anger or joy. This sets a feedback loop into motion that bypasses cognitive belief systems and identifications. Instead, the focus is firmly on the needs of the body. Rhythmic drawing supports this focus. Individuals will use bilateral scribble-style movements to express, for example, "a pain in the neck" rather than drawing an image or the story of an event. In the second step, clients then draw what they need "if I had a massage now" in order to release inner tension or emotional charge. Then they will reconnect with their felt sense and draw "how it feels now," in order to notice the changes the "massage" has made. They will continue with their body-based interventions on the paper until the pain in the neck is gone. Such self-regulation is surprisingly simple and effective. Only then will we look at the option of a renewed identity: "Who am I without being a pain in the neck?"

A more regulated nervous system in combination with a pain-free body will allow access to more positive self-images. In this manner, emphasis throughout is put on healing, repair, and renewal rather than on recovering the story of what happened. To remember traumatic events is important for clients in order to understand what shaped them, but it is not necessary to relive every detail. Without adequate resources and support, such memories have the potential to be retraumatizing and push clients even farther into helplessness and being overwhelmed. Similar to a surgeon, the focus is not on how a patient acquired an injury, but what can be done to heal the injury. Levine coined the term *re-membering* as opposed to remembering. To

reconnect with the split-off parts is important, just like a shaman calls back the spirit that took flight. In Guided Drawing, this process turns into a carefully titrated dance between what happened once, how the body responded at the time, and what the body needs now in order to heal.

Heller and LaPierre describe this feedback loop between sensory awareness and motor impulses:

> A process unfolds, a healing cycle is set into motion in which nervous system regulation increases and distorted identifications and beliefs diminish and eventually resolve. In a positive healing cycle, the increasing nervous system regulation helps dissolve painful identifications, and as painful identifications and judgments dissolve, increasing capacity for self-regulation becomes possible.[5]

Rhythmic repetition of whatever is felt is crucial. Not only does the rhythmic repetition of simple scribbles get clients out of their head and stop them from controlling their actions, repetition also gives safety and provides a structure. We have expressions such as "finding your mojo," "get into the zone." Similar to dancing or lovemaking, we have to discover an appropriate rhythm in order to let go; otherwise we will count steps and feel nothing. All clients know this either from sport, sexuality, meditation, drumming, or something else. Rocking a baby is soothing. Rocking with crayons on the paper is soothing. It allows clients to shift from voluntary motor impulses to more involuntary ones. It supports individuals to move from *doing and making* to simply *being present.* It allows clients to connect with the "good" part within themselves.

> The felt sense is not a mental experience, nor is it only a bodily awareness; it is the coming together of the (1) body's direct sensory and emotional responses to internal and external events, (2) the mind's attention to and synthesis of the information gathered by the senses, and (3) the level of congruency between these channels of experience and their integration to form the awareness of a particular state of being, a situation, or a problem. On the somatic level, to access the felt sense is to retrieve the knowledge and wisdom implicit in bodily experiences. On the level of the mind, it is a process of developing a capacity to sustained, focused attention that supports relaxed, nonjudgmental awareness so that the internal process, both psychological and physiological, can truly be heard and tended to. The capacity to accurately assess whether the signals between the body and mind are congruent or disjointed is critical to stabilizing internal chaos and making sense of the world.[6]

Congruency here is the important factor. The tracking of sensory cues after a round of motor impulses is essential. Guided Drawing is neither about sense-lessly acting out in random release, nor is it a meditation, where pure sensory perception reigns and motor impulses are reduced to observing the breath or the heartbeat. It is not doodling, where scribbles are made on the paper while the mind is making a shopping list. Instead it is the nonjudgmental awareness of body sensations, the process of mirroring these with crayons on the paper, followed by the tracking of the sensory feedback to these drawn motor impulses. Dürckheim described the mind as the "witness" in this process, an attitude he learned from his meditation practice with Suzuki. Suzuki himself coined the term *loving awareness*.[7] It is an attitude of trusting an inner knowing deep within. For most clients, this trust has to be gained first, before they can safely rely on it.

Congruency can be observed by the therapist through the body posture of a client, through facial expressions, through verbally shared information, and through the way events are expressed in the drawing process. I will say more about these later on. Body posture can easily be observed—for example, how a client resonates or not with certain shapes. Does he draw verticals while being slumped over? Is only one hand active, while the other is inert? I have observed many clients sharing sad or terrifying events while smiling, cut off from their emotions. The lack of pressure of the crayons on the paper is a sound indicator for emotional states, and so is excessive force. Some are drawing so fast that their senses are certainly not capable of keeping track; it is a cool way to shut down the felt sense. Others are draw-ing painfully slow in an attempt to control every move on the paper. Most clients will need support and feedback from the therapist in order to find congruency. Some may have never experienced being completely aligned with themselves. Others may only be able to focus on a tiny part of their bodies, because in their experience the body is not a friend. However, they can learn to hold their nonjudgmental awareness by focusing on minute changes within one tiny part, and draw these, until they feel safe enough to gradually expand their focus.

Congruency is easier to achieve by drawing with both hands. It is certainly a fuller and more complete approach. Because both hands are engaged, there is the assumption that both hemispheres of the brain are stimulated. Hanson, based on Bruce Perry's NMT, suggests that bilateral repetitive stimulation of the brain is an important component of trauma therapy. In order for

treatment to be effective, the brain must be able to reorganize itself through the procedural memory in the brain stem, where we store learned action patterns such as swimming, walking, or riding a bike.[8] The neurosequential model recommends repetitive activities that target both halves of the brain. In particular, bilateral stimulation allows for increased communication between the two brain hemispheres across the corpus callosum. This allows clients to rely equally on both brain hemispheres. Importantly, NMT also theorizes that bilateral stimulation allows the brain to either reorganize itself or continue to develop from where it left off.[9] I have witnessed the latter in particular when working with traumatized children at the Clay Field. Young children will not verbalize what happened to them, but given the chance, they will continue exactly where their development was interrupted due to adverse life experiences.

It also confirms my experience with Guided Drawing. If we can find an approach that can make clients feel safe enough to allow the bypassing of cognitive belief systems and negative identifications, the deeper layers emerging from the limbic system and the brain stem, what Jung called archetypes and instinct, will take over and reorganize the brain and thus the body-mind toward more regulated and authentic states of being.

Malchiodi likens bilateral drawing to

> Shapiro's model of eye movement desensitization and reprocessing (EMDR)[10] treatment that involves dual attention stimulation and consists of a practitioner facilitating bilateral eye movements, taps, and sounds as sensory cues with an individual. When combined with trauma narratives, it is believed that visual, auditory, or tactile cues help the individual by directing focus on the present rather than what has happened in the past.[11]

Quite frequently I have observed that traumatized individuals initially find it difficult to coordinate movements with both hands. They will then in the course of a session discharge pent-up tension and emotion until they find more balance; the ensuing sense of resolution may include, but does not depend on, a conscious memory or biographical narrative.

In this way, individuals will progressively oscillate between the expressions of rhythmic motor impulses that are then perceived in a sensory feedback loop as the motor impulses resonate in the body. Different motor impulses provoke different sensory states, until a client may sit more upright or feels less uptight due to certain gestures on the paper.

FIGURE 6.1. The top-down and bottom-up approach: communication patterns between the brain stem and the cortex.

Brain science can become very complicated. Hence, I will try to explain the neurological core events leading to either a bottom-up or top-down intervention as simply as possible. In figure 6.1, we see on the left the brain stem, and on the right the prefrontal cortex. The amygdala on the far left represents the oldest part of the brain stem. It is an ancient evolutionary system we even share with fish, and it is in charge of our survival. On the far right we have the social engagement system, which represents the most sophisticated aspect of cortical human development. Here we have facial expression, eye contact, language, and communication. Levine has stated on numerous occasions that he considers PTSD as a conflict between the ancient brain stem and the prefrontal cortex, which likes to be in control. When the human animal experiences a life-threatening situation, most energy is withdrawn from the prefrontal cortex, and thus the social engagement system, because in the context of our survival, it is considered a luxury. Instead the amygdala, as the smoke alarm, activates an instinctual response in the hippocampus.

The hippocampus has two pathways. It can make two choices:

- an *active response,* such as running away or fighting for your life, or

- a *passive response,* such as freezing, dissociating, or playing dead.

From the moment that the hippocampus is activated either to respond with fight-flight, or with freeze, large areas of the prefrontal cortex are shut down. We know that someone in shock can hardly speak. We have all seen clients in a dissociated state and who cannot make eye contact. The brain stem is activated when we experience a traumatic event and also when we remember a traumatic event. The physiological response is the same. Such memories are what make clients suffer from PTSD.

Levine based decades of his research on observing how animals cope with life-threatening situations, sometimes on a daily basis. Animals, however, do not develop PTSD except when they are held in captivity or as pets. Since we share the same survival system in the brain stem with animals, he began to investigate what animals do—and how we can learn from them to improve our human stress responses.

**Orienting:** When you watch a group of kangaroos or deer in the field, and a sudden noise alerts them, all of them will look up instantly, assessing the situation. Is there danger or not? The amygdala is the agent that makes them look up. In humans, Broca's area is the agent that will then quickly evaluate the event. Should the noise have proved harmless, it will turn off the amygdala, and make the deer go back to grazing, or whatever humans like to do. If, however, a predator is approaching, they will all flee. Sympathetic arousal has been activated in the hippocampus, and the animal's survival instinct responds with fighting or fleeing.

Levine and Rothschild both have used this orienting impulse, observed in animals, as a top-down intervention for clients suffering from PTSD. In this case, clients are asked to simply orient in the environment they find themselves in at that present moment. If it is the therapist's office, they will actively check out where the door is, where the potted plant is placed, what kind of artwork is on the wall, how the view is from the window. They are encouraged to orient with the aim to assess whether the present environment is safe, even though their body-memory system is trapped in terror. Rothschild called her approach "dual awareness."[12] In the grip of a flashback, for example, clients experience two realities: on one hand, there is the safety of the present environment; on the other, the memory of imminent threat, which activates a range of fear responses in the body, over which the client has no control. Orienting can assist clients to become aware that the fear they are experiencing is a memory, and that they are not in imminent danger, even though they feel afraid.

**Fight-flight:** If we go back to the deer and kangaroos, and they have decided that the threat is real, their amygdala, through the hippocampus, will activate a chain reaction in the body, such as the release of adrenaline and other hormones, which then activates sympathetic arousal, with accelerated heart rate, tension in the muscles, intense focus, and a huge surge in energy that can be exhilarating. This massive arousal of survival energy enables us to fight or flee until we are safe. In this powerful state, a grandmother has been reported to lift a car in order to save her grandchild. The daughter of a friend of mine scaled a six-foot-high fence in one jump a fraction of a second before another car crashed into hers. In her normal state, she could not even imagine jumping over a fence that high.

Levine describes how deer, carefully observed through binoculars, transition from a state of activated vigilance to one of normal, relaxed activity. They begin to vibrate, twitch, and lightly tremble. Starting at the neck, around the ears, these shudders then travel to the shoulders, and then finally down into the abdomen, pelvis, and hind legs. In this way the animals discharge the now superfluous activation and reset their autonomic nervous system. Deer might go through this cycle of activation and settling perhaps hundreds of times in a single day. They move easily between tense hypervigilance and relaxed states of being.[13]

Individuals might experience this discharge after a tense encounter as "the legs turning into jelly," along with an exhilarated state of having successfully dealt with a dangerous situation. Some even try to imitate such an adrenaline high through bungee jumping or other thrill-seeking events.

**Freeze:** If individuals could not run away, however, because they are too small or too weak to fight or flee, they collapse internally. Animals will play dead at this stage in the hope the predator will lose interest or not see them if they don't move. It is important to understand that this is not a voluntary decision, but one made by the autonomic nervous system. Many women blame themselves or are accused of not defending themselves when sexually assaulted. If the autonomic nervous system experiences something so overwhelming, it will decide to dissociate and freeze, and they can literally not help it. Such women will not be able to speak, move, or defend themselves, but have something like an out-of-body experience instead. It is nature's way of managing unbearable pain and distress. If the predator eats its prey, it will now hurt less.

However, if the predator loses interest and moves away, and the rabbit or mouse, for example, has survived, the animals will take awhile to make

sure they are safe now, and then begin to shake. Levine filmed innumerable animals recovering from playing dead and shaking. Even beetles do it. What he discovered by watching his videos in slow motion was that while shaking, all animals completed what they could not do while they were under threat: they completed the thwarted fight-flight response. They switched in the hippocampus from the freeze channel to the fight-flight channel, and now in the safety of their present state, did whatever they wanted to do but could not do while they were being attacked. This completion of the fight-flight response turned the amygdala off and reset the equilibrium.

This latter discovery became the cornerstone of Levine's innovative trauma therapy in treating PTSD. The human animal, however, has far more difficulty to simply shake and recover from a traumatic event. Either the shaking freaks individuals out even more, because it is another out-of-control experience, or it comes on top of other unresolved traumatic situations and adds to more dysregulation of an already dysregulated nervous system. Yet it seems to be the only way to actually recover from a traumatic event.

> Many war veterans and victims of rape know this scenario only too well. They may spend months or even years talking about their experiences, reliving them, expressing their anger, fear, and sorrow, but without passing through the primitive "immobility responses" and releasing the residual energy, they will often remain stuck in the traumatic maze and continue to experience distress.[14]

Talking does not do it. Prefrontal cortex therapies are not able to reset the alarm system in the ancient brain stem. This is the reason why we need bottom-up therapies that are able to connect with the brain stem and the autonomic nervous system. Through rhythmic repetition, sensory awareness, and nonjudgmental body focus, it is possible to connect to the brain stem, and from there find the movements individuals wanted to make, but could not, because they were too overwhelmed at the time. In this way, it is possible to overcome immobility and overwhelming powerlessness. The hopeful message here is that it is possible to heal. Trauma is not a life sentence. As human animals, we are actually quite well equipped to cope with trauma to guarantee the survival of the species. The solution, however, cannot be found within our sophisticated prefrontal cortex; we have to find the way back to our instinctual origins.

At one stage, Levine trained EMTs how to apply gentle touch to support victims of car accidents so they could allow themselves to shake. The patients

were assured they were safe now and that their shaking was a natural occurrence to discharge the residue of activation, so their nervous system could settle down. This does not work, of course, if medical interventions take priority to save someone's life. Patients who have had an accident, however, and were then anesthetized and had surgery, struggled even more with post-traumatic symptoms later on. Every opportunity to discharge the trauma had been taken away; instead they had even become more overwhelmed and rendered helpless.

Levine is very clear on the fact that people who have an active response to a traumatic event will have had a bad or even shocking experience, but they will not develop PTSD. Those who dissociated and froze while something happened to them will suffer from post–traumatic stress until they can find an active response. Only this completion will settle the amygdala and stop it from discharging stress hormones into the body. Rothschild calls PTSD a healthy survival response gone amok.

> The amygdala is immune to the effect of stress hormones and may even continue to sound an alarm inappropriately. In fact, that could be said to be the core of post–traumatic stress disorder—the amygdala's perpetuating alarms even after the actual danger has ceased. Unimpeded, the amygdala stimulates the same hormonal release as during the actual threat, which leads to the same responses: preparation for fight, flight, or ... freeze.[15]

**Top-down:** So how can we assist clients stuck in the freeze response? Here is where the top-down approach becomes crucial. First and foremost, there is the issue of safety. One cannot engage in any form of trauma processing before having established safety. A woman who lives with her abuser needs to be safe first, before any therapy can commence. Next is the question of does the client feel safe

- with the therapist?
- in the art therapist's studio?
- at home?

Also:

- How can trust be established?
- How can a client find resources?
- How does a client find orientation?

Fenner wrote her doctoral thesis on the resources clients find in their art therapist's room.[16] I was part of her research and was amazed by my client's response that she liked looking at a tree outside the window of my office, a tree I had hardly noticed before.

During the top-down phase, I like to use a variety of art therapy exercises that help to build resources. These are usually multimedia exercises, where collage materials, magazine images, paints, wool, foil, buttons, clay, plasticine, cardboard, fabrics, glue, glitter, and so on are on offer. I use small toy animals to build a safe place if the client cannot think of a safe place for herself. We might create a "hope book" with each page illustrating a quality the client wants to manifest in her life, such as trust, love, a friend, or forgiveness. I found the creation of magic wands useful, where a simple stick or small branch is decorated with positive affirmations and past achievements. These can be wrapped openly or disguised with wool, ribbons, and fabric around the stick. During all these exercises, the eyes are open, of course, and clients engage with the therapist. The focus is on positive psychology, with the aim

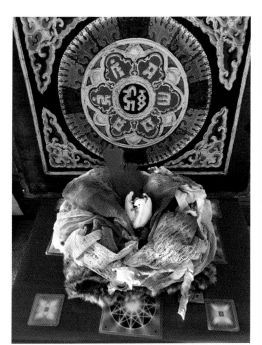

FIGURE 6.2. Small toy animals can be used as inspiration to build a safe place, especially when clients have difficulty imagining their own safety. Here, fabrics and collage materials were used to create a nest for a swan and an owl. In the Middle East we have trained therapists working in refugee camps to build entire landscapes of interconnected safe places from collage materials, much to the children's delight and relief.

of deeply and viscerally informing the client's nervous system that "You are safe now." Usually such exercises are considered fun and a welcome deterrent from the client's overwhelming experience on the inside.

FIGURE 6.3. Other options are helper figures, such as this angel created from clay and feathers, functioning as a transpersonal protector.

FIGURE 6.4. A strength tree. The client was asked to create a tree of which each root represents a supporting person in their life and each branch stands for "something I am good at." It prompted the client to talk about positive events with family and friends and focus on her achievements rather than her failures.

Rothschild teaches to "apply the brakes," where the therapist's focus is on regulating the client's nervous system until they can do it themselves. The image of applying the brakes came to her when she taught a friend how to drive a car. Sitting in the passenger seat, she suddenly realized that in order for this lesson to be safe, she needed to teach her friend first and foremost how to stop, before she hit the accelerator.

> Developing trauma brakes not only makes trauma therapy safer and easier to control, it also gives clients more courage as they approach this daunting material. Once they know they can stop the flow of distress at any time, they can dare to go deeper. Developing "trauma brakes" makes it possible for clients, often for the first time, to have control over their traumatic memories, rather than feeling controlled by them.[17]

In figure 6.5, Rothschild's simple model shows, on the left side, the height of activation from 0 to 100, and at the base, the length of a session in minutes. If we allow clients to run with their dysregulated nervous system, they might become increasingly activated as they tell the story of what happened to them. Then, toward the end of the session, the therapist faces the impossible task of releasing a highly upset client into city traffic to go home. So the aim is not to get the whole story told, with all the activating details, because the activation is in the detail. A client might easily say: "I got raped" and stay relatively cool. But as soon as the details emerge, it gets very upsetting, often too much so, and is therefore retraumatizing. It is the therapist's task to assist the client in down-regulating at regular intervals (fig. 6.6). This can be explained and agreed on at the beginning of a session. I often use this model as a form of psycho-education, explaining precisely why I will interrupt a client, if need be.

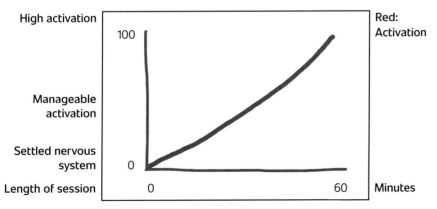

FIGURE 6.5. Rothschild's model of unmodulated trauma activation spiraling out of control and retraumatizing the client during a therapy session.

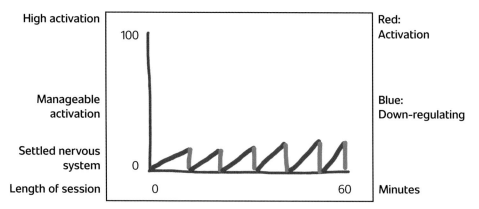

FIGURE 6.6. Rothschild's graph of applying the brakes to down-regulate arousal states.[18]

During the top-down phase, the therapist might need to point out to a client to notice how activating the retelling of an event is, how she can hardly breathe, how she is talking faster and faster, or how she loses contact with her surroundings as she disappears into her trauma story. In each of these cases, the therapist might suggest holding the magic wand or looking at the artwork of the safe place until the client can calm down. Orienting in the therapist's studio is also an important tool to bring the social engagement system back online. Trauma is a memory. How is the here and now? How is the present moment, where it is safe?

Resourced in this way, it becomes possible to gently face the unbearable. On one side there is now the freeze response, tonic immobility, and terror, and on the other there are the safe place and the resources the client has created. A process ensues where the client moves between trauma and safety, avoiding too much activation. As soon as it gets to be too much, the focus is shifted back onto the created resources. In this way, nervous system regulation is gently introduced. Clients learn that they no longer need to be trapped in helplessness, but can do something. The top-down approach fosters conscious control over fears and teaches the first steps toward nervous system regulation. Some clients may never be able to move any farther. If nothing else, however, the top-down resources will be able to improve their quality of life.

**Bottom-up:** For others, we can now move to Guided Drawing, and clients can check in with their body and their physiological responses to threat, and act them out on paper. Here, the bottom-up approach begins. It is body-focused and will oscillate between freeze states in the body, such as a stiff neck, a frozen shoulder, a tight diaphragm causing nausea, numbness in the

heart or in the gut—and an active response to these. Going back to the top-down and bottom-up chart in figure 6.1, we are now moving inside the hippocampus from a freeze state to finding an active response to what happened through completing the thwarted fight-flight response.

In fear, we contract or freak out. Either way, we get stuck. During the drawing process, it is important to remind clients of their resources, if necessary. Too much pain, too much emotion, or too much fear will activate the trauma to an extent that it becomes retraumatizing. Very different to my personal training in the 1970s and to today's exposure therapy, full emersion with the hope of some kind of catharsis is no longer desired.

**Pendulation:** When we approach Guided Drawing, clients are not encouraged to "completely lose it" but rather to move from pain to resolution, from tension to massaging it into release, from fear to protective movements. Levine introduced the process of pendulation in order to make the processing of the trauma story safe. Pendulation is similar to applying the brakes insofar as it also offers an alternative place to focus on. The core difference is that the down-regulating system now has to be a felt sense—it has to be body based. I will explain his concept of a healing vortex versus a trauma vortex in detail later on. Levine bases this concept on his essential observation that all life moves in a rhythm of contraction and expansion. The heart contracts and expands, our lungs do, and so does every cell in our body. Just like a jellyfish moves forward, we open and close. So, when clients are trapped in tonic immobility, they have stopped moving. In a purely physiological context, and taking the ancient needs of our brain stem into account, the story of what happened is not so important for our recovery, but getting unstuck and being able to move again is. Only movement will bring us back to life. And the only place to find this rhythm of contraction and expansion is in the body.

While there is focus on the frozen shoulder that the client has had since he was involved in a car accident, he will initially draw the tension and contraction he experiences in his shoulder. He will then switch sheets of paper and put all his awareness into "what movements his shoulder wants to make." This may happen by gently becoming aware of the sensations in his shoulder, and without judgment he will detect impulses embedded in the freeze. He will then draw these motor impulses. And then stop and check how the shoulder feels now. And then draw again the tension, and then the release. In this way, the thwarted fight-flight impulse gets released in a titrated way that is no longer overwhelming.

Levine emphasizes the importance of titration, of slowing down the sequence of events and reducing their size. Looking at manageable aspects of the trauma while building resources keeps being overwhelmed in check. Trauma could be characterized as an event that was too much, too big, and happened too fast. Cars, for example, move way too fast for our nervous system. Our human body was designed for a walking and running pace, but not for going 100 miles per hour. In the case of a motor vehicle accident, it can help to "make more time," to slow down the process to such an extent that the client can find a sequence of events he can respond to, one by one. For each step he will take the time, and his sensory awareness, to find out what he wanted to do at the time. All these impulses that got compressed into three seconds of impact that are now locked into his frozen shoulder can be expanded into an hour-long event. Such expansion of time allows the titrated completion of the embedded active motor responses, and the completion of these fight-flight impulses will settle the amygdala and turn off the alarm, because only now has the brain stem truly understood that the danger is over.

The same applies for all traumatic memories held in the body—tension in the muscles, the knot in the gut, the lump in the throat. All these are freeze responses: they are frozen motion, defensive movements we did not execute at the time of the event. The idea of a massage through drawing the releasing movements can be a helpful image. Massage does not so much carry the association that I have to tell my therapist the full story of what happened; rather it evokes a feel-good situation, where I may not be cured but will definitely feel better afterward. A massage uses repetitive movements to counteract contraction. It is rebalancing, and clients do it themselves, which is empowering. Let us see how the dance between motor impulses and sensory awareness continues.

# 7

# Sensory Awareness and Motor Impulses

A large proportion of mental health clients suffer from physical symptoms that negatively impact on their lives. Autoimmune and anxiety disorders, ADHD, PTSD, emotional dysregulation, and a score of other symptoms are all characterized by strongly felt body sensations. Mostly these sensations are experienced as adverse, painful, and alienating: one's own body becomes an enemy, charged with overwhelming, uncontrollable sensations that can be triggered by also uncontrollable events. In the process, individuals lose their ability to objectively evaluate external events with their five senses, their *exteroceptors,* which are sight, smell, hearing, touch, and taste, because of overwhelming inner sensations. Touch and taste are considered proximal senses, designed to assess close contact, whereas visual, olfactory, and auditory perception deals with impressions farther away. The exteroceptors are crucial for safe orientation in the world; they also make life richly textured and give us a sense of feeling alive. Just think of the arts and how they enhance our lives. Fear, on the other hand, triggers the instinctual survival responses of the autonomic nervous system in the brain stem into fight-flight or shutdown. We share these ancient instinctual responses with all reptiles. In order to save your life, all higher brain functions are shut down. We can no longer think straight, we can no longer put words to emotions, and external sensory perception is turned into the blind tunnel vision of "run for your life": the *interoceptors* take over. Clients experience these as a racing heart rate, cold

sweats, feeling nauseous, or fainting. Rothschild and Van der Kolk state that a traumatic event and states of PTSD are characterized by the exteroceptors being hijacked by the interoceptors.[1] The interoceptors are grouped into two major types:

- *Proprioception* describes the *kinesthetic* sense of our ability to locate all parts of the body in space, and also the *internal* sense, which gives feedback on body states such as heart rate, respiration, internal temperature, muscular tension, and visceral discomfort.

- The *vestibular* sense allows us to be upright and in relation to the earth's gravity. Located in the middle ear, it can cause dizziness, vertigo, motion sickness, and loss of balance.[2]

All of us experience sensory recall quite frequently. The smell of roses might trigger a romantic encounter, or a particular song played on the radio makes you remember a whole period in your life when you were young.

In the same way, negative memories might be triggered. However, because of the shutdown of the exteroceptors during a traumatic event, the recall of events will be incomplete, distorted, or completely missing. The interoceptors, however, do react with the same amount of distress as they reexperience the memory. Lauren's attacker was wearing a black T-shirt. She does not consciously remember this detail. But whenever she sees a man with a particular physique in a black T-shirt, she will have a panic attack. She only recalled after many therapy sessions that he was wearing this black T-shirt. Until then, this detail was dissociated, and her panic attacks seemed to happen randomly, which was even more distressing, because she never knew when she would be triggered into a meltdown.

Rothschild emphasizes the need for trauma therapists to help clients understand their bodily sensations. Can they feel and identify them on the body level? Can they find words to name and describe them? Can they narrate what meaning the sensations have for them in their current life? In this way, though not always, it can become possible to clarify the relationship of the sensations to past trauma.[3]

I think it is obvious how Guided Drawing through the bilateral scribbling of body sensations can assist in such understanding. Flashbacks can be triggered through both the exteroceptors and the interoceptors. Bushfire victims and those who were in the London underground bombing, for example, were easily set off by smelling smoke; at times this was a real occurrence, but often

enough it was not. However, their body reacted with overwhelming panic to the extent that they could not determine whether there was real danger or if this was a memory. A trauma therapist gave them small bottles with essential oils to carry in their pocket. Every time they would have an olfactory flash-back, they could pull out this little bottle and smell the essential oil. This was usually just enough to bring on the exteroceptors again in order to orient in the present moment. Only then could they make an informed decision as to whether they should run for safety or they were dealing with a memory. Rothschild calls this state of mind dual awareness,[4] in which clients perceive two simultaneous realities, the panic remembered from the bushfire and the present moment, which is safe.

In order to better understand the relationship between sensory percep-tion, motor impulses, and the autonomic nervous system, I find Rothschild's diagram (fig. 7.1) helpful. It shows the central nervous system, which commu-nicates with the brain and the spinal cord. The peripheral nervous system's main function is to connect the limbs and organs to the brain and spinal cord. It consists of nerves and ganglia outside the brain and spinal cord. There are two divisions to the peripheral nervous system:

- The *afferent sensory division* is responsible for the detection of infor-mation in our external environment and internal organs. This division relays the detected information to the central nervous system. The brain then integrates and organizes information in preparation for appropriate action. The sensory division has two subdivisions:

  - the *exteroceptors,* the five senses of touch, taste, smell, sight, and hearing, which all orient in the outside world.

  - the *interoceptors,* with proprioception and the vestibular sense designed to relay information from our internal organs to the cen-tral nervous system. The interoceptors receive their information from the autonomic nervous system, which is involuntary and beyond conscious control.

- The *efferent motor division* sends motor information from the cen-tral nervous system to various areas of the body so that we can take action. This motor division has two subdivisions:

  - the somatic nervous system, whose voluntary motor functions are under conscious control. This system relays impulses for action from the central nervous system to the skeletal muscles and the skin.

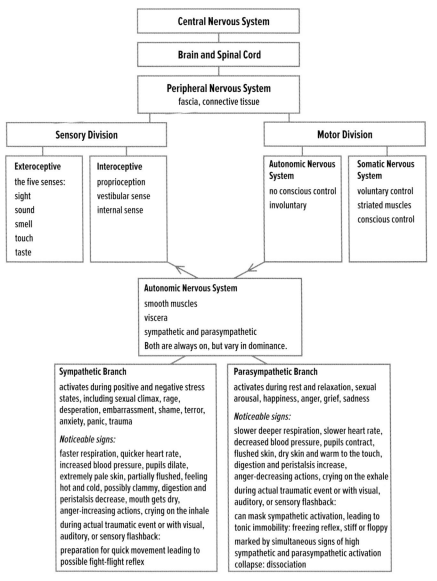

FIGURE 7.1. Map of the central nervous system, depicting the sensory and the motor divisions and their relationship with the autonomic nervous system.[5]

- the autonomic nervous system, whose involuntary functions cannot be consciously controlled. It oversees largely unconscious bodily functions, such as heart rate and respiration, and it mediates, through the vagus system, our capacity for social engagement, trust, and intimacy. This system also relays impulses from the central nervous system to the smooth muscles, cardiac

muscle, and glands. Its two divisions, the sympathetic and para-
sympathetic branches, respond extremely rapid to the signals
they receive from the central nervous system.[6]

As discussed in the previous chapter, it is the autonomic nervous system
triggered by the amygdala signaling alarm that orchestrates our response to
danger. The reality of traumatized individuals is dominated by the intero-
ceptors and sympathetic or parasympathetic involuntary responses from the
autonomic nervous system. We can bring relief to such clients by calling the
exteroceptors back online and emphasizing voluntary control of the striated
muscles, for example through drawing their movements; this will empower
clients significantly and reduce their sense of being overwhelmed by uncon-
trollable forces within their body. Malchiodi writes:

> In work with trauma reactions, I find that bilateral expressive work is useful
> with both individuals who are easily hyperactivated (fight or flight) or are
> susceptible to reacting to distress with a freeze response; these individuals
> often need experiences that involve movement in order to reduce their
> sensations of feeling trapped, withdrawn, or dissociated. Making marks or
> gestures on paper with both hands simultaneously also creates an atten-
> tion shift away from the distressing sensations in the body to a different,
> action-oriented, and self-empowered focus.[7]

Clients who are dissociated or are suffering a flashback, for example, are not
fully present. They are either parasympathetically numb, have no energy,
feel faint, or are internally overwhelmed by their sympathetic arousal states,
such as racing heartbeat, jumpiness, blind rage, or other physiological and
emotional responses. What is missing in the sensory division are the extero-
ceptors: What can you hear, see, smell, touch, or taste on the outside in this
present moment? It can really help to bring back into focus as many external
sensory experiences as possible, be this the touch and smell of finger paints,
the movement of crayons and the patterns they create, listening to a bird in
the garden, or looking at the artwork of one's safe place from a previous ses-
sion; even having a drink of water can apply the brakes. Whatever helps a
client to emerge from the overwhelming inner experience. In Guided Draw-
ing, the transition is then made to contact the involuntary motor impulses
through rhythmic repetition and then perceive the voluntary responses that
are embedded within them.

The autonomic nervous system also consists of two divisions, the sympathetic and the parasympathetic branch:

- *Sympathetic activation* describes normal activity cycles as well as elevated positive stress states, such as sexual climax and the high we experience when bungee jumping or passionately watching a football game. Negative stress states are fear, rage, or shame accompanied by a racing heartbeat, increased blood pressure, sweating, feeling flushed, having dilated pupils, clammy skin, feeling hot and cold, and having a dry mouth. The digestion decreases as every system in the body gets ready to fight or flee. I find sympathetic arousal characterized by two core components, which can be easily observed: anger-increasing actions and crying on the inhale.

- *Parasympathetic activation* describes, on the positive side, relaxation states and calming down, including the expression of contented happiness. The heart rate slows, respiration deepens, the skin has a warm rosy color, and the gut starts making rumbling noises as digestion increases. Clients visibly calm down. I find it a helpful diagnostic observation that individuals now cry on the exhale, similar to an upset child who is now being comforted, even though it still hurts.

Confusingly, metabolic shutdown during dissociative episodes such as a flashback or during an actual traumatic event can mask high sympathetic arousal. Someone experiencing the freeze state is immobilized and might appear calm, but underneath the internal numbness, these individuals are highly activated and in a state of terror. It is important not to confuse a collapsed state with relaxation.

Clients in sympathetic hyperarousal states tend to talk too fast, move too fast, and accordingly also draw too fast. In Guided Drawing, they can be prone to blindly acting out while shutting down their ability to feel anything. Their sensory division is offline. All emphasis is on motor impulses charged with a rush of adrenaline-driven fight-flight responses. Such acting out can be of cathartic relief, but only temporarily—similar to the man who hits his wife in a fit of rage, then later on collapses and *feels* guilty of what he has done. Sensory perception and motor impulses are not connected at the time of the event. Clients in hypoaroused states, on the other hand, tend to be overwhelmed by their interoceptors; they feel too much and cannot move. Their blood is ringing in their ears, their heart is racing to the extent

they feel faint, yet they can barely lift an arm to pick up a crayon, and if they do begin to draw, it is jittery and hardly leaves a mark on the paper. Both client groups have little ability to orient in the external world; both are held hostage by inner events. These clients benefit from drawing at least initially with their eyes open. Both need assistance to focus on the missing division by, if motor impulses dominate, bringing in increased sensory awareness, or, if they are in sensory overload, through encouragement to move and find a rhythm that activates their motor division in a way they can perceive as safe.

For the therapist, it is important to be able to read the physiological signs to support clients accordingly. The emphasis is not primarily on what happened in the past but on nervous system regulation now. These client groups are so out of balance that processing their trauma story can be dangerously destabilizing. It is not that the story is unimportant, but it is not necessarily the key to finding the way back to a sense of autonomy in the voluntary motor division and a connection to the five senses in order to feel present and alive again.

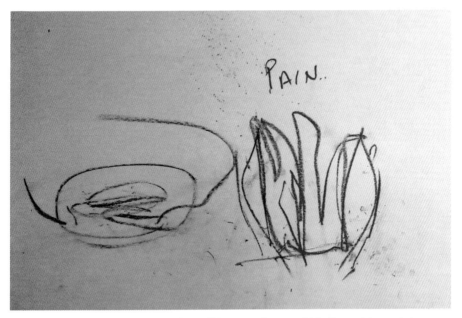

FIGURE 7.2. Steve begins his session talking very fast, and his therapist needs to remind him a number of times to slow down, as otherwise she cannot follow him. She continues to encourage this throughout the session, and at one point when he becomes highly activated, teaches him a breathing and grounding technique, which appears to work well, prompting him to state that he feels calmer now. He begins drawing his right hip, which is very painful and causes him to limp.

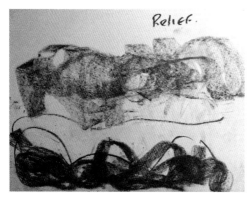

FIGURE 7.3. In his second drawing, Steve uses the image of water to soothe his hip, which brings him "relief." This is the first time he is able to focus on his body.

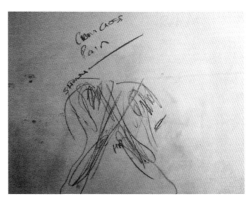

FIGURE 7.4. Steve's attention then shifts back to the severe pain in his hip, and he now adds the opposite shoulder. Both hurt. He connects both with crisscrossing lines.

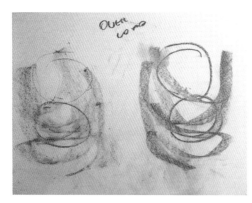

FIGURE 7.5. The pain becomes overwhelming, and Steve needs to take a break. Such circular drawing movements can easily spiral out of control. This is when the therapist helps him breathe calmly to ground himself again. She also uses humor, which works well with him.

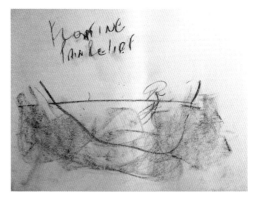

FIGURE 7.6. She reminds him that the water therapy in the second drawing worked well. Resourced in this way, Steve is prompted to make one more try. He ends the session with the sensation of floating in water, which gives him "pain relief."

A friend and colleague of mine applies Guided Drawing as a dual diagnosis counsellor. The following case history might illustrate how clients with highly complex needs are able to find relief through simple bilateral drawings. Steve is a single father and the sole caregiver for two teenage children. His mother was addicted to methamphetamine while she was pregnant with him. He was born addicted and diagnosed with ADHD. His father was violent. He has innumerable health issues, such as pulmonary fibrosis (lung disease) caused by rheumatoid arthritis, as well as spinal nerve damage from an accident three years ago that affects his right arm. He has been diagnosed with depression, hospitalized for a suicide attempt, and is on a cocktail of

psychopharmaceutical drugs. He uses methamphetamine regularly and drinks one to two bottles of bourbon per day. He wants to change his addiction patterns for the sake of his children, who now begin to show signs of being affected. His housemate is a war veteran diagnosed with PTSD who drinks heavily. All are on the brink of homelessness.

What we can observe in this one session is how a client who has overwhelmingly complex health issues becomes empowered to do something himself. With the assistance of his therapist, he is shown how to regulate his arousal states, and how he can ease his painful conditions through drawing. The immediate result from this first session enables Steve to reduce his alcohol intake to a bottle of bourbon lasting three or four days, and he has been abstinent from methamphetamine since. His therapy is ongoing.

## The Triune Brain

Paul D. MacLean, a leading neuroscientist, developed the famous triune brain theory for understanding the brain in terms of its evolutionary history. According to this theory, three distinct brains emerged successively in the course of evolution and now coinhabit the human skull. These three parts of the brain do not operate independently. They have established numerous neural pathways through which they influence one another. This interplay of memory and emotion, thought and action is the foundation of a person's individuality.[8] The Triune Brain theory leads to a better understanding of the survival instinct such as the fight-flight response and its ability to override the more rational neocortex.

- *The reptilian brain,* with its instinctual knowledge, is the oldest part, and we share this survival system even with fish and crocodiles. Our reptilian brain includes the main structures found in a reptile's brain: the brain stem and the cerebellum. MacLean describes it as reliable but somewhat rigid and compulsive.

- *The limbic system,* with its affective knowledge, is mammalian by nature. Here we experience universal emotions such as grief, rage, joy, disgust, and fear. It emerged in the first mammals to record memories of behaviors that produced agreeable and disagreeable experiences, so it is responsible for what are called emotions in human beings. The main structures of the limbic brain are the

hippocampus, the amygdala, and the hypothalamus. The limbic brain is the seat of the value judgments that we make, often unconsciously, that exert such a strong influence on our behavior.

- *The neocortex* is in charge of our conscious processing of events through thoughts and insights, which gives meaning. It first assumed importance in primates and culminated in the human brain with its two large cerebral hemispheres that play such a dominant role. These hemispheres have been responsible for the development of human language, abstract thought, imagination, and consciousness. The neocortex is flexible and has almost infinite learning capabilities.

We experience this triune brain in action through five distinct building blocks: thought, perceptions, emotions, movement, and sensations. Rothschild, Levine, and Ogden name the five building blocks slightly differently, but all agree that an individual's lived experience has these five components.[9]

- *Thoughts* focus on meaning and cognition. They are linked to the neocortex.

- *Affect,* our emotions, arise from the limbic system, our mammalian brain.

- *Perception* includes all five external senses: the exteroceptors sight, smell, hearing, touch, and taste.

- *Sensations* include the felt sense communicated through the interoceptors such as heart rate, breath, and the movements inside the body, for example gut-wrenching feelings, tingling, shaking, and feeling warm or cold.

- *Behavior* describes how we move, including procedurally learned action patterns. It is anchored in the motor division. Behavior is the only one that can be observed from the outside.

Perception, sensations, and behavior are all functions of the brain stem, the oldest part of the brain, also called the reptilian brain. Affects come up from the limbic system, and cognitive processing happens in the neocortex. The therapeutic goal is to bring about the greatest possible congruency between all five aspects.

Clients who experience a traumatic event will dissociate the most distressing aspects in order to cope. This is why weeks and months and even

years later they still feel fragmented, cannot feel parts of their body, have no energy, or are easily triggered and fly into a rage. These dissociated parts may momentarily surface as flashbacks, but they are not connected to a client's conscious experience. In a panic attack, for example, affect and sensations are associated, but clients have no idea what they heard or saw that triggered the anxiety (perception), what they need to do to reduce the anxiety (behavior), or what the fear actually stems from (meaning).[10] In a visual flashback, perception and affect are associated, but the rest of the experience can't be accessed.

In therapy, it is important to notice which parts are missing and to then draw mindful attention to the dissociated building block. In part this happens through the idea that clients can draw a massage to counteract painful, tense, or numb sensations. They are encouraged to find within themselves behaviors that empower them to actively respond to their needs. Otherwise clients tend to be repeatedly drawn toward dysregulating bodily sensations, overwhelming feelings, or invasive sensory cues, and are easily obsessed with negative belief systems. Rather than following these prompts deeper and deeper into their trauma vortex, they are encouraged to create a new experience through a massage or a martial arts response. The therapist can encourage this through verbal prompts, such as: "As you feel this tension in your shoulders, I wonder what will happen if you bring your attention to your sitting bones in contact with the chair?" Clients can be supported in gradually piecing all the parts back together, by bringing all five functions back online.

# 8

# Body-Focused Trauma Therapy

The majority of psychotherapies work with *explicit memory,* the cognitive, declarative part of the brain, or the episodic memory that reaches through our autobiography into the unconscious. Explicit memory, however, is like the tip of an iceberg. *Implicit memory,* on the other hand, encompasses the vast hidden landscape of the limbic system and the brain stem. The limbic system influences our core emotions. Whereas the brain stem is instinctual, run by the autonomic nervous system, it influences all learned action patterns and emergency responses.

When we work with adverse events in early childhood or with trauma, most cognitive approaches do not reach the depth of implicit memory, where these experiences have left their imprint. Of course, it is satisfying to put events into perspective and to be able to tell the story, but often it is not possible. When dealing with complex trauma, there are no early childhood memories, or only distorted and fragmented ones. Babies' bodies remember body sensations, but babies cannot recollect actual events and put them into context. The same applies for clients who were drugged while they were assaulted or while they underwent surgery. In all cases, though, "the body keeps the score." Sometimes it can be futile to speculate as to what happened or why someone feels the way they do.

| EXPLICIT MEMORY | | IMPLICIT MEMORY | |
|---|---|---|---|
| **Declarative** | **Episodic** | **Emotional** | **Procedural** |
| • objective<br>• cold<br>• information<br>• voluntary<br>• semantic<br>• orderly, factual<br>• devoid of feelings | • autobiographical<br>• warm textured memories<br>• interface between rational and irrational<br>• coherent, personal, emotional, spontaneous | • mammal-universal<br>• hot, powerfully compelling: fear, anger, disgust, surprise, joy, grief<br>• Memories appear and disappear outside the bounds of conscious awareness. | • action patterns<br>• learned motor impulses; emergency responses; attraction or repulsion<br>• instinctual: fight, flight, freeze<br>• primitive motivational action blueprints of all living organisms |
| Most conscious | | Most unconscious | |

FIGURE 8.1. Levine's basic memory.[1]

According to Levine's chart from his book *Trauma and Memory* (fig. 8.1), the declarative part of our explicit memory has the ability to find words for experiences, and its episodic aspect can put a timeline to events. Both are located in the prefrontal cortex. Episodic memory includes our dreams, autobiographical stories, and our need for meaning. It oscillates between conscious and unconscious states of being. Levine further distinguishes implicit memory, however, as emotional and procedural.[2] Implicit memory is brain-stem memory. Emotions here are located in the limbic system and are "mammal-universal," such as surprise, fear, anger, disgust, sadness, and joy. They are the same emotions we can also witness in animals. Procedural implicit memory describes the things the body does automatically, such as swimming or riding a bike. They are the motor impulses we learn as action patterns in early childhood, when we begin to crawl and then to walk. Here we also respond to powerful instinctual attraction and repulsion, and the previously discussed survival impulses in the brain stem. Implicit memory is predominantly nonverbal; it describes our embodied identity. Developmentally implicit memory predominantly comes online while we are infants, and we move toward the more sophisticated conscious explicit memory in adulthood.

In this context, it is important to distinguish between two types of trauma:

- A *single event trauma* can usually be successfully treated with, on average, eight therapy sessions, according to Van der Kolk, given that

the client had a regulated nervous system before the event and is not alone but surrounded by supportive family and friends.

- *Complex trauma,* on the other hand, is complex indeed. Courtois and Ford define it as "resulting from exposure to severe stressors that (1) are repetitive or prolonged, (2) involve harm and abandonment by caretakers or other ostensibly responsible adults, and (3) occur at developmentally vulnerable times in the victim's life, such as early childhood or adolescence (when critical periods of brain development are rapidly occurring or being consolidated)."[3]

Children learn through sensory impressions, which they need to process so that their brains can produce useful body responses, as well as useful perceptions, emotions, and thoughts. During infancy and early childhood, they develop sensorimotor "building blocks" that become the basis for all further academic abilities, behavior, and emotional growth.[4] "Over 80 percent of the nervous system is involved in processing or organizing sensory input."[5] If the sensory input is overwhelmingly terrifying or confusing for a child, is ongoing, and remains without repair, children's nervous systems develop serious dysfunctions. They literally lose their ability to make sense of the world. Sensorimotor dysfunction can affect awareness, perception, cognitive knowledge, body posture, movements, planning and coordination of movements, emotions, thoughts, memories, and learning.[6]

For children and adults, such complex trauma triggers are embedded in their implicit memory system. They have been experienced during the earliest stages of their biography. In utero, as babies, and as toddlers we do not question the world around us and the way the environment makes us feel. These body sensations, however, shape what we will later call "identity."[7] Implicit memory is entirely body-based; it is not cognitive, and as such has little story to tell.

> When people experience trauma, they feel *bad;* children, in particular, think they *are* bad when they feel bad. Chronic bottom-up dysregulation and distress lead to negative identifications, beliefs, and judgments about ourselves. These negative identifications, beliefs, and judgments in turn trigger more nervous system dysregulation, and distress is created.[8]

The difficulty is enhanced by the fact that when children experience trauma and the resulting dysregulation, they write this felt sense into their implicit body memory as identity. Children do not rationalize that "Mom is having a

bad day." If their mother is distressed, they are distressed and feel bad, and subsequently they build their identity of being bad around this felt sense. This is the basis for complex trauma, where internalized body memories are carried unquestioned into adulthood as identity.

Somatic Experiencing has coined the term global high-intensity activation, in short GHIA, or colloquially referred to as "high global."[9] High global refers to individuals who have experienced intense stress states in utero or as babies. Babies in the womb cannot escape. Babies whose mothers did not want the pregnancy or whose mothers live with domestic violence are born with a stress level equivalent to soldiers after three years in open combat.[10] Such a pregnancy, from the child's perspective, is one of inescapable threat. The same applies to babies who are exposed to a toxic family environment; they cannot escape. Relations shape development.

> Neither the mother's personality, nor the infant's neurological abnormalities at birth, nor its IQ, nor its temperament—including its activity level and reactivity to stress—predict whether a child would develop serious behavioral problems in adolescence. The key issue rather was the nature of the parent-child relationship: how the parents felt about and interacted with their kids. As with Suomi's monkeys, the combination of vulnerable infants and inflexible caregivers made for clingy, uptight kids. Insensitive, pushy, and intrusive behaviors on the part of the parents at six months predicted hyperactivity and attention problems in kindergarten and beyond.[11]

Gerhardt states that babies cannot develop an orbitofrontal cortex on their own. It takes relational atonement for a baby to be invited into human society.[12] Mothers are biologically designed to respond in a nonverbal way to their baby's stress signals and feel them as their own; they will then do everything to relieve the symptoms and regulate the baby's nervous system. So, when the baby cries, she will pick her child up and rock him or feed him or change his diaper. She regulates his distress and thus teaches his nervous system how to regulate stress. Only from thirty-six months of age onward are infants capable of self-regulation. And according to Gerhardt—and difficult for young professional mothers to accept—this atonement needs to be offered by the primary caregiver. If this dance of the mirror neurons is not in sync, either because the mother never experienced it herself or lives in an unsupported environment, the baby will not only suffer but also not learn to self-regulate later in life. Gerhardt considers this misattunement the cause

for mood and eating disorders, and individuals' drug and alcohol abuse as attempts to regulate their nervous systems.

Over time, the body adjusts to chronic trauma, and the most intolerable aspects are shut down. Parasympathetic dissociation makes the pain go away. However, the consequences of such numbing are also that teachers and friends are likely not to notice anything is wrong. Van der Kolk gives the example of sexually abused girls, who, because they do not trust anyone and are so shut down, and thus are considered "weird," rarely have girlfriends to keep them informed and safe. However, once they enter adolescence, they tend to have chaotic and traumatizing contact with boys, because they have not learned to articulate what they want and need and how to defend themselves.[13] Isolation and retraumatization enter a toxic vortex that easily spirals out of control.

Many such clients suffering from complex trauma cannot feel large parts of their body. Numbing can go to the extent that individuals cannot distinguish an object such as car keys they hold in their hands with closed eyes. The sensory perception is simply shut down. Self-harming is often an attempt to feel anything at all, and thus get some kind of stress relief. Numbing can easily oscillate with hyperactivity and risk-taking for the same reason.

When infants are exposed to chronic and repeated stressors, they only have the option of parasympathetic shutdown, of dissociating from feeling anything. "Because the fetus goes into a parasympathetically dominant freeze state before the nervous system is fully formed, psychological resiliency is impaired, and subsequent psychological resiliency does not develop adequately."[14] It is widely acknowledged today that a single traumatic event, be it a motor vehicle accident, a natural disaster, or an assault, can be dealt with successfully if the individual is supported at home and had a functioning regulated nervous system before the event. The impact of caretaker abuse, of childhood relational trauma, is infinitely more severe. The majority of children, also as adults, do not remember what has happened to them. They have no story to tell. Their brains are permanently wired to stress, and they do not know it any other way. They do not know relaxed and trusting states of being, because they have never experienced them. They may feel jumpy, which makes it hard to concentrate on any task or job, or they are shut down and then have no energy, to the extent that they can't even get out of bed in the morning. Even combat soldiers are better off, because they enter their career with functioning regulated brains. Developmental trauma clients need

long-term therapies, even though they are the population groups who are notoriously underfunded and under-resourced. They are managed by social workers and fill our prisons, or are drugged into submission, and later in life develop a score of health problems.

Bessel van der Kolk, in his book *The Body Keeps the Score,* writes emphatically about the vast population groups who suffer from complex trauma and who struggle with the lifelong consequences of their dysregulated nervous systems. The majority of clients I see suffer from developmental and complex trauma. Even if they are functional on the outside, internally they are in permanent survival mode; they are easily upset, easily activated, and easily shut down. Dealing with chronic high stress levels on an ongoing basis becomes toxic over time.

A vast amount of physical health problems is related to complex trauma and GHIA. Even our language relates strong emotions with the body: "You make me sick." "I was scared shitless." "This makes my skin crawl." "My heart sinks." "It took my breath away." "I was scared stiff." What develops over time is mental illness and mood disorders. Drug and alcohol addiction are widely regarded as a form of self-medication to ease the unbearable. Eating disorders, diabetes, heart disease, plus the entire complex of autoimmune diseases such as fibromyalgia, chronic fatigue, rheumatism, arthritis, even migraines and PMS are linked to chronic stress.[15] A chronically overactivated nervous system that does not know how to calm down creates a toxic internal environment, even if it is just from the amount of adrenaline and cortisol that is released into the body; these are hormones that are supposed to be activated only on occasion in order to fight or flee. Our body is not designed to cope with these stress hormones on a daily basis.

Especially if there is actually no external enemy around, GHIA individuals expect a threat at all times. Over time their chronic fear begins to focus on an internal enemy, and their physiological systems begin to attack themselves. This is the basis of many chronic illnesses. Medical doctors, however, rarely relate chronic illnesses to childhood trauma, because it took decades of internalized stress for them to develop. High global individuals also tend not to be aware of the connection, because the trauma is written into their implicit memory system and has created an unquestioned sense of identity in them; chronic hypervigilance feels "normal." Because these traumas have shaped individuals before they had access to language and conscious processing of traumatic events, they do not respond favorably to talk therapies. They have

no story to tell; they are the story. Babies will not remember what happened to them, but their bodies will keep the score. "GHIA affects every system and every cell within these systems; skin and connective tissues, brain chemistry, organ systems, nervous and endocrine systems, and the immune system."[16]

This is the reason why art therapies are so important in this context. They do allow nonverbal expression of inner stress states. They also can teach more organized ways of being. Van der Kolk describes a successful program of ballroom dancing for highly traumatized impoverished teenagers. What they learned, in a fun way, was an organized social event, doing things together, synchronizing the mirror neurons with a partner, finding a rhythm and safe attunement with another human being. A modified version of yoga had a similarly lasting effect for other client groups. Drumming circles can do this and have been used successfully as trauma interventions. These are rhythmic, bilateral therapies that do appeal to the implicit memory system. They have a body focus, are rhythmic, and teach relational attunement. These are the therapeutic interventions complex trauma clients need and can relate to. They do not ask for a story, but can assist in reducing stress and regulating the nervous system. And most of all, they can, over time, repair the broken pathways in the brain and create new options to live.

Guided Drawing works strongly with implicit memory with its focus on involuntary and voluntary motor impulses, on rhythm and bilateral organization, and on sensory awareness. It encourages a feedback loop between motor impulses and the felt sense that is often damaged in complex trauma clients. It can be an almost entirely nonverbal therapy, if need be. Aspects of Guided Drawing are capable of making implicit memory visible. The drawing process mirrors the tension and collapse in the muscles and viscera, as well as the powerful emotions associated with our tribal, limbic heritage. The drawings can tell the implicit memory story of threat and survival—and with sufficient safety, support, and mindful attention to the felt sense, clients can begin to recover who they really are.

# 9

# Trauma Healing

Somatic Experiencing as a trauma healing approach is based on the belief that trauma is a natural occurrence of life and we can recover from it. Its focus is on empowerment and self-direction. It does not promote exposure therapy, emotional catharsis, or pushing through "resistance." It does not search for memories. Instead it uses the content of the client's story to track activation in the body. Imagery and motor patterns are paid attention to where they are connected to felt physical sensations, rather than to the cognitive and emotional process.

In this way, the frozen memories held in the body, the straightjacket of shame, the compulsive acting out, the flashbacks, the risk-taking, the addictions and obsessions, whatever holds us hostage can gradually be down-regulated. We can exhale. We can begin to put events into a timeline to form a coherent narrative.

One of the core teachings of Somatic Experiencing is that PTSD is not resolved through the story, through recalling the explicit memory of an event; it is also not defined by the severity of the event. One child might experience being vaccinated as a severe boundary breach, while another does not find the process upsetting at all. There is no objective as to which events are or are not traumatizing. Individuals enter situations with different nervous systems, different support systems, and different personal histories. The symptoms of trauma held in the

body are the unresolved and incomplete responses to something that was experienced as an unbearable level of helplessness and being over-whelmed. Something happened that was too big, too much, or too fast. Therefore, titrating the memories into manageable bites is crucial; also crucial is to avoid being drawn into the trauma vortex, which is easily triggered through telling the story of what happened. The overwhelming emotion is always in the details. Guided Drawing allows clients to move with ease, for example, between tension and release, pain and soothing, upset and settling due to the idea of "receiving a massage." In this way, only one aspect of the story is paid attention to at a time, and each step is resolved, before clients move on. Thus, while clients progress, their autonomic nervous system learns to regulate along the way with every step they take. Van der Kolk writes about Levine:

> This work lays the frozen shame, grief, rage and sense of loss to rest by helping trauma's explosive assault of the body to be completed and resolved. Peter's work helps us transcend what he calls "the destructive explanation compulsion" and to create an inner sense of ownership and control over previously out-of-control sensations and reactions. In order to do that, we need to create an experience of embodied action, as opposed to helpless capitulation or uncontrollable rage.[1]

The following four images illustrate the effects of a traumatic event on the nervous system and Levine's discovery of pendulation as a way of moving clients out of being stuck in either hyperarousal or hypoarousal states. It describes a process where the trauma vortex is introduced to a countervor-tex in order to assist the autonomic nervous system to down-regulate after a stressful event. Pendulation describes an inherent rhythm of the nervous system, of each cell in our body, of each organ, of all our muscles. Like a jellyfish, all these systems move between expansion and contraction. Levine considers this rhythm as the core of all life forms. Our heart and breath are clear illustrations of this autonomous rhythm. We can only move if certain muscle groups expand and others contract. When we are stuck, when we are scared stiff, when we have frozen in fear, we need to find our way back to the rhythm of life.

Pendulation is not the same as Rothschild's "applying the brakes," where a conscious decision has been made to shift focus away from fear.

Applying the brakes can be used initially in order to kick-start this inherent ability of the involuntary nervous system. In the same way, artwork of a safe place or other resources can facilitate a first glance away from the trauma story, and give a taste of new options to life. Pendulation, however, is based on a felt sense; it has to come from deep within the body as a physiological response to a threat. It will emerge as subtle motor impulses that are contrary to the contraction or fragmentation a traumatized client may experience. Pendulation might manifest as a wave of warmth gently expanding in the chest, or as subtle as the trembling of butterfly wings in the stomach. For some clients, such sensations have texture, imagery, and color; for others the emphasis of their experience is on movement or the motion of emotions. Because effective pendulation has to arise from the autonomous nervous system, it cannot be made, manipulated, or controlled as such. It has to *emerge.* Clients need to open up for it and receive it.

Such a process requires subtle awareness, sometimes almost meditative stillness, in order to perceive the minute changes within the body's felt sense. A genuine trauma response has to come from the autonomic nervous system in order to be lastingly effective. Only if clients can allow such impulses to arise rather than manipulate, make, and do things will they find that their responses are connected to the involuntary motor division, which is connected to the autonomic nervous system. Shaking in order to discharge activation, for example, cannot be made, or clients will actually attempt to shake off inner sensations rather than allowing themselves to *be* shaking. Rhythmic bilateral stimulation helps clients to get enough out of their head to find a structure that allows them to let go and surrender to the deeper knowing of their bodies and nervous system.

Clients' attention tends to go to the trauma vortex. They have come into a session to tell their story. It is the therapist's job to gently draw their attention toward the healing vortex. The trauma vortex is destabilizing; the healing vortex contains, at times, surprising resources. The body will know what to do once clients are sufficiently supported, feel safe enough, and begin to trust the process. Levine teaches this process in the Somatic Experiencing training as the Stream of Life Model:[2]

FIGURE 9.1. The river of life flows within the healthy rhythm of sympathetic arousal and parasympathetic settling. Individuals experience excitement and rest states. The charge and discharge process flows with ease. Individuals in this state are relaxed yet alert, and their responses will be fluid and resilient. They will be emotionally stable and have the capacity for healthy relationships.

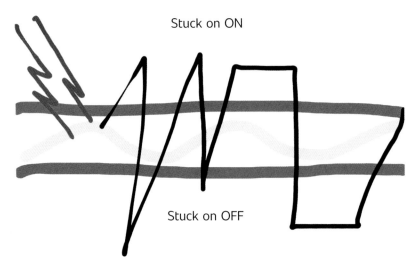

FIGURE 9.2. What happens now is a boundary breach, illustrated with the red lightning bolts. The flow of life is upset and spirals out of control into either hyperarousal or hypoarousal. If the nervous system gets stuck in *on,* clients experience panic, rage, hypervigilance, elation, and manic states. If it gets stuck in *off,* they suffer from depression, have no energy, and feel exhausted and "dead." The emphasis in both states is on being stuck. The rhythm of life has frozen and stopped.

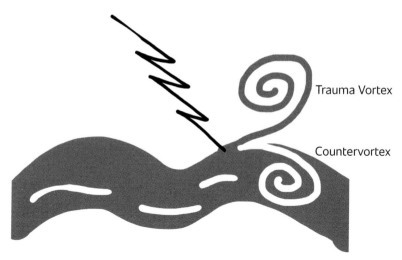

FIGURE 9.3. The boundary breach that has occurred creates a rush of overwhelming arousal that cannot be contained within. Part of the life force is split off into a trauma vortex containing all the out-of-control energy of the traumatic experience. We have survived, however as we keep going, part of the self has gone missing and is split off. Levine's research has proven that nature at all times provides a countervortex as an inbuilt ability of the nervous system. Initially this countervortex is small and needs strengthening. It can then be used to deactivate the trauma vortex.

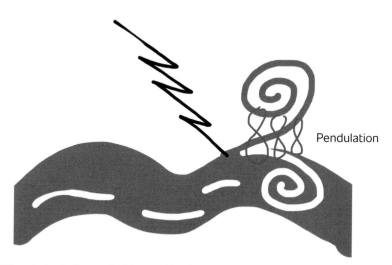

FIGURE 9.4. Now pendulation between the countervortex and the healing vortex can begin. Being safe and supported and able to trust, clients can begin to sense their inner response. The rhythm of life can begin to pulse again through pendulating between the two vortexes. The trauma experience is now given the space and time to find sufficient resources in the healing vortex to actively respond to what happened. Gentle pendulation between these two vortexes will restore the flow of life.

Pendulation will gradually pull the counter or trauma vortex back into the boundary and reintegrate it into the flow of life. In Guided Drawing, the internal massage therapist could be viewed as the healing agent who applies pendulation and knows what is needed to bring relief. This is utterly empowering for the client. It helps clients to move out of helplessness, which is the core feeling of PTSD sufferers: "I couldn't do anything." Clients move between the two vortexes, between pain and contraction, between activation and settling, and they can apply their own healing strategies accordingly.

Another way to illustrate this is with the following table. It is based on Stephen Porges's Polyvagal Theory.[3] I even use the following chart at times to educate clients, so they can become actively involved in their healing process.

The vagus nerve regulates the autonomic nervous system and the three states of

- social engagement system: ventral vagal complex (VVC)

- fight-flight: sympathetic arousal states or parasympathetic rest states

- freeze states: dorsal vagal complex (DVC)

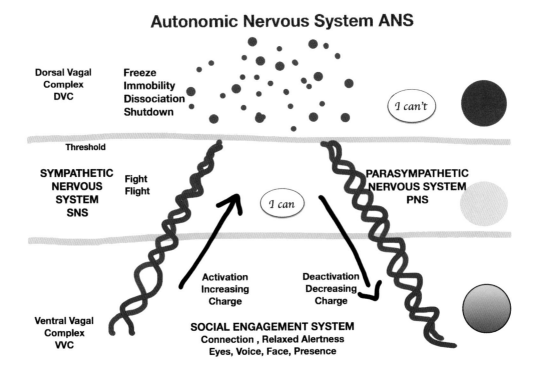

FIGURE 9.5. Porges's nervous system regulation model.

The Polyvagal Theory is Porges's discovery as the neurophysiological foundation of emotions, attachment, communication, and self-regulation. Similar to Levine, he bases his theory on the evolution of the brain from fish and reptiles to mammals and finally humans. The reptilian brain, the DVC, for example, is the most ancient part of the brain. It can go into metabolic shutdown to preserve energy if under threat.

According to Porges's theory, the autonomic nervous system regulates three fundamental physiological states. Their activation depends on our perceived level of safety or threat. Whenever we feel scared or challenged, we instinctively turn to the social engagement system. We turn toward the people around us and ask for help, support, and comfort. If no one, however, comes to our aid, or danger is imminent, our organism reverts to a more primitive way to survive, to sympathetic arousal of fight-flight. We fight off an attacker, or we run to find a safe place. Should we not succeed in doing so because we can't get away, we are too small or too weak, because we are held down or trapped, the autonomic nervous system tries to preserve life by shutting down and expending as little energy as possible. We are then entering the dorsal vagal complex, and experience a state of freeze or collapse.[4]

Porges likens the three layers of the autonomic nervous system to traffic lights going from green to yellow to red; from go, to alert, to stop—and I finally understood his theory. I had struggled with this very medical model for years. Therefore, I will keep it simple as well. It is a very helpful model.

The red wavy line in figure 9.5 is the trauma vortex; the blue wavy line, the healing vortex. The model shows the importance of bringing the countervortex along at all times. In Guided Drawing, this will play out, for example, that clients draw the tension or pain they experience in the body, and then, in the following drawing, apply, via a massage, what this tension or pain will need to ease off. Then they will again draw how the tension feels now, and then apply another round of massage movements.

In the bottom third of figure 9.5 we find the ventral vagal complex (VVC), which has a green traffic-light button. This "go" setting describes a relaxed alertness within the flow of life. We can communicate with eye contact through the modulation of our voice and facial expression and thus engage socially. The focus is on the face.

The middle section describes the sympathetic nervous system (SNS), which has a yellow traffic light button. This is the "alert" setting signaling danger. It mobilizes our defense strategies through fight-flight in the spinal

cord. We feel this most acutely in the chest region as accelerated heartbeat and increased inhaling. Social engagement now decreases; in the context of our survival it is not crucial. Instead, individuals experience sympathetic arousal (left side of fig. 9.5) as a surge of energy; the adrenaline is pumping as they feel fear or exhilaration. The core sensation is "I can do this." *I can defend myself. I can deal with this. I want to punch this guy in the face. I am feeling really angry. Don't mess with me! I am warning you, leave me alone.*

I assume everybody knows the sensation of ending up in a dark alley at night with footsteps sounding behind you and how the heart rate increases, the breath comes in short gasps, and the legs now make big strong steps, ready to bolt at any moment. And then we come out at the other end of the alley, we see lights and people and know we are safe. Instantly we exhale, our heart slows down, and parasympathetic down-regulating has begun (right side of fig. 9.5). If need be, our legs shake slightly, or we feel a bit wobbly until the now superfluous stress hormones have been discharged. Once the social engagement system has come back online, we are also quite happy to turn to our friend and smile and make a comment on what has just occurred.

Should events, however, not have such a benign outcome and get to be too much and overwhelming, when there is no light at the end of the dark alley, the sympathetic activation goes into overdrive until we cannot take it any longer and cross the threshold into collapse. We are now literally "scared stiff." The legs give way and we can no longer move. This is the realm of the red traffic light button, that of the dorsal vagal complex (DVC). There is no longer a blue healing vortex, and the red activation vortex fragments into dissociation and shutdown. This is an experience of overwhelming stress, and the body responds with tonic immobility; it is also deeply characterized by the sensation of: "I can't." Individuals now feel they can't move, they can't do anything. They are frozen in terror, and something inside them has given up. And while individuals may now appear eerily calm, they are most definitely not relaxed. Tonic immobility masks extreme stress, driven by fear. The core bodily sensations in DVC are in the gut. Our language illustrates this metabolic shutdown quite vividly as pissing myself, being scared shitless, the stomach being in knots, or having a gut-wrenching experience.

For a therapist it is important not to confuse dissociation with relaxation. A relaxed client, for example, looks rosy and warm and is able to make contact with ease, whereas tonic immobility is characterized by feeling chilled

to the bones, often pale or blotchy skin, and eyes that stare without making eye contact. Here, clients state that they cannot do anything or that they feel numb: *I can't move my shoulder; I can't breathe; I can't feel my body; I can't draw this.* They feel frozen in shame or paralyzed in terror. They shrink away from the unbearable and frequently retreat to a nonphysical place on the inside. I have listened to many clients who survived their childhood by pretending to be invisible as the only way to avoid abuse.

If you remember from the previous chapter, top-down strategies are necessary here, along with exercises to make the client feel safe enough to move from tonic immobility—which, don't forget, is involuntary—into the yellow realm of parasympathetic settling. However, and this makes working with dissociated clients so tricky: the moment they cross over the threshold, the entire complex that had been dissociated before will now come back online. Clients can move from unresponsive "dead" states into rage in an instant. In order to avoid retraumatization, and many clients instantly are confronted with feeling out of control again, it is important to have a number of options available that can help to focus on the healing vortex rather than overwhelming fear, grief, shame, or anger. They will only be able to find an active response to what "freaked them out" before if they feel safe and in control.

Accordingly, it is important to titrate any active response in a way that is safe and makes it possible to handle it. When in the past something happened too fast, events now can be slowed down. If something was too big, it is possible to look at only one small aspect at a time, and to respond to this small aspect only, until the radius can gradually be expanded into the whole picture. If blind rage gets overwhelming, drawing exercises to release anger in a controlled way give clients a sense of getting a grip on things, that they can handle what happened. Clients need support in any way that suits them in order to be able to contain and repair the experience this time around.

One of the best buffers against dorsal vagal shutdown is the human engagement system. It can help to ask clients to make eye contact, to realize they are not alone. Many individuals were desperately alone when terrible things happened to them. Even to sit next to the client for support can bring palpable relief and a sense of safety. Unlocking metabolic shutdown or dissociation in psychological terms requires as a basis a visceral understanding of being safe now. You need to feel this safety in your gut. Only then will the autonomic nervous system attempt to complete the interrupted fight-flight

impulse. And it is this completion that resets the brain stem, where individuals move from survival to living.

Once clients are sufficiently resourced, they can begin to find an active response to past events. With every completed action cycle, they will feel more energized, more alive, and more relaxed and at peace with themselves. Now parasympathetic settling will occur in widening cycles of being. The breath deepens, the heart rate calms down. Clients are capable to reorient in the room; their social engagement system comes back online; they arrive in the here-and-now.

Guided Drawing progresses step-by-step in this manner. Focusing on one aspect of the embodied sensations of unease or disease embedded in the red trauma vortex and then resolving it physiologically with a releasing or containing massage through activating the blue healing vortex. Gradually new body sensations of safety and well-being emerge. Over time these will empower clients to become more courageous and resourced to address the narrative. The story held in the muscle pain emerges, the frozen emotions one tried to control, or the nausea because of something one could not digest for decades. However, individuals now do not confront their memories helplessly and filled with fear, but equipped with tools to actively respond to what happened.

## Interventions to Support and Strengthen the Healing Vortex

The following interventions are designed to support and strengthen the healing vortex. They are able to call it into action through reminding the autonomic nervous system to move again. The healing vortex itself is a deeply felt sense; it is a physiological phenomenon. However, we can use external tools to strengthen it and bring it into our clients' awareness. An easy way to follow up and consolidate such interventions is to ask clients how they *feel* now as they hold their crystal or notice that they are not alone.

- *Art therapy exercises,* mentioned in chapter 6, such as a sculpture of the client's safe place, a magic wand, a medicine pouch, a created helper figure like an angel of superman.

- *Spiritual resources* the client is comfortable with, such as holding a crystal or saying a prayer.

- *Orientation* through checking out the therapist's workspace, to take note of where the escape routes are, or simply where things are: the location of the sink and the art materials. Highly traumatized individuals are so locked into their inner world that they need to activate their exteroceptors first as a resource. This orientation might also include focal points that delight the client, be this the view from the window or a painting in the therapist's office. Such a focal point becomes a resource whenever too much activation threatens to overwhelm. Clients can be surprisingly clear as to what works or does not work for them as a resource. I remember one woman who was adamant that the grass moving in the wind outside my window was unbearably activating, but the trunk of a large tree was solid enough to give her a feeling of stability.

- *Physical resources* may involve cushions to hold in front of the body, or stuffed behind the back or on the sides for protection and to hug. The therapist may put her shoeless feet on top of the client's feet for increased grounding and nonthreatening contact, if the client can tolerate this. Large scarfs can be tied around the chest, putting light pressure on the upper arms. Like swaddling a baby, this can give a sense of being held together when someone feels like falling apart.

- *Human support and social engagement* are important. Trauma is isolating; clients are withdrawn and often feel as if they have a contagious illness. Sometimes just chatting or playing a game together can be therapeutic and assist in building trust. Sometimes it helps to put a client in charge of where she wants the therapist to sit to keep her safe. This might even be next to the client. Many clients were utterly alone when they were abused as children. It can make a huge difference to have a benign parental figure being on "their side." This might be the therapist actually sitting next to the client to the extent that the client can lean into the therapist for support, either directly or with a cushion between them, depending on the culture around touch in the workplace and what the client is comfortable with. The therapist also needs to be comfortable with such an intervention. Clients will nonverbally pick up through the mirror neurons if a therapist is stressed or strains to support them and will translate this unspoken information as: "I know, I am always too much."

- Some *ancient cultural resources* have proven effective for thousands of years. All indigenous cultures I know of have rituals that are designed to deal with trauma. These may be drumming circles, dancing, and chanting ceremonies facilitated by a priest, shaman, medicine woman, or elder. Many involve trance states achieved through engaging in rhythmic action patterns. In trance the spirit is called back and demons are fought with the help of white magic in order to restore goodness. Van der Kolk writes:

> Mainstream Western psychiatric and psychological healing traditions have paid scant attention to self-management. In contrast to Western reliance on drugs and verbal therapies, other traditions from around the world rely on mindfulness, movement, rhythms, and action. Yoga in India, taiji and qigong in China, and rhythmical drumming throughout Africa are just a few examples. The cultures in Japan and the Korean peninsula have spawned martial arts, which focus on the cultivation of purposeful movement and being centered in the present, abilities that are damaged in traumatized individuals. Aikido, judo, tae kwon do, kendo, and jujitsu, as well as capoeira from Brazil, are examples. These techniques all involve physical movement, breathing, and meditation. Aside from Yoga, few of these popular non-Western healing traditions have been systematically studied for the treatment of PTSD.[5]

## Interventions to Support the Creation of a Healing Vortex Through Drawing

Guided Drawing allows the art therapist to suggest certain shapes as interventions to support the creation of the healing vortex in a nonverbal, body-focused way. Such interventions are designed to support clients in

- finding structured release to facilitate an active response in a safe way
- discovering ways of calming down
- becoming aware of inner resources of confidence and competence
- fostering body-awareness
- finding an appropriate rhythm to let go and get unstuck

The following images are a few examples of what such an intervention might look like.

FIGURE 9.6. A large bowl shape drawn bilaterally, but with both hands connected rather than mirrored. Both hands began to swing from side to side in a rocking motion. This rocking can have a soothing effect and help to settle down. It is a comforting movement tapping into the developmental need of being held and rocked like a baby. This movement can also support grieving clients.

FIGURE 9.7. Here the hands move bilaterally up the spine and then draw a corner, wherever they hit resistance, a blockage, pain, or fear. The tension is then released to the sides. In order to "break the pattern," it is crucial for this exercise that clients draw distinct corners and then release the pent-up tension to the sides. This movement supports discharge of sympathetic arousal. Simultaneously it builds embodied structure.

FIGURE 9.8. A lemniscate or horizontal figure eight shape in Guided Drawing represents the drawn equivalent to EMDR.[6] Both hands move jointly and create a rhythmic flow that connects opposites, including the two brain hemispheres. The rising and settling rhythm is harmonizing and deeply soothing. Occasionally, traumatized individuals cannot initially draw this shape, but most clients really love this flowing, rhythmic exercise.

FIGURE 9.9. Mandala drawing is a valuable resource. It can range from coloring in templates, which some of my clients chose to do between sessions to tide over difficult times in their daily routine (or lack of routine).[7] Others create simple centered designs of any size as their own personal artwork. Any art materials that inspire can be used. A mandala diary can become a source of inspiration. A nine-year-old girl created this mandala while she was coming to terms with the death of her mother.

# Interventions to Support Completion of a Thwarted Fight–Flight Response

The trauma vortex is characterized by the sensation of helplessness, rage, injustice, confusion, and utter lack of power. In the collapsed state, clients often do not feel their body at all, or do not know what they want to do, or what they need and want; and they have no energy to change this. Masked underneath this deadness, however, is compressed rage and terror, unmanageable and explosive. In this frame of mind, clients may make statements such as: "If I start crying, I will never stop." "If I let my anger out, I won't be able to guarantee anything." The fear of losing control is palpable, and so is the vastness of rage or grief. There is a certainty that whatever lies underneath the frozen life force is terrible and out of control, just as it once was. It is crucial to release this rage, once it can be accessed in a titrated manner with pendulation; otherwise individuals risk feeling even more hopeless and overwhelmed, as seemingly no one can help them to recover from what has happened. So it is of utter importance that the healing vortex is established first to the extent that it can be accessed under duress.

If you remember the graph of Levine's trauma model (fig. 9.2), clients are either stuck in *on* and are then fatally drawn into their trauma vortex, or they are stuck in *off,* trying to avoid it at all cost. Neither attitude is helpful in the long term. Those who are drawn to retelling and reexperiencing their boundary breaches and injuries tend to get increasingly unwell. Under-resourced exposure can set off a toxic cycle of increasing sympathetic arousal to the extent that clients quite literally "spin out of control" and then only have the option of dissociating, as otherwise the overwhelm gets unbearable.

Pendulating between any of the previously established healing vortexes will assist clients to titrate their experiences so they can keep them within a tolerable range. It is quite OK to interrupt a client in her expression of rage if there is too much activation. Initially it will be the therapist's job to pace the recall of traumatic events until the client's nervous system has learned to self-regulate.

The sensorimotor art therapies are perfectly suited for the completion of the thwarted fight-flight impulse. The rhythmic drawing process is closely linked to the peripheral nervous system and its two branches, the sensory and motor divisions. The interoceptors are directly informed through body

sensations arising from the autonomous nervous system. From here the survival impulses emerge, and if the client feels safe enough in the setting, she is now able to respond to them with active motor impulses. Instead of just feeling helpless and overwhelmed, clients might now discover their rage, and along with it, they begin to discover the strength in their arms, which could push the attacker away. These impulses are acted out as an active response to what once happened. Clients might discover their ability to say "No!" and enforce this by taking action to repair a boundary breach with authority. The drawing of the boundary might be accompanied by words spoken, shouted, or written, such as "Fuck off," "Keep out," "Leave me alone," "Go away."

After each action cycle, the therapist needs to encourage the client to become aware of body sensations. "I wonder how the movement you just drew resonates in your body?" And then this changed felt sense is drawn. Or the therapist might ask: "I wonder if there is anything your arms want to do now?" And then this impulse can be put on paper. It is important to find an adequate balance between motor impulses and sensory awareness. Just blindly acting out is not going to change anything, as many who work with children diagnosed with ADHD know all too well. Perceiving how the drawn motor impulses resonate in the body will lead to answers.

At the beginning this might simply be about becoming aware whether the drawn rhythm is too fast, or too slow, or adequate. Then subtle changes are noticed, such as less tension, less pain, or feeling "better." When the drawn motor impulses have been effective, they will eventually trigger a healing response in the involuntary motor division, which clients may perceive as tingling, shaking, waves of warmth spreading on the inside, light pouring into their body, or other sensations. It is necessary to give clients plenty of time to either simply perceive these healing responses from the autonomous nervous system or to draw them in slow motion with as much sensory awareness as possible.

There is often a sense of wonder that accompanies the process at this stage. There is clearly a sense of healing, of peace, of slowing down and becoming well again. This involuntary phase cannot be manipulated. It cannot be made to happen—it is truly involuntary. What we can do, though, is acknowledge its unfolding and allow time and a slow pace to perceive this healing process

will all the senses. These peaceful body sensations might be accompanied by imagery or sounds or words. It is this physiological completion within the involuntary motor system, however, that settles the amygdala and turns the PTSD symptoms off.

For the activation cycle, I have found the following Guided Drawing interventions most helpful to structure a client's experience. When looking at the pictured shapes, it is important to remember that all these drawings are created on large sheets of paper to allow a mirror image of the body. The therapist may suggest such shapes in order to point the way toward structured release. All the following exercises can be practiced similar to a martial arts exercise. They may involve fine-tuning the release at the end of a line, or the adequate pressure of the crayons, and may include making sounds when releasing a line, similar to a tennis player when hitting the ball. At times it certainly helps if the therapist accompanies such release with supporting sounds to keep up the flow such as: "Great," "Keep going," "Yes," "Yep," "Yeah...." At the end of each round of such motor impulses, it is important to check how these resonate in the body. Only if the motor impulse connects on the inside and leads to sensory awareness will change occur.

FIGURE 9.10. **The vertical** in the context of our uprightness in the spine represents the ego. Almost all states of overwhelm and trauma affect the sense of self of an individual; hence it impacts the ability to stand tall and with confidence. Accordingly, most interventions to assist clients to be able to complete thwarted activation cycles involve versions of a drawn vertical or ways to liberate it. The drawing of a vertical requires conscious effort through directing one's energy toward a chosen goal. It is important to release at the end of the stroke "as if to let go of an arrow." This action requires confidence and trust in one's own ability. Holding on is associated with fear and lacking confidence, thus the need to control the outcome by pressing the crayon down at the end, or withdrawing by moving back down without having released the vertical.

FIGURE 9.11. Drawing verticals strengthens the spine and the ability to stand up for myself. If clients get "upset" easily or "carried away" by their anger, it helps to add a baseline. The baseline can be drawn as a back-and-forth movement until one feels firm ground, and then a decision is made to draw a corner and to release upward in the vertical. Or, like pictured here, the release is drawn to the sides, which is less confrontational. This latter version may assist releasing self-aggression, such as when working with clients who self-harm, until they have gained sufficient confidence to move forward and out.

FIGURE 9.12. Releasing tension with horizontal lines clears space. It actually clears the debris away from the spine. Pushing sideways is less confronting than drawing verticals. These motor impulses usually give a sense of liberation, pushing out of a tight and narrow space.

FIGURE 9.13. Adding a vertical and then drawing a corner in order to release tension sideways is a stable way of dealing with inner conflict. It is important to monitor that clients actually draw a sharp corner rather than just blast their tension or anger out, which can be too activating. In this way pain and tension all along the spine can be released.

FIGURE 9.14. Lightning bolts are suited to release tension in a safe way. Rather than straight lines, the drawn corners induce decision-making. One has to make a conscious effort in order to change direction. This helps clients to gain more control over their anger rather than being over-identified with it and as a consequence being carried away with it. This shape offers a first attempt at anger management until more complex shapes can be offered.

FIGURE 9.15. The rectangle is most suited to actively repair one's boundary. The large rectangle is drawn with the focus on each corner. With every change of direction, a decision is made to protect "my space!" Clients can be encouraged to say "No! Stay out!" at every corner in order to repair previous boundary breaches. The effect of this exercise is significantly more decisive and empowering than drawing a circle.

The two following interventions are highly activating, but at the same time most useful, when a well-resourced client is ready to complete a thwarted fight-flight response. Crayons are held in both fists. Either a fat preschooler crayon or a bunch of oil pastels for each fist are suitable. Chalk crayons crumble too easily under the pressure. Holding the crayons in the fist gives this exercise a sense of increased strength, more so than holding the crayons with the fingers. In both cases the basis is the diagonal cross, often called a Saint Andrew's Cross. The hands alternate in their diagonal strokes across the paper either with a repeated downward movement for running or a repeated upward movement for punching. The key here is to make sure clients stay comfortably upright and release the strokes with an outstretched arm. It can help to add a sound such as karate fighters or tennis players make for increased effect, or saying clearly "No!" or "Get off," or whatever is appropriate for the client at the time.

If clients cannot let go and release the lines at the end of each stroke, it indicates a lack of confidence and trust in one's ability to have power. It will then show up as someone being dragged along with the movement across the paper, and in the process clients lose their uprightness in the spine; such collapse is retraumatizing and not to be encouraged. The inability to release the lines frequently goes along with rapidly increasing emotions *and* feelings of helplessness. So at times it is useful to just practice small, short lines, which I call drawing "growing grass" in order to deactivate overwhelming associations with this shape. The drawn lines do not need to be powerful hits; it is far more important to be able to discharge the pent-up tension within, to let go

of it in a focused and directed way while firmly standing one's own ground, certainly without getting overwhelmed again. Maintaining uprightness while releasing pent-up energy is empowering.

While clients draw these alternating upward or downward diagonal strokes, they naturally rotate around the spine as long as they stay upright. In the many schools of bodywork I have encountered, the spine is associated with identity. When babies move from crawling to walking, their sense of being a separate self develops, along with their increasing confidence in standing and moving upright. Playful rotation around the spinal axis is a developmental milestone for toddlers; they like to feel their spine, be it through dancing or spinning or wiggling from left to right on a chair. Activating and strengthening the felt sense in the spine are important, especially for clients whose identity has been under attack.

In addition, it is instrumental when working with trauma to pay attention to the vagus nerve, which connects the internal organs with the brain; it runs within the spinal cord. I discussed its function earlier in this chapter. Regulating the energy flow in the spine is equivalent to regulation of the vagus nerve. The vagus nerve channels heartbreak and gut-wrenching feelings; through it we register rapid breath, racing heart, tense voice, and the relieved exhale and calming down once we are safe and can make eye contact again.

For the following drawing exercise to work, attention has to be paid to uprightness and the activation of movement in the spine through the slight rotation of the vertical spinal axis. This rotation is facilitated through bilateral alternating punching movements or through pushing oneself forward in order to flee. Individuals will either need to fight or to flee. Hence the following exercise has to be adjusted to a client's needs. If in doubt, they can try out both directions, and most certainly only one will resonate with the client.

**Fighting and boxing.** The impulse to fight is usually an adult response. It implies that we have a core belief in our strength. Here the fists are filled with crayons and alternate in punching movements. These motor impulses are directed diagonally across the paper to stimulate rotation in the spine. It is important to assure the clients that this action has no consequences for their safety. Many clients have in the past been exposed to physical aggression or emotional threat, and knew as children or as the wives of violent men that any kind of resistance, protest, or fighting back would have deadly consequences. They really need to understand the difference between being safe now to do so, different from the past, when they were not. If this is not clear,

FIGURE 9.16. The right hand is drawing.

FIGURE 9.17. The left hand is drawing.

clients might happily express aggression in the session and then go home and wait all night for the terrifying implications their actions have provoked, as they would have done in the past. There will be no punishment now for speaking up.

**Running to a safe place.** This is a dynamic, activating intervention that utterly helps to complete the flight impulse. Now the lines are released downward and out, as if leaving behind whatever one wants to get rid of. One might take the image of skiing, where one pushes off with the sticks in order to move forward. It is important, however, that the client knows where to run to. Where is the safe place? Just running is not sufficient. Many marathon runners keep running for decades and never arrive. As long as clients are running *away* from something, they are still living in past memories. In that case, the amygdala is not turned off, whereas if clients run to a marked safe place, once they have arrived—and this can be played out with active imagination—they can actually relax and exhale. That is when the autonomic nervous system registers that the danger is over, that "I am safe now."

FIGURE 9.18. The right hand is drawing.

FIGURE 9.19. The left hand is drawing.

Van der Kolk writes movingly how Porges's Polyvagal Theory helped to underpin why many seemingly disparate and unconventional techniques worked so well for trauma clients. How yoga, meditation, martial arts, ballroom dancing, or Brazilian capoeira all could function as nonpharmacological treatment models. Yoga helped many women to calm down. Martial arts offered a successful program for rape victims. Ballroom dancing classes taught teenagers with attachment trauma the rules of the social engagement system through doing something together while being rhythmically attuned to each other's mirror neurons. In addition, all these body-focused arts require and develop core strength and an upright posture to allow the flow of energy up the spine. All are essentially healing arts.

> Some 80 percent of the fibers of the vagus nerve (which connects the brain with the many internal organs) are afferent; that is, they run from the body into the brain. This means we can directly train our arousal system by the way we breathe, chant, and move, a principle that has been utilized since time immemorial in places like China and India, and in every religious practice I know of, but that is suspiciously eyed as "alternative" in mainstream culture.[8]

Guided Drawing helps effectively discharge arousal states through drawing verticals, verticals in combination with a drawn corner and release into the horizontal, or with the alternating crossover movement of punching or running on the paper. And it offers round, flowing, rhythmic patterns to create safety, calming down, and containment. At the core of the therapeutic effectiveness of all these motor impulses is sensory awareness. It is a critical aspect of trauma recovery. If we are not aware of what our body needs, we cannot take care of it. It is important to pay attention to the moment-to-moment shifts in our inner sensory world. These shifts carry the essence of the organism's responses: the emotional states that are imprinted in the body's chemical profile, in the viscera, and in the contraction of the striated muscles of the face, throat, trunk, and limbs.

It can be helpful to evoke the inner massage therapist, who has the ability to shift discomfort and pain. It allows clients to titrate their tolerance of rage, fear, or anxiety. They can touch on the stressful sensations, but then they also have tools to release and shift the stressors.

Sensory awareness teaches us to befriend our body. We can learn to tolerate inner sensations and experiences. We can quietly sit with fear or tension and observe its movements. Out of this awareness emerge new action patterns. Once we can start to approach our bodies with curiosity rather than with fear, everything shifts.

# 10

# The Bottom-Up Language

Because top-down approaches are primarily language- and image-based, art therapists can successfully employ many of the known counselling strategies. These may include person-centered techniques, inquiries into or depictions of a client's biography, or Jungian depth psychology with its focus on symbols. A therapist might invite active imagination emerging out of the artwork. Gestalt therapy offers a useful paradigm of identifying with every aspect of an image as "I am...." For example, looking at a landscape: "I am the sky. I am blue and expansive and connected to the universe," or "I am a fence. I am setting a boundary. I'm made of barbed wire. I am prickly. I can hold you back and keep others out."

When offering a bottom-up approach, these counseling techniques mostly do not work. Instead it is crucial to accompany clients in a way that supports trusting their body and keeps them as much as possible out of their head. The mind tends to offer a running commentary of judgments, especially once we begin to focus on the body. Anyone who has ever practiced meditation will know how the "monkey mind" can play havoc from the moment we try to be still. It will jump around, chatter nonstop, and try everything to keep in control. In clients who have self-value and self-esteem issues, this chatter is rarely kind. Instead, their self-talk is judging them for their lack of skill and talent, or their inability to do this or be that. Often this is further enhanced by fears locked in the body, and thus the body is simply not experienced as a safe place to go to. Over the years we developed a language to support the

sensorimotor process, which has proved effective. This simple chart may illustrate the three core phases, which I have flippantly called "Flow, How, and What."

| PHASES | THERAPIST'S LANGUAGE EMPHASIS | PHYSIOLOGICAL RESPONSE | ANALOGY TO A CAR |
|---|---|---|---|
| **FLOW** | motor impulses: "Yes," "Great," "Keep going," "Hmm," "Yep" Making supportive sounds | • abdomen<br>• entire physical body<br>• core emotions | • gas pedal<br>• accelerates and supports movement |
| **HOW** | sensory awareness: "How does that feel?" "I wonder how this resonates in your body?" | • heart<br>• chest<br>• felt sense<br>• feelings | • gears<br>• shifts awareness and emphasis<br>• fine-tuning |
| **WHAT** | cognitive integration: "Do you have an image?" "What are you doing? What does this mean to you?" | • head<br>• reflection<br>• cognition<br>• meaning | • brakes<br>• stops movement and blind acting out |

I like to compare the whole process of verbal interventions to driving a car. We have the gas pedal in order to accelerate the process and bring it in flow. Then we can shift gears to regulate the speed. And we can put the foot down on the brakes to stop the process, if there is danger ahead (should it get too activating), or if the journey has come to an end.

## Flow

The way to keep the focus away from the monkey mind is to encourage motor impulses and rhythmic repetition. The therapist has to support this process through a language that encourages rhythm and repetition. When they come in for an art therapy session, many clients will expect to draw and make things. To be asked to close their eyes and draw with both hands is already a challenge. Because clients may feel initially uncomfortable about this, even when trust has been built in prior sessions, they will rarely engage in more than two or three repeats, and then open their eyes again. If the therapist

then engages in questions and meaning, the process will stay in the head. So instead, the therapist might encourage drawing more repeats of the same shape while making supportive sounds such as "Yes," "Great," and "Keep going." Often a simple "Hmm; yep; hmm" is sufficient. Such sounds can give clients the assurance that they are on the right track rather than making a fool of themselves. It is important to avoid value statements such as "Good," because they imply that the client could potentially do something "bad."

It can also be explained to a client, as a form of psycho-education, that rhythmic repetition has the purpose of contacting deeper layers within the body, and how important it is to get out of one's head for a while. Shock and trauma are stored in the autonomic nervous system, and the only way for us to contact this part of ourselves in the brain stem is through the involuntary motor division. In order to encourage regulation of arousal states, of impulsivity and chaotic dysfunctional organization in the brain stem, Perry promotes patterned, repetitive, somatosensory activities such as drumming, movement, yoga (for regulated breathing patterns), and massage (for the experience of safe rhythmic touch).[1] We need to be able to surrender to rhythmic movement patterns in order to connect with our deep primal trust in life that is developed in the first months of our existence; this trust is always nonverbal and body-based. Cognitive processing might help us understand what happened, but it will not be able to undo the physiological responses in our body. There is an art in supporting clients in a way that they can come in contact with their motor impulses and gain trust in them to the extent that they can later on actually rely on them to find a healing response.

It might help to understand this approach by describing how we work with children with Guided Drawing. They will be given sticks onto which colorful ribbons are tied at the end. One in each hand, they are encouraged to move with the sticks, dance with them, and twirl them until they find movements with them that they like. They are then encouraged to draw the same movements with a crayon in each hand. Adults will have to find these movements through rhythmic repetition on the paper. These movements can be unintentional until sensations emerge that make them more distinct. While I accompany clients with little sound, such as "Great" or "Yes, keep going," I will monitor my own mirror neuron system to find out if clients draw with an appropriate rhythm. If they draw too fast, it has a confusing effect on me. If they draw too slow, it will make me sleepy and I find it difficult to stay in the moment. The "right" rhythm indicates that my client is alert and present, and

I feel alert and present too. Interventions can help to fine-tune the rhythm. I might ask a client to "draw faster than you can think" when I get the impression they are overcontrolling every move, and then support the accelerated pace with little encouraging sounds. "How" questions such as "I wonder how the speed you're drawing with feels?" can slow down the pace to the extent that the client can actually feel something rather than just being overwhelmed, or suppress sensation through intense action cycles.

If clients get lost in a sensorimotor haze, or get overwhelmed, or begin to blindly act out, the therapist can call them back by applying the brakes. In this case, "what" questions are employed. The therapist might even say the name of the client: "Peter, I wonder what you are doing here?" in order to get the client to stop and open his eyes for reflection. "What" questions stop the flow and bring cognition online.

It is a delicate dance. Even clumsily worded "how" questions can interrupt the flow. Some clients, who are already "too much in the head" and like to control everything they do, will jump on every opportunity to be released from surrendering to their sensorimotor impulses. The same applies for hypervigilant clients or those in shutdown, who are afraid of their interoceptors. In order to support their process so they can trust their body again, the therapist has to proceed very carefully in facilitating flow phase prompts without activating the clients too much, but at the same time assisting them to safely touch on inner sensations. "How" questions introduced too early might bring up too many body sensations. It is not unusual to spend a whole session, or the majority of the time in flow, building trust through gentle, rhythmic motor patterns, while assuring the clients that they are doing great and there is no need "to do or achieve 'more.'"

We recommend as an easy rule that as long as the hands draw motor impulses, we stick with almost nonverbal flow interventions, with the occasional "Yes; hmm; great," and otherwise we are simply present. Many times, I catch myself subtly moving with the client. Even if clients have their eyes closed, they will sense this as supportive through their mirror neuron system. In the same way, the therapist can down-regulate activation in the client by deeply exhaling. Soon after, the client will exhale as well.

What traumatized clients learn during the flow phase is that they can titrate their physiological experience through massaging out pain and tension, so they can stay active. They also learn to regulate arousal states. Basically the flow phase wants to build increasing tolerance for sympathetic and

parasympathetic activation cycles through rhythmic repetition. They can, for example, use both rhythm and particular shapes to return hyperarousal and hypoarousal states to the window of tolerance. The flow phase rebuilds trust in the body

> by focusing attention exclusively on body sensations, and movement, experiencing them as distinct from emotions and thoughts. In this way, clients gain an effective tool with which to address their disturbing body perceptions and sensations; learning to uncouple sensations and movements from trauma-related emotions and cognitive distortions.[2]

In this way, they can discover "good" parts within themselves through rocking in a bowl shape or shooting off arrows. They can build islands of trust and grow from there.

## How

The "how" phase has two core functions:

- to enhance sensory awareness
- to foster body perception

Sensory *awareness* is passive-receptive, whereas sensory *perception* distinguishes structures within the body, can orient within it, and is capable of making decisions on this basis, such as employing voluntary motor impulses with intention in order to effect change.

Sensory awareness is a felt sense; it can be quite diffuse at the beginning, which will manifest in multilayered, even chaotic, movement patterns on the paper. Clients might, for example, respond when asked "I wonder how this feels?" with a simple global "Good." They are often "at a loss for words" when they are deeply engaged in flow. As long as they are feeling "good," it might be wise to support them to continue with their motor impulses. If these come to an end, though, and it is time to change the sheet of paper, it can be appropriate to check in again: "I wonder how this movement resonates in your body?" In the nonverbal flow phase, clients might now rub their belly or chest like a child and not say much at all. This is again a positive indicator that they have engaged in deep contact with themselves. Even if clients do not answer as such, the question alone will activate sensory awareness in their nervous system, and the therapist should not insist on a verbal response, unless clients

are stressed and panicky, in which case they often no longer actually hear anything, and it is clearly time to become directive, apply the brakes, open the eyes, and down-regulate through orienting in the room, through social engagement and other resources. "How" questions while clients are drawing will interrupt the flow. They might be necessary for lowering activation, but should be avoided otherwise, as they interrupt a client's connection within.

In this way, the session proceeds from flow drawings, and more flow drawings, while the therapist introduces gradual sensory awareness whenever an impulse feels finished, when the paper is changed. The client's responses might graduate from the initial "good" to more differentiated sensations, such as how it feels "tingly" in the arms, or "tense" in the solar plexus. Sensory qualities emerge. Clients are able to perceive that certain drawn movements bring release, that they can discharge tension and they *feel* different afterward, or that they can use a rocking movement to calm down. And the therapist supports awareness through: "I wonder how it feels now?" and through interventions suggesting certain shapes "to repeat, trying them out, if they work."

Body perception will prompt more active responses than passive sensory awareness. Body perception can be actively enhanced through introducing Guided Drawing's archetypal shapes. The therapist might show the client how it is possible to release the end of drawn lines with ease while staying upright. The shapes of Guided Drawing can structure confusion and chaotic movement patterns and bring clarity and intention into the process. Now clients gain sensory orientation on the inside. They are capable of distinguishing, for example, their spine; they can clearly sense its base as solid, but the farther up their perception rises, they feel it blocked. Based on this sensory perception, they can then take drawing action to release or contain, using the given shapes of Guided Drawing with their individual modifications until their sensory awareness tells them that they are now feeling "better."

Interventions suggesting certain shapes bring clarity into the often diffuse felt sense. Sensory awareness says: "It hurts here." Sensory perception can distinguish the movements of contraction or tension in the body that cause the pain. Based on this perception, clients can then draw intentional movements to ease or release the pain. Perception has intention and can deal with the attached emotions in the same way through directing their flow to release, contain, or soothe them. The dance between the flow phase and the "how" phase continues throughout. The therapist supports motor movements with

little "yes, yes" sounds and then checks in on how it felt. As clients become more comfortable, trusting, and skilled, the therapist will step back from verbally supporting flow. It can get irritating for an experienced client, whereas it is necessary for beginners.

Once an active response has been drawn, it is important to again fine-tune awareness: "How does it feel now in your belly after you have released the anger?" When the nervous system begins to settle and calm down, it is important to switch again to sensory awareness, which is now much clearer due to the perceptual input. It is important to understand that the healing response arises from the involuntary motor division connected to the autonomic nervous system. This response can only happen when flow has slowed down and is rhythmic and present, and no longer blocked by fears arising from our biography. Many clients become aware at this point that their bodies respond with subtle involuntary impulses such as vibrating, shaking, trembling, tingling, or spreading waves of warmth or light. These involuntary impulses will frequently use the pathways that were created through the Guided Drawing shapes, but are not identical with them. These are not intentional responses that can be manipulated, but genuine involuntary events that happen within that are perceived with sensory wonder. Many clients will call such experiences "spiritual."

## What

Cognitive integration happens at the end of a session, and occasionally between drawings as well. All three steps are organically included in the dance, but the emphasis on cognitive processing happens toward the end of a session. Experienced clients might easily be able to drop back into flow after a verbal exchange and after having written a few words on the paper of their drawing, but the majority will not be able to do so, and then valuable minutes of the session are spent on getting back into contact with flow. Toward the end of a session, though, it is important to allocate sufficient time to integrate the sensorimotor experiences. If not, they may disappear, similar to a dream we don't pay any attention to; they are forgotten. The new felt sense needs time to adjust to consciously; sometimes everything has changed and shifted at the core. It might feel strange and unfamiliar, and some clients are initially keen to get back to their old felt sense, because their identity has been rewritten from the inside in a way they do not understand. To begin

with, they have no paradigms to relate to this new self. They have lived, for example, for decades as a victim. This new felt sense demands an entire shift in their identity. Their implicit memory presents them with someone on the inside they do not know. A female client with an abuse history felt "powerful and capable" after her drawing process came to an end; this was actually a self she did not know, and it took time to familiarize herself with this new sense of self within her. Many traumatized clients are stuck in multiple defensive layers and action patterns that now have become obsolete. Adaptation to these "powerful and capable" aspects of self take time, sometimes years. They will affect clients' relationships, their patterns of behavior, their interests and work; the changes will impact on every aspect of their lives. They will tend to go back to the old paradigms under duress, but they will also gradually be able to build a new identity.

> Individuals who are able to construct more realistic or positive meanings in the wake of trauma are more successful in overcoming the impact of traumatic experience than those whose interpretations remain distorted and negative.[3]

It is necessary to relate the sensorimotor drawing process to biographical life events at this stage. The drawings document what has taken place. They show the pain and hurt, and they show the repair. Clients can perceive an embodied timeline that has emerged in the nonverbal story they have told. They will be able to write statements, often affirmations, underneath their drawings. Because of the bottom-up approach of this modality, they "arrive" at this cognitive understanding or return to it after they have ventured through the underworld of their often faceless and confusing sensorimotor nightmares. This usually involves them having found an active response to events that have disempowered and overwhelmed them in the past. As they resurface to their cognitive function, it is important to acknowledge the changes that have taken place. They now feel different. Occasionally this new self emerges as an image of deep symbolic significance, but mostly it will manifest as a distinct "new feeling." It might require time and the therapist's insisting support to consciously honor what has taken place.

Rather than focusing on the story of what has happened at the beginning of a session and through this reinforcing and further embedding the trauma in the client's psyche, Guided Drawing will spend time toward the end of a session to tell the story of empowerment and healing. The therapist and client might go back over the created drawings and point out themes, where

the injury or pain was depicted, how then an active response brought visible change, and how this transformed past events. Clients will write statements on their final drawings, which frequently sound like healing affirmations that have emerged from a deep inner source of wisdom.

Van der Kolk states that the role of the therapist is not to interpret the trauma but to facilitate self-awareness and self-regulation.[4] Sensorimotor Art Therapy involves detecting latent sensations and action tendencies. When these are focused on, clients are able to discover new ways of orienting and moving through the world.

# 11

# The Expressive Therapies Continuum and Guided Drawing

One way to further illustrate the bottom-up approach in Guided Drawing is by looking at the Expressive Therapies Continuum developed by Vija Lusebrink and further enhanced by Lisa Hinz. Lusebrink, one of art therapy's pioneers, investigated how certain art therapy activities stimulate different regions in the brain and how we can assist clients through targeted creative exercises to awaken and structure these neurological pathways.[1] Her concept distinguishes three core assessment levels, which can be related to Guided Drawing to enhance our understanding of the bottom-up approach:

**The kinesthetic-sensory level** represents simple motor expressions, usually scribble drawings with crayons, but also pounding clay, painting to music, mixing paints, and sculpting wood or soft stone. In the context of other arts therapies, they involve, for example, drumming and rhythmic dancing. Sensory perception can be supported with painting with finger paints or shaving cream, stroking wet clay, or exploring objects with closed eyes. Music may be added, or aromas and essential oils, to stimulate multiple senses and personal memories. These art activities relate to Piaget's early childhood sensorimotor stage and support learning through repetitive movements and through

the senses.[2] These dynamic kinesthetic expressions with concurrent sensory feedback affect primarily the motor and sensory cortex of the brain.

Lusebrink states that an emphasis on kinesthetic activity will decrease awareness of the sensory component of the expression. Reversely, emphasis on the sensory component will decrease and slow down kinesthetic action. The focus can be directed only to either the experience of sensations or motor impulses, but not to both simultaneously.[3]

In Guided Drawing, the therapist can verbally support this sensorimotor level through interventions based on the "flow" and "how" Phases. Flow interventions will support rhythmic movement and activate kinesthetic motor expression. "How" questions are designed to slow down motor impulses enhancing sensory awareness.

The kinesthetic-sensory level addresses a complex set of neural networks that is the organizing base in the brain stem. Perry points out in his neurosequential model of therapeutics that impairment in the organization and functioning of these neurotransmitter systems will trigger cascades of dysfunction in all higher brain systems and disrupt development.[4] Reactivity to stress responses or developmental problems due to complex trauma need to be treated at this sensorimotor base first until they are better regulated; only then can treatment move sequentially up in the brain.

**The perceptual-affective level** focuses on forms and their differentiation as well as the expression of affect. Lusebrink and Hinz relate this stage to the VVC, our social engagement system. According to Perry, this will address the limbic system, which is relational-related.[5] While Perry's focus when working with maltreated and traumatized children is on establishing nurturing interactions with trustworthy peers, teachers, and caregivers, in Guided Drawing the relational qualities become internal discoveries. We recognize the socioemotional tribal patterns that once shaped our identity, how we learned safety, love, and belonging, but also how we learned violence, pain, grief, and isolation. We detect the internal structures and emotional patterns that are deeply related to our embodied sense of self.

Here, shapes are drawn and differentiated. Such shapes have boundaries and color to mark particular areas. They are perceived within a space, in relation to each other or on a background. Exercises may include nonverbal communication on the paper, drawing from reality, self-portraits, and those

of family members. Color and shading are used to express affective modi-
fication of forms. Such exercises can be enhanced through music in order
to identify certain mood states, through collages of faces to identify emo-
tions, body maps of feelings with a particular focus on anger, sadness, fear,
and happiness. Psychopathological variations may appear as disintegrating
forms, incomplete forms, or the overemphasizing of details or their lack of
it. Affect in this case often shows an indiscriminate mixing of colors, clashing
or inappropriate application of colors, and the merging of figure and ground.

The perceptual-affective level in Guided Drawing manifests as the ability
to perceive and differentiate the structure of the inner body, such as its skele-
tal build, and the distinct movements of muscles, the viscera, and the breath.
This clarity of perception of the felt sense will then enable clients to identify
emotions that cause such movements, and they will be able to express these
with clarity. Drawings on the previous kinesthetic-sensory level often appear
chaotic and multilayered, whereas they will now emerge with differentiation
in shape and color. Body perception can be identified and expressed through
color and rhythmically repeated shapes. Certain colors become synony-
mous with particular emotional states. There are anger colors and healing
colors, and they have distinct movements and shapes. Clients are capable of
applying their "massages" with self-motivation and a sharp sense of what is
needed. The therapist still supports this level with some flow, but primarily
with "how" interventions. There will be increased emphasis on the sensory
as inner perception. There is no longer just an awareness of sensations, but
these sensations begin to form a felt body that can be clearly perceived and
represented. Clients, for example, are now able to locate their pelvis and spine
as bodily structures, and they are capable of drawing these structures, includ-
ing distinct biographical details that have affect and a felt history that they
can sense. This felt body has a sense of identity and an emotional response
to past and current events. Accordingly, clients will be able to identify the
movement of emotions in the body and will find pathways to express them.
Emotions are characterized through colors and shapes and rhythmic repeti-
tion; their needs can be met either through expressing them or containing or
soothing them with, again, colors and drawn shapes.

The cognitive-symbolic level emphasizes the cognitive integration of
forms and lines. This may lead to concept formation, its categorization, and

also to problem solving, spatial differentiation, and integration. It includes adding words and meaning to the artwork.

The symbolic component is intuitive, emphasizing right brain hemisphere global processing, which takes input from the sensory and affective sources as well as from autobiographic processing, and symbolic expression. Images charged with affect, the symbolic use of color, symbolic abstractions, and intuitive integrative concepts are associated as a symbolic relationship from which individuals derive meaning.[6]

In the context of traditional art therapy modalities, the most favored medium here would be collage, preferably with a multimedia approach. Such collage activities can be themed, such as creating timelines or a family collage, soul cards, or strengths books. These are activities that support complex problem-solving and ordering concepts. On the symbolic level they will foster the identification of archetypal qualities, the realization of internal wisdom, and that of one's own journey. Lusebrink relates this level to the prefrontal cortex. Therapeutic techniques can now become more verbal and insight-oriented.

When I see new clients, I almost always commence with art therapy activities on the cognitive-symbolic level, working with collage or small toy animals around themes of family of origin or current conflicts. These exercises give me insight regarding the complexity of clients' problems and how capable they are to process their issues cognitively. On this basis, I make decisions as to whether a bottom-up approach is safe, or whether we first need to build resources. Such exercises are also necessary to build trust and a relationship before deeper issues can be addressed.

In the context of the Guided Drawing bottom-up approach, clients arrive at the cognitive-symbolic level toward the end of a session, like deep-sea divers returning to the boat. They need time to process what they have experienced while they were underwater; they need to understand this new person they have become, the changes that have taken place. Many emerge from what could be called an altered state of consciousness, and they need to put meaning to the sensorimotor events. It helps to have the drawings at hand, as they document the process. There will be body sensations, emotions, and insights contributing to a collage of new perspectives. These can now be tested in "the real world." Clients might orient in the room, make eye contact, and say and write statements about how they feel now. Old paradigms have ceased, but what do the new ones feel like?

| GUIDED DRAWING AND THE BRAIN | | | | |
|---|---|---|---|---|
| **Expressive Therapies Continuum** | **External Drawing Action** | **Internal Body Awareness** | **Triune Brain** | **Approach** |
| cognitive-symbolic level | • understanding the language of implicit memory<br>• linking it to conscious autobiographic events, if possible | • understanding the symbolic expression of color and shape and intended direction<br>• ability to give meaning to the felt sense in the body | *Neocortex*<br>• episodic, auto-biographical memories<br>• coherent, personal, spontaneous, reflective<br>• rational and irrational | top-down |
| perceptual-affective level | • directing motor impulses with intent<br>• application of particular archetypal shapes for orientation and to affect change<br>• having inner orientation | • sensing resonance in the body of particular directions and structures of shapes<br>• experiencing the encoded emotions<br>• expressing affect through colors, shapes, and movement | *Limbic System*<br>• mammalian universal emotions such as fear, anger, disgust, surprise, joy, grief<br>• fluctuating outside the bounds of conscious awareness. | |
| kinesthetic-sensory level | • drawing motor impulses according to sensed physiological tension and pain | • sensing resonance in the body, which will lead to massage movements executed as motor impulses | *Brain Stem*<br>• procedural action patterns<br>• emergency responses: flight, fight, freeze<br>• attraction and repulsion | bottom-up |
| | • feedback loop to sensory awareness | • feedback loop to motor impulses | | |

At the beginning of a session, the initial question is rarely conscious, but predominantly a motor impulse, based on physiological pain or discomfort. The answer at the end of a session is also rarely conscious, but predominantly sensory; we perceive it as a renewed felt sense. The purpose of interventions during the drawing process is to increase perception. Perception increases our ability to orient. Normally this involves external orientation. In Guided Drawing, the emphasis is on internal orientation. The shapes and how the movements are directed in order to create these shapes give orientation. This is motor impulse–driven orientation. Once we then begin to "feel" these movements, once we begin to be aware of their sensory resonance in the body, affect rises, and we respond emotionally. This might be anger, grief, or joy and relief. In order to complete the bottom-up approach, cognitive integration is important. Interventions now need to enhance understanding of the multilayered collage of motor impulses, sensory awareness, perception of the shapes and their direction, and the attached emotions in order to find meaning in what healing story the implicit memory tells. Finding such meaning, and consciously acknowledging it, is deeply satisfying. It creates lasting resolutions in the autonomic nervous system.

# 12

# Line Quality

Line quality is an essential diagnostic art therapy tool.[1] It can offer valuable insights, in particular regarding emotional states and conscious awareness. Whether clients feel under pressure, blocked, frustrated, broken, tentative, or relaxed and fluid, it will become apparent in the lines they are drawing and the way they apply paints. Apart from the shapes created in Guided Drawing and their significance, it is important to look at the individual lines. How much pressure has been applied? How fluid or hesitant are they? The quality of a line reveals much about a client's level of awareness concerning a certain issue; it expresses states of conflict or resolution. Just as we as therapists can observe our clients' behavior from the outside, we can observe the line quality as a manifestation of their physiology on paper. From a diagnostic point of view, the line quality is just as significant as any chosen shape. Guided Drawing works with four categories of line quality:

- disconnected line quality
- dense line quality
- subtle line quality
- transparent line quality

The **disconnected line quality** (fig. 12.1) appears when motor impulses are dissociated from sensory perception. Clients draw abruptly or in mindless repetition; they doodle. The layout is scattered, with bits here and there. Individuals talk or think about unrelated issues while they draw, afraid of or resistant to, focusing in silence on their inner reality. The drawings look inanimate and fragmented.

FIGURE 12.1. Disconnected line quality.

Pencils and felt-tip highlighters are the preferred tools, reflecting a linear rationality. Colors may be rejected because they evoke emotions, or they are used solely for decorative purposes. Most times I have observed this disconnected line quality with psychiatric patients, clinically depressed or medicated clients, those suffering from anorexia or bulimia, and those with severe nervous system hypoarousal. Such individuals feel dead on the inside, and their expression is equally lifeless. Such clients can only access their prefrontal cortex and are cut off from their limbic system and the brain stem. They are neither in contact with their emotions nor with their inner body rhythms.

At times this is a beginner's syndrome, and with some support clients begin to connect, feeling less awkward to rhythmically repeat a shape. Others might need to build resources first before they feel safe enough to relax into a sensorimotor approach. It is of more concern when this phenomenon occurs in the midst of an otherwise flowing process, in which case it becomes an indicator for dissociation.

Brigit remembered during her therapy a sexual assault when she was seven years old. Suddenly the vivid richness of her drawings died into lifeless shapes. Eventually she found she could face the memory, but not the attached emotions. We worked out a way she could tell the story from the perspective of her inner child by using the graphic tools of a seven-year-old. With colored pencils and a small pad of paper, she started out. The drawings looked stunningly like a child's product. She drew the house they lived in, scenes with a table, chairs and family members all lined up at the base of the page, as a child of that age would do. She told the story of the assault from the perspective of

the seven-year old, when part of her development had arrested. Once she had worked out the timeline and could look at the entire story, she could dare to allow emotions in. From the moment these were integrated, she continued to draw her embodied self in a rich and colorful way.

A **dense line quality** (fig. 12.2) appears thick and heavy. From rhythmic repetition, single lines merge into a growing mass, leaving a shape looking like a large two-dimensional block. The motor impulses are monotonous, either heavy, slow, and "boring" or driven, loaded, and aggressive. Here we find senseless acting out, blind rage, or clients feeling stuck in a rut, weighed down and unable to see an alternative.

FIGURE 12.2. Dense line quality.

Paints are applied as thick paste and mixed to the point that they look "dirty." Spaces are densely filled in and tend to appear flat. The atmosphere is physical, emotional, earthy, and heavy. In the context of the Expressive Therapies Continuum, this is the kinesthetic level, with little sensory awareness.

When clients can bring their motor impulses and sensory awareness together at this level, however, they derive great pleasure from indulging in this dimension, especially if they are normally too much in their head, and were once forbidden to be aggressive, or get dirty, or enjoy their sensuality and sexuality. They may like to "feast like pigs" and joyfully smear paint on the table and their arms and faces, and so they should. In this way they can connect with their vitality and fulfill early childhood developmental needs. There can be a real hunger for lots of paint, lots of mess, lots of *having;* like an infant they just want to "have stuff," and lots of it. Especially if the client always felt short-changed, had to be quiet, behave well, or spends all day on a computer, the emersion in messy, sensual, rhythmic delight can be deeply healing and fulfilling.

Others, however, get carried away with aggression, tearing up the paper, breaking and throwing crayons. Clients here tend to be highly identified with certain emotions and inflexible concerning change. They are "stuck" with a certain issue, and they have little ability to reflect their actions or a change of perspective. There is anger, and nothing but anger. Or they make global statements such as: "I will never stop crying." To release vital energy that was cut off before can be significant and greatly healing, but the process itself might need input from the therapist to regulate the intensity of some emotions.

Clients who generally lack awareness may have to learn to discriminate and become more conscious of their actions. There is no gain from blindly acting out anger or to disappear in a vortex of self-pity. Such individuals may need to be interrupted and questioned about what they are doing. They need encouragement to relate their drawn actions to life experiences, to track them in their bodies, and to name them to increase their sensory awareness and cognitive insight.

Trauma held in the body frequently appears as dense line quality, while being surrounded by otherwise subtle flowing motor impulses. The frozen shoulder or the knot in the gut emerge as compact clusters where movement has been trapped in the freeze response, masking intense emotions.

FIGURE 12.3. This is Cath's first drawing, where she connects with pain and anger deep in her gut. The change in line quality is obvious. Initially the vertical is drawn lightly and almost transparently, whereas the trauma stemming from sexual abuse in her childhood is locked in a dense, tightly frozen knot she drew with lots of pressure and tight up-and down movements until the paper tore. She is fearful of connecting with it.

FIGURE 12.4. In her fourth session, Mary recovers the memory of two car accidents that left her fearful of driving. The sensation of fear is locked in her solar plexus. Two distinctly different line qualities are clearly visible. The surrounding body-space is filled with curling motor impulses that show her lack of structure and the state of confusion she is in, whereas the accident is drawn with repetitive pressure on the crossing lines with a dense line quality.

FIGURE 12.5. Sian worked in child protection. At times a case would get under her skin as it reminded her of her own sexual abuse when she was just a toddler. In these instances, she would experience such rage that she feared no longer being professional. Consequently she shut down and went into deep depression. When she came into the session, she needed a safe way to release the rage. She chose finger paints and a mandala structure to be safe in her explosive release.

FIGURE 12.6. Subtle line quality.

The **subtle line quality** (fig. 12.7) appears light, refined, and differentiated. The lines express a range of varying qualities: sharpness, softness, fragility, trembling, firmness, clarity—sometimes one line reflects several different states at once. Even extensive repetition leaves each single line visible, creating multiple depths. The impression is of animation. Shapes suggest a three-dimensional appearance. Spaces are filled with patterns or shapes based on rhythms. Crayons are used in a distinctive way by also holding them flat or sideways.

The atmosphere is awake and conscious, even if one does not know what is going on. Movement and rhythm change frequently and appear appropriate to and in accord with the experience inside.

Colors are applied as clear, relatively unmixed substances and with variety. They display a range of expressions, and in the case of watercolors and pastels, have transparency. Shades can flow into each other without losing their clarity.

Here clients are not identified with their issues to the extent that they are stuck with them. There is sufficient sensory awareness to accept change, controversy, and transformation. This is still the kinesthetic level, but motor impulses are now in balance with sensory awareness. Clients have access to structured body perceptions; they can orient on the inside and are able to express both their felt sense and the associated emotions with clarity. They are, for example, capable of associating certain colors with specific emotions and able to apply their self-massages with intention, inner direction, chosen shapes, and distinct movements. Clients in this frame of mind are looking for solutions and change; they are flexible and welcome shifts.

FIGURE 12.7. The line quality displays changing textures, variety in pressure, and vivid expression of different sensory states, even though conflict and strong affect may be expressed.

The **transparent line quality** (fig. 12.8) is light and clear. It is characterized by a natural quality of mastery. It appears to be simultaneously individual and universal. It happens, often unexpectedly, usually toward the end of a process as a sign of deep inner resolution. This line quality allows immaterial states of being to shine through. The presence of the invisible becomes visible.

The tone appears animated and inspired. It shows a three- or even four-dimensional quality, like a Japanese *sumi-e* brush painting, where a line reveals not only the depth of a landscape but also nature's transparency to universal consciousness.

FIGURE 12.8. Transparent line quality.

Crayons are used in a light, clear, and simple way. Patterns and shapes are purified of all unnecessary extras. Watercolors and pastels are the preferred materials. The attitude is one of unveiled simplicity. All turbulence and upheavals are resolved. The atmosphere is clear, light, and balanced, and clients share feelings of peace, gratitude, and joy. This line quality is an expression of the perceptual-affective level in the Expressive Therapies Continuum, yet it integrates the cognitive-symbolic level as well as a highly refined version of the kinesthetic-sensory level. Drawings may have profound symbolic or spiritual significance for the client and be stunningly beautiful.

FIGURE 12.9. This mandala is an expression of the transparent line quality. It was created with simple black chalk pastels yet displays multidimensional vibrancy. There is a clear sense of a nonphysical dimension shining through. It was created in the context of a meditation experience and filled the artist with joy and gratitude.

Using these categories, it becomes obvious that a circle drawn with a thick, pasty line reflects a different conscious state from a transparently light one. It is important, though, for clients and therapists alike to observe the various line qualities in a nonjudgmental way. One client might need to acquire some really "dense" grounding in order to get out of his head; another has to learn about variety and differentiation to become unstuck and leave old fixations behind. All shapes and their line quality are momentary reflections of individual states of consciousness. Nothing is fixed. Most of us have highly refined aspects of our personality as well as neglected areas, where we are frozen in fear and hurting; all of these want to come into the light of being without being judged.

# 13

# Intervention

In order to understand the value of the following chapters on the primary shapes, I would like to clarify why these shapes are so important. There are clients who favor a nondirective approach and, if they are able to self-regulate sufficiently, this is most desirable. However, the majority of clients will come into therapy because they feel stuck; many are suffering from either unmanageable states of hyperarousal, or are shut down, or both. These are the clients that want "help," and if left to a self-directed process, will feel unsupported. For such clients, it is necessary that the art therapist, similar to a medical practitioner or bodyworker, suggests alternatives that will bring relief. The line-quality can inform the therapist where individuals are resourced, relaxed, and in flow, and where they are blocked, frustrated, and holding trauma in their body. In Guided Drawing it is possible to offer new directions in the form of particular shapes. These so-called primary shapes are of either a female yin connotation or a male yang one, and they can act as nonverbal intervention tools. This is what makes this sensorimotor process so valuable, because the shapes allow body-focused interventions to

- bring clarity into chaotic layers of scribbling
- assist in the release of inner tension and blockages
- support pendulation in order to regulate the nervous system
- offer containment and boundary repair

In addition the therapist can assist with

- finding the appropriate rhythmic repetition in congruence with inner states
- choosing appropriate art materials for certain emotional and physiological states
- offer psycho-education to understand the impact of trauma phenomena and treatment options

The following chapters will inform on how these interventions can be applied through suggesting the drawing of certain shapes, because once clients begin to *move* differently, they begin to *feel* differently. Rather than the continuation of dysfunctional physiological patterns along with a traumatizing recount of events that happened, this therapy offers a clear focus on repair. The way out of dissociation and freeze is through movement; the way out of toxic identifications is through moving in a different way.

The healing of hurtful patterns happens through strengthening the connection with the instinctual core self of a client, that part that was never hurt and remained intact. Nature has not designed us to be sick; biographical events have made us sick. Levine considers PTSD as a conflict between the brain stem and the prefrontal cortex. Nature has equipped us with ancient survival tools to cope with adverse life events, tools we share even with crocodiles and fish. Our instinctual brain stem knows how to recover. However, the prefrontal cortex of modern people is too sophisticated to surrender to the involuntary responses of the autonomic nervous system, in particular, when we already feel out of control.

Jung discovered the same principle, though he viewed it more in the context of a divine eternal core, where all beings are whole and intact: the Self. He shares, however, the idea that the individual needs to surrender to darkness, pain, and suffering at a point beyond conscious control, and only then can a turn-around happen. Hippius called this a "quantum leap," as something she likened to nuclear physics where, rationally inexplicable, the core Self is activated in the deepest and darkest moment. The neurosciences equate this process with the surrender to our instinctual core in the autonomous nervous system. Levine links our "gut instinct" to what we tend to call "intuition":

> I believe intuition emerges from the seamless joining of instinctual bodily reactions with thoughts, inner pictures and perceptions. How this holistic

"thinking" works remains somewhat of a mystery (though speculation abounds).[1]

For Levine this embodied intuition is the driving force for the bottom-up approach. "I sense, I act, I feel, I perceive, I reflect, I think and reason; therefore I know I am."[2] The focus on internal bodily awareness is the foundation of spiritual practice worldwide, be this in Tibetan Kum Nye, the twirling of the dervishes, indigenous dance and drumming circles, yoga, tantra, Zen, taiji, and many others. All use the structure of a discipline that enables individuals to safely relax into deep parasympathetic states. The ego as the controlling force of the prefrontal cortex experiences a planned death, in order to merge with a greater sense of being alive and connected. A Tibetan teacher once explained meditation to me as "controlled suicide of the ego"; to become truly alive, we need to learn to let go. Levine has demonstrated that the occurrence of a healing vortex is a natural event:

> While trauma is about being frozen or stuck, pendulation is about the innate organismic rhythm of contraction and expansion. It is, in other words, about getting unstuck by knowing (sensing from the inside), perhaps for the first time, that no matter how horrible one is feeling, those feelings *can and will change*…. In order to counter horrible and unpleasant sensations, effective therapy (and the promotion of resilience in general) must offer a way to face the dragons of fear, rage, helplessness, and paralysis.[3]

Such effective therapy involves clients being encouraged through appropriate interventions to get a taste of the opposite of fear and pain. This countervortex or healing vortex might come as a body sensation, an image, a felt sense, a particular posture, or a small movement; it might be music or a prayer or human contact. Through drawing such experiences, they can become "islands of safety" and encourage the discovery that maybe there is not just overwhelming "badness," and maybe the body is not the enemy after all.

Even for survivors of the Holocaust, there was an accessible healing vortex in the darkest hour of their existence. In our Somatic Experiencing training, we watched a moving video case history in which Levine works with an almost eighty-year-old man who recalls how he watched children fly kites on the other side of the fence while he worked in the crematorium of the Treblinka death camp. These kites were his hope that an alternative did exist, even though he could at the time only touch this hope in his mind. This was, however, his healing vortex; it gave him enough strength to survive.

The idea of drawing a massage has the advantage that it implies the message of healing and relief of symptoms. No one will book a massage in order to increase pain; we expect relief and well-being from the treatment.

In Guided Drawing, it is obvious how different the male linear, angular quality is from the natural flow of the female shapes. In the Tao, yin is described as the passive principle, yang as the active one. The shapes with a female emphasis rotate and flow uninterrupted, be it as circle, spiral, or figure eight, while the male shapes are characterized by a clear direction and by angular breaks, as vertical, horizontal, jagged peak, cross, triangle, or rectangle. Each male yang line demands a conscious decision to focus on a particular direction, and it takes effort to aim at it. A change in direction will involve reflection, so the line can be broken, like through a prism, to follow a different course. The female yin instead winds its way around resistance, flowing like water a-*round* obstacles. It connects us with the organic flow of life and its various rhythms. The male yang will take a decision about the best or most appropriate way and then follow it with intention.

From a diagnostic perspective, it is important to look for balance. Is a client only capable of circling in a dreamy manner, and all yang is amiss? Or are there only constructs and hard lines and aggression on the paper, and any roundness and female yin are lacking? Clients who are stuck only have a few options available. Pendulating between yin and yang, rhythmic circular motor impulses, and directed intentional action patterns offers a balanced approach; it does not fear or avoid one or the other. Siegel calls the ensuing process "navigating the waters between chaos and rigidity."[4] Too much yin creates chaos. Too much yang leaves us frozen out of life and our bodies.

## Too Much Yin = Chaos

At the beginning of a cycle, as long as issues are predominantly unconscious, drawings tend to be dominated by round, undirected movements. Individuals who are happily embedded in their circle of family and friends might never question such quite unconscious flow. However, the majority of clients who show up in sessions suffer this roundness more like a vicious cycle. They feel stuck in cycles of addiction or depression. They might experience the circling as unstoppable emotional charge, or as oppressive family or workplace conditions that keep them trapped and disempowered. When there is too much yin, yang is amiss. Without structure, endless circles become chaotic

or oppressive as well as tiring. In Taoism, yin is the passive element. Clients may even present as feeling sleepy and having no energy; they seem not to be present. An overload of aimless flow lacks sympathetic arousal and taking action. Sessions will need to focus on *doing* something. Clients need to find out what they want and how they can act on this accordingly, rather than just letting things happen. Interventions that assist in discovering and strengthening the inner vertical through linear and angular shapes can introduce yang motor impulses as a countervortex. Drawing verticals or shapes that help clear the blockages in the spine encourages a sympathetic response. To find an active response to counteract passive endurance fosters self-esteem and self-value.

The drawing of linear and angular shapes is activating. Clients *do* something, as opposed to letting things happen, which is circular. Hippius likens the round shapes and circular movements to the collective unconscious, and linear and angular shapes to consciousness. In client groups where the ego needs to be strengthened, an emphasis on the yang shapes will be beneficial. In this case, drawings will depict linear, directed shapes trying to break out of the mothering, initially nurturing, then increasingly smothering round. In clinical settings, almost all patient groups suffer from a weak ego that is overwhelmed by uncontrollable, unconscious issues. Clients improve significantly when the vertical movement in the spine is encouraged to "stand up for myself," to stand alone, to be confident in making decisions.

Innumerable fairy tales and therapy sessions deal with the fears and terrors of the infantile ego. They tell about screaming injustice, brutal parents, family secrets, of being invisible or of needing to be invisible to stay unharmed, of being imprisoned, captured, and sent out into the world alone. Clients suffer terrible wounds. They may be trapped in abusive relationships, depression, addiction, and other dis-orders, and the therapeutic emphasis has to be put on strengthening, liberating, and supporting them. Many are overwhelmed by emotional cyclones; they suffer addiction, depression, feeling trapped and held back, not knowing what to do. All these dilemmas manifest as circular impulses on the paper. Clients lack drive, action, and a way out and forward, as well as the self-esteem to do so, which would manifest as linear and angular drawing patterns, if they could access them.

This woman (see fig. 13.1) in her fifties has had extensive therapy using emotional regulation, mindfulness, and art therapy. After ten months, she is now able to sit in a session and speak without becoming extremely distressed

(feeling like vomiting) or going into a panic attack, and she is now able to self-regulate to a degree. She has started reducing her alcohol intake from several bottles per day to a quarter bottle of wine in the last few days, and she no longer uses Valium daily. This progress is likely to fluctuate, but setbacks may not last as long now, since she has greater resources and capacity.

The way out of such tornadoes of hurt is through strengthening self-esteem and determination with linear motor impulses and angular corners to foster decision-making. Verticals and corners break the cycle. The male yang shapes are also the most suitable to complete an active response in the context of a thwarted fight-flight complex.

I recall an eleven-year-old girl who was living in foster care. Her father was a drug dealer, her mother an addict. The parents were separated, and the mother's abusive boyfriend was in and out of jail. Jenny had never in her life experienced even the most basic structure, such as cooked meals and bed-time; instead she had tried drugs, alcohol, and sex and was part of a gang when she was picked up by the authorities. Jenny arrived hunched over and sat slumped on the chair in front of me, her hair covering her entire face. She would only shrug or move her shoulders slightly in response to any question.

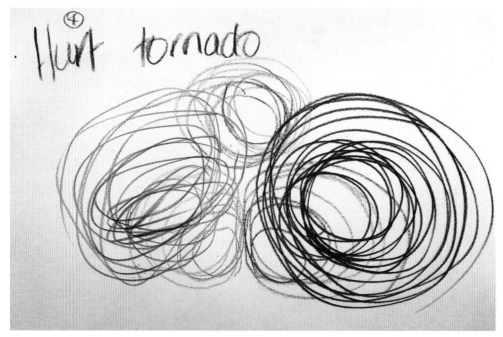

FIGURE 13.1. "A tornado of hurt" resulting from severe childhood trauma, multiple physical ill-nesses, mental health issues, and drug use.

She had no voice, no confidence, and her body language screamed distrust and hopelessness. I began by slowly putting colorful materials in front of her, wool, glitter, crayons, paper, glue, and more collage materials. She reacted with surprise that I did not want anything from her, and instead offered her something. After about ten minutes the hair was brushed back, and even though she still did not speak, she began quite enthusiastically to put together a collage. A few sessions were spent building resources in this way, using small toy animals, a self-box, and paint. She began to talk. For the third session she arrived upset and angry, and I suggested she draw vertical lines and release them "like arrows." She took enthusiastically to this "shooting" exercise, and it remained a session ritual for quite a while. Along with these verticals she shot off the paper, she could express her bottled up anger but also come more into contact with expressing her needs; she gradually found a voice. While she painted or collaged for the rest of these sessions, her questions began to focus on how she could get to know the other girls in her school. She was always the one who spent the lunch break behind the gym smoking cigarettes with the bad boys. She did not know how to interact with these "other" girls. As Jenny's social interaction improved, so did her learning difficulties. This might illustrate how the simple drawing of verticals, together with other art therapy exercises, could improve Jenny's self-esteem and confidence.

Linear and angular shapes are well designed for sympathetic responses such as fight-flight. They can assist clients to complete motor impulses that were thwarted in the past. In the mythological context, the struggle is about liberation from the Great Mother forces, which are often depicted as highly traumatic, such as the beast that threatens the community and which needs to be heroically slain by the hero. The hero carries the lance, which is synonymous with mastery of the vertical linear motor impulse and controlled aggression. Many American movies are spectacular role models for this striving. The hero battles against overpowering forces of evil, be it criminal gangs, political conspiracies, or the wild forces of nature. He will always win, and he will win *alone,* against all the odds and against the expectations set up in the plot, and much to the audience's relief.

## Too Much Yang = Freeze

On the other end of the spectrum are those clients who are frozen out of their bodies. They are so contracted they can barely move and are often numb

to their felt sense. They tend to draw in a fragmented way, doodling in bits and pieces without flow or connection. Others "scrub" in intense zigzagging movements up and down to illustrate tension or fear, which I call the "yes, but ..." motor impulse: "Yes, I want to, but I can't." These client groups greatly benefit from any kind of rhythmic motor impulse that will give them a sense of warmth and life. Simple round, repetitive rocking can create soft containers and boundaries that are needed to build a sense of safety that is so painfully amiss. These rhythmic movements do not need to be directed and intended, but are more "allowed to happen." Anything that supports such clients to relax and can activate parasympathetic states of well-being is beneficial.

Many complex trauma clients have never experienced the physical world as a friendly, safe place. Often sensitive, creative personalities, such individuals have hardly ever experienced themselves as an integral part of their families as children or of the wider community. They often live with a deeply rooted sense of isolation and of being misunderstood. Some lead strange or secret side existences and pass unnoticed in their potential. Many are considered "weird."

Like the Ugly Duckling, this last type of person is invariably born into families in which they feel alien, in which their beauty and gifts remain unnoticed for a long time. Their potential cannot unfold. At best, they are forced to become self-reliant from an early age onward. Such lack of support can create enormous inner tension, where we grit our teeth, hold ourselves together at all cost, put up defenses and "get on with life." It is a survivor's stance of intense contraction. If lucky enough, these clients have developed a strong ego to survive but do not feel fulfilled or satisfied.

Myths reflecting this alienation from the family bonds are the numerous stories of abandoned children such as Jason, Oedipus, the biblical Joseph, Moses, and Snow White. For varying reasons of self-interest, the parents reject the child. Often outwardly invisible, the contact with the internal ground is disturbed. Lack of connectedness with one's vitality and sexuality, or the perversion of these forces, is a key symptom.

Psychologically, this is the field of dissociation, frozen feelings, suppressed grief, and mental control at all cost, which may manifest as anorexia, self-harm, chronic fatigue, and autoimmune diseases. Meaninglessness, numbness, and depression are key themes. The inner landscape here is not so much the suffocating, hot, and hellish inferno of the emotionally charged mother-womb (which too much yin evokes), but one of isolation and cold, like on a mountaintop, or one lacking all nourishment, like the desert. Feelings are

those of loneliness and exposure, of abandonment, disconnectedness, and emotional hunger. Like Snow White, these individuals survive, but have a dead-in-a-glass-coffin life. Others are locked up in an ivory tower, powerless and disregarded as impractical dreamers or high-flying idealists lacking the vitality to realize any of their dreams.

Here the life cycle needs to be restored. Circular, rhythmic movement patterns that rock, soothe, comfort, and create nests and arms that hold are essential. The round yin shapes can encourage parasympathetic settling, helping clients to relax and feel safe. The round shapes connect and flow. They can help restore broken connections not only in the nervous system but also in life. Simple rocking movements can get clients out of their heads and encourage positive body sensations. Some of these might be reminiscent of early childhood developmental needs such as being held and rocked.

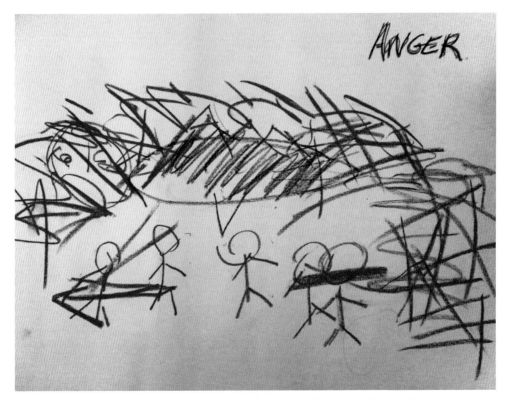

FIGURE 13.2. Sue has been using cannabis for thirty years. She has no formal diagnosis but identifies anxiety as a long-term problem. Her mother was and is emotionally abusive, and so was her last partner. Both her adult sons are addicted to methamphetamine and also abusive toward her. This drawing is about hating her mother and hating her own feelings associated with this hate. This is an example of disconnected line quality. There is no flow and no warmth, but there is visible fragmentation of all relationship patterns.

②No life force. No energy. Nothing to resist with.

⑧I surrender I let the old fall away and become compost for this opening to my own courage ⤳ trust ⤳ hope ⤳ radiance

FIGURE 13.3. Ciara suffers from a debilitating spinal disorder. At times the spasms and the pain are unbearable and only "bombing" herself out on medication brings relief. If possible, though, she uses Guided Drawing at home on her own to ease her condition. Her first drawing she describes: "No life force, No energy. Nothing to resist with." Six drawings later, in the same session, after she has restored rhythmic connectedness, she writes: "I surrender. I let the old fall away and become compost for this opening to my own courage and trust and hope and radiance."

Emerging out of a tonic immobility usually means confrontation with the unbearable thing that caused dissociation in the first place. In order to resolve whatever trauma caused these individuals to freeze, pain and suffering, anger and brutality need to be confronted.

In Jung's language of archetypes, this process is called the night sea journey. In mythology, this is pictured as the descent of the hero or heroine into the underworld, which is marked by a ritual death. The mythological guardians at the threshold are representatives of our fears. Their purpose is to scare anyone away who is not sufficiently resourced to face the unbearable; because once we have crossed over, we enter the totality of the unconscious, not just aspects. We do not just feel a bit or remember vaguely. It is an all-engulfing experience in which inescapably the truth can no longer be avoided. Here we suffer the crushing weight of shame and guilt, of violent emotions. It is the re-membering of once endured abuse, almost always concerning something that has happened to our bodies. It is facing the shadow aspect of the parent or their representatives, the uncaring mother, the ogre father, in their full supernatural power, enlarged as they once were as the gods of our childhood.

It is absolutely crucial that clients do not enter this state under-resourced. Only pendulation can make this process safe enough; otherwise it will be retraumatizing. The mythological heroes and heroines, the ones who manage to return from the underworld, enter this dark night of the soul with a highly individual skill set that gets them through. They know when to feed honey biscuits to a beast in order to appease it, and when to be quiet and not speak or not eat. How many girls in fairy tales have no voice, no hands, no shelter when they face their ordeals? Yet they have quiet inner resources that see them through. While male protagonists tend to solve their mythological battle with a heroic deed, women seem to go into the forest and face solitude and grief. Clarissa Pinkola Estés writes that the women's healing time is in solitude.[5] If we take this not quite literally, but with an archetypal interpretation, there are times when it is important to stand up and fight, and others when it is important to retreat and heal. The fighting aspect is supported with the male-yang shapes of Guided Drawing; the healing time resonates with predominantly round and flowing yin shapes.

The descent into the mother-tomb of the underworldly unconscious is characterized by two key phases: total loss and total gain. Something destabilizes the previous identity to the core. One is chopped and hacked to pieces in the mythological language, or falls apart in today's. One is dismembered,

buried, lost, and forgotten under the overpowering avalanche of recovered memories. Status and social standing no longer count. The ego disintegrates in an overwhelming experience.

It can be very hard for clients to let go of control and of their sense of being in charge, to "lose their mind," have their "head bitten off" and to be swallowed by the giant embrace of the goddess's cycle of life and death. Often the experience has been forced upon them by life circumstances and fate, and quite frequently through illness or mental breakdown. They then have to face a situation where they feel powerless, out of control, and initially without any apparent sense of direction.

To navigate this phase safely, it is of core importance to keep the rhythm between a trauma vortex and a healing vortex going in order to avoid being more overwhelmed. Clients can withdraw when it gets to be too much. One can learn to press the "Pause" button of the inner remote control. One can apply the brakes and employ the accumulated resources, even if this means just opening the eyes for a moment and orienting in the here and now. The focus is not on what happened, but on re-membering—to call back the spirit that took flight in the shaman's language; to integrate the dissociated fragments.

One of my favored interventions at this critical stage is the drawing of mandalas. Mandalas strengthen the core of the intuitive Self in clients. They offer a holistic pattern as a resource. They can be viewed as the creation of a *temenos,* the Greek word for "sacred space." These drawing exercises can range from filling in mandala templates, to creating individual designs, to keep a mandala diary. *Mandala* in Sanskrit translates as "circle"; they can be successfully employed as a spiritual practice for individuals in crisis.

It is possible for clients to move out of metabolic shutdown. The core need is to be safe. Animals also only begin to recover when they feel safe. This safety is facilitated through round, flowing drawing shapes that can counter-balance sympathetic arousal states and encourage parasympathetic settling. Linear and angular shapes will then be employed to complete the thwarted fight-flight impulse in order to reset the amygdala into equilibrium.

It is possible to transform fragmentation into a oneness that was inconceivable before but now feels like a homecoming, as being "the one I have always been." The solution, also in the graphic expression in drawings, is always bafflingly simple. This is an effortless state of being. There is nothing to hide, nothing to suppress, nothing to control. It is a meditative state of

deep resolution. One has entered a new dimension of being, where individuals have moved from survival to being alive. The senses are awake. The body is relaxed. There is no fear, no fight, just peace, loving awareness, and the rhythm of breath.

# PART II

The Body Speaks in Shapes: The Body Language of Rhythmic Drawing

# 14

# Female Primary Shapes

This chapter aims to introduce the ABCs of the language of Guided Drawing. It looks at the different shapes like letters in the alphabet. These shapes enable clients to tell their story. A structured starting point for fearful clients can be to practice one or two of the primary shapes, as suggested by the therapist. Such movements can be taken in repetition until clients feel confident enough to start on their own. Gradually many shapes come into play to tell a story. Another less directive beginning is just to flow with whatever the hands want to do in accordance with their body perception.

Hippius named the flowing round movements "female," the angular and linear ones "male." This chapter first introduces the primary shapes with a female connotation, and then the ones with a male connotation. The female, yin shapes are

- bowl
- arch
- circle
- spiral
- figure eight
- wave

The male, yang shapes are

- vertical
- horizontal
- cross
- triangle
- rectangle
- jagged peak
- dot

I shall explain these shapes in their correspondence to body sensations, in particular to trauma, and also to frequently associated emotions and feelings. Some mention will be made to the shapes as *Urformen,* the German word for archetypal shapes and their relationship to mythology, as it enriches the understanding of these shapes. None of the statements are meant as fixed interpretations. In each case, the experience of the client is the important key to their meaning.

A therapeutic approach using these shapes in the context of Guided Drawing goes back more than eighty years. Though no academic research has been conducted to prove the statements I shall make, common sense and thousands of client contact hours support this empirical knowledge. Rather than just "believing" my statements, however, I can only encourage you to try for yourself how it feels to draw certain shapes bilaterally on large sheets of paper, in rhythmic repetition, and with closed eyes, in order to find out how they are able to structure the perception of the felt sense.

In *The Transformation Journey,* I focused on every variation these shapes can take, as well as their significance as archetypes. My emphasis this time will be on the body-relatedness of the shapes and how they are suitable as trauma-informed intervention tools. Those interested in a more in-depth exploration of the symbolic significance should look into *The Transformation Journey.*

## The Bowl

**Physiology:** The largest bowl shape we experience in our bone structure is the pelvis, and while there are other places in the body that can be drawn as a bowl, such as the diaphragm or the back of the head, the most common

association with this shape is the pelvic floor. The pelvic bowl is the space in which we settle down to relax or which we dissociate when we are "upset." It is where our spine is anchored. The lowest chakra is not located in our feet, but at the base of the spine; as such, the pelvis represents the inner ground, our sense of being at home within. It cradles our center of gravity, the *hara* point of core strength.[1]

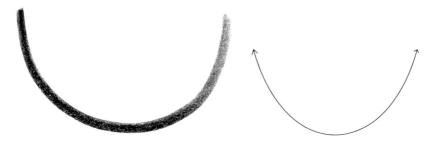

FIGURE 14.1. The bowl.

As embryos we are held in the womb, supported by the pelvis. It is where the gut instinct of motherly, protective security or the lack of it is experienced. The attachment with our primary caregiver shapes the complex matrix of our implicit memory, our unquestioned embodied identity. Early attachment shapes the relationship toward our own body and toward social contact. Later in life, this area of trust is expanded into our sexuality. The bowl evokes how much we can or cannot trust our gut feelings; and without this inner compass, life gets pretty difficult to negotiate.

The bowl shape in relation to the pelvis as the container for the abdomen evokes all issues associated with the dorsal vagal system. Here we can experience deep relaxation states in parasympathetic equilibrium, but also dissociation and fragmentation due to adverse experiences. On one hand, rhythmic repetition of a rocking bowl shape allows clients to feel grounded, settled, relaxed, and at one with themselves; they may even enter a meditative state or one of profound well-being. However, metabolic shutdown due to shock triggered by the dorsal vagus nerve manifests as nausea and diarrhea in order to expel poisons and release toxins.

Clients suffering from complex trauma, in particular perinatal and early childhood trauma, and often as a consequence also of sexual trauma, tend to be dissociated from their abdomen; they can't feel their body and are out of touch with their gut instinct, which helps us to stay safe. Infants have no

option to fight or flee. Their tiny bodies may arch trying to get away, but will shut down if the stressors are unbearable. Especially if parents are the source of trauma, and toddlers are repeatedly and for a prolonged period exposed to overwhelming situations, their nervous system never learns to settle. They are literally so upset that they are driven out of their bodies, causing lifelong nervous system dysregulation.[2] These are the clients who need to draw the bowl shape the most in order to discover a sense of how to settle. However, they are also the ones most easily triggered by this very motion.

**Archetype:** In Jungian psychology, the above trauma aspect would be symbolically described as *prima materia* (primary matter), as an undifferentiated, black, unconscious, and unredeemed substance that the alchemist attempts to transform into gold, into the philosopher's stone, into consciousness and resurrection; Jung dedicated his most important books on psychology and alchemy to this subject.

In yoga the base of the spine is the seat of the kundalini, the mystic snake, representing the complex energy systems that rise up through the chakras. In this context, the pelvic floor as the base chakra is the source of hidden spiritual forces awaiting their revelation. Associated Hindu imagery may refer to the crown chakra as a lotus flower, whereas the lower chakras are submerged underwater in sleeping consciousness, steeped—similar to Jung's *prima materia*—in muddy darkness.

Hippius referred to the pelvic floor as "the ground of suffering."[3] If clients have a history of complex trauma, their problem area is most likely the gut and dorsal vagal dysregulation.

Recurring images associated with the bowl are a cradle, supporting arms or hands, a nest, a boat, a cup, a cauldron, and other containers. As a positive archetype, the bowl is frequently described by clients as nourishing, protective, cradling, hugging—a shape that symbolizes the Great Mother in her positive characteristics. It is the pure, receptive gesture of unconditional love represented by female goddesses such as Mary, Sophia, Tara, and Guanyin.

**Intervention:** The rhythmic movement of drawing the bowl evokes a swinging or cradling sensation, especially when the hands move in parallel. This synchronized motor impulse predominantly triggers an experience of well-being and safety. A **parallel motion** of the hands (figs. 14.1 and 14.2) represents an unbroken relationship with the supportive, cradling ground. This quality can be consciously introduced through an intervention in situations of distress as a comforting gesture. An upset client can use this shape

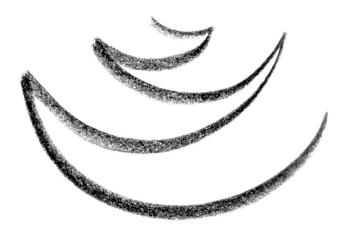

FIGURE 14.2. Bowl drawn with parallel motion.

to be rocked for comfort. It taps into the developmental need of an infant for soothing attachment. In this context, it is one of the most important interventions to assist clients to down-regulate and connect with parasympathetic settling.

Since many traumatized clients have a conflicting relationship with their body, an additional rising and settling motion (fig. 14.2) can be helpful to build trust. In this case, clients will only "wiggle" down as far as they are comfortable to go in their body, and as soon as it gets too activating, they can swing up again. As trust grows, the baseline can be gradually lowered with this titrated approach.

As such, it is a useful intervention to build trust; it can loosen up tensions and blockages. Sexual trauma in particular is held in the pelvic floor and is easily activated with the bowl shape. Figure 14.2 offers a way to gradually build tolerance and to deal with fear, and also to uncouple the perception of the pelvis from the trauma, because the pelvis can equally be a resource; it is not identical with the trauma.

There is a surprising difference in drawing the bowl shape with both hands parallel, rocking rhythmically (figs. 14.1 and 14.2) to drawing it in a mirrored fashion with the hands opening and closing (fig. 14.3). This creates a shape that does not sit on the ground, or *is* the ground, but one that opens and closes toward it. This suggests the possibly of something underneath or outside the bowl, which may cause sensations of weakness or lack of safety. One could fall through. To open the pelvic floor also touches the whole field of sexuality, especially for women.

FIGURE 14.3. A bowl drawn with mirrored motion.

Feelings of threat and uncertainty occur much more easily with the **mirrored motion,** where the hands connect and separate. Here the hands have a relationship of equals rather than the sensation in the rocking bowl in which we can be contained like an infant. In the mirrored version the left hand and the right hand, the left and right side of the body, and both brain hemispheres come together and move apart. They may meet with ease at the lowest point or may avoid connection or crash into each other. Is such an encounter conflicted or harmonic? The mirrored bowl is the more problematic variation, but also the more mature "adult" version.

If two **separate bowls** (fig. 14.4) emerge, the two sides of the body avoid connection, maybe because they are hard to synchronize. Occasionally a drawn dialogue where each hand has a say can prove insightful. In that case, the hands alternate in drawing—no longer bowl shapes, but in whichever way each feel compelled to move—expressing their contradicting felt sense.

Does the client know a similar pattern in an existing or past relationship? How can the dynamics of that relationship be illustrated? Not through drawing the people, but the forces that happen between them: the flood of shouting or threats coming from an authority figure. How does the inner child on one side stand up to the internalized parent on the other? How are boundaries maintained or not? Words and key sentences can be added in written form to the energetic dialogue on the paper.

FIGURE 14.4. Separate bowls.

No one is perfectly balanced and symmetrical in body and mind; slight irregularities are natural and normal. These become apparent in the drawings. One side is rounder than the other, or wider or more spread out. The pressure of the lines can also vary. On the left side, perhaps, we find evenly relaxed lines, whereas on the right, tension is expressed. Contrary to most peoples' assumptions, these irregularities have comparatively little to do with being right- or left-handed. Sometimes the nondominant side is stronger and more aware than the normally used one when it comes to the inner world.

FIGURE 14.5. Flat bowl.

When such a **flat bowl** appears (fig. 14.5), individuals tend to feel unprotected and exposed. They may not know how to be contained and held. Too much openness can point toward being flooded by external influences without discrimination and defense. This version frequently appears when clients abuse drugs and alcohol.

FIGURE. 14.6. Bowl with a vertical in its center.

The **bowl with a vertical in its center** (fig. 14.6) seems to relate to a natural impulse to include the base of the spine as part of the pelvic structure. Often it occurs as an organic coming-out, effortlessly and with drive and

joy. It can be drawn as a rising and falling motion. Clients may experiment playfully with how far they want to venture up and out without strain; when standing on truly supportive ground, no exaggerations or feelings of inferiority are necessary. By reversing the emphasis, the movement flows down toward grounding and parasympathetic settling, which can be emphasized by exhaling consciously in order to calm down. This inward motion may also mimic the digestive process, literally and symbolically.

All drawings represent a projection of the body onto the paper. For diagnostic purposes, the **location of the bowl** on the sheet is of significance. Given that the paper is pushed right to the edge of the table, the base line of the sheet correlates to the chair, and the bowl is the pelvis of the individual sitting on it. A deeply experienced ground corresponds to a bowl that sits on the bottom line of the paper. Whatever space on the paper below the bowl is not included can be regarded as dissociated, unconscious, unwanted, or feared. In this case floating, elevated bowls appear that do not touch the ground. For some clients, drawing settles down once they have gained trust; for others it becomes an indicator for serious upset.

Here are some examples of different interpretations of the bowl shape according to an individual's needs:

FIGURE 14.7. A harmonious rocking movement with an emphasis on settling down. The triangular motor impulses on either side were drawn downward and emphasized with exhaling. Initially the bowl was drawn with both hands parallel, and then, as confidence grew, turned into the more mature mirrored version.

FIGURE 14.8. Example of an upset, dissociated pelvis of a client, Mary, suffering from complex trauma. The rocking movement has no focus and is constantly shifting. It is floating way above the base line and would indicate that the felt sense does not reach below the diaphragm. Even though the client called this image "sleep and rest," nothing indicates that her nervous system is truly settled, even though the shape might have given her relief.

FIGURE 14.9. Mary, three sessions later, at the end of her process; she is now connected with her inner ground. There is vibrancy, energy, and congruence. The previously unfocused layers of the bowl shape have settled into each other like Russian dolls. Her soul has been retrieved. Her body has become alive.

FIGURE 14.10. Claire had been raised in a strict Roman Catholic environment and had been sexually abused as a child. In her therapy, she struggled with her spirituality, her sexuality, and female identity. Her pelvis feels lifeless.

FIGURE 14.11. Rita, felt nauseous, like vomiting, when she began drawing. The finger-paints gave expression to her disgusting "bleak", inner sensations. "Little tears like rain" emerge as she recalled her stepfather physically and sexually abusing her.

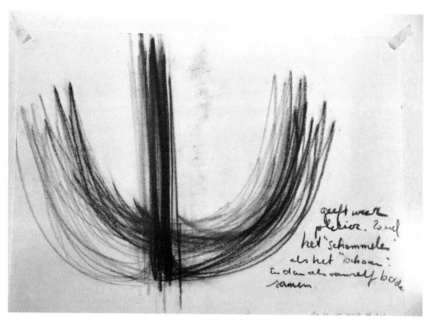

FIGURE 14.12. Peter, as a successful businessman, clearly had structure and focus but struggled in his marriage to express feelings and his sexuality. The bowl is elevated; an indicator that he is not quite settled in his pelvis, and part of his inner base is dissociated. His writing focuses on a multitude of questions he had around his sexuality.

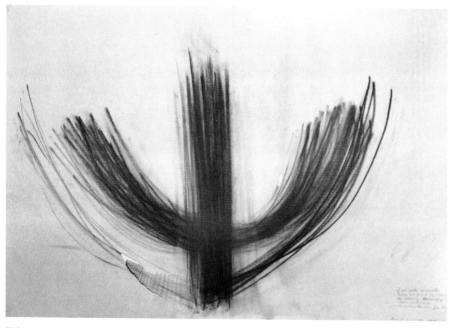

FIGURE 14.13. Peter's subsequent drawing shows visible activation. He expresses his anger in intense upward strokes, using significant pressure, each one designed to release the tension he senses in his gut, much of it being frustrated sexual energy. He obviously expresses something he could not in the past. He commenced with the upper bowl. The release allows him to drop down into a deeper layer within his pelvis.

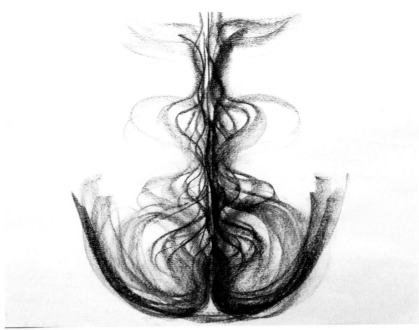

FIGURE 14.14. This is the bowl shape drawn by a relaxed client who felt deeply resolved. The transparent line quality reflects the sense of free-flowing vibrancy.

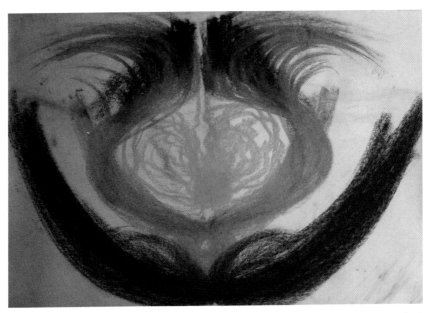

FIGURE 14.15. This young woman had confronted early childhood sexual abuse during the session. In this, her last drawing, her pelvis is visibly reclaimed, in balance, settled, and filled with life. Most importantly, a vibrating green heart appears in the center, symbolic of restoring her ability to love. Up to now, her feelings were so confused that she never knew what she wanted or needed and was unable to express herself accordingly; consequently she had ended up in numerous controlling and abusive relationships.

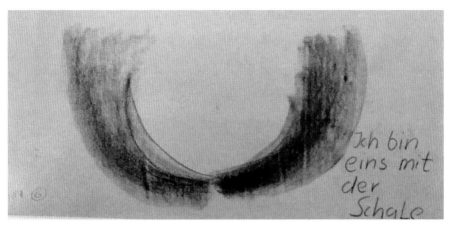

FIGURE 14.16. This drawing emerged at the end of a process. The client was Elizabeth, a Roman Catholic nun who had previously broken her lifelong silence over being gang-raped at the age of eight. In the last session, she had drawn fragmentation and rage. Now she was in a state of wonder and felt finally heard. This bowl shape became synonymous for her healed pelvis. In meditative silence, she experienced a distinct felt sense in which God's hands held her and put her back together. She writes: "I am one with the bowl."

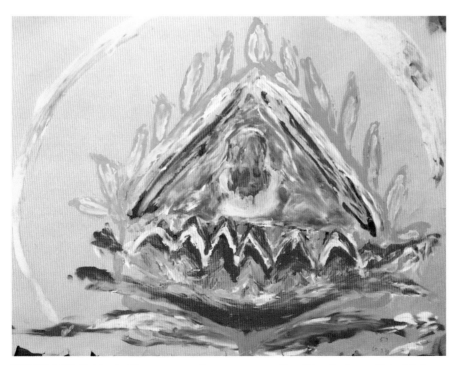

FIGURE 14.17. Painted with eyes open from memory after this client meditated following a deep release in the previous session. For her, this image pictures a profoundly spiritual experience. The bowl is represented as a lotus flower floating on water. Her inner child is sitting inside the Christian trinity surrounded by the green leaves of nature and a yellow arch symbolizing the cosmos.

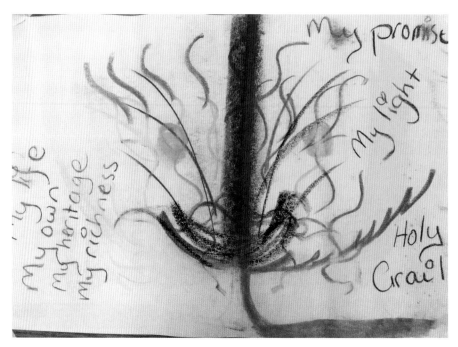

FIGURE 14.18. Jennifer writes about her experience in which a smaller bowl sits elevated inside a large yellow light-filled bowl. Her spine is strongly connected and erect: "My life. My own. My heritage. My richness. My light. Holy Grail."

The bowl shape is the most important of the female shapes. It is a valuable intervention tool to support clients' parasympathetic settling when they need soothing, comforting, and being held. In case clients at the beginning do not know how to start, I will give them this bowl shape to draw. It easily connects them with their felt sense introducing a body-focused approach. At the same time, the rocking movement illustrates clients' relationship with their inner sense of grounding and accordingly allows diagnostic insight.

## The Arch

**Physiology:** The embodied arch is most commonly associated with the shoulders. The arms might be perceived as arching down, extending from the shoulders. The shoulders, and closely linked to them the neck and throat, separate the head from the rest of the body. The throat, neck, and shoulders act as a gateway, allowing body sensations to be blocked or to rise. Much of our bodily sense of being in control is invested in the shoulders. Here we keep cool and brace ourselves to confront difficulties. "Keep your shoulders back," being upright and in charge manifests in our body posture,

primarily in the shoulders. Ego control is a shoulder issue and highly valued in environments where the show of emotions and sensitivities is considered inappropriate. We all know the military posture of a rigid spine, including a particular angle of the chin that will close the neck to hold emotions at bay. The tie as business attire is the symbol for those who have to professionally cut off their body.

The shoulders and neck have the function of inhibiting socially inappropriate desires through "bottling up" emotions. The tension held in the shoulders, the weight of responsibility we carry on them, and the fear of speaking up all manifest as often painful contraction patterns in the shoulders and neck. When we express compliance, we slump in the shoulders, and the spine and the core collapse. When we try to "disappear" to be invisible in order to keep safe, the droop in the shoulders and the slump in the spine and core increase. Contraction and release in the shoulders regulate sympathetic arousal states. We are mortified when our shame rises past this muscular checkpoint and we blush; at other times we swallow hard to keep emotions down.

FIGURE 14.19. The arch.

Children whose parents are the source of trauma are caught in the terrible conflict of needing to reach out for support while fearing to get hurt. Their arms stretch out, longing for love, and simultaneously pull back in fear. Such conflict manifests in the shoulders and neck as lifelong patterns of tension causing migraines, for example, or can be the source of stuttering and speech disorders.

To a lesser extent, the arch is associated with the diaphragm, but it has a similar gateway function, here between the abdomen and the chest. Accordingly, the abdomen deals more with regulating dorsal vagal "gut" issues, which make us feel sick in the stomach. This membrane in the body responds to primal fear. It is here that our autonomic nervous system initiates metabolic

shutdown when we are scared stiff. A tense diaphragm makes us feel nauseous, the mind goes blank, and everything feels numb. Clients report being really cold, as in chilled to the bones. Once the diaphragm can relax, warmth and life begin to flood back, and parasympathetic settling can reconnect them to their social engagement system.

**Archetype:** A large arch may be perceived as a full cover of some sort, such as a tunnel or bridge, a dome, a blanket to hide underneath, or a uterus. The feeling, then, is one of being underground, inside a mountain, inside the earth, inside darkness. It protects an inner space. Secure children like to draw a rainbow arching over their world. It is "my room," where one is safe and secure. While the bowl is turned upward toward heaven, the arch is open for anything from below: the earth, the underworld.

In its positive dimension, the shape is experienced as a shield of protection. It marks a safe place. It can secure something precious or secret. It can be a greenhouse or a pregnancy. In both cases an emerging, growing part of the personality needs a safe nourishing environment to gain sufficient strength for survival in the outside world. In its resolved state, the arch may become transparent like a rainbow, a well-known symbol for transformation, or may be pierced through and opened up by renewed self-confidence, pushing its way up into freedom and light.

The arch, however, can also encapsulate the full spectrum of what Jung calls the night sea journey. In it, the hero or heroine has to descend into the underworld of the unconscious. The unresolved internal space is experienced as hell, prison, or the grave. Symbolically, the arch is the whale that swallowed Jonah; it is the land of the dead into which Orpheus was banned; it is the wolf that devours Little Red Riding Hood, and the witch that captures Hansel and Gretel. Beneath the arch the hero faces life-threatening dangers and has to fulfill a task of transformation, or he will lose his life.

> The original departure into the land of trials represented only the beginning of the long and really perilous path of initiatory conquests and moments of illumination. Dragons have now to be slain and surprising barriers passed—again, again, and again. Meanwhile there will be a multitude of preliminary victories, unretainable ecstasies, and momentary glimpses of the wonderful land.[4]

Such is the mystical language of trauma recovery, where we have to retrieve our vitality from tonic immobility in the land of the dead. The journey through the underworld can be likened to the perils of facing the primal fears

associated with traumatic memories locked in the body. Yet, these ancient myths mapped out pathways for their audiences how these threats could be successfully negotiated in order to regain the lost life force. For thousands of years these stories taught their peoples how they could bring back the water of life from the underworld.

**Intervention:** In a full course of drawings, one often finds a lengthy series of images where everything happens beneath an arch. Some clients draw the arch first "to make sure," and then express what they need to underneath it. The arch gives them the necessary secrecy and protection, maybe from feelings of shame, as if the conscious mind must not see and judge what happens under the cover. For others, the arch is an integral part of their body experience of dominating shoulders or tension in the diaphragm. The latter clients tend to be unaware they are drawing the arch as they struggle to have their own voice heard and make their own choices. The arch in this context represents collective social taboos. We swallow our opinion for fear of being ostracized. Our need to fit in employs censoring muscular contraction in the shoulders and neck.

This shape illustrates the conflict between individuality versus the collective norm. The arch keeps us safe, but it also keeps us small for the sake of collective conformity. This is a developmental issue. While in children's drawings the rainbow indicates a securely attached child safely embedded in the family circle, this might no longer be appropriate for an adult. In particular, at middle age, there is a push in many clients to be self-employed and less dependent, to get away from the security of conformity and become heard with their own voice. This is when the arch becomes an obstacle.

The arch blocking verticals is a common theme in Guided Drawing. The vertical represents the individual's upright stance, such as the spine in the body, and also speaking up and having a say. The arch, on the contrary, will enforce whatever collective norm represses such rising impulses, because we fear change and dread the consequences of standing out, and we do not want to hurt loved ones with desires that do not fit into the agreed-upon paradigm of togetherness. So how do clients find a way out of this? A mirrored opening up and closing motion might clarify the felt sense. How does it feel to be open? How does it feel to close up? Into which direction would I like to put the emphasis? Do I need protection? Do I need to get out? How does it feel to be able to be in charge of expanding and contracting?

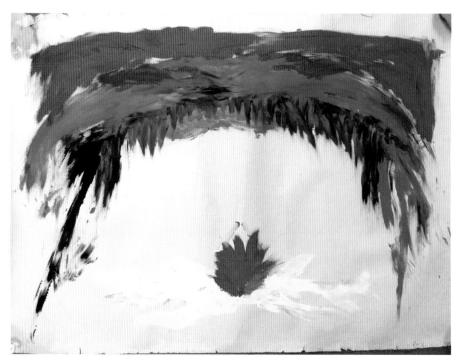

FIGURE 14.20. First, let's look at the positive experience of an arch. The shoulders in this painting were experienced "like steel" arching over the emerging impulse of something new, an inner fire in the pelvis, which later developed into the experience of child birth.

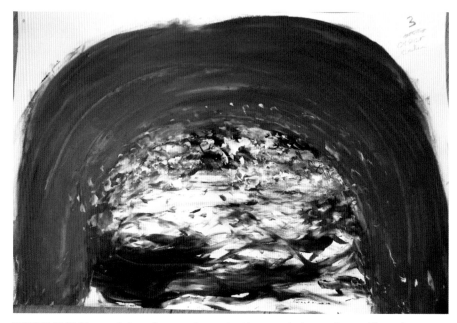

FIGURE 14.21. The arch here is oceanic, protective, a calming embrace. There is no impulse to erect a vertical. It is again an embryonic containment that can be experienced as blissful.

FIGURE 14.22. The arch here is experienced as "gentle, soft eyes." It is a protective, almost womb-like space. It allowed the middle-aged woman to connect with a reassuring inner resource.

FIGURE 14.23. A very strong vertical balances the arch as shoulders on top. Even though it is cross-shaped, it does not weigh down the vertical; the arch here is not oppressive.

FIGURE 14.24. The arch here represents the client's felt sense of her shoulders, which are raised in such fear that her neck and head almost disappear. She calls it: "The monster I saw in my dreams." She spontaneously associates the image, once she opened her eyes, with her nightmares, in which she was chased as a child by her abuser.

FIGURE 14.25. This client's vertical feels swamped. An oppressive arch pins her down. She can neither speak up nor stand up for herself. Next, she uses arched lines to fight and get out. In the end she is able to visibly strengthen the vertical.

The conflict between opening up and shutting down is more likely to be expressed as the **mirrored arch.** Depending on whether the emphasis is on the upward closing movement or on the downward opening one (fig. 14.26), it becomes obvious whether a client is struggling with having a voice or is being silenced; is able to get out or is being locked in. A tense diaphragm may be eased out of metabolic shutdown with a gently rocking mirrored arch.

FIGURE 14.26. Mirrored arch.

The dynamic version of this motor impulse, however, appears frequently and touches the subject from a slightly different angle. These are the **arched lines** (fig. 14.27) emerging into a fountain or erupting as a volcano. Most clients experience this motor impulse as freeing, as liberation from a state of hindrance or depression. It occurs at a time when emotions are finally boiling over.

This is the shape for temper tantrums, blind rage, aggressive turmoil, and struggles oscillating between power and powerlessness. Clients may experience emotional outbursts about injustice and hurt that have been inflicted upon them. They may live in settings that are in collision with their values, and they may be at a loss about how to change the situation. They suffer, or feel angry, but do not know exactly why they do.

FIGURE 14.27. Arched lines.

Accordingly, many go on a liberation rampage with this motor impulse to "let fly." While there are definitely benefits in releasing inner tension in this way, it is not necessarily safe to do so. Clients with anger management problems, for example, know the cycle of promising to be "good" versus explosions of rage; the guard in the shoulders is down when they have loosened up with alcohol, and then their actions have detrimental consequences. Because the lines are just blasted out, the impulse to get out, have a say, to be free is caught instantly in another arching motor impulse and is pulled down. If we enlarge these arched lines, they will end up in two arches or two circles, just bigger ones. There are sayings such as "What goes around comes round." The outburst comes around as guilt as loved ones have been hurt, as regretting or fearing the consequences.

The movement becomes a conflict between round and linear motor impulses. The upright impulse illustrates the individual striving to be free, and the round the need for protection in the circle of family or friends. The financial security of employment, for example, has the price of conformity in a workplace culture. Such compromises bend the impulse to be upright and independent. The upward vertical strives toward freedom from constraints. The round pulls down, holds back. No matter how intensely the urge to be "free" is expressed, if the emphasis is on the round, the ends of the *arched* lines will be caught in yet another, just slightly bigger circle. Frequently, clients' body posture will collapse at this stage; they will get pulled along with their outburst and be bent over the paper. They have lost their uprightness in the spine, and with it, their power. It is then that clients face the consequences of their actions as punishing, that they get caught in yet another round of guilt and fear.

FIGURE 14.28. Sorting the seeds.

Interventions to support clients in drawing directed lines with an intention and to gain confidence in their stance can save many rounds of frustration from feeling trapped and stuck underneath a visible or invisible arch.

Initially it can help to introduce to clients the shape of moving up along the vertical then draw a corner and release tension to the sides (Figure 14.28). This shape, through the introduced corners, makes the expression of aggression significantly safer. It gives frustration a direction. The motor impulse now demands a decision. It is no longer just a senseless outburst.

By learning to direct their intentions in a particular direction, clients learn to take responsibility for their actions and voice what they want and what they do not want. The moment a line is straight and directed, it will not come back. To the extent that clients can put the emphasis onto the release in the horizontal, they will feel liberated, emerging out of a state of repression or depression from underneath the arch. The task here is to sort out, align, and direct one's strength. Anger ultimately is a necessary survival impulse; its essence is saying "No!"

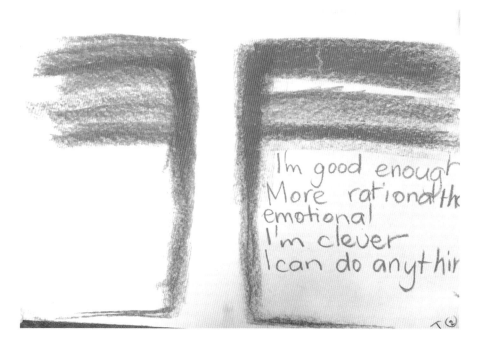

FIGURE 14.29. As described above, this client drew the "sorting the seeds" shape as a way to release overwhelming emotions and suicidal ideation along with depression and helplessness. The motor impulse gave her a sense of control and clearly empowered her: "I am good enough. More rational than emotional. I am clever. I can do anything."

Based on the archetypal significance of this shape, I have called it "sorting the seeds." This is what female heroines have to do in many myths and fairy tales. They have to separate what is good from what is bad for them; to learn what supports them and what abuses them, and to be able to act accordingly. Cinderella sorts peas and lentils, "The good into the pot. The bad into the crop."[5] Psyche, in the tale of Cupid and Psyche, and Vasilisa in "Vasilisa the Wise"[6] sort grains. Female heroines have to prove themselves not with the physical wielding of swords and guns but through the mental sorting of an inhuman amount. The intellectual ability to distinguish, to separate, to differentiate has to be sharpened; this will set us free. Unsurprisingly, in all these situations, the slaving task has been imposed by a negative mother figure, representing the unconscious.

Drawing this shape channels sympathetic activation into manageable, titrated states of arousal. The force of activation is broken with a corner; it is being consciously redirected. If we picture this break at the neck, the energy

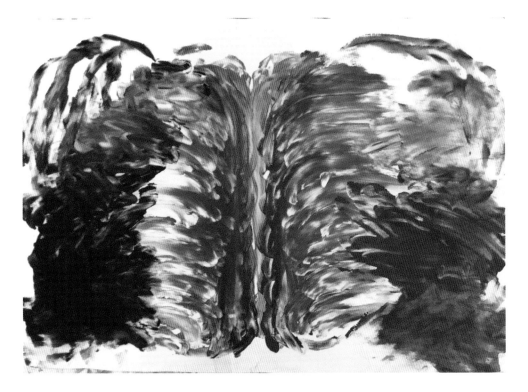

FIGURE 14.30. This finger-painted version of "sorting the seeds" by a different client shows clearly how the oppressive black and brownness have been pushed to the sides with green and yellow paint. The vertical spine has been liberated, and it has gained a vital-looking charge in red.

moving up the spine will now flow into the arms and hands. In this way we can now take charge and handle issues without getting overwhelmed.

A female client, let's call her Anna, was caught in a messy custody battle concerning her ten-year-old son. She had been divorced, but every time her ex came to her doorstep to pick up or return her son for an access weekend, he used the encounter to abuse her emotionally in the most humiliating way in front of her boy. These negative encounters reinforced time and time again the low self-esteem she was suffering from throughout her marriage and made her feel trapped, as if this nightmare of abuse would never end. Anna took up the suggested intervention of drawing up her spine and then releasing, with a decision to the side, whatever she wanted to get rid of, whatever blocked her. She took the exercise home and began to draw this shape with dedication on a daily basis. The increasing clarity in her body posture prompted her to clean up her apartment, take old clothes to the charity shop, and get her overdue tax return done. Then another access weekend came around, with another nasty incident of abuse. Anna felt herself shrinking back into her shell. But then she saw her son emerge from her lounge room wordlessly holding up one of her drawings. She had not even shared with her boy why she was drawing these. In an instant her body remembered the resource she had created over a number of weeks. Anna could stand up, respond to her ex with clarity, and the abuse stopped from then on.

The following three drawings are an extract from a one hour-session. This was Val's third Guided Drawing experience in a group. Her process is entirely self-directed. It is a vivid example of how she moves in clear steps from feeling shut down and boxed in, via rage, to empowerment, applying the shapes discussed in this chapter. Val is in her late twenties.

What I notice is that Val is not releasing the lines, but is taking all attempts to express herself back. Such scrubbing back and forth increases frustration. Not pictured here are two drawings in which she expresses more anger and then pendulates in to a healing vortex with a blue finger-painted circle.

In the last image pictured here, Val states: "I had a sense of real control and gatheredness." This is an embodied sensation. Rhythmically repeated motor impulses can teach clients to move in a different way, and therefore they feel differently. Val here breaks the cycle. Initially she is stuck and blocked. She then experiences powerful emotions that threaten her to fall apart until she finds an upright stance. The "sorting the seeds" shape allows her to gain control and reclaim her power.

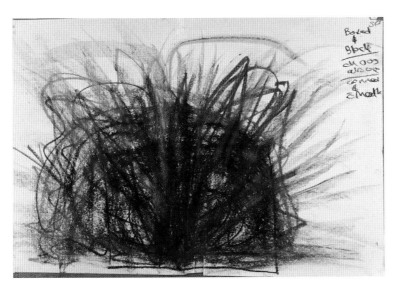

FIGURE 14.31. On the first drawing, Val writes: "Boxed & Block. Cornered." She explains: "Black area—physical sensation in my pelvis. I felt blocked in, tight, vacuous, empty, tight, and constricted. Red and yellow—felt in the upper chest, head, and arms. Chaotic, busy, and scattered energy moving in every direction; ungathered feeling. Felt distressed with the feelings in these two areas. Green—creating an arc of safety. Lastly, pastel pink—I felt my body needed to connect from head to heart, to open the tight and constricted pelvic space. Pastel pink was trying to help these parts connect and communicate, smooth it over to create a union. It became an explosive and frustrating energy."

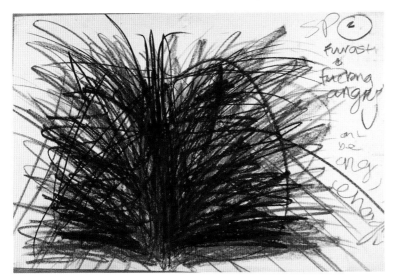

FIGURE 14.32. Val's second drawing: "Furious & fucking angry. Can't be angry enough." She explains: "Extreme anger rising in my pelvis and belly. This was taking over my whole body. I have written 'furious and fucking angry.' Images and people that came to mind were my boyfriend and male boss. Feeling very angry and frustrated with my boss in particular. In the bottom right corner I wrote 'Can't be angry enough,' meaning I didn't feel able to put my anger to paper; I felt restricted in expressing it, like the paper wasn't big enough to hold it and I didn't want the paper to keep breaking on me (expecting that the paper would break)."

FIGURE 14.33. Val writes that she is feeling "angry, mad, oppressed, immobilized, stuck, small." She explains: "Related to my boss mostly, somewhat about the patterns I hold in relating with my boyfriend. At some point I clearly realized that my right hand had been much more active than my left. When I involved my left hand more, I felt a strong connection to the sense of my dad. At this point my left hand furiously began marking the paper like something had been unleashed. I kept tearing the paper and was very conscious about needing to tape this up myself, like 'I hold myself together' and 'No one will break me.' I marked it with the black to really make that clear. After this, I did the uprights and then progressed to make the center line extremely upright and bold, as well as adding the outward horizontal lines. What was noticeably different with these upright lines compared to previous Guided Drawing processes was that I had a sense of real control and gatheredness in making my uprights."

## The Circle

**Physiology:** Our very first sensory imprint of the circle is in the womb as an all-containing experience. Epigenetics now has evidence of how formative this "information transfer from one generation of mammals to the next" in the womb is.[7] While pregnancy and infancy can be the basis for core trust and loving attachment between mother and child, it can just as well be the root cause for complex trauma. The fetus and the baby have no means of escape and have a highly underdeveloped nervous system. If the pregnancy has been unwanted, or the mother was under a lot of duress during the gestation

FIGURE 14.34. The circle.

period, it creates a state of inescapable threat that can cause stress symptoms in infants that are matched only by those of soldiers after years in open combat.[8] Van der Kolk, Karr-Morse, and Wiley investigated the correlation between perinatal and early childhood trauma and physical disease in adulthood. The foundation for secure or insecure interrelational capacity finds its imprint in the implicit memory and remains there largely unquestioned as a felt sense—it writes our embodied sense of "identity."

This theme expands developmentally into the family of origin. Is the circle of one's family predominantly a haven for safety, or the source of trauma? Physiologically our core sense of secure attachment or existential threat manifests in the viscera. Secure children have a primary caregiver who can regulate distress states for them, until they are able to do so themselves, at approximately thirty-six months of age. Only then is their autonomic nervous system able to regulate independently. If preschool children have been exposed to repeated dysregulation and prolonged states of distress, their nervous system adjusts accordingly, and they know nothing else. When things get unbearable, traumatized babies and young children, who cannot fight or flee, only have the option of metabolic shutdown. If the dorsal vagal complex is activated in this way, it causes not only lifelong instability regarding relationships and emotional dysregulation, but also impacts significantly on the digestive system. Dorsal vagal dysregulation causes gut problems, which in older children and adults manifests as eating disorders and immune system breakdown. Such clients not only are partially dissociated and emotionally unstable, but also lack gut instinct as their inner radar to assess situations and stay out of danger.[9]

The circle in the body is often synonymous in drawings with the gut or the womb. In addition, it illustrates how comfortable we are in being contained and held, embedded inside a circle of family and friends. The rotation makes emotional regulation and dysregulation visible. Freeze states, where clients can barely move and have no rhythm, oscillate with "spinning out of control" into dangerously accelerating sympathetic arousal.

Clients presenting with interrelational complex trauma frequently use alcohol and drugs in an attempt to regulate their nervous system, either to calm down or to have more energy.[10] Addictions, depression, psychotic states, and other mood disorders present in Guided Drawing as vicious cycles and are inevitably round.

Group pressure can be "circular," like a cult demanding conformity to the extent that no one is allowed to be different or to speak up. No one is allowed to leave the group, and no one can enter it from the outside. This provides safety, but also stifles individual growth.

**Archetype:** The circle is probably the most ancient symbol. Its meaning is as endless as its form and has filled many books. It is the "great round," the life cycle, the cosmos, and the shape of our planet. The primordial state, before the world was separated into day and night, land and water was endlessly round. Such slumbering existence is contained in the egg, the womb, the nest. Nature's rhythm is round like the cycles of the sun, the moon, and the seasons. This roundness can be self-fulfilling and content to the point of inertia. It is the space where no conscious action happens, where everything circles in endlessly rhythmic complacency. Everything is contained; everything is fulfilled.

This may be experienced as pleasant or unpleasant. In both cases, the circular movement will override any other impulse. Such life cycles, which lack all conscious awareness, are considered in Jungian psychology to be the collective unconscious. It is pictured in all its timeless imagery as round. Neumann speaks about the round as an archetype that represents all aspects of the divine Self; he describes the round as without a beginning and an end, prior to any process, as eternal, without any before and after, without time. It has no above and no below, no space, because it does not originate in the three-dimensional world of human perception, where we live in a time-space continuum.[11]

To the prepersonal consciousness, the World Parents or the Great Mother represent life, nature, security, protection, nourishment, and warmth. The

circle symbolizes the "positive elementary character" of the good mother.[12] The ego is not separate, but contained in the circle like an embryo in the womb. It is identical with the round and magically identified with the world surrounding it. The positive mythological equivalent would be the biblical paradise, the Garden of Eden in which Adam and Eve live in harmony with all nature, as long as they do not touch the tree of knowledge.

The negative equivalent would be the hot fiery belly of hell, where souls are trapped in unending suffering. Because once we transition as toddlers into the world of duality, the ego struggles on many different levels to maintain its individual personal consciousness against the overpowering pull of the unconscious. It is this lack of duality, this lack of separation that can make the circle such a dangerous force. The yin quality of round flowing shapes, and the circle in particular, require no conscious effort. Clients can dreamily float and curl and rotate in its orbit without ever waking up. The medieval alchemists described the unconscious as a state of *nigredo,* as one of utter blackness, also as *prima materia* or *massa confusa.*[13] From this primal confusion, the philosopher's stone had to be extracted; the dark matter had to be turned into gold. Jung took the alchemist's imagery and scriptures as a metaphor for the unconscious and the need to bring the light of consciousness into it—a process that is complex, difficult, lengthy, and fraught with danger.

Jung associated the shape of the *ouroboros,* the heavenly serpent of ancient Babylon eating its tail, with the symbolic depiction of the collective unconscious. He describes the collective unconscious as all-containing, but also as all-devouring; it devours conscious identity. Thus, circling rotation can be experienced as heaven or hell, depending on whether clients are in the process of losing or finding themselves. It can be a blissed-out state of pure surrender in meditation or a psychotic nightmare where boundaries are blurred. When clients struggle with being traumatically overwhelmed, blurred realities, and lack of control, it is hell. Both states are characterized by a lack of ego.

Eventually, at the end of the ego's travels through the world of duality, many individuals seek to merge again with the perfection of the whole. This wholeness is made visible in all cultures as a mandala, from Sanskrit, which translates as "circle." Seekers of wholeness search for transcendence, yearning for their transpersonal Self. When an individual reaches this stage as the fulfilment of meditation practice, however, as enlightenment, it happens on a basis of rigorous discipline and practice. The egoless state is achieved in

the context of embodied structures that are being transcended, and not as a drug-induced high, which can easily tip into darkness and chaos. The circle will either be needed for survival as womb, or feared as death, or longed for as spiritual oneness.

**Intervention:** Many drawings are initially dominated by round, circular movements that have no conscious direction and no center. This can be one large round motion or a curling playful motion all over the page, executed with a sleepy or driven quality. The power of the circle should not be underestimated. If it represents a trauma vortex, it can take on such force that "even if I wanted to, I couldn't stop." Such drawn circles may look like bombs, fueled by an unstoppable pull of fascination or fear.

On the other end of the spectrum, circles are mandala-style illustrations of inner centering. Here, all energy is focused and held in the center and unfolds from there. Such circles can be as simple and transparent as a Zen master's *sumi-e* brush painting, or have beautiful designs. The circle represents the beginning and the end of conscious development.

The **uncentered circle** in its purely rotating stage is the symbol of all unconscious action patterns. Clients just flow along without any yang input; they make no decisions, have no intention and no insight. All energy is invested in perpetual rotation. As a motor impulse, this movement can develop dangerous dynamics into which clients are drawn. The trauma vortex is fueled by such unstoppable pull. The ego here is weak, powerless, and either sleepy and unaware or swept along and overwhelmed. As an infantile state of consciousness, it depends on a maternal orbit.

In the very first therapy session with Guided Drawing that I ever facilitated, when I was young and utterly inexperienced, my client was a seventeen-year-old adolescent who had just been released from youth detention for drug-related issues. He drew the circle with fervent vigor, going around and around and around, and even though I felt uncomfortable, I was too inexperienced to dare to interrupt him. After ten minutes of intense rotating, he was literally catapulted off his chair, ending up lying momentarily unconscious on the floor of my workroom. I was horrified. When he opened his eyes, he said: "Wow, this is better than dope." For him the rotation was like "shooting myself into the eclipse of a galaxy." He was fascinated, and thought it was a fantastic experience. Because of this initiation into the circle, I have never dared to offer it as an intervention tool except as a mandala shape, even though I know colleagues who do. It is a shape I treat with caution.

FIGURE 14.35. Circle formed out of two halves.

For interventions to support positive parasympathetic states, I prefer the circular impulse as the bowl or the arch. They require a natural interruption of the flow through rocking back and forward, and yet have the same effect of providing a safe holding space.

This can also be achieved through the **circle formed out of two halves** (fig. 14.35). Drawing a circle in this manner contains an invisible vertical. Because of this vertical axis, it is rarely experienced as frightening and threatening, in contrast to a full, purely yin circle. The motion is more one of binding and combining, embracing and holding together something that is contained. However, most clients stuck in toxic rotation need a stronger intervention.

FIGURE 14.36. Here is an example of unintentional round motor impulses. She drew in small curling movements. When she opened her eyes, she was surprised to see a full figure with legs and arms surrounded by "a world." She called it "I go onto a discovery journey."

FIGURE 14.37. This drawing illustrates a circular pattern of confusion. The young woman called it a "peaceful mess." There is no vertical and no clear focus. Such drawings almost inevitably point toward low self-esteem and lack of order in a client's life. If we liken the vertical to the ego's ability to respond actively to life situations, here it is clearly not in charge and is overwhelmed.

A frequent motor impulse is the emergence of **two circles** (fig. 14.38). Frequent associations are "lungs" or "breasts," as well as the inhalation and exhalation of breath. The movement can take on a "needy" or a "giving" connotation. If clients move their arms like swimming the breaststroke, it would be the "giving" motion, or an extroversion. The reverse is an inward motion, which could be associated with needing, eating, or taking something in to fill up a vacuum inside.

FIGURE 14.38. Two circles.

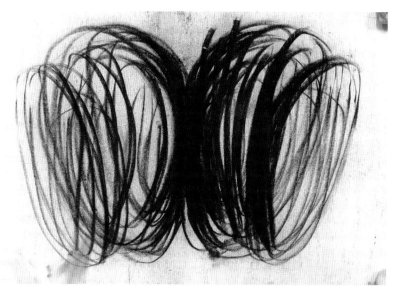

FIGURE 14.39. This drawing illustrates enormous rotating acceleration as a psychotic energy pattern, drawn within seconds by a highly traumatized woman. Jane was spinning out of control. She was so shut down that she could not take in any interventions. She associated linear and angular lines with abuse only. We continued with mandala drawing as a crisis intervention, which was successful enough to avoid hospitalization and being medicated.

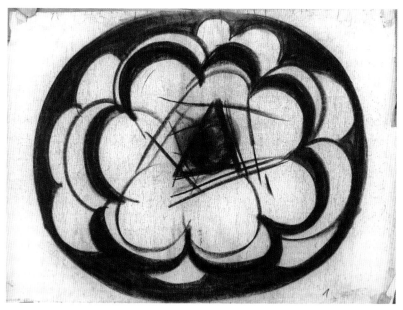

FIGURE 14.40. The suggestion to draw a mandala appealed to Jane as a spiritual resource, even though the only instruction she could take in was that she had to start with a center, which she was not allowed to attack, but had to move around it. This is one of her mandalas in the following session. She draws the center and then slashes lines around it, but can keep the promise not to hurt her core. Gradually protective outer layers emerge. This drawing took her about three minutes; she was still highly activated, but visibly improved from the previous session.

If appropriate, my preferred intervention for clients who are seriously overwhelmed and stuck in a vicious cycle is the **dragon-fighting exercise** (fig. 14.41). Hippius named the exercise with the idea that the circle is the "dragon" and the vertical the "hero," with the vertical lance conquering it. Fairy tales picture the dragon sleeping on a treasure or guarding a princess. When the "hero" wins, he is rewarded with the transformation of the beast, because the dragon is in fact the princess or the treasure in their unredeemed state of being.

Clients may be encouraged to practice this motor impulse like a martial arts exercise. The most important feature of this movement is to break through the roundness of the circle with a straight vertical line and to release all tension at the end. The exercise is done with one hand only; the other hand rests on the *hara* point, the Japanese name for "earth center," located 1.5 inches below the navel. It is considered the source of vitality in all martial arts.[14] Clients are encouraged to exhale and make a sound, similar to tennis players as they break through the round.

There needs to be a clearly cut corner, a clean break, so the entire round movement is transformed into a vertical one. If one does not succeed to make a clear break, one is catapulted into yet another circle. In that case, the dragon has devoured the hero, and there will be no change.

It is a simple motor impulse, but with enormous potential for change. The circle and whatever it represented at the time can be lastingly transformed. The round ceases to exist, as its energy is radically turned into a vertical. It can end a vicious cycle. The terrible pull of a trauma vortex can be broken with an active intervention: "It stops here, now!"

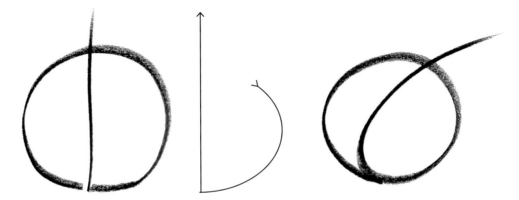

FIGURE 14.41. Dragon-fighting exercise.

FIGURE 14.42. No change: catapulted into yet another bigger circle.

FIGURE 14.43. This finger-painted dragon-fighting exercise became a powerful state-ment while the young woman was dealing with childhood sexual abuse. Her state-ment was: "Never again. It stops here!"

Frank was a middle-aged man who suffered from clinical depression. He drew heavy circles with great pressure and dreadful drive. All my attempts to show him the dragon-fighting exercise failed, because he "needed" to inhale at the point of coming out, and thus could not release a vertical. Growing up in a cult, he had been sexually and emotionally abused during his childhood by several female authority figures. The cycle of depression, even though he suffered in it, was like a magic hood, which rendered him invisible and there-fore safe. To become seen was inevitably associated for him with humiliation. It took several sessions until he could draw a vertical while exhaling and let go of the line at the end. The moment he felt safe enough to come out, he drew a powerful vertical I shall never forget. The following week, his psychi-atrist could reduce his medication.

Entirely different is the quality of the **centered circle,** which has a focal point. The circle that has gained a center is fundamentally different from the previous one. Energy is no longer invested in rotation, but in focusing on a core. The drawing movement here is a *circumambulation,*[15] a meditative circulating around a center. Jung considers this spiritual core

as having no form and no name, because it is from another dimension than the physical one. We can only come in contact with this core through moving around it with our senses attuned in a contemplative way. The drawing now happens with awareness; it is focused and radiates tranquility. The circle may now give protection and boundaries. The rotation, however, no longer has any emotional charge. Now the circle becomes a vessel for initiation, a container for transformation and renewal, a mandala, or a sacred space.

At the end of each meditation retreat, Roshi Yuhoseki, the old Zen master I studied with, performed a *sumi-e* drawing ceremony. First, there was a ritual grinding of the ink stone, the laying out of the paper, and then he dipped the large brush into the ink—and in one powerful stroke, accompanied by a loud roar, he drew one circle. It was an expression of total focus, of immense collectedness, of utter presence.

*Mandala* is the Sanskrit word for "circle." Religions throughout the ages have used circular images to express transcendence. The circle surrounds

FIGURE 14.44. This is an example of a centered circle. It represents a womb in which the female client felt pregnant with her inner child. She was childless and in her fifties. The blue outer circle is "grief;" however, there is light inside and the vital core of new life "longing to come out."

FIGURE 14.45. Val, whose drawings we saw in the last chapter, writes: "I took green and blue paint and my hands formed a circular motion while I had the phrase 'You are allowed here' repeating internally." She connects with her healing vortex and consolidates her place in the world, now in a soft, round way, different to the fighting she experienced beforehand.

the *temenos,* the sacred ground in which a ritual structure can be laid out in order to reconnect with the divine.[16] I use mandalas frequently as a crisis intervention tool. In this case, clients draw with open eyes and the designs can be simple, do not need to be "beautiful," but provide structure and safety. Mandalas offer a restorative drawing experience during times when the ego feels weak and fragmented. In my experience, mandalas are a way of regaining wholeness. They can be drawn on a daily basis, if need be, as mandala diaries or coloring-in templates. Mostly, though, clients will follow their own designs.

The circle as cycle of life and death represents the beginning and the end. It has three significantly differing aspects: the circle as womb symbolizes core safety and containment. The circle as peripheral rotation represents the unconscious and can take on an overwhelming cyclonic quality. The centered circle as mandala illustrates transpersonal oneness. It now symbolizes the death of the ego and the resurrection of the Self, as Jung defined our eternal spiritual core.

FIGURE 14.46. The life of this client has been dominated by surgeries. As an infant, she spent many months in the hospital. This drawing was created after her health had required another operation. The previous drawings show pain and fragmentation, which are still visible in this one. However, she now feels being held in a large bowl shape and from this inner ground emerges in concentric circles a healing core.

FIGURE 14.47. Finger-painted mandala by an elderly woman who had suffered terrible abuse as a child. This mandala represents the restored wholeness of her inner child at the end of the session.

FIGURE 14.48. Mandala design by a young woman with artistic skills. She kept a mandala diary to see her through a challenging time.

## The Spiral

**Physiology:** A spiral always has a center. All movement emerges from this center or returns to it. In this way most if not all life-forming processes move spirally. György Doczi and John Edmark have applied logarithms and the so-called golden ratio to prove how nature employs the spiral patterns we see in pinecones and sunflowers.[17] As a template of growth, the spiral is found throughout nature as budding seedlings, rolled-in leaves or butterfly wings before they unfold, snail shells, the shape of an ear, a fingerprint, the umbilical cord, and how an embryo develops in the womb. The Milky Way and in fact the entire cosmos is an ever-expanding spiral motion.

Preanatomy cultures have likened the winding forms of the human and mammalian brain and intestines to a sacred labyrinth that allowed insights

into the inner world.[18] Yoga practice focuses on the spiral movement of the kundalini up the spine, ascending and descending through the chakras. The contracting spiral is associated with turning inward, but also with being uptight, wound up, or in distress states such as curled up in a fetal position.

FIGURE 14.49. The spiral.

**Archetype:** A spiral is not a whole as such; by its very nature, it can never be complete. The two-dimensional spiral is one of the most ancient symbols for eternity, but it seems to have never been a symbol for the Absolute.[19]

In Gnosticism, a medieval branch of Christian mysticism, the spiral is the serpent or dragon that coils around the World Tree, or the central axis of the world, the axis mundi. The imagery is similar to Hindu visualizations of the kundalini energy rising up the spine through the chakras, and illustrations of the Tree of Life in the kabbalah. The spiral, in this context, is the driving life force that sets everything in motion.

Neolithic pots as symbols of the body and the womb were often decorated with spirals. The intestines became synonymous for an inward path. The labyrinth hence became the path of knowledge, requiring initiation rites until entry to the inner sanctuary could be granted. In order to receive knowledge, old perceptions have to be resolved; only then could the wonders of a "preformal state of the womb" be revealed.[20] Neumann likens these rituals to matriarchal agricultural rites, in which the grain-seed descends into the darkness of the earth only to "resurrect" as spiraling seedling in spring.[21] In order to assure this life cycle, which was utterly necessary for the survival of the entire community, rituals of descent into the underworld and the mysterious resurrection of the dead were celebrated over thousands of years in Babylonia and ancient Egypt, by the Aztecs and the Hopi. In Crete, the Minotaur

lived in such an underground labyrinth. The spiral is the entity that springs from such resurrection.

With growing consciousness, humankind adapted these rites to the loss and retrieval of identity. In this context, Jung describes the underworldly labyrinth as the unconscious, and the spiral as the resurrected divine child, the unfolding Self. In order to find this eternal Self, adepts had to enter a labyrinth, which took on the symbolic function of a womb or the intestines of the inner world. We know such rituals of death and rebirth were enacted in ancient Greece during the Eleusinian mysteries, and they became the foundation of Christian mysticism.[22] The core symbol of such descent and resurrection is the spiral; it represents both—as inversion, it is the labyrinth-path into the inner world, and as unfolding extroversion, it is the reborn infant Self.

**Intervention:** The dynamics of the spiral as a motor impulse in Guided Drawing are similar to what has been discussed in the previous section about the circle. Here as well, the spiral may appear as the peacefully expanding center of a mandala, or accelerate with frightening pull into a trauma vortex.

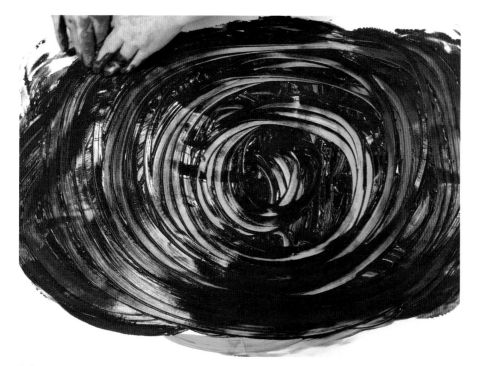

FIGURE 14.50. This client celebrated regaining a joyous and dynamic sense of being alive after a period of depression and grief. She used finger paints to express the intensity of her emotions.

A **large rotating spiral** (fig. 14.51), in its regulated state, can appear as an exercise of going out and turning inward in a seamless flow of introversion and extroversion. The movement on the paper contracts and expands. As long as this flow follows a peaceful rhythm, it can even be a meditation. However, when the spiral has the dynamics of either confusion or a tendency to take on overwhelming rotation, clients can easily get caught in all the concerns regarding uncontrollable circular rotation. Levine speaks of a trauma vortex. We refer colloquially to hyperarousal as "spiraling out of control" or that something can set our head spinning into dizziness.

Hypoaroused states or tense contraction are frequently drawn as tight inward-spiraling motor impulses. When we double over and curl up under attack, it is an inward spiraling motion of self-protection. When we come out of shutdown, when we begin to relax, we refer to it as "unwinding" or "winding down."

FIGURE 14.51. Large rotating spiral. Such spirals can accelerate dangerously into trauma vortexes, in which the client "disappears."

FIGURE 14.52. No orientation. Round motor impulses aimlessly rotate without any sense of an inner center. They are unfocused and lack awareness of the sensorimotor feedback loop.

FIGURE 14.53. Dragon-fighting exercise using a spiral. Described in the previous section, a version of the dragon-fighting exercise applies here as well. This is a beneficial intervention to avoid retraumatization through too much activation of sympathetic arousal states. Through drawing a clear break of the rotation in the "eye of the storm," clients can transform the circular energy in its entirety into a vertical. This would be the most dynamic breaking of the cycle. Other art therapy exercises suitable to strengthen self-esteem and taking charge can also be suggested.

The spiral pictured in figure 14.52 is drawn with a change of direction whenever it switches from introversion to extroversion and back. Here the emphasis is not on flowing growth, but on the conscious decision to turn inward or outward. Such spirals never develop a dangerous pull, as the drawn corners at the end of each expanding or contracting impulse create decision points, which strengthen the ego through an active response.

FIGURE 14.54. Spiral with an emphasis on introversion. This movement pattern can contract painfully to the extent of shutdown. In its regulated state, however, it represents a search for the core.

FIGURE 14.55. Spiral with an emphasis on extroversion. In hyperaroused states, this shape can trigger "spinning out of control." It may require intervention in order to avoid too much activation of the trauma vortex.

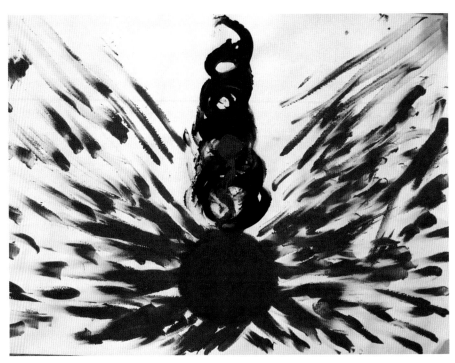

FIGURE 14.56. This rising black spiral makes intense pain in the lower abdomen visible. The young woman experienced physical and emotional pain radiating out and rising, snakelike, inside her. Her trauma vortex is highly activated. Because she is in charge, however, through painting it, she could also find a way out through releasing past memories and healing her pelvis in later paintings.

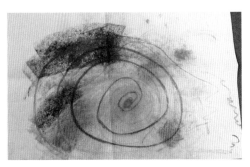

FIGURE 14.57. Inward spiral drawing by a nine-year-old boy whose mother was dying of cancer. He finds a satisfying ordering principle as he draws the spiral over the unstructured shades of confusion and despair he experienced. He arrives at a core, which he emphasizes, which could be likened to his retrieval of a sense of identity.

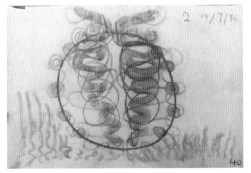

FIGURE 14.58. Rising bilateral spirals illustrate rising energy flow in the spine. This drawing appeared toward the end of Mary's sixth session and was part of a deeply felt resolution after two traumatic car accidents, which had frozen her in fear. Here, Mary experiences a sense of liberation and embodiment.

**Two bilaterally drawn spirals** (fig. 14.59) are a way of gently illustrating the growth impulse in the spiral. Often the butterfly is associated. The potential for accelerated hyperarousal states is given with this version as well.

FIGURE 14.59. Two bilaterally drawn spirals.

FIGURE 14.60. The mirrored spirals in this example represent a feeling of fullness in the pelvis of the female client, an impulse of growth unfolding from her ovaries. She was childless, middle-aged, and grieving for the lost opportunity to have her own family. In her subsequent drawing, the lines, which here look like bare branches in winter, reach out and turn into a blossoming tree. The spiral became a symbol for loss and renewal in her life.

## The Lemniscate and the Figure Eight

*Lemniscate* is a term for a horizontal figure eight. Of all the primary shapes, this is the safest option. It is without exception experienced as positive rhythmic flow, without any threat of overwhelm.

FIGURE 14.61. The lemniscate.

**Physiology:** The rhythmic flow from one circle into the next, as well as the crossing over from one side to the other, is deeply harmonizing. The rising and falling motion is simultaneously settling and uplifting. The motor impulse can connect the left and right sides of the body, as well as the left and right brain hemispheres, and bring them in sync. Clients who suffered as children during their formative years from an imbalance between their parents through divorce, constant quarreling, or death and departure will feel this split as an implicit imprint in their body. It might influence the dominance of one hand or manifest as lack of bilateral coordination.

Part of one side of the body develops a pattern of chronic tension, such as a frozen shoulder or a twist in the spine, as if forever turning away from something that once happened. We have observed such imbalance in hundreds of Clay Field sessions.[23] Children whose parents undergo divorce will, for example, divide the Clay Field into two sections with a wall or fence in the middle separating the two halves of the field. They will then only build things in one half, and either do something completely different in the other half or ignore that other part as wasteland. They certainly do not have access to their entire potential in the field in a balanced way. In the Clay Field, children and adults will then search for ways of connecting the two halves through water channels, bridges, or through a mediating figure in the center. In Guided Drawing, the connection happens with the shape of the lemniscate.

I recall a psychiatrist in one of my training groups who was intrigued by these statements and by the fact that he could not coordinate his movements sufficiently to draw the lemniscate. He went home and practiced. His described his parents as in chronic tension with each other, promoting opposing education styles and value systems, which made it impossible to please both of them. Any behavior his mother would reward would be punished by his father and vice versa. This tension in his childhood had left him with chronic physiological coordination problems, which prevented him from enjoying any sports, for example. Drawing the lemniscate over a number of weeks on a daily basis brought him significant relief.

It is possible to link this motor impulse to Shapiro's EMDR.[24] It is the same movement Shapiro suggests to her patients through the motion of the therapist's finger. In Guided Drawing, clients will find this rhythm themselves.

It is certainly the most effective shape for a trauma intervention in order to assist clients to settle sympathetic arousal states or find a way out of metabolic shutdown in a gentle and safe way. It is pendulation between a trauma vortex and a healing vortex made visible.

FIGURE 14.62. Anthony Twig Wheeler described pendulation in a Somatic Experiencing seminar as the skill to find the point where we can assist clients to jump off the trauma vortex onto a healing vortex.[25] This skill involves simultaneously that clients understand that their therapist does not try to deny the trauma, but that they need a countervortex as a necessary tool to regulate their nervous system.

In Buddhism, the lemniscate is related to the practice of meditation. In his scriptures on raja yoga, Swami Vivekananda uses the image of many figure eights horizontally on top of each other to describe the structure of the spinal column. They form two circles, connected in the middle. Piled one on top of the other, they represent the spinal cord. The crossing point can be pictured as a hollow channel that runs through the center. This latter channel is closed at its lower end, as long as the latent creative forces of the kundalini (or "libido," as modern psychologists would say) are not awakened. In its dormant state, the kundalini, frequently illustrated as a coiled serpent, blocks the entrance to the channel at the crossing point of the two circles. According to Buddhist teachings, such unawakened libido is absorbed in subconscious and purely bodily functions. The purpose of kundalini yoga is to direct the libido to the higher centers along the spine.

All exercises through which the chakras are activated and made into centers of conscious realization will release the energies of the kundalini. This is the path of transformation toward "perfect unfoldment and conscious realization."[26] In meditation, according to Lama Govinda, the spinal cord can be experienced "as fine as a hair and at other times so wide that the whole body becomes one single current of force,"[27] a force that he describes as a flame of highest inspiration, able to annihilate all limits and expand until it fills the whole universe.

**Archetype:** Throughout medieval Europe, the lemniscate or figure eight was known for representing white magic, as opposed to the circle, which symbolized black magic. White magic, associated with all healing arts, respects another person or entity. It does not manipulate the other or impose its will. Communication flows between two circles, each one rightfully being its own world. In black magic, the individual has to conform and stay within the one circle, the matriarchal *ouroboros,* and is exposed there to the pressure of group demands and the fascinating splendor and terror of the unconscious. At the core, black magic works with fear. The lemniscate or figure eight is based on a relationship of equals. The flow is fueled by love and characterized by respect for the other-than-me.

Medical professionals and chemists use the figure eight winding its way around the Greek wand of Asclepius with its intertwined snakes as a symbol of healing.

**Intervention:** The shape of the **lemniscate** (fig. 14.61) is accordingly one of the most important intervention tools in Guided Drawing. It can assist

FIGURE 14.63. Similar to the settling with the bowl shape, clients can move up and down inside their body in a rhythmically rising and settling motion. It is important to find a rhythm that is pleasurable and matches the felt sense. If it is drawn too fast, some clients end up feeling dizzy. If it is drawn too slowly, the rhythm gets lost. This is a very organic flowing movement without any of the dangers implicit in the rotation of the circle.

dissociated clients to gently find a rhythm they are comfortable with. The rising and settling motion teaches their nervous system that it can do the same. The rhythmic repetition heals fragmentation, melts freeze states, and brings gentle motion into blockages. The swinging motion from left to right and back is almost always joyful, has lightness, and evokes a healing vortex. The lemniscate can teach highly activated clients how they can calm down and how to find a supportive rhythm. It is an excellent trust-related exercise. The descending motor impulse of "falling down" is always caught and lifted up again. The rising and falling of the movement soothe, comfort, and vitalize. Drawing it can communicate deep understanding for effortless flow and unconditional support.

Each circle can remain distinct and communicate in flowing exchange with the other entity. While drawing, one can emphasize either of the two poles, or the crossing of the lines in the center, or—and this happens most of the time—the rhythmic flow between the two circles.

FIGURE 14.64. This young woman drew a rectangle and then a lemniscate to rein in her rage. It was a successful self-directed intervention halfway through her process after she had expressed explosive anger that became quite unmanageable. Even though down-regulating like this made her feel "weird," because it was so unfamiliar, and restricted, like a "Stepford wife," she folded her hands at the end and felt significantly more collected.

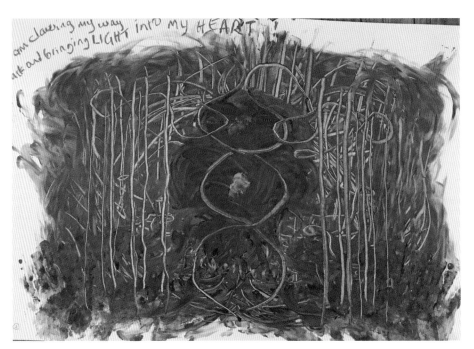

FIGURE 14.65. This client was badly affected by a recent surgery and the anaesthetic. She felt she had lost her identity; in her daily life she was easily confused, forgetful, and felt scattered. She scratched the paint with her fingernails: "I am clawing my way back out bringing light into my heart;" the latter she did with the figure eight movement. This drawing restored her and made her feel whole again.

FIGURE 14.66. Figure eight.

The **figure eight** (fig. 14.66) connects top and bottom, head and body, abdomen and chest. It matches the flow of the kundalini through the chakras in the spine. It can be a helpful exercise for dissolving pain, mainly in the

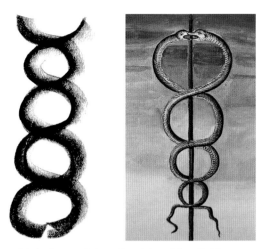

FIGURE 14.67. On left, multiple figure eights. On right, rising libido as entwined snakes.

solar plexus, resulting from tensions between the upper and lower part of the body, from blocked emotions in the stomach that do not correlate with the mind's image of oneself, for example. The movement resolves blockages as it transports energy down from above and up from below. It connects opposites and brings them into a flow.

**Multiple figure eights** (fig. 14.67) create a swinging, rising movement that is likely to be related to the spine. In many yoga illustrations, the chakras are interlinked through this winding crossing-over motion, connecting center after center at each crossing point. The DNA code is similarly pictured as passing information on in this configuration.

When **two figure eights** (fig. 14.68) are drawn bilaterally, it is important that the hands work out a rhythm for crossing over without getting in each other's way. It is possible! And once one succeeds, the swinging around an invisible axis is usually vivid and joyful. Together they form a rhythmic mandala.

FIGURE 14.68. Two figure eights.

The body experiences these figure eights as an opening toward a space above, a flowing back to the center to open again to a space below, and then a return to the center. The movement can be supported by an affirmation such as: "I open up for heaven above; I receive and take it in. I open up for the earth below; I receive and take it in."

FIGURE 14.69. The bulb.

FIGURE 14.70. The heart.

Both the heart shape and the bulb are contained in the rhythmic repetition of bilateral figure eights. The bulb contains a message of potential growth; the heart is a movement of giving and receiving.

Closely related to both the lemniscate and the figure eight is **the wave** (fig. 14.71). The wave is rhythm and motion, rise and fall. Essentially it is a vibrating vertical or horizontal line. It is energy that moves between two poles without losing direction. These poles can represent the up and down of emotions, or polarities, like life and death, day and night. In its horizontal form, the wave is often associated with water; in its vertical state, it frequently pictures flames and fire. The vertical wave also expresses feelings such as joy, sadness, or vitality, something that "moves" the person drawing.

The wave appears most often as movement within another shape and context, and there it expresses motion, often e-motion.

FIGURE 14.71. The wave.

FIGURE 14.72. Rising wave lines, as in this drawing, depict quite frequently the experience of rising libido in the spine. The bowl represents the pelvis, the vertical the spine. All is held in a heart shape and secured with a rectangular boundary.

# 15

# Male Primary Shapes

Guided Drawing deals with the movement that creates a particular shape. It does not so much look at the image of a rectangle on the paper but at the motor impulses it took to create it. Once the movement is repeated, the sensory experience of this shape is investigated: what implicit memory patterns it evokes in the body, which emotions are attached to it, and which needs in the felt sense arise from it.

The primary shapes with a yang or male connotation are all those created with straight and linear or angled and pointed motor impulses. For example, drawing a rectangle means moving in one direction, then stopping and deciding on a new direction, then executing that move until the next stop, next decision, next move, next stop, next new decision, and so on. The movement is broken up into many small parts, and each step demands conscious decision-making. Like a beam of light refracted by a prism, an angular line is "broken" and reflected.

The other key male shape is the line, which either has a marked beginning and end, in which case limitations have to be imposed (which also involves a conscious decision), or it is directed, like shooting off an arrow. In this case, the direction of the line demands focus, aiming at a goal, and trained skill, but also the confidence and knowledge it requires to let go at the right moment.

This process characterizes the principal quality of the male shapes. Their predominant purpose is decision-making, differentiation, and awareness. They evoke perception, consciousness, and mindfulness, and they represent structure as well as rules and systems of order.

FIGURE 15.1. Girl at one year, seven months: random swirls and tapping; joyful motor impulses without any spatial awareness.

FIGURE 15.2. Girl at three years, four months: contained in a circle; beginning spatial awareness.

FIGURE 15.3. Boy at age four: lines and angles organized into a meaningful representation.

These children's drawings (figs. 15.1–15.3) illustrate that initially, their kinesthetic motor impulses at age two are scribbles and swirls, gradually evolving at age three into round spaces and circling. The right brain is associative, connected, and lives fully in the present. According to Siegel, the left brain comes online at around the age of the three, when children begin to ask "Why?"[1] Left-brain cognitive processing deals with a skill set learned in the past, and it can project this into the future in order to achieve a specific goal.[2] This is when linear and angular shapes appear. Accordingly, we will not attempt to heal attachment trauma by drawing corners and shooting off arrows. Early infancy issues need connection and flow with round shapes. When it comes, however, to the development of learning abilities, to the strengthening of self-esteem, and building confidence to speak up, the value of the yang shapes is significant. While the round shapes deal more with

flow and connection, the linear and angular shapes evoke the perception of inner and outer spaces and structures. They give orientation; they differentiate and distinguish. Clients can only draw them by making a conscious effort. The process requires the application of skills such as directing lines with intention, focusing on a goal, and releasing them toward it. The yang shapes are all designed to execute what Levine calls an "active response" to shock and trauma, when we froze in fear—and held onto this fear sometimes for decades.[3] The female-yin shapes support *being* states: being in flow, being in touch, being held, being safe, being whole. The male-yang shapes are *doing* shapes; they support action patterns and intentional motor impulses.

The introduction of certain shapes as intervention tools enhances perception in the context of Lusebrink's definition of the perceptual-affective level.[4] While the male-yang shapes in particular provoke emotions and support their safe release, they also structure the inner experience into a perceived context both physiologically and emotionally. Chaos, being overwhelmed, and blind fear can be differentiated, channeled, and released. The spine is cleared of emotional baggage until it can stand freely erect. Clients can begin to locate their pelvis, their diaphragm, and their shoulders and neck on the inside. They learn to witness their breath. They gain orientation on their inside and tools to take appropriate action should their inner responses veer into states outside their tolerance. According to Lusebrink, this perceptual-affective level relates to the ventral vagal complex, designed to bring the social engagement system online, which allows us to be in the present moment. The following section will be dedicated to a better understanding of the male shapes with a yang connotation.

## The Vertical

**Physiology:** The vertical in the body corresponds to the spine, and in this context the upright spine corresponds to the ego as the embodied sense of identity. It is interesting that the sense of "me" and "mine" in toddlers develops at the same time as they begin to discover their unassisted uprightness. The younger infant is still in unseparated union with the surrounding world and completely dependent on it. Only the upright child is able to say "I am," and enforce this newfound sense of self with want-driven temper tantrums.

Of the group of male-yang configurations, the vertical line (fig. 15.4) is the most important in the diagnostic context. The drawing of a vertical or its

absence will give the therapist crucial insight into the psychological strength or weakness of a client:

- Self-regulating clients with their social engagement system online will be able to create clear verticals. Such individuals present with a relaxed uprightness in their posture.

- Psychologically overwhelmed clients are often unable to draw a vertical at all, or such verticals are swamped on the page by round and arched circular motor impulses. This tends to correlate with drooping shoulders, a slumped posture, and a lack of tonus.

- Dissociated clients tend to create fragmented or thin and fragile-looking verticals, or the vertical is absent, and they present as disembodied and withdrawn.

- Highly activated clients may explode into aggressive outbursts with vertical lines drawn with lots of pressure, but are unable to focus and direct them effectively; they are therefore easily in danger to get overwhelmed. Here the posture can be rigid and tense, or clients are pulled into their emotional storm by leaning over the paper to the point of collapse.

The vertical makes the flow of libido in the spinal cord visible and is able to illustrate the polyvagal system in an intriguing way. The shape itself and the vertical motor impulse are also associated with male sexuality; the flow of libido, or conflicts around the lack of flow, become, in this context, manifest in the drawings. Through drawing verticals, a client's sense of self can be encouraged and supported. To the extent the ego is strengthened, the outgoing lines become straight, erect, and focused. Whenever the ego is lost, stuck, or overwhelmed, the drawn verticals are bent, lack grounding, are put down, or are inundated by circular movements in which the vertical disappears.

In some life situations, it takes great courage and a true decision to break out of the circle and confess: "I shall no longer be part of this; I have chosen a path of my own." This can mean to break away from addictive habits, or to make a public stance for human rights. It may be the decision to follow one's own heart, or vocation, instead of conforming to others' expectations of "what I should do."

Individuals with a "strong backbone," "standing up" for their ideas or for others, become truly visible; they will stand out, make a difference, be

different, unlike any other. These are the "tall poppies." There is no longer shame or embarrassment about being seen. Such individuals are the keynote speakers and leaders who no longer blend into the crowd. However, such success usually only comes after a long road of trials and tribulations.

Then there are the ones who not so much search for worldly victories but inner mastery. All meditation practices focus on sitting upright and directing the energy flow in the spine through the chakras toward transcendence. We find the same in movement meditations such as taiji or yoga and the martial arts. Atonement, at-one-ment with life's essence as enlightenment, aims to spiritually transcend the ego through transforming the flow of libido in the upright spine. The Judaic tradition tends to separate spirituality from the physical body, whereas Eastern religions picture their gods in eternal sexual union with their *dakini,* their female counterpart. In Buddhism and Hinduism, the physical body is the vehicle to attain spiritual awareness, for example through deep emersion with the breath and the flow of kundalini energy up the spine. In the Jewish, Christian, and Muslim tradition, transcendence is an out-of-body or after-death experience, and sexuality is viewed as compromising spirituality. Guided Drawing favors an embodied approach to spiritual practice.

The vertical's sphere in general is one of conscious control, the ability to differentiate, to structure, divide, and analyze. The vertical represents the power to conquer, to fight, to handle weapons, to shoot, to spear, and to wield a sword. It stands for phallic sexuality, which can turn easily into frustration, aggression, and depression if the flow of libido is blocked. It is the left-brain ability to distinguish between right and wrong, to enforce law and order, to administer and manage life. Its domain is the power of the intellect, including all abstract, technical systems. In today's technology-driven information age, the downside also becomes apparent. A domination of yang lacks yin—the female principle of nature, of flow, of vitality and human connectedness. Too much "action" creates nervous system overload. We need also "round" parasympathetic times of rest and introversion.

**Archetype:** There is abundant scope to choose from; the vertical symbolizes the hero archetype. Our admiration for heroines and heroes fuels myths, fairy tales, religion, movies, novels, and real life. The hero as the self-realized human being is probably the most longed-for Western archetype. Greek and Roman mythologies are populated with them; usually half god and half human, these individuals face tremendous challenges. Here we find Hercules

with his twelve labors, Jason, Achilles, the beautiful Helen, Orpheus and Eurydice, Persephone, and many more. In Christianity, it is Saint George killing the dragon and Saint Francis communicating with animals. Protagonists of more recent times are James Bond, Dorothy from *The Wizard of Oz,* Luke Skywalker in *Star Wars,* Xena the warrior princess; Frodo in *The Lord of the Rings,* and Harry Potter. In effect, all those Hollywood movie heroes seem to win forever against the most overwhelming opposition. Each culture has its own set of admired individuals; their function as role models is promoted through building legends around them. Mass communication systems with their cult around sports stars, pop stars, and movie stars promote contemporary myth.

Fairy tales seem to be ancient instruction manuals on how to deal with trauma. The protagonists all suffer from complex trauma issues: the death of a parent, abusive stepfamilies, abandonment, neglect, poverty to the point of starvation, and violence, including the threat of imminent death instigated by a parent. They suffer, and we suffer with them, until there is a dramatic turnaround. In trauma-informed language, an active response takes place, which resolves the injustice and threat, and then they can live happily ever after. Vasilisa, Hansel and Gretel, Little Red Riding Hood, Rapunzel, Cinderella, Snow White, the Frog Prince or Iron Henry, and Rumpelstiltskin are just the best-known performers in this drama of life.[5]

Robert Johnson points out the downside of the hero business in his essay on the Fisher King and the Holy Grail. Percival's father and all his brothers have died in knight errantry and heroic battles. Percival intuitively finds the grail but forgets to ask the crucial question of salvation. He is incapable of making the mysterious experience conscious, and therefore no healing can occur. Hence, he must spend

> the next twenty years in the exhausting work of rescuing fair maidens, fighting dragons, relieving besieged castles, and aiding the poor—all the male experiences which intervene between early youth and middle age, when one has a second chance to visit the grail castle.[6]

The Dying King or Fisher King in the grail castle represents the danger implicit in being at the top as the urge of those in power to consolidate it to make it last. If there is only yang, without yin, the system gets out of balance. If there is only ruling and no serving, the reign will become increasingly rigid; governments become inflexible with an overadministering bureaucracy. The Dying King or Fisher King is Amfortas, who suffers from a terrible wound

that leaves him cold, and he is never again to be warm. He is unable to stand erect. He can neither recover from his illness nor die. He is stuck in inflexible constrictions, meaningless rituals, and hardened positions that have drained all life out of him. His rigidity leaves him so unyielding that he is both unable to let go and die, and unable to heal and rejuvenate himself. In his land, "the cattle do not breed, the crops do not grow, the orchards do not bear, wives are widowed, and men are in despair. One finds himself uncreative in every realm."[7] The only relief Amfortas finds is when he is fishing from his boat in the moat surrounding his castle. To fish in this sense is to reconnect with the feminine principle, with the instinctual, to do one's inner work.

This is a pretty good description of the freeze stage, of tonic immobility. Healing occurs when Parsifal can ask the question about the meaning of life, because life is about more than having power. Only then can the Fisher King drink from the Holy Grail. The "water of life" miraculously restores his health and strength. The whole kingdom returns to a springtime of joy and beginning life, resurrected from winter's cold encrustation and inflexibility.[8]

Snow White, by the way, suffers a similar freeze response in her glass coffin on top of a mountain. Snow White's poisoned piece of apple flies out of her throat, where it was choking her, when the king's hunters carry her downhill. To go down, to turn inward, to relax, to settle the nervous system after a cycle of activity and busy-ness is just as important as the aim for success.

FIGURE 15.4. The vertical.

**Intervention:** The vertical is the visual expression for the ego as a force of consciousness that can make decisions, focus, separate, and divide things; it can disconnect, interrupt, cut off, divorce, and select in order to restructure,

reflect, and recognize. It is left-brain serial processing. Adjoined images are a knife, sword, and other cutting instruments, but also beams of light, rays of sunlight, X-rays, or any other abstract erect shape.

In its physical expression, the vertical represents male sexuality and vitality. Associated images are the phallus, totem pole, spear, arrow, as well as the act of shooting and spearing. If the flow of vital energy is blocked or perverted, all these qualities will take on a negative quality, such as aggression, anger, and violence.

If the sexual undertone is a positive one, the vertical relates to any process of growth in an upright form, be it a sprout, the stem of a flower, or a tree trunk. The physical equivalent would be the back, the spine, the spinal cord, the phallus, and the flow of vitality in these.

In its subtle state, it can show the rising of psychic energies such as the kundalini and its ascent through the chakras or energy centers in the spine. The vertical is also the present, separating past and future, and is, in this sense, the "I am here and now." It represents the axis between top and bottom, heaven and earth, brain and gut. Understandably, it is crucial whether the vertical movement rises up or down.

Clients draw the **upward vertical** (fig. 15.4) in a multitude of different ways. In hardly any exercise is it so obvious how much potential energy we have, and how badly we use it. There are a number of important intervention options concerning the vertical. In particular, and this applies for all the following observations and interventions, is the one primary fact that the drawn verticals have to correlate with an upright posture. Similar to martial arts, wherever clients lose their uprightness, where they are pulled along into collapse and the loss of their *hara,* their core strength in the abdomen, they are being victimized by their actions; they are no longer in charge. I encourage clients at times to activate a felt sense as if they would sit on a horse. To sit deep down into the saddle helps them to move forward upright. Drawing verticals is an exercise of harnessing vitality: they can imagine the power of the horse underneath their body and align with its power.

Like all the others, this is an exercise of minute awareness, of tracking sensations in the body, and for therapists to observe the posture of their client. The vertical not only pictures an individual's spine, but more so the flow of vitality in its spinal cord. Is the drawn vertical relaxed and at ease in its uprightness? This would mirror clients at ease with themselves. However,

most clients aren't. They arrive in sessions crippled with fears and doubts, and are shut down or highly activated. This is reflected in their body posture and their ability to draw verticals.

Focusing on clients' uprightness and their ability to release their ideas, thoughts, and feelings into the world with confidence, through releasing drawn lines like arrows, can be a challenge. If the right point of release is found, this is fed back to the body as increasing uprightness of the spine, as well as a firm grounding in the abdomen. It does not involve the loss of energy, as some suspect, but an increase, as libido now flows through the body freely without blockage. It can be helpful occasionally to add sound to the release of a vertical, similar to tennis players' way to increase the impact of their hit. Just like in martial arts, or dance, or sports, rhythmic repetition writes implicit memory. We can change our attitude through changing the way we move. Once we move differently, we feel differently. Once we feel differently, we can think differently.

Some of the manifestations of energy flow as they can be observed in clients' drawings follow in figure 15.5.

A    B    C    D    E    F

FIGURE 15.5. A: The energy is blocked once it reaches a certain height, and the crayons are pushed down to stop moving forward. B: A decision to move forward is taken back in a little hook; this is like a last-minute withdrawal from one's own courage and commitment. C: The ends of the line hang down limply in a depressed, unmotivated, exhausted manner. D: Some like to draw arrows with little peaks on top, not realizing that, from an energetic point of view, they have put a lid on their release, stopping the energy from coming out. E: Such a broken, fragmented vertical can be the result of physical or emotional abuse. F: This is a focused vertical, filled with vibrant strength, moving forward with ease and able to release the energy at the end of the line with confidence and trust in one's own abilities.

Next, I will describe the most common difficulties clients encounter when they draw verticals. Interventions here are necessary to support them to arrive at more consciously directed action patterns.

How much or how little *pressure* does a client put on the crayons? The paper tearing is an indicator of a lot of downward pressure. Individuals in this case push more down than forward out of fear. This is usually an indicator that they are putting a lot of pressure on themselves to "perform" something they are not ready for. Here, clients benefit from being shown that they can gradually build up the vertical to a height they feel comfortable with. I may encourage them in such a case to draw "grass" instead (fig. 15.6). These are small, releasing motor actions that gradually grow strength organically. Grass then tends to shoot up quite quickly into confident verticals. Such motor impulses are then more in line with what a client wants and can do rather than what they think they should do.

Many begin with a *scrubbing* up-and-down movement (fig. 15.9). From an energetic point of view, this is like someone driving back and forth in a parking lot rather than choosing a direction to go toward. I call it the "Yes, but …" movement: "I want to, but the others…." Often the emphasis is on either pushing forward or pulling back. Tracking body sensations can reveal which way a client wants to go. That is then the direction to be practiced: forward, withdrawing, sideways, or otherwise. A decision has to be made, and focus put into it. Then that one-direction motor impulse is rhythmically repeated, and the tracking of the felt sense can confirm how this feels different in comparison to the indecision before.

Others are *holding on.* They desperately want to express themselves, but neither fully trust their own ability, nor that they will be heard. They will push the crayons down at a certain point and block moving forward or releasing the line. It appears at times as if there is an invisible wall, usually at shoulder or neck height, and their voice cannot come through (fig. 15.8). Again, drawing "grass" here can help to build confidence that it is safe to release—to speak up—in small steps.

This fear may also manifest as clients try to avoid connecting with their actions. They throw their head back every time it comes to the point of release. They are breaking the flow of libido in the spine at the height of their neck. It is a subtle form of avoidance, where they comply but are in denial of what they are actually doing. Maybe they have grown up with a paradigm that to be angry is "bad." Whatever drives this behavior, it is important that

FIGURE 15.6. Growing grass. Motor impulses begin with short strokes and then grow up. Clients release the line at the point before they would lean forward. Thus they do not lose their center.

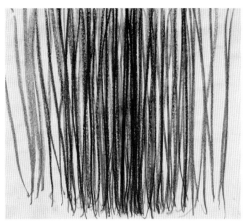

FIGURE 15.7. Being carried away by anger. This happens when lines are not released in time. Clients lean more and more over the paper and lose themselves in their identification with an issue.

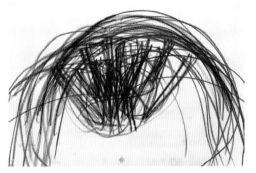

FIGURE 15.8. Holding on. This reveals an internal wall where all lines are stopped. This client has no voice and fears standing up and being seen.

FIGURE 15.9. Scrubbing. This up-and-down and back-and-forth "Yes, but ..." movement' gets very frustrating. Clients invest a lot of energy and get nowhere.

the therapist picks it up and directs sensory awareness to this pattern. Again the "growing grass" exercise might help to titrate activation states so they become manageable.

Others will hold onto their lines and release them way too late (fig. 15.7). By then, they have been pulled across the table, over the edge of the paper, and their bodies are slumped over, actually collapsed. They are so identified with their issue that it pulls them completely out of alignment with their vertical in the spine. Clients get *"carried away"* by their anger or enthusiasm. It happens easily and expresses identification with an issue. An intervention to

find the point of release before "it gets hold of me" is important. To conquer this minute moment of fear can only be done through carefully tracking the sensation. Trust is gained through becoming aware of body sensations such as "feeling stronger" and more competent.

The direct release of raw anger in straight lines can easily be too activating. A useful intervention to deal with too much charge and identification with an issue is the exercise of moving up the spine bilaterally and, before it gets too much, or the spine feels blocked, or "I am freaking out," a corner is drawn, and then the charge is released to the sides. This helps enormously to get some control over an emotional issue.

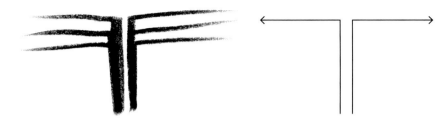

FIGURE 15.10. Sorting the seeds.

I have called this exercise "sorting the seeds" (fig. 15.10), which is what female protagonists in fairy tales and myths have to do when it comes to waking up and being more conscious of their actions. Male heroes learn to handle weapons and fight, whereas the mythological maiden has to

FIGURE 15.11. Lightning bolts: If clients cannot or do not want to draw "sorting the seeds," they can be encouraged to express their rage with lightning bolts. These movements tend to be intense, yet the corners will gradually induce reflection and more consciousness into their anger. To the extent that anger is allowed to flow in a safe way, it can move from depression (bottled-up anger) to aggression and to expression to actually become creative.

FIGURE 15.12. This woman suffered from PTSD due to childhood sexual abuse, which manifested in sleeplessness and chronic high activation levels. Here she finds an expression for her inner tension. To stand up and be visible was initially fraught with anxiety for her, as it was coupled with abuse. Yet the circles in the background, which she had drawn at the beginning, indicate that she was now held sufficiently to assert herself safely.

distinguish between what is good for her and what harms her existentially. After she has been sent off into the unconscious realm pictured as the underworld, the forest, or a foster home, she has to work through separating this from that in order to become more conscious. In this way, Vasilisa sorts seeds for the Baba Yaga, Psyche for Aphrodite, Cinderella for her stepmother.[9]

The exercise of sorting the seeds becomes particularly useful when it comes to anger management. The release sideways is less confrontational. The corner allows clients to make a firm decision. It gives clients a hold within their body. The corner introduces decision-making and reflection, which can help manage rage and temper high-activation states, so they do not get overpowering for the client—and the therapist.

If anger management is not handled with care, the repercussions can be severe. During my Somatic Experiencing training, I had a session with one of the trainees. She encouraged me enthusiastically to express my anger through pushing her away. We had both our hands and arms outstretched,

and I pushed against her. I could do it well. However, I then went home and found myself sleepless all night; my whole nervous system was in hyperalert. I felt tense and jumpy, icy cold, and very, very stressed. The next morning of the training I sought help. A more understanding therapist assured me that my actions would have no repercussions, and she supported me through standing next to me instead of on the opposite side. Finally, I could begin to breathe again and come out of shutdown. I grew up with a father who suffered from severe World War II–inflicted PTSD. To even mildly protest in his presence would have been a death sentence. He would have exploded and punished me severely. My nervous system expected such repercussions all night. This incident was an important lesson for me about the importance of safe expression of anger.

Should clients find the expression of anger too upsetting, or if they get too easily carried away, it helps to draw the **vertical with an added horizontal or bowl shape** (fig. 15.13). The spine is thus anchored in the pelvis. Such a movement supports grounding.

A round base flows more intuitively; the versions with an added corner are more deliberate. The round form (A in fig. 15.13) relates to an earthy, vital, often emotional grounding, which can be healing and reviving, especially if clients have been cut off from their pelvic floor.

The more decisive form (B and C in fig. 15.13), with the conscious break at the base, encourages sublimation. The free flow of vital, often sexual energy is broken in order to make it more conscious and less volatile and overwhelming. Both exercises have their particular value, depending on what is needed and necessary to develop. Clients can repeat drawing the base line until they are ready to move up and out.

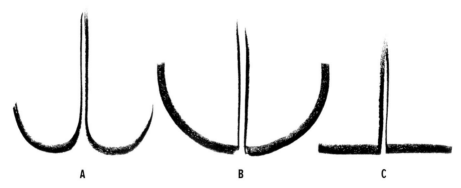

A                                    B                        C

FIGURE 15.13. Vertical with an added horizontal or bowl shape.

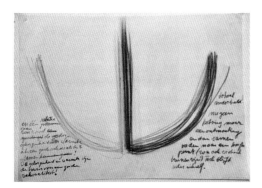

FIGURE 15.14. A male client who struggled with his sexuality. He could be blustering and dominant, but had trouble being gentle and to "feel things." His wife had filed for divorce. The bowl shape represented layers of difficult emotions he held in his pelvis, which he now tried to connect with his uprightness as a renewed masculine identity.

FIGURE 15.15. This is one of Julie's drawings. Her work appears previously in chapter 3, figures 3.7–3.12. She begins by drawing "grass" and then finds this powerful vertical. She writes: "I feel I am someone who is looked up to. People respect me. I am just being me." This is really the essence of the upright vertical.

The **beaten line** (fig. 15.16) usually appears in a cluster, as an outburst, which can be vehement and emotional. It is an actual beating of the paper, either with lust or despair. In its traumatic aspect, it can express intense recall of physical abuse. In its liberating aspect, it can free up repressed energy. I have watched clients use this movement for explosions of all sorts, as well as for dancing, hopping, or drumming on the sheet. It can be energizing like beating fire out of something as an act of evocation. The motion may represent an attempt to break through or loosen up a hardened posture, and the associated frame of mind.

FIGURE 15.16. The beaten line.

FIGURE 15.17. Clearing the ground.

All attention has so far been on the upward vertical. However, the **downward vertical** is just as important. The most destructive aspect of this motor impulse is when clients release the downward movement in an aggressive way toward themselves. This is the Guided Drawing equivalent of self-harm. It is a stabbing in the gut as a form of self-aggression and self-injury, and pendulation is needed. The therapist clearly needs to apply the brakes and encourage a healing vortex in the client. This might be the reversal of the inward pointing lines into extroversion, but many clients may not feel safe enough to do so. In this case, using resources to build self-esteem alternating with releasing some of the trauma in a manageable way is an option. Releasing the tension and self-aggression downward and then sideways can be an initial intervention (Fig. 15.17).

The cause for self-harm is almost always interpersonal trauma, and clients have internalized the perpetrator, which on the inside makes them feel powerless, soiled, and "no good." A possible intervention is to have the drawer act out both parties and not only one. One hand can draw the perpetrator, the other hand the victimized self, even if this self appears as no more than a tiny scribbled lump huddled at the bottom of the sheet. Such dialogue can make shockingly apparent how a client has internalized and continued to reenact abuse.[10]

The dialogue between top dog and underdog, between "Super- and Mickey Mouse," as Frederick S. Perls provokingly called the two parties,[11] usually reveals a mind that holds the position of the perpetrator against a meek subdued body—a body intensely connected with the identity of the client. The mind can drive abusive thought patterns with pathological intensity, to the extent that only self-harming behavior can relieve some of the

FIGURE 15.18. Maggie had innumerable felt sense memories of early childhood sexual abuse, but no conscious story. She started with a brown crayon in each hand. On the left is a huge penis, drawn with her left hand, in the center, drawn with her right hand, her tiny child self. She then takes a yellow crayon in each hand in order to help her inner child defend herself. She writes: "You don't control me. I am free. It is safe to stand up. He no longer has any power over me."

FIGURE 15.19. Next, Maggie felt sufficiently empowered to take action and clear away the oppressive body sensations. She liberates her spine from everything that contracts her and keeps her small.

internal pain. If the direction of the vertical can be turned around into an upward movement, there is a chance that the suppressed needs, emotions, and feelings, previously locked in the body, are released, and the destructive mind-set gets kicked off its pedestal. Only then, insight and empathy have a chance.

FIGURE 15.20. Downward vertical: when the vertical is drawn with a downward left and downward right emphasis, the lines benefit from "arriving" somewhere. Rather than just being pulled directly into the abdomen, the motor impulse finds containment in the bowl shape. This relates to the pelvis and the spine anchored in its base.

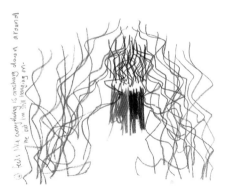

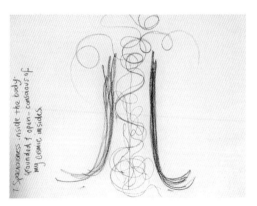

FIGURE 15.21. Ciara suffers from painful spinal degeneration; according to her surgeon, she is in danger of becoming a quadriplegic. Surgery, however, worsened her condition. Guided Drawing allows her to address the underlying complex trauma issues and to live with her pain rather than brace against it. Bracing worsens the pain and causes spasms in her spine. Drawing massages helps her to stay empowered and manage her mobility. She draws on her own at home and posts her drawings by email to her therapist. The first drawing "feels like everything is crashing down around me but I'm still holding on to. Holding on is using so much energy."

FIGURE 15.22. Ciara continues by grounding herself inside her pelvis with intention. Letting go rather than holding on is the answer. She discovers "spaciousness inside my body. Grounded and open. Conscious of my cosmic insides." Flow emerges through letting go and anchoring herself in her pelvis.

FIGURE 15.23. Ciara calls the last drawing of this session "Tree of Life." Within one session, she could move from fragmentation and barely feeling alive to a powerful and beautiful connection with her inner ground and the life force flowing from it. Weekly drawing sessions in this manner have given Ciara hope and have improved her physical condition significantly.

Clients who are dissociated, who are in fear and shutdown, either benefit from drawing figure 15.20, or they need even rounder motor impulses such as the lemniscate to assist them to flow and connect internally. Like Ciara, they will benefit from an emphasis on downward movements and a felt sense of settling into a safe place at the base of their spine.

Because there is, of course, a positive connotation to the downward vertical. In that case, the quality of the motor impulses is gentle, soft, and loving. Here we turn inward and settle down. Especially in combination with the bowl shape, such as in B in figure 15.13, we can relax into ourselves. It mimics the digestive process. In a spiritual context, it can represent all that descends from above, from heaven, as "in-spiration." It is a caring yang impulse that is similar to the movement of exhaling. The instruction for Zen meditation, for example, is to "sit down inside the pelvis" and to let go with the outgoing breath. This is partially the purpose of Buddhist prayers—to emphasize exhalation. Have you ever listened to Tibetan monks singing sutras? They seem to exhale forever. My Zen teacher would say: "You exhale. The incoming breath is a gift, none of your business. You exhale."

Clients at this stage are confident. Their conscious abilities are not under threat. They can turn inward without fear. Many are exhausted from the constant demands of modern life. After all the hero business, they can come home, calm down, and recharge. There is no fight here, no pressure, but settling and loving self-care. Similar to the Fisher King, such clients need to reconnect with their inner nature, with feelings and emotions and their vitality to come into flow again.

Part of this release can be grief. The downward movement and the letting go can flow like tears. In this case, it is the parasympathetic crying on the exhale that settles the nervous system. It is not the upset raging grief of sympathetic activation that would move up. Here it is the grief that accepts and can let go.

While there is much focus on strengthening the ego and identity with the motor impulse of the upward vertical, the reverse is the case with the downward version. Now it is a movement that suggests surrender. It is letting go of control and intentional action, and the acceptance of a more existential state of being. Much spiritual practice has this focus. Zen speaks of the "death of the ego" in its aim to transcend it. The search is for a greater connection with a universal state of oneness. Perhaps the great mystic Rumi's explanation illuminates this surrender:

> When someone beats a rug with a stick, he is not beating the rug—his aim
> is to get rid of the dust. Your inward is full of dust from the veil of I-ness,

and that dust will not leave all at once. With every cruelty and every blow, it departs little by little, from the heart's face, sometimes in sleep and sometimes in wakefulness.[12]

With this shape, we are ready to sacrifice the hard-earned power of the previous victories and let go of pride, self-importance, and vanity. While our I-ness is beaten out of us, bit by bit, we learn to serve a greater goal than our selfish personal interests.

## The Horizontal

FIGURE 15.24. The horizontal.

The horizontal (fig. 15.24) has little value from an intervention perspective. It balances and adjusts, separates top and bottom, above and below, and in this way can be related to the shoulders or the diaphragm. It is also viewed as a horizon or base line. Any impulse to push up into a vertical experience will sense the horizontal as a limiting, blocking wall.

FIGURE 15.25. Frustrated blocking horizontal. Uninterrupted scrubbing from left to right. Such motor impulses might bring temporary release of tension, but they "go nowhere" and end up leaving clients deflated and hopeless.

However, the **horizontal drawn bilaterally** (fig. 15.26) is dynamic and an important intervention tool. It liberates the spine. Tension is released to the sides, and in the process, space is cleared for the vertical. Back pain, feeling under pressure, or being oppressively weighed down can be pushed aside. The extroverted movement can be associated with claiming a sense of "mine": my space, my room, my rights, my body. Some like to exclaim "No!" loudly, with every move, or "Get out" and "Fuck off."

FIGURE 15.26. Horizontal drawn in mirrored movement, extroverted.

Boundary violations through interpersonal abuse can be actively addressed in this way. All those who have to deal with an overwhelming intrusion, women who have been sexually assaulted, men who feel suppressed in their vitality, individuals who have been abused in their childhood or exposed to the pressure of parental expectations. All these tend to experience this exercise with relief. The sensation is distinctly physical and deals noticeably with body-related inner tension.

The reverse movement with both hands drawn together in the center is likely to have the opposite effect (fig. 15.27). This horizontal applies pressure, tightness, enclosure, and it hurts to draw it. Similar to the self-harming downward vertical the therapist needs to be cautious here and watch out for self-aggression.

In its positive aspect, this introverted version may bring something within to a point. The quality of lines, primarily, will tell the difference between this and the abusive version. It is not suitable as an intervention tool, however.

FIGURE 15.27. Horizontal drawn in a mirrored movement, introverted.

# The Cross

**Physiology:** The word for "cross" in German is synonymous with "back." A "cross-ache" would be a backache. The Swiss author Rosenberg studied the cross as an ancient symbol for meditation; his approach is surprisingly body-focused.[13] Dürckheim associated the spine with the vertical and the shoulders with the horizontal, both together forming a cross within the body, not unlike its Christian counterpart, which promotes a cross with an elongated bottom axis. My Zen teacher Roshi Yuhoseki claimed this imbalanced Christian cross was due to our Western egocentricity. He saw a correlation between Westerners, who highly identify with the outer material aspects of life, and the Christian cross, which he considered "out of focus." He thought the spiritual teaching of the death of the ego to regain the center was the inner healing counterpart Westerners needed.

Religions that integrate the physical body and sexuality rather than demonize it tend to have a more balanced cross, such as those found in Asian and Native American mandalas; such crosses have four equal sides, which places the center deeper down in the body. According to Eastern physiology, we are naturally grounded in the pelvis, like children with their relaxed body posture. However, once we get "uptight," cut off from the internal base, once we are "up-set," the center of gravity slips into the upper body. This out-of-focus posture leads to tension in the back as the spine has to hold up something that is top heavy and weak at the bottom.

Most clients seem to use the cross shape to express tension and pain in various parts of their body. The cross illustrates collisions, accidents, injuries,

FIGURE 15.28. Christian cross. This cross is associated with the back and the shoulders, also inner and outer structure. It can be experienced as static and stable or rigid and inflexible.

and surgeries. Negative self-talk, being put down, and trauma experiences that wiped someone out manifest in drawings as being crossed out, more frequently with the diagonal crossing of lines.

Near-death experiences, such as severe car accidents, anesthetics, and invasive surgeries, are often pictured as cross shapes. Sexual trauma, physical violence, and self-punishing mind-sets with aggressive self-talk can be crucifying and really cross someone out.

**Archetype:** The cross is one of the most ancient of symbols. It is loaded with meaning, and not only in Christianity. To find and mark any center, one needs to cross two diagonals. The axes of the cross attract a list of associated opposites as extensive as the history of art and religion. The vertical male and the horizontal female can represent heaven and earth, yang and yin, man and woman, day and night, and innumerable other polarities.

Carl Jung describes extensively the alchemical process of discrimination and purification of the elements, and then their transformation and unification.[14] The cross is one of the main symbols in the Great Work, uniting the pairs of opposites such as king and queen, prince and princess, father and son, mother and daughter, sun and moon, heaven and earth.

Traditional theater and opera quite frequently use the constellation of two couples, one royal and the other common, to illustrate the drama between the higher and lower functions in people. Mozart wrote *The Magic Flute* as a symbolic enactment of his initiation into the Free Masonic order. There, Tamino and Pamina are the representatives of the spiritual dimension, whereas Papageno and Papagena stand for vitality. All four have to undergo trials imposed by the dark powers of the Queen of the Night and fulfill Sarastro's conditions of initiation into the temple of wisdom. The Queen of the

FIGURE 15.29. Saint Andrew's cross is the more dynamic cross, often drawn with strong emotions expressed through slashing movements of crossing out and obliterating something inside.

Night and Sarastro represent the archetypical parents. But while Papageno and Papagena are longing to get married, have sex, and have many children, Tamino and Pamina walk through the gate of death, a purgatory of fire and water in the temple of Osiris. They are transformed and achieve eternal life through their love and inner strength. At the end, all four are united.

In Christianity, the four ends of the cross are often pictured as the four evangelists, with Christ or the Virgin Mother and the Divine Child in the center, thus emphasizing the rejuvenating function of the cross. The evangelists in Gnostic tradition are also related to the four elements and to astrological signs.[15]

Native Americans use the "four corners" of the earth, the four wind directions, and the four skin colors, red, yellow, black, and white, to evoke the Great Spirit in the center.

The common association of the cross with death comes from the death of duality in the process of crossing and being reborn as a new entity in the center. In Christianity, the human Jesus dies on the cross and is resurrected in the center as divine Christ. In analytical psychology, this reflects the death of the ego and the birth of the Self. The Self in this context represents wholeness, as in being an "in-dividual," someone who can no longer be divided.

**Interventions:** The **two-axis cross** (figs. 15.28 and 15.29) usually represents the more fixed, negating aspect of the shape. This is emphasized even more when the vertical axes are **drawn downward** in a crushing, eradicating way. Accompanying feelings may be "to be crossed out," "x'd out," wiped out, being erased. Pain, utter meaninglessness, desolation, being exposed and abandoned ("Father, Father, why have you forsaken me?") often accompany such experiences. It is the core shape to express traumatic experiences, being smashed to pieces, broken or exposed to unending blackness and death.

Being crossed out, x'd out, is the common feature in the drawings in figures 15.30–15.32.

The cross **drawn upward** is symbolically related to resurrection, the rising up from the dead. The Saint Andrew's Cross in this context is pictured as the image of a man with his hands and legs outstretched, like Leonardo da Vinci's famous Vitruvian Man, or the resurrected Christ on the cross.

The truly dynamic aspect of the Saint Andrew's Cross, however, comes into play with the focus on the actual drawing of these axes rather than the shape. Intriguingly, the most effective active **trauma response** is embedded in these symbols that so often tell the trauma story in the first place. Rhythmic repetition of each of the axes will be able to assist clients to complete

FIGURE 15.30. Drawing of a car accident the client was involved in at an intersection.

FIGURE 15.31. Anguish regarding abusive self-talk gradually turns into the expression of anger.

FIGURE 15.32. The blue circle pictures the female client's abdomen after she had surgery for a hysterectomy. The surgery itself, but also the impact this had on her female identity, made her feel "You are worth nothing."

the thwarted fight-flight response. In both cases, crayons are held in the fists rather than with the fingers. It helps to have the large fat oil pastels that are on offer for preschoolers. The paper needs to be firmly secured with tape on the table so it does not slide away, which is otherwise frustrating. Depending on their trauma story, clients will either need to fight or to flee; they do not need to do both. It was either one of these responses they wanted to do and could not, when whatever fearful event happened to them.

FIGURE 15.33. When Carol touched finger paints for the first time, she froze in shock. The contact with the paints triggered recall of horrific physical, sexual, and emotional abuse she suffered as a child. She paints herself ghostlike, as a skull. She survived by being invisible and "dead."

FIGURE 15.34. Carol had, however, sufficient resources to embark on an intense journey of expression. When she comes out of tonic immobility in her next painting, she explodes into chaos and rage.

FIGURE 15.35. This crucifixion painting appeared when Carol began to piece together the fragmented parts of her being. She emerged out of chaos and dismemberment as broken and whole. Such a paradox is characteristic for the emergence of the Self as Jung defines it.[16]

FIGURE 15.36. At the end of the session, blue tears stream down her body. Carol has now got skin. She has got a boundary. She has a heart and can feel. To be able to feel was the most important for her. She had been shut down for so long. It was a sign for her that she could now open up for life and love.

When they need to **fight,** they draw alternating punches diagonally across the paper, releasing the lines at the end. Clients can accompany every punch with a roar to emphasize the effectiveness of their hits. It is important to follow the diagonal axes of the Saint Andrew's Cross and not just straight up. It is also important to observe all the features discussed in the chapter on the vertical, such as that clients sit straight and do not get pulled across the table because they cannot let go and are too identified with their emotions. Short

punches do the job as well. Loosening uprightness in the spinal axis will revictimize clients and will not settle the autonomic nervous system.

The alternating diagonals provoke a twisting motion in the spine. This rotation around the spinal axis strengthens it and can reconnect dissociated, fragmented parts. The motion will certainly activate the flow of libido up the spine, especially in conjunction with the release of pent-up tension through the punches. It is a movement that toddlers naturally do as part of their development in order to strengthen the sensations in their spine. They will either twirl and dance pirouettes, or more frequently will twist upright with their arms outstretched and rotate from their left to their right side. My granddaughter, who is two and a half years old, will do about three to five twists and then stop. It is obvious that she senses her body and loves the sensation. And then she will exclaim "Whee!" and then do it again.

Clients are also encouraged to do about three to five punches and then check their sensory response. What do they notice in their body? Tracking the response carefully, rather than blindly acting out, is important.

When clients need to flee, they draw diagonally from the top down, releasing the lines off the table, literally leaving whatever they are running from behind them.

FIGURE 15.37. Fight: the right hand draws diagonally across toward the left top corner.

FIGURE 15.38. Fight: then the left hand punches across toward the right top corner.

FIGURE 15.39. Flight: the right hand begins in the top left corner and draws diagonally across toward the right bottom and releases the line off the paper, off the table, as if leaving it behind.

FIGURE 15.40. Flight: then the left hand draws diagonally across from the right top of the page toward the bottom left corner and releases the line.

It is the same movement you would do pushing yourself off the ground with the poles while skiing. It is a propelling forward motion. Runners do it as well: their elbows support the motion forward.

It is essential when clients draw the **flight** response that they know where to flee to. Running itself can be endless, and while activating the sympathetic response is momentarily satisfying, it will not turn the trauma response off. It is important to be able to arrive and then be safe in order to settle the autonomic nervous system. Rothschild teaches in her courses how to develop a detailed escape route with a client. For example, beginning from noticing where the door is in the room where the rape took place, opening it, walking into the hallway. Opening the front door, running across the front yard. If the safe place is too far away, allow a magic carpet to come along, jump on the carpet, and off you fly until you arrive at the entrance of your friend's home. You get off the carpet, walk up the steps, open her front door, walk into the hallway, open the door to her kitchen, and there she stands. She will give you a hug, and you know you are safe.

Each client will develop her own story. And while this imagery is activated, clients run on the paper. And again, motor impulses alternate with tracking the sensations. Only then will the autonomous nervous system gradually take in the knowledge that I am getting away now and that I can find safety. It is important to take sufficient time to track all body sensations at the point of arriving and verbalize them. The autonomic nervous system needs time to reorganize itself after sometimes decades of hyperarousal.

The effect of such completion of a thwarted fight-flight response is lasting. Being safe now, the implicit memory systems will re-member and reintegrate the aspects that were split off due to stressful overload in the past, and the individual is able to return to life.

The **six- and eight-arm crosses** (figs. 15.41–15.42) are more complex versions of the basic cross. With increasing axes, the focus is drawn toward the center of the cross. The axes concentrate the energy in the center or expand from it. They express different perspectives and polarities, but predominantly oneness. The structure of these crosses can become the layout for mandala designs. In their dynamic versions, drawn bilaterally and with closed eyes, they will almost always illustrate something that happens in the core of a client.

In the six-arm cross, the Saint Andrew's Cross has gained a central axis of "I am." The figure suggests the Greek letter chi, spelling out the name of

FIGURE 15.41. Six-arm cross.

FIGURE 15.42. Eight-arm cross.

Christ, symbolizing the individual who has consciously realized divinity within.[17]

In Buddhism, the eight-arm double cross is called the "wheel of transformation." It has an almost circular, radiating appearance, which is frequently used as a basic structure for mandalas. In numerology, the eight is related to cosmic order and a perfect balance of forces. Buddhism knows the eight-fold path to enlightenment. The eighth day of creation signifies a new beginning on a higher level of vibration, on to the next octave when one dimension has been fulfilled in the seven.

When the axes are multiplied into ten- and twelve-arm crosses, their emphasis on oneness and unity is even stronger.

Another step will turn the shape into **radiation** (fig. 15.43), whether its cause is an explosion or a burst of light. In such radiation, all beams derive

FIGURE 15.43. Radiation.

from the center and expand from it. Implosions happen rarely. When they do, they should be handled with caution, as most times they are destructive.

I remember one client who could not come to terms with the loss of her child to leukemia. She drew such an imploding star with clenched teeth, until her anger and her tears could erupt and be released.

## Case Example

Peter had marriage difficulties, and his wife had filed for divorce, which had thrown him seriously off balance. Both were middle-aged and had no children. Peter struggled with a range of relationship issues, with sexual frustration, an inability to feel anything except anger (feelings had been his wife's job), and a lack of self-esteem. These drawings are an extract from his fifth session.

Peter is initially talkative, animated by a number of insights, but also quite intellectual in how he processes these. All the more amazing is what happens next. Once he closes his eyes, he seems to be taken in a flash into an altogether different dimension. The atmosphere instantly becomes concentrated and highly intense. Suddenly the axes are like beams of lightning that hit the center of his Self with unbelievable force (fig. 15.44). He tears the paper twice with both diagonals; he can hardly start the second one, not due to aggression but sheer dynamics. The picture is of stunning simplicity and clarity of lines. He expresses a feeling that "this is what it is all about," but more he cannot say. He is like one in the midst of an electric fusion. All his sexual fantasies are taken to an internal plane, where he is hit by a divine spark, and freed into a new dimension.

Peter is almost shocked by what has happened. He feels an immense need to express whatever opens up in his core. In figure 15.45, he uses the double

FIGURE 15.44. Lightning.

FIGURE 15.45

cross, the "wheel of transformation," to expand from the center around a vertical. He is intense and highly alert. He needs more. He does not want to say anything.

FIGURE 15.46. "Radiating outburst of love."

Now he bursts into pure radiance (fig. 15.46). He uses several different colors to express the totality of the experience. He cries and laughs. He shakes and trembles. Later he says he felt flooded with love and light of unbelievable force. He felt overwhelmed by all he had to give. He felt joy about the magnitude and plenitude of his gift, and sorrow that his heart had been blocked for so long. All this is released simultaneously and with great visible intensity. Only a fraction of the experience can really be grasped with words.

## The Triangle

**Physiology:** One distinction of the triangle is that this shape is widely experienced as positive. It has a supportive constitution; its effect is usually associated with constructive attributes. However, we do not really have triangles

in our physical body. They feature in the energy body as light structures, but they have no embodied equivalent. For dissociated clients and those who are afraid of their body, though, these light-structures can initially be the only way to connect.

FIGURE 15.47. The triangle as "Higher Consciousness."

Phyllis Krystal used the triangle consistently in her work as a visual aide to picture the client-therapist relationship and how both relate to what she called the "Higher Consciousness."[18] I frequently apply this exercise. In this case, I will start the session with a brief guided meditation, in which we picture client and therapist, or each group participant, sitting inside a circle of light. This circle is placed on the ground surrounding each individual at arm's length. In a dyad, the two circles are connected like a figure eight. We then visualize a beam of light rising up our spine, extending it beyond the head until it connects with the Self or Higher Consciousness at the top, the peak of the triangle. I then introduce the Higher Consciousness as the source of "unconditional love and universal wisdom," which clients are encouraged to picture in whatever way they are comfortable with. I ask for its "guidance, presence, and the insights we are ready to receive." The Higher Consciousness then sends down a cone of light, like a "shower of liquid light," which will surround the client. The light has five core qualities; it is energizing, healing, cleansing, protecting, and unconditionally loving. For many clients, this visualization is an important spiritual resource, which they need as a session ritual. For the rest of the session, they can visualize themselves sitting inside this light-filled triangular cone.

I learned this meditation during my many years of training with Phyllis Krystal and have found it a valuable tool. It helps to defer transference and to set the scene for the influence of inner guidance. Also, during a session, I may refer back to the peak of the triangle, if the client has a question about how to

proceed. The Higher Consciousness in this exercise is a projection of the Self. It is, of course, ultimately an internal experience.

FIGURE 15.48. The triangle with peak-upward configuration.

**Archetype:** The triangle is a symbol of unity. It appears as such in many world religions, as the trinity of Father, Son, and Holy Spirit; Brahma, Vishnu, and Shiva; or Hecate, Demeter, and Persephone. It can express an abstract image of the divine, frequently with an eye in its center. The triangle is the symbol of the "good father" on all life levels, similar to a trigon, a 180-degree aspect in astrology, which is always regarded as supportive and harmonizing.

It is also the first male-yang shape that can create a closed figure, an inner space, something a single point or line (an axis between two points) running into endlessness cannot do. Possibly this is why the triangle is closely associated with divinity. It is the first form that brings something out of an endless eternal state of being into the three-dimensional world.

It is the graphical expression of a duality that has been overcome. The triangle is the classical thesis-antithesis-synthesis blueprint, the peak representing synthesis. Similarly, the triangle can also be seen as a basic image for all contact between partners and with the world, or as father, mother, and child. Even though diversity and separation rule the horizontal dualistic plane of existence, on a higher level of consciousness, synergy and unity are present.

**Intervention:** Of all the male yang shapes, this is the one that is experienced as the least threatening. If a client cannot draw any other linear or angular shape, the **peak-upward configuration** (fig. 15.48) will work. It makes clients feel safe. Even the associated imagery as tepee, house, roof, or blessing usually represents a protective benevolent entity. However, as an intervention tool, I hardly ever use it.

Again, there is a difference between the rather static way of drawing the shape using one hand and the more dynamic version of the **bilateral motion** (fig. 15.49) using both hands, in which case the upward or downward movement along the sides becomes more significant.

Drawn with an **upward** movement, the triangle evokes feelings of ardent enthusiasm, inspiration, and joy. Fire is often associated with the shape, which actually represents this element in alchemy. With a slight alteration at the base line, it is also the alchemical symbol for air, which emphasizes the elated sky-drawn character of the sign, such as when the triangle turns into the image of a boat with wind-filled sails.

FIGURE 15.49. Triangle drawn bilaterally.

FIGURE 15.50. This triangle became one of Ciara's tools: "If I put this protection around me, I can loosen my grip. Unclench, dissolve the hardness so that something else can come through."

FIGURE 15.51. The triangle with peak-downward configuration.

If the emphasis is on the **downward** movement, a protective, securing quality becomes apparent. Clients apply this shape to exhale and down-regulate; they use the shape to "sit down" within themselves.

The triangle with **peak-downward configuration** (fig. 15.51) is associated in alchemy with the elements water and earth. Here the synthesis, the solution, the uniting aspect lies in the depths. The peak aims toward the wisdom of the night, the knowledge of the earth. The solution lies in the underworld of the unconscious. The sacrum, the deeply rooted "sacred" center at the bottom of the spine, is related to this shape.

The root chakra in yoga is located in the pelvic floor; it is the home of the kundalini, the latent serpent power, with its potential for growth, and it is traditionally pictured as a downward triangle. Tantric yantras are ritual mandalas that use the downward peak triangle in the root chakra as the symbol to evoke the essence of the great goddess Kali.[19] I have witnessed many times how this "night" triangle turned into a face or a mask. These often take on a demonic quality in accordance with their underworldly origin. Sometimes the corners of the horizontal are extended into horns, thus creating the image of a devil or a bull. If we can tolerate confronting these images, they hold powerful potential.

Two triangles put together form the **hexagram** (fig. 15.52), known as the Star of David, symbol of the Jewish religion, and in this context is by some fatefully associated with the Holocaust. The hexagram is a highly complex form of united opposites, balancing male and female aspects. The two triangles, like the vertical and the horizontal, are both male shapes, but with yin-yang connotations. The peak-downward configuration points to the female

earth aspect, whereas the peak-upward triangle reaches up toward heaven. The hexagram unites these polarities.

FIGURE 15.52. The hexagram.

Accordingly, the hexagram appears frequently as a uniting symbol. Many prefer it to the cross, as it is less tense, high-strung, and exposed. The hexagram is beautiful in its completeness and harmonious equilibrium. Its emphasis is circular without being round.

The hexagram frequently provides the structure for harmonizing mandalas.

FIGURE 15.53. Mandala by a nine-year-old boy who had lost his father due to an accident. Jeremy's mandalas became a resource along with guided imagery and other art therapy activities. He pictured himself holding a ribbon, which was tied to the top of a maypole, which represented the Higher Consciousness mentioned before. This ribbon was his "telephone line" through which he could communicate with his father. Some of these encounters he verbalized; others he just sat quietly holding his ribbon, deeply engaged with his father. Jeremy drew this mandala after one of his meditations. The fact that he could make contact with his dad and ask him questions and get answers was deeply settling for him.

# The Rectangle

**Physiology:** There are also no organic rectangles in our body. We do like to surround ourselves with them, however. All artificial definitions of space and time employ the rectangle as a shape. Buildings and rooms, windows and doors are rectangular; street grids are, and our entire planet is parceled into longitudinal and latitudinal squares for orientation. We structure time through the four seasons, the four moon phases, and the four solstices. The Tibetans and Native Americans speak of the four corners of the world. There are four wind directions, and the four elements. Not only the alchemists used the square as their symbol for earth.

The rectangle marks our boundary and keeps us safe. It can evoke strong reactions, such as resentment against imprisonment or a meaningless drill. Yet it also provides a profound sense of protection and order. The main focus on this shape in Guided Drawing is around the repair of interpersonal boundary breaches. Whenever our personal space has been invaded and disrespected in the past, it leaves a weakness or gap in the personal boundary, which can easily trigger individuals into activation states, or leave them feeling fundamentally unsafe. This is a clear felt sense. I believe loved ones can keep us safe by putting an aura of care around us. Mothers do this for their children. A convicted pedophile once explained to me that he could in an instant identify girls who did not have this maternal protective layer around them, which made them easy prey in his eyes.

We learn boundaries. They are part of our procedural adaptation to circumstances in our biography. Loving care and respect teach us healthy boundaries. Abuse and neglect violate them and confuse us about what it means to feel safe. Children internalize these as implicit memory systems; they do not know any different. However, many times such learned procedural habits interfere with appropriate responses to present life situations. When we learned as children to override our own needs and felt sense in order to please an authority figure, we are likely to do so as adults as well. This happens to women, for example, who end up in sexual relationships that make them feel bad, for which they blame themselves. Even if they said "No," their bodies did not know how to viscerally protect them and how to send out signals through their body posture that were congruent. In this case the "no" is not heard, because it is not confirmed by their somatic boundary. Verbal requests are processed by the neocortex, which is easily overridden

by more instinctual responses. In her ground-breaking book *Fat is a Feminist Issue,* Orbach argues that women use their body weight to make themselves unattractive if they have not learned to assert their somatic boundaries, for example due to abuse.[20]

Ogden speaks of a "somatic sense of boundaries."[21] We react with visceral and muscular signals to closeness and distance. We orient toward someone we like, and we turn away if we do not want to engage in contact. When our boundary is disrespected, we tend to react with tightening muscles, leaning back or moving away.

There are two core types of interpersonal boundary breaches: we either become victimized by others, in which case unwanted contact comes too close and overwhelms us, and we do not know how to defend ourselves; or we fail to respect others' boundaries, which may trigger defensive reactions or rejection in others, or we may even subject others to bullying and abuse. Most perpetrators have themselves been subjected as children to caretaker abuse involving severe boundary violations.[22]

When we have insufficient internal boundaries, we experience that others make us feel bad, ashamed, sad, or angry. We may have difficulties protecting ourselves from sexual advances; or we end up disclosing too much about ourselves too soon, without having established appropriate trust, and then react with withdrawal and shame. Healthy internal boundaries confirm our individuality with our own beliefs and opinions. We can open up for new ideas and experiences without feeling threatened. We are capable of choosing to say yes or no to regulate interpersonal relationships.

**Archetype:** The rectangle symbolically defines the earth and the body as a dimension of realization. The relationship between spirit and matter is perfected in this shape. The rectangle represents the incorporated Self as spirit, enclosed in a body on this earthly plane of existence. This can be felt as a limitation or a way to freedom. The body, with its earthy weight pulling down the free-roaming spirit, may be experienced as imprisoning the soul; or it can contain and protect it.

Jung explains the step from the triangular three to the rectangular four as a process of integration and incorporation. The spirit associated with the triangle opens up its peak, taking in a second horizontal, thus forming the rectangle. In this way, the alchemists imagined spirit descending onto the earth in order to realize itself. This *quaternio* consists of two male and two female components.[23] Christian tradition would regard them as Father, Son, and

Holy Ghost (which was originally Sophia, the female aspect of divinity, also known as *philo-Sophia*) and the Virgin Mary as the earth mother. According to Jung, we are called to realize our potential when the earth archetype manifests. We have to leave the inspirational-ideas world of the triangle and put in the hard and often painful work by implementing these in the physical world.

FIGURE 15.54. The rectangle.

**Intervention:** The rectangle is an ordering, structuring force. When drawing, one moves in one direction, stops, decides on a new one, takes that turn, and follows this one, stops, decides again.... The process requires exactness, decisions, and clarity. There is nothing high-flying about this shape. It sits heavy on the ground.

The rectangle is an important intervention tool whenever clients need to learn to actively protect themselves against boundary breaches. These might have been caused by physical, emotional, or sexual violence, but also surgeries that invade our personal space. Most traumatic events involve interpersonal boundary breaches, where the protective membrane of our skin has been attacked or even broken. The active repair of the boundary is one of the core exercises to create a safe place. Some individuals have never known an implicit memory state of being safe. Boundary violations seem to leave holes in our aura. They can be tracked and physically remembered, even decades after the event. The restoration of the full membrane around us—the repair of such cracks in our boundary—can change the felt sense deeply. The implicit memory now knows "I am safe." It is the boundary of one's personal space, one's room, garden, or house, something that warns off others effectively and keeps unwanted people out. It protects the *temenos,* the sanctuary inside.

While the circle can hold and protect as well, it is more passively containing, whereas the rectangle requires a conscious active defense. The rectangle in this case is most effectively drawn with both hands together. Clients are encouraged to loudly say "No!" "Get out," "Fuck off" at every corner. They mark, defend, and repair their boundary with force. The four corners can additionally be affirmed with self-created symbols, power animals, crystals, or guardians. The boundary marks "my space."

Madeline was adopted and had lived all her life with a sense of not having a right to her own space, which would have been an implicit memory from her mother's feelings toward an unwanted pregnancy. Instead she felt she had to be "eternally grateful" to her stepmother for taking her on. When she drew the rectangle, her body felt so thrilled and elated that she spontaneously climbed onto the table and sat inside the rectangular boundary she had drawn, beaming with relief. Soon after, Madeline bought her own house, which she had not dared to do, thinking it would be "selfish."

FIGURE 15.55. "My family in the jaws of the monster." In this "family portrait," Naomi pictures herself as the small black dot. Father, mother, and the two brothers are present as stick figures. She does not even exist to that extent. She is only a dot. The giant jaw gives expression to the monstrous events she was inescapably trapped in as a child. Her mother suffered from a mental illness that made her particularly violent toward Naomi; her father and both brothers sexually abused her from two years of age onward. They lived isolated in the outback on a farm. There was no way out.

FIGURE 15.56. This is a rectangle with a positive connotation. Called "My space," it is a rather typical drawing to assert one's own space and repair a boundary breach. It can be important to loudly say "No!" because at the time many did not dare to, or could not. Drawing a rectangle in this way is not only empowering but also heightens spatial awareness.

I recall clients who experienced psychic attacks, felt invaded by multiple personalities, or had auditory flashbacks, who benefitted significantly from this shape. Drawing the rectangle is an ego-strengthening exercise. The four corners give order and structure. They are orientation points. They set a boundary.

With a negative connotation, the rectangle can be experienced as fencing in, being trapped and imprisoned, and it is then associated with being "put into a box," into a coffin. Rarely, clients project the jagged movement of military marching, "one, two, three, four," onto the rhythmic motor impulse.

Another particular version of the rectangle is the **angular spiral** (fig. 15.57). This shape is valuable as an exercise in crisis situations. It creates order and strengthens consciousness. It provides a path in situations where there is seemingly no way out.

FIGURE 15.57. The angular spiral.

In this case, clients draw with their eyes open. The four corners provide orientation and decision points. Drawing a path toward a center or a progression out of a central point may gradually instill a sense of direction or purpose. The angular path strengthens the ego. Many decisions have to be made (stop, decision, new direction, stop, decision ...). At the same time the locked-in feeling easily provoked by the rectangle is avoided because of the spiraling movement.

Rachel was desperate. She had an alcohol problem, was suicidal, and though outwardly very successful, her private life was without orientation and support. When the full horror of sexual abuse from early childhood onward unfolded in her therapy, she spent hours every day drawing angular

spirals with meticulous accuracy. The ritual kept her going and prevented her mind from spiraling out of control. The angular spiral became her path in the darkness. She applied all her concentration and skills to those drawings, and later claimed that they had saved her life.

## The Dot

**Physiology:** The dot is the seed that contains future life. It is the first impulse of creation. It is the starting point, the nucleus, the atom that encloses the code for growth. The single dot is **the dot** (fig. 15.58), the one, the only one; it is implying that the individual is unique in the entire universe. Many dots may form vibrant rhythmic patterns that resemble cell structures under the microscope.

There is often a state of expectancy and anticipation associated with the dot. Something has been brought to the point, gets pointed out, is poignant—and something will come of it.

**Archetype:** The dot is the beginning and the end. It is the seed that will bring forth life, and it is also the speck of dust in which all matter ends. It can be the center, perhaps of a mandala-like shape, the focus of attention. When **many dots** (fig. 15.59) or clusters of points appear, they represent the collective, and the collective's potential. They are the undifferentiated mass of lentils Cinderella has to sort out. They appear as grains or impulses, raindrops or stars, also tears or a dotted expression of joy. They go along with an animated, lively, or inspired state of mind, often indicating that something wants to happen, come about, be. Australian indigenous dot paintings

FIGURE 15.58. The dot.                    FIGURE 15.59. Many dots.

have a particular way of capturing the energetic expression of landscapes and events.

**Intervention:** A dot is not a circular movement but a stabbing one. A circular movement would be a round shape with a female connotation, whereas the dot here is a focused act of bringing something to the point. For intervention purposes, the rhythmic dotting on the paper can be suggested to loosen up tight and tense sensations in the body. Clients can thus loosen up the flow of emotions and feelings that were blocked before. Some like to make a lot of noise drumming with crayons on the table. Others tap lightly with their fingertips painting hundreds of vibrating dots, creating an atomized state of being of sometimes outstanding transparency and animation.

The most significant session I have experienced involving the dot was with a young man in his late teens. Jason was highly gifted and diagnosed with a dissociative disorder. It was the first time we met. He was shocked when he saw the large white sheet of paper. For him it was immaculate, and

FIGURE 15.60. A beautiful example of many dots is Maria's drawing. Maria was a Roman Catholic nun who had chosen that life in order to be safe from men after a sexually abusive childhood. This drawing emerged after years of therapy. It is her healed pelvis pictured as a fertile vessel filled with seeds, her ovaries alive and receptive, and her core filled with the water of life.

there was no way he would dirty it with the blackness of his imprint. Staring at the sheet, he experienced the vastness of the universe. He was very lost, unable to find an identity within his body or any place on earth. Any contact with matter or himself, even touching the paper, meant to smear, to soil, to foul the perfect.

After one hour of an incredible internal battle in which we put several untouched white sheets aside because Jason had looked them "full," he committed himself, trembling with intensity, fear, and anticipation, to drawing one single dot in the middle of the paper. It literally felt as if he was landing from outer space with force. After the act, he commented: "Now, I am." It felt like a moving decision to be born and to live.

In the following session, together with his parents, they admitted that Jason was adopted but had never been told. Once he was given this important truth about his identity, virtually all his dissociative symptoms gradually disappeared and, yes, he could *be*.

FIGURE 15.61. This painting emerged at the end of a session. This client had also remained childless, and being in her fifties, had been grieving the lost opportunity. From deep within—and after several weeks of "feeling pregnant"—she birthed this "sunbird" with a profound sensation of blissful ecstasy. Her elation is expressed in the release of atomized dotting patterns in multicolored paints.

# PART III

The Unfolding Process
Accompanying Sensorimotor
Drawing Sessions

# 16

# Body-Focused Intervention Tools

While as a therapist I sit apparently calm and collected with a client, internally a multitude of observations and decisions are continuously being made. The vast majority of these are nonverbal. In this chapter I will attempt to make the process more transparent from the accompanier's perspective: how the previously discussed components of trauma theory, body focus, choice of art materials, primary shapes, archetypes, motor impulses, and sensory awareness form a continuous narrative inside the therapist that accompanies the client's process. This narrative might be communicated as a relaxed and assuring "mm-hm" sound, but inside, the therapist has a lot more going on.

If we encourage clients to drop deeply into a sensorimotor process with closed eyes, the therapist's role is that of a cognitive presence. Similar to deep-sea diving, it is only safe if someone above, on the surface of the ocean in the boat, holds the lifeline. In a similar way, the therapist holds the function of an auxiliary neocortex to allow clients to focus safely on limbic and brain stem issues. As an intervention style, this requires that the therapist is able to give plenty of nonverbal cues to keep clients comfortably in their non-thinking body-focus. For the deep-sea diver, a hand sign and a tug of the line provide nonverbal feedback and orientation. We do not want clients to come up for air at every interval; they do not need to verbally share every insight straight away. It disrupts the experience. Yet we need to communicate with

them, providing guidance and safety. This requires that the therapist is aware of a wide range of factors in order to guide individuals through their internal explorations.

Art therapy has the advantage that there are always three in the therapeutic relationship: the client, the therapist, and the artwork. Accordingly, there appears to be less transference between therapist and client in art therapy than in verbal psychotherapies, because the transforming relationship happens between clients and their artwork.[1] The therapist has the role of facilitating and encouraging transference onto the artwork and that of bringing awareness into this relationship within the creative process. In addition, the introduction of inner guidance may add an internal "spiritual" authority for those who are open for it.

There is also the complex and often inexplicable dimension of countertransference and how therapists can assist clients to regulate their nervous system through regulating their own. The therapist taking a breath and exhaling when fear is palpable, or shifting position when the client becomes rigid and cannot move, will trigger responses in the client. I constantly check my own nervous system and my somatic responses when I enter the therapeutic dyad and find regulating my own responses will communicate nervous system regulation to the client. If the therapist can't handle what the client presents and responds, for example, with a body posture of crossed legs and arms, the client will, without a word, understand not to go "there." If I try to explore what a client expresses, I often adopt the same body posture and then check my sensory responses to it. I may give feedback from this position to the client, or just wait to see how the client responds to seeing me "like this." The drawings will also suggest postures and internal somatic states that have a history and meaning. Clients may stand up and move in the way the motor impulses in their drawings have suggested; they may even explore them further by exaggerating them. In the Guided Drawing process, clients mirror neurons that not only dance with the therapist's, they primarily find their mirror in the drawings.

The following are some of the core indicators I observe in a session. These provide the basic structure for prompts to intervene. Sometimes I will share my observations with the client, but only when I feel certain that clients will not be interrupted in their internal explorations or take these as criticism during the cognitive integration phase. A lot of my focus is on congruency. The more clients "come together," the more congruent their

responses will be, whereas dissociation creates incoherent or confusing communication patterns.

- *What is the atmosphere like?* Is it loaded, tense, frightened, or peaceful, creative, relaxed? Is this quality expressed in the drawing, or does the artwork contradict the atmosphere?

- *What is the client's attitude?* Is it careless, avoidant, superficial, or aware and present? Does the client want to be here voluntarily, or has an external authority decided to have this session?

- *How self-directed does this individual present?* Or is this a client who expects "help"? And if so, is the therapist roped into being the "rescuer," or is there a genuine need?

- *How is the client's body posture?* Upright or slumped over? Rigid or collapsed, nervous and fiddly, painfully tense, or relaxed and open?

- *How regulated is the client's nervous system?* Is someone talking very fast, drawing very fast, and accelerating both, in which case the therapist might suggest ways to down-regulate? Or is someone so frozen in fear that he or she can hardly move, not make eye contact, and the crayons mark thin shaky lines on the paper? Such a client is not safe. So how can resources be made available to counterbalance the fear? Ogden interestingly suggests walking the edge of hypoarousal or hyperarousal, as otherwise the therapy is too safe. It needs to be safe, but not too safe.[2] If we tone down clients' arousal states too early, for example, they feel we do not accept their stressful experiences.

- *How does the client present physiologically?* The therapist can observe the breathing patterns and notice when clients inhale and in which context they noticeably sigh and down-regulate through exhaling. What does a client's skin tone communicate? Relaxed clients look rosy and warm; highly activated states make individuals flushed in the face, whereas fear drains all blood from the cheeks and clients look dreadfully pale.

- *Which building blocks of the triune brain are online and which ones are off?* What is the balance and congruency between cognition, affect, perception, sensations, and behavior? Some clients only want to talk with their arms folded, and all other systems are shut down. Others are overly emotional and "can't think straight." Then there are those

who seem to be locked in rigid behavioral patterns that block out everything else. What approaches and art materials would benefit an individual most to enhance connection and congruency?

- *Does a client have access to implicit memories, or is focusing on the body frightening?* In the latter case, what fear-reducing resources would assist this individual?

- *Is the size of a drawn shape in accordance with the internal sensation?* Is the experience of someone's pelvic floor really as gigantic or tiny as it is drawn? Which experiences have led to a distorted self-perception?

- *Is there congruency between the verbal sharing and the drawn action?* For example, when the quality of lines is dynamic and energetic, the client conversely refers to herself as tired and exhausted? Or the client is sharing an obviously painful event while smiling.

- *Does the rhythm of drawn movements express the related, momentary, inner motion?* There are three options: too fast, too slow, or the "right" rhythm. Clients who move too fast tend to overrun their sensory responses; they avoid "feelings." As the therapist, this tends to make me feel confused. Clients who move too slow try to control what they are doing, which becomes incredibly tiring, because they are not present either. The appropriate rhythm might be slow or exuberant or aggressive. In all cases, though, the "right" appropriate rhythm communicates as presence and alertness.

- *What does the layout of the shapes express?* Is the mirrored projection of the body centered and grounded, or squashed into a corner, or ungrounded and floating in the air? Which body parts are emphasized, and which ones are left out? Also, most clients will work on a theme during a session. For example, there might be three drawings in the sequence with an emphasis on something in the center. This central shape appears at the beginning, then in the third drawing, and then in the sixth drawing, while changing in color and quality over this time. Clients may name these centers as various sensations in their body. In one drawing it is the heart, in the next one the solar plexus, and then it is something they felt in their head. All, however, are drawn in the center of the sheet, which indicates that they all illustrate one theme, even though the related sensations may move around in the body.

- *What does the line quality indicate?* Is there a buildup of tension, cut-off fragmentation, density caused by strong identifications, by holding on or by holding back, or a flow of energy with a wide range of expression?

- *Is the choice of materials in this context adequate?* Could a client benefit from paint, or would it be better to use thick solid crayons to be able to really exert pressure?

- *Is there a significant difference in shape and line quality between the two hands?* Do both sides relate in a balanced way, or does one side appear incompatible or even absent? What internal dialogue does this indicate? Such a dialogue can be drawn by giving each hand the chance to "express its opinion" separately while the other one "listens."

- *What does the direction of a drawn shape suggest?* What is reflected in the way motor impulses are directed? Is it constructive and focused, or does it repeat restrictive, destructive procedural patterns from the past? Is aggression directed against the client? Is he moving to and fro indecisively, instantly taking every impulse back?

- *Is someone avoiding all male or all female shapes?* Is this justified by a theme, or could it be important to introduce the opposite category?

- *Are the expression of motor impulses and sensory awareness in balance?* Are clients just acting out without any awareness of how these patterns resonate inside them, or are they in such sensory overload that they can barely move?

These are some of the core observations I focus on as a therapist. Clients tell a story when they draw. It is the story of their implicit body memories, which is initially unclear to them as well. Because Guided Drawing does not emphasize explicit memories, clients often do not know what will emerge as they follow their body sensations on the paper. Assurance and understanding come from tracking how the drawn motor impulses resonate in their felt sense, not from interpretations about their symbolic meaning. Clients are "feeling what happened," not talking about it.[3] This requires directed mindfulness.

Traumatic and early attachment experiences are primarily remembered and reexperienced implicitly in the form of body sensations; addressing these sensations directly through drawing them can foster the integration

of past experiences. Mindfulness helps clients consciously attune to intero-
ceptive cues that are usually processed unconsciously; they become aware
of muscle tension, their heart rate, or taking a big breath. After some initial
interventions designed to teach clients some "massage techniques," such as
releasing or containing, they learn, usually quickly, to regulate arousal states
on their own, and can discharge pent-up emotions and inner tension through
releasing lines. They can take action to contain and soothe activation states.
They can repair and assert their personal boundary. The archetypal shapes
have given them tools to act. They have also learned to direct their energy
with awareness. They know now that scrubbing up and down will get them
nowhere, and that they need to make decisions with regard to directing their
energy on the paper in order to move to a new place inside.

Pierre Janet, a French psychiatrist, developed a trauma treatment model
in 1898 that is still valid today. He maps out the three core phases of therapy
as stabilization, trauma exploration, and integration:

**Stabilization** describes the initial stage, when clients come into therapy
and are scared, shut down, freaked out, distressed, or otherwise. They need
active support from the therapist and are often too unstable to address any-
thing that happened to them in depth, as it would destabilize them even fur-
ther. This is the stage where more traditional approaches come into play in
order to build *resources with art therapy* approaches, such as the sculpture
of a helper figure to feel supported, or of a safe place in order to have some-
where to go to, the creation of a strength book for self-esteem, or mandalas
for internal structure.

Guided Drawing can be used to build *somatic resources* through particular
shapes, such as the bowl for containment and soothing, or the vertical for
feeling more upright. Learning how to safely release tension, or massage an
uptight knot in the stomach, makes clients feel better about themselves. It
reduces feelings of helplessness and teaches them that they are capable of
turning things around. Julie's case history in the "Directive Guidance" sec-
tion in chapter 3 is an example. When working with her in the distressed
state she was in, I gave her just one shape, "sorting the seeds," to increase her
self-esteem with the vertical and to encourage her to release emotions in a
stabilizing way through drawing a corner and discharging her inner tension
sideways. Somatic resources need to be tailored to an individual's unique
needs and goals.

Ogden mentions how reframing "learned helplessness" can be a stabilizing *cognitive resource.*[4] Self-destructive or eating-disordered habits can be viewed as "survival resources," adaptive behaviors to adverse childhood experiences. Being invisible might have been the safest way to survive a punitive home environment. Putting on weight might have been the only way not to attract unwanted sexual attention. Rather than continuing the self-punishment, these behaviors can be reframed as creative skills; this tends to make clients feel better about themselves as they realize they did the best they could under the given circumstances. Some clients will never be stable enough to move on to trauma exploration. As Rothschild once said in a seminar: "Some clients may never heal, but we can always better their quality of life."

During the stabilization phase, top-down approaches tend to be dominant, and interventions are likely to be more directive, until inner strength and awareness have been gained.

**Trauma exploration** is the phase of exactly when trauma exploration happens. In the previous chapters, I drew on a number of trauma informed concepts. It is important that clients know their resources so they can, if need be, apply the brakes. It is important that they can access a healing vortex under duress and in this way encode new, positive information alongside the old traumatic events, for example through drawing what is needed step-by-step as the memories unfold. The therapist either suggests top-down strategies or a bottom-up approach to regulate inner events. Sensorimotor bottom-up processing will dominate, however.

Sensorimotor Art Therapy has the advantage that it can now distinctly shift to nonverbal implicit memories. As we identify and draw somatic symptoms in the here and now, as we become aware how learned patterns of behavior impact on current relationships, we become aware of the procedural learning patterns, how we acquired certain postures and behaviors. Procedural learning is recorded in habitual patterns. We repeat what we learned. This is how Mark learned to hunch his shoulders to just be less there and noticeable, as a way to avoid provoking his father. This is how Janine learned to just slightly twist her body away from direct contact in order to protect herself from being slapped. Yet, the resulting tension held in the arms or in the legs is also a precursor to action. The arms can fight and the legs can flee. "All mammals, including humans, are equipped with a cascade of defensive reactions in a hierarchical system designed to protect them against threat, from mild to severe."[5] As we draw the inner tension, we can begin to

replace a once thwarted defense with a mobilizing defense: we can restore empowering action. Cath draws a tight black twisted ball in her solar plexus, only to use red finger paints on the following sheet to expand and rise to her full size with a large red figure with outstretched arms. She writes: "I am allowed to be angry." Others need to learn to modify dysregulated mobilizing defenses such as freaking out or rage, or need to focus on healthier options than drugs and alcohol to self-medicate arousal states. Ogden differentiates between trauma-related hyperarousal, which needs regulating to become more tolerable, from attachment trauma, which needs to experience the emotions in order to come out of shutdown so clients can heal.[6]

If clients mindfully follow the sensations of hyperarousal in the body until they settle, they can recalibrate their nervous system. Pendulation is an inbuilt phenomenon of the nervous system and helps them to do so.

In all situations that we have survived, we did so because there were external resources or personal strengths that got us through. Many times, though, we were not aware of them. By drawing attention to these strengthening resources, we can reorganize how we remember. We may now discover that we reacted with amazing precision within a split second to avoid a worse outcome. In this way, we can continue the process of reframing what happened until we feel less helpless, less overwhelmed, and instead more capable and empowered.

Explicit memory is actually never an exact recall of what happened, but a process based in part on revisions we make as we remember events. Traumatic memories tend to be fragmented, which distorts what and how we remember. If we were too young to explicitly remember, or drugged or unconscious, there is no story to tell anyhow.

**Integration** is the final phase of the therapy process. Emotions and beliefs based on past experiences are not necessarily the so-called truth, and they can make us blind to our present environment. Procedural patterns learned in the past can get in the way with current relationships. Ogden calls this phase "upgrading our beliefs."[7] We now need to revisit core beliefs based on new inner experiences. When Madeleine sat inside the rectangle she had drawn and felt her own space, she realized she had a right to her own space, even as an adopted child. Based on this experience, she could go home and buy her own house the following month without "feeling selfish." Body postures go along with core beliefs. Global statements express such beliefs: "No one will ever help me." "I will never stop crying once I start." "All white people

are racist." "All men are just after the one thing." They can only be undone if we can undo the body posture we acquired when we learned such beliefs. As long as Dennis is slumped over, his eyes downcast, and he is hardly breathing, no praise will reach him, and he cannot absorb it. While Dennis could explore the procedural memories encoded in his slumped-over body during the exploration stage, he now needs to upgrade his belief systems in order to make them fit his new and unfamiliar upright posture and ability to make eye contact. It is a bit like getting new clothes, only here they are mental ones.

This is also the phase for forgiveness through deeper understanding, maybe through the realization that our parents were themselves victims of transgenerational abuse. Compassion with oneself is essential, maybe as the insight that "I did the best I could under the given circumstances."

Integration can also mean that the deep inner changes now make life-changing decisions inevitable: to divorce a partner, to leave an unfulfilling job. Changes bring hope and new options, but they also may bring grief and loss as we leave old skins behind. The intelligence of our bodies is not static. As we keep the dance of discovery alive, meaning gradually becomes transparent.

While Pierre Janet describes this three-stage process in the context of long-term therapy, I find it applies just as much for each session. In each individual session there will be an initial stabilization phase, where I inquire how clients are feeling and what their immediate needs are. Depending on this, we might check in on available resources, a crystal placed on the table, a benevolent guardian figure (sculpted from clay and collage materials in a previous session and kept safe by the therapist), or through guided imagery, including a reference to the Higher Consciousness or a meditative body-focusing exercise.

Then clients begin to draw their implicit body sensations and procedural motor impulses, exploring their trauma story. They will connect with their implicit body memories through rhythmic repetition in order to get into "flow." As the therapist I will support a deepening of the sensorimotor explorations through sounds and small verbal cues that do not distract from the rhythmic flow. The client will titrate the experience with applied "massages" and in this way encode new positive information alongside the old traumatic events. I will support this new learning through "how" questions to enhance sensory awareness.

Toward the end of the session, the new felt sense needs cognitive integration. The body feels different, the posture is different, emotions and senses

have changed—and how can this be verbalized? Clients might write affirmations that have emerged out of this new felt sense onto their drawings, or say them to other group members, in order to integrate them and anchor them in the neocortex.

In the following chapter I will illustrate the application of this Sensorimotor Art Therapy process with a case history using Guided Drawing. My hope is that it illustrates the wisdom that is active in our deepest nature, where we do not think but can surrender to being healed.

# 17

# How to Become a Lion

Cath is in her early thirties. She is married with two young children. She has a history of childhood sexual abuse, the perpetrator being a close family member, which has been the cause for years of depression and an anxiety disorder. The abuse started when Cath was a preschooler, and recall is blurred for her, with only fragmented conscious memories. Once she was old enough to tell, she confessed the events to her mother. The consequences, however, were even more confusing for Cath, because the perpetrator, her maternal grandfather, denied any involvement; she was considered a liar. She got no support, and instead her difficulties increased. Only as an adult Cath found out that a number of her cousins had suffered the same fate. This knowledge, along with much psychotherapy, eventually helped her to believe herself.

Cath has seen "many" psychiatrists and psychologists, but from a healing perspective found Reiki and kinesiology more helpful, for which she has been seeing a therapist for the last two and a half years.

After the birth of each of her children, she was diagnosed with postnatal depression. This became so severe after the birth of her second child that it required hospitalization for six weeks, and later for another eight weeks, during which she received electroconvulsive therapy (ECT) treatment.

Initially Cath had two group sessions, which focused on building resources and in which she worked with collage, plasticine, and toy animals. These sessions revealed that she easily escapes into her spirituality, and then tends to be ungrounded and in la-la land. But they also revealed that with sufficient support, she is able to access her strength.

In the first group session, for example, Cath creates a plasticine model of her family of origin, which contains a black box "full of dark secrets" she just knows are there without being able to name them. She also creates a small plasticine sculpture out of multiple colors, which she then smashes with her fist and covers it with black.

In thc second part of this group session she creates a themed self-box, which she calls a "Healing Center for My Inner Child." There were other choices for a theme that Cath could have made; yet she decides clearly to create a countervortex to offset her dark childhood experiences. She decorates an old shoebox lovingly with collage materials of various textures. She chooses pink felting wool to create a nest-like bed inside and fierce defenses with spikes fashioned from broken CDs on the outside.

In the second group session, during this stabilization phase, Cath was asked to choose three small toy animals from a large assortment of play-size animal figurines. The task was then to create a landscape with a home for each animal with collage materials on a large sheet of paper—and to develop a story around how the animals can meet and have an adventure together. She chooses a unicorn and a magic dragon, two animals that are strong but have no base in reality. Her only earthbound animal is a cockroach, which she tries to "heal" in the ensuing story she creates. Sharing it, she cries inconsolably. When the therapist asks what solution the unicorn and the dragon suggest, their answer is killing and burying the cockroach. After she has enacted the cockroach's death and burial, she chooses a lion to replace it. At the end of the session, she can make eye contact with other group members and stand proud and "be a lion."

The animal story reveals much about how badly she struggles with her sexual abuse history, how she easily dissociates the strongest part of herself and flees into fantasy to cope (the unicorn and the dragon), while the earthbound part of her feels dirty, disgusting, and reviled (the cockroach). Yet the story also reveals that she is capable of accessing strong resources (the lion) and that she has an intense desire to heal the past. In the context of the triune brain, her neocortex (cognition and meaning) and limbic system (affect and emotions) are online, but her brain stem is shut down in a complex trauma response.

She loves art, and the body focus in the Guided Drawing process resonated strongly with her in the first group session a few months ago. The following drawings demonstrate two sessions of the trauma exploration phase.

The first one was a group session with fifteen participants; the second was an individual session. These were Cath's second and third experience with Guided Drawing. The prior session had been a group session, which was in parts designed to teach participants core shapes they could use as "massage techniques," such as the bowl shape for settling and connecting with the pelvis, and the sorting-the-seeds shape to release tension in a safe way.

As Cath sent me her drawings for this book, she added her own commentary to each one. Her words are set in italics. The titles, in quotation marks, are the words she wrote on her drawings at the time.

All sessions begin with a guided imagery exercise, such as to set up a circle of light at arm's length around each participant. They then visualize a beam of light up the spine to access the Higher Consciousness and download from there guidance, light, love, wisdom, or protection, according to their needs. Cath finds this exercise helpful. It makes her feel safe.

During the group session, all participants draw or paint in silence for fifty minutes. Then the drawings are shared in small groups with a therapist present. The drawings are laid out in sequence, and one by one each client shares her experiences revisiting the steps taken during the drawing process. The therapist will offer insights and questions to further understanding of the implicit memories that have been depicted.

During the following group session, I sat not far away and would have been able to intervene, if necessary. Cath did not need any external support though. She was able to regulate her arousal states independently.

## Group Session

Figure 17.1: the black tight movements are an expression of metabolic shutdown, of the freeze response, of not being able to move, feeling stuck yet highly activated. And without an external intervention, she knows what to do. She pendulates to her healing vortex. She responds to the tight black movements with the opposite color, which is white, and the opposite movement, which is a rocking movement. I can only assume that this rocking would have been something she would have craved for as a little girl. Unfortunately, the white bowl shape is hard to see. It is large and almost touches the ground. It is a perfect resource for her. It is the infant rocking bowl, sealing her pelvic floor rather than the opening-closing motor impulse for the bowl shape. Once she feels safe enough, she allows an upward, releasing

motor impulse, which opens up the defensive emotions, the anger and hate that she shut down at the time. Caretaker abuse creates complex conflicts in children—they are dependent on the adult family members surrounding them, and they existentially need to love the individual who also hurts them.

In one single drawing, Cath has moved out of tonic immobility and dissociation (the black tight movements) through accessing a healing vortex (the white bowl), and she has come in contact with her rage about what happened (sympathetic arousal) as an active response. The black tight scribbles may represent the physiological equivalent of the image of the cockroach she had in a previous session.

Cath explains her color-coding system to me: "black for me is dark; red is harming, trauma, injury; yellow is healing, and so is white; and pink is gentle girly."

Figure 17.2: she again starts with black crayons, and pushing very hard, she can now "become a little bigger." There is now less shutdown and a bit more movement. What has been tightly held inside the immobility response now opens up like a can of worms. It brings out Cath's rage around the harm and injury that has happened to her. She chooses red finger paints and allows her emotions to

FIGURE 17.1. "Hate." *Began with very small tight movements, wanted to fill more of the page but couldn't. Brought in the white rocking motion and then the up. Felt anger, hate—mean feelings.*

erupt. She can, however, apply the sorting-the-seeds movement and release her sympathetic activation in a way that does not overwhelm her. She has acquired skills to express herself, and skills to heal herself as she applies the white paint in massaging movements. These latter impulses also demand release.

I hope you, as the reader, can appreciate how Cath, in a self-directed way, pendulates between the trauma vortex and the healing vortex as she deals with the implicit memories of her abuse. The harm done to her is clearly visible in this second painting, and so are the huge emotions associated with the events of which she has only some conscious memories, because the abuse started while she was very young. Metabolic shutdown, otherwise called dissociation, is an ancient defense response of the brain stem, which is reptilian in nature. In shutdown, we conserve energy in order to survive, when no other form of defense is possible. It is instigated by the autonomic nervous system and is an involuntary response. Whenever clients come out of such a dissociated state, whatever caused them to shut down will now open up again. It is like we have to move back through the trauma in order to heal. This is only possible if we can bring sufficient resources along. Otherwise the

FIGURE 17.2. "It's OK." *The black could become a little bigger; still pushed very hard. Red came in trying to go up and out. Then white up movements, and round massage movement on the right side first then outward.*

confrontation with the events of the past becomes retraumatizing and will lead to even more desperation, disempowerment, and hopelessness.

Cath's description of figure 17.3 indicates that her aggression is the response most needed, but also the most feared. It is encouraging to notice that she has access to a "healing movement"; she knows it is there for her, should she need it. Resourced in this way, she can have the courage to express some more of her anger, a response that was most likely impossible in the past. The urge to fight back would be the emergence of her thwarted active response to the abuse. Her statement, "Broke paper, would have ripped it all up," indicates that this anger is huge. The temperate title for the drawing is "I have allowed myself to be angry," which indicates that anger was not allowed when she was an underage child in conflict with an authority figure in her family. Her implicit recall in these drawings speaks clearly enough. So instead of activating another healing vortex, she "pushes through" toward release of her anger, as if the adult in her can encourage her child-self to be more daring. She draws this release with arched movements, and she has no trouble letting go at the end.

FIGURE 17.3. "I have allowed myself to be angry." *Again small hard movements, right hand pushed harder. Broke paper, would have ripped it all up. Black—nearly moved to healing movement then thought I should allow more aggression out. Then pushed through to the release.*

Figure 17.4: since she bypassed drawing a healing vortex in the last step, it needs attention now to down-regulate her sympathetic activation level. The gentle red spiral can no longer be seen because she then went over it in a second impulse to release more anger. Her anger is now directed and focused and looks powerful. It is straight out rather than curved and undirected as in the last drawing. Accordingly, the upright movement does not look under pressure, but appears as one powerful red bundle of energy. She is standing up for herself.

It is interesting that she uses the white bowl this time not as a rocking movement, but mirrored. She draws the white straight down with both hands together, then makes a decision (paints a corner) and anchors her pelvis deep down inside her. To the extent that she is able to express a successful defensive motor impulse with the red paint, she is equally capable now to reclaim her inner base with authority. The rocking motion in her first drawing was like rocking and soothing a child. Here she takes charge as an adult in a position of strength and claiming what is hers. And yes, the boundary breach is still there, as a blue intrusive phallic shape.

FIGURE 17.4. *Started with spiral as gentle round movements with the right hand only. The center is red. Then white bowl and more up. Before I could finish, blue on right side. Like I needed the reminder that there is injury in my gentle/protectedness.*

FIGURE 17.5. "One step (to recovery) one step one step." *Want to fill page with crazy black. Different swirl motion. Round. Then brought in red upward trying to break free. Slow deliberate movement repeating. One step, one step, one step to recovery, one step each time to move up. Feeling of slow is OK.*

In her words: "Black is dark. Red is harming, injury." These are the two dominant colors in figure 17.5. I call the combination of red and black the trauma colors. My assumption is that she follows on from how she ended the last painting. The boundary breach of the blue invasive phallic shape now takes precedence. Interesting though is that she does not panic. It is "crazy black" swirling as she asserts her space. What was a tiny compact black swirl in the first drawing, and slightly larger in the third, has now taken full-blown focus. When we are able to tolerate focusing on what happened in a nonjudgmental way, if we mindfully follow the sensations of hyperarousal in the body until they settle, they can recalibrate our nervous system. Her response is strong. "Step-by-step recovery," she calls it. Moving slowly indicates that she feels in charge, her movements are "deliberate," and she is no longer panicky but able to actively respond to what happened.

None of these are cognitively conscious steps. She genuinely follows her inner guidance. The red vertical is a defense response from her autonomic

FIGURE 17.6. *Healing beginning. Pastel (round and up movement) × 2 then very gentle center out-ward movements fingertips. Again before finishing had to mark "/" with fingernails. Felt like it was saying "I'm still here."*

nervous system. And it is these involuntary responses that settle the amygdala and call the trauma activation off.

Figure 17.6: the black round has been cleared. "Healing" can begin. Her radiating strokes look like a cleansing movement. This is not pushing out, but "very gentle" sweeping out with the fingertips. The injury from the abuse is still there, but its power is faint now and looks more like a scar than an open wound.

Figure 17.7: if I had been in a one-to-one session with her, I would have acknowledged at this point how hard she had worked and that she had a right to feel exhausted. This is parasympathetic settling after not only a session of drawing, but after Cath's nervous system has been in high activation mode for almost three decades. When deep healing occurs, it often is so unfamiliar for clients that they have trouble accepting it. This is when the integration phase becomes important, where we have to recalibrate our belief systems. In Cath's case, she can only see "uncoordinated, deflated" movements and feel tired. If we, however, take into account that she has lived most of her life with post–traumatic stress, involving constant fear and constrained rage, all

of these kept as a tightly held secret hidden under depression, it is no wonder that she feels deflated once it is all over. It is time to rest. It is a pity that I was not there for her in this moment due to the group situation. The drawing, by the way, does not look uncoordinated.

Figure 17.8: the most important aspect when looking at this painting is that she painted the vertical downward. This is the reverse of all the motor impulses she has used before, which were defensive, aggressive, and extroverted. In figure 17.8 she paints in "girly healing pink" a gathering movement, which brings the lines in toward herself. Starting at the top of the page and at the upper sides, she draws healing in and down. This is introverted, gentle settling; it is equivalent to what shamans call soul retrieval, to call the spirit back.

You may recall the cockroach in her animal story, which has a certain similarity with the black pressured swirl of her first and third drawing. The cockroach was her only way of being in the world. Driven out of her body by the abuse, her spirit had taken flight. Now she invites herself back in.

FIGURE 17.7. "Feel deflated." *Very uncoordinated right started very small hard movements. Left white strokes all the way up. Straight. I didn't like the idea of being so unco so brought in [infinity], then there was some more unco movements and some others. I felt so deflated. I ired and like my "will" has left me.*

The black penis shape is like a shadow, still there, "blocking acceptance." This is now a cognitive integration issue; how to accept what happened, which will ultimately pose the questions of how to forgive.

Cath was not in my group for the "show and tell" part after this drawing session, when each participant lays out her drawings in sequence and then shares her experiences. Others may comment and share insights and observations. This session is much about trying to decipher the sensorimotor body language and the story the implicit memory has told. Because while I, for example, write this cognitive reflection about Cath's process, this is not what is reflected during the session, where the neocortex is kept at bay in the background in order to allow the autonomic nervous system to take charge.

Since I did not facilitate the group-sharing session, I can only report her own words, summing up the session as follows: "Upon reflection: Don't tend to allow myself to stay in the crap. Feeling of not allowed to be angry." This

FIGURE 17.8. "Gently bring the energy back—block." *Pink and white gentle girly colors (felt like giving myself permission to use girly ones). Movements down toward me words of: accept the gentle healing. Very slow fingertip gentle movements toward myself. Then a dark block feeling. Didn't want to put in on the page but it had to go on. Hand full palm back and forth movements blocking acceptance energy. Then returned to the accepting energy hoping to bypass block. Finished with a couple strong straight outward movements. Freeing.*

statement tells me that her anger is still there and that, as in the past, she struggles with allowing it to emerge. She also acknowledges her strength of not staying in the crap, which is an important resource.

## Show and Tell

For learning purposes, I will add a few suggestions of what to focus on in a show-and-tell session, once the drawings have been laid out in sequence. The process can be facilitated as simply as looking at "Where did you start, and where did you arrive?" Or the question of "Which one of these drawings feels like the most important to you?" This will allow clients to find an entry point to their story, because beginners often have no idea what they actually put on paper. This motor impulse–driven language, which has no images, symbols, and story, initially makes no sense. Gradually, though, they can begin to track their answers in the body and be able to cognitively integrate their discoveries and achievements.

In Cath's case, my immediate attention would go to her application of color. I would question her, for example, about the development of the tight black squiggle over the series of drawings. The black is in her first, third, fifth, and eighth drawing. Black moves from small and tight (fig. 17.1), to slightly larger (fig. 17.3) to its full-blown size (fig. 17.5)—to become a shadow of the past in the last painting (fig. 17.8). The tight black swirl in the first drawing could be taken as a question or intention her unconscious presents her with—and then we follow the steps of resolution during the course of the session, trying to understand them—until a response to the initial question has been found.

Such an initial question in a drawing is not necessarily conscious, but predominantly a motor impulse based on physiological pain or discomfort. It hurts "there" or is tight in my belly. I do not know why, and it does not go away, but my attention is drawn to it. This is how we start the process, focusing on a physical phenomenon that wants to be noticed, and translating it into a visible motor impulse on the paper. The final answer to this niggling tension or pain tends to be predominantly sensory; we perceive it as a renewed felt sense. Along the way we have experimented with rhythmic drawing of shapes and tracked their effect on us with our senses. What feels "good" is sensory, what feels "right" is sensory. Motor impulses have been adjusted accordingly.

When I look with clients at their drawings, I try to follow these steps as they have created them, the decisions they have made because they needed

to move in a particular way and then changed the direction of their motor impulses until it "felt better." Only now, in the aftermath, we may ask: What story have you told here? How have you learned to move in a particular way or hold back? Cath, how did you learn to reduce yourself to a tiny tight ball of tension inside? And how is it now that you have space inside? How is it that you gave yourself permission to be angry? And how does it feel to experience gentle pink energy flowing back into your body?

Cath's only option at the beginning was to hold everything in, curled up tightly inside her, similar to the colorful plasticine ball she smashed and covered with black in her first session. Gradually she could establish sufficient resources and support to dare to let her anger out. Only then could she safely call her spirit back. Acceptance is not yet possible, but freeing and healing it certainly is.

The purpose of interventions during the show-and-tell session is to increase perception of internal orientation. In group settings, this increases the awareness of all participants. In individual sessions, such inner perception can be introduced through interventions during the process. In which way have movements been directed in order to create particular shapes? In which way can we understand this motor impulse–driven orientation? In Cath's case, it is significant how she deals with her inner vertical, the flow of libido in her spine. Initially it is totally blocked (fig. 17.1), then erupts in anger (figs. 17.2–17.5). In the process, however, her libido becomes increasingly directed, focused, and empowered (figs. 17.4 and 17.5). In the last drawing, her energy flows top-down into her as nonthreatening "gentle healing" (fig. 17.8). Once we then begin to "feel" these movements, once we begin to be aware of their sensory resonance in the body, affect rises, and we respond emotionally.

Many participants will only allow the surfacing of such emotions in the dyadic processing of their drawings or in groups in the ensuing show-and-tell session. On their own, they are not sufficiently aware of their perceptual-affective structures as Lusebrink defines them in the Expressive Therapies Continuum, or do not feel safe enough.[1] Cath has gained sufficient insight into these perceptual structures in the previous Guided Drawing session to be able to trust her emotions. In her case, what surfaces is anger; for others, it might be grief. In the following session, for example, Cath responds with joy.

While Cath calls red "harming, trauma, injury," her application of the red color is actually in the context of mobilizing her defenses. The red makes

the injury and the trauma visible, but it also enables her to deal with it. Her knowledge of the sorting-the-seeds shape makes a profound difference. It gives her a solid structure to channel her anger up her spine, break it, and release it to the sides. In this manner, it never becomes overwhelming. Red is her anger, her rage. The sorting-the-seeds shape empowers her to find an active response to what has happened; a response she was obviously incapable of expressing at the time. The red is huge in (fig. 17.2) and then gets increasingly more directed and focused (figs. 17.4 and 17.5). Figure 17.3 shows a defensive response, just not as directed, and not red.

White is her healing color. She brings it in as a healing vortex right from the start as the rocking bowl shape in the first drawing. It recurs as a decisive grounding motion in figure 17.4 and as spirit retrieval in combination with pink in the last painting (fig. 17.8).

Her sixth and seventh drawing (figs. 17.6 and 17.7) with the green and yellow are a completely different color choice. They appear to me as a taste of the new paradigms to come. This could be posed as a question: "I wonder what your life in green and yellow would feel like? All you seem to have known so far is red and black—and white for survival."

My other focus would go to the choice of shapes and the directions she has chosen to channel her energy. There is clearly a theme in her process regarding the vertical, which mobilizes her defensive response in sympathetic arousal until—and this is really important—she can draw it in a downward motion tentatively in figure 17.4 and affirmatively in figure 17.8. This could result in questions to ask Cath: how her spine feels now, and if she could track changes regarding her uprightness and settling during the session.

Closely linked to her experience of the vertical is her use of the bowl shape. It appears as white and almost invisible in her first drawing (fig. 17.1), reappears in figure 17.4 having gained strength and the more mature mirrored way it has been drawn. It then boldly holds and contains the full load of the trauma as a black bowl shape in figure 17.5.

In the course of the session, she moves from trauma-related tonic immobility (fig. 17.1) via sympathetic defensive arousal states (figs. 17.2–17.5) to parasympathetic settling (figs. 17.4, 17.7, and 17.8) and healing (figs. 17.5–17.8) until her ventral vagal complex, her social engagement system, is back online, including the shadow of the past but no longer controlled by it.

To point out these elements as questions, be it with the focus on the color or the shapes used, allows clients to begin to be able to read the story their

body has told. It is the language of implicit memory. As a facilitator, the role is not to interpret these as I have done here for learning purposes. Such an analysis would likely be overwhelming for a client. But knowledge of this implicit memory language can enable a therapist to point out connections, themes, and procedural action patterns a client expressed during the course of drawing. Individuals may be encouraged now to consciously track sensations in the body according to how they have drawn certain patterns; they may experiment with postures and feel how they resonate in the felt sense. They may then link these sensations to past experiences to make them conscious. However, they have also drawn the solution—more importantly than remembering what has happened, individuals can now track in their body how they can heal.

## Individual Session

This individual session took place the following day. Cath asked for it, most likely due to questions arising from the group session the day before. Cath and I sit opposite each other, which makes it easier to sticky-tape the paper down. For some clients this is too confrontational. Cath was OK with me sitting facing her. To begin with, I ask her if there is anything she would like to focus on during this session, to which she responds that she does not know. She shares that she is feeling nervous—and OK. I guide her through the Higher Consciousness focusing exercise again, and encourage her to feel her feet on the ground, her pelvis in contact with the chair, and the uprightness of her spine. Out of this meditative silence she begins to draw.

Figure 17.9: she commences with black crayons. Tight up-and-down movements evolve into jagged peaks released to the sides. When she opens her eyes, I ask her if there was any color or shape she could think of to ease this tension. She asks for red finger paints, which I pour into a container for her, and she begins to massage the tightness up and out. During this process, her hands gradually "come down"; she moves from using her fingertips to the full hand, and then to the base of the hand. She uses the base to really push out. When I inquire how this feels, she responds that she is experiencing herself a lot stronger. When asked to put this sensation into words as an "I am ..." statement, she says: "I can do this," which I encourage her to write on the sheet.

Haptic perception, the perception through touch, links full contact of the hands to full body contact. Painting with the fingertips relates to being

in the head, whereas pushing with the base of her hands comes from the pelvis.[2] What I also perceive is that the black trauma knot is nowhere near as tightly curled up as it was at the beginning yesterday. The red defensive motor impulse is now a pushing away. When I mention this to her, she just mumbles that this was "right" and matched the situation in the past. Thus I encourage her to keep going and explore this impulse of pushing away in the next drawing as I change the paper for her.

The "noticeable energy flow" up her left leg and out through her left arm would be a response from the involuntary motor division, directly connected to the autonomic nervous system. This is a repairing and life-restoring response, and an indicator that she is coming out of shutdown. Such "discharge," as Levine calls it, is a subtle version of the shaking response observed in animals, when they come out of tonic immobility.

Figure 17.10: when she asks for white paint next, I respond by pouring it into her hands directly from the bottle. She has her eyes closed. So much can be communicated with such a simple gesture: "You are not alone. There is support for you. You are worth receiving what you want, and lots of it." This

FIGURE 17.9. "I can do this." *Tightness inside—dark. Kneading out the tightness massage. Eventually a feeling of "I can do this." I am capable. More free. Noticeable energy flow up left leg and out left arm.*

is a nurturing gesture. I like that she writes: "Holding paint in my hands … felt like an amazing gift to give myself." She actually does not project the "help" onto me, but it enhances her inner connection. She holds and then plays with the paint just in her hands, then paints circles on the paper in many easy swirls. Next, she wants black and then blue. Each time I pour more paint into her outstretched hands. With the black paint, she begins to push out with the base of her hands, until her arms are fully outstretched. She pushes beyond the edge of the paper. I support her with small confirming sounds: "Yes, great. Yes. Keep going." Once she opens her eyes I ask her: "I wonder how this pushing resonates in your body?" (A "how" question for sensory awareness.) She responds that she feels "really present" and writes it down as "so there." Tracking the sensations in her body also reveals that she has a sense of lots of space, that she can make space, that she can have space. She writes it down as: "I can take up space." At the beginning of the previous session, she had no space inside; now she can fill it comfortably.

FIGURE 17.10. "I can take up space—so there!" *Holding paint in my hands, giving myself permission to take my time, felt like amazing gifts to give myself. At one stage I felt like a child playing. Feelings of tenderness and nurturing. Felt my heart space opening, creating space inside.*

It is my Gestalt training that prompts me to insist on using "I am ..." statements. They resonate much deeper than simply writing "much space" or "take up space."

Figure 17.11: resourced in this way, she goes back to the initial question posed in her first drawings in this session and in the last one (figs. 17.1 and 17.9) the question regarding her sense of inner tightness, of feeling constricted. She begins with ocher crayons, then white, then black, and finally red paint in the center. Her movements oscillate continuously between the trauma vortex (tight, stuck) and an active response to it through sympathetic defense patterns such as releasing in an arched way, or pushing out. Knowing that she is no longer helpless, she can actually tolerate exposing the wound. It is there. It happened to her. But she is not overwhelmed and rendered powerless by it. It has moved into a window of tolerance for her.

If you recall the graph from chapter 9 concerning Levine's Somatic Experiencing Stream of Life Model (figs. 9.1–9.4), here we have reached the fourth stage, where pendulation between the trauma vortex and the healing vortex gradually pulls the trauma vortex (visualized as a figure eight) back into the window of tolerance. The most important acknowledgement here is: "I no longer need to be afraid." This allows her to actually sit with it. Which is what

FIGURE 17.11. *Opening up, identifying a scary wound. Felt this in solar plexus and heart.*

we do when she opens her eyes. We both look at it. We both acknowledge it is there. When I ask her where she feels the injury the most, she holds her solar plexus and then her heart with both hands.

Caretaker abuse is always, and often more devastatingly, the abuse of love. It becomes very confusing for a child to understand what love means and implies. And since this is an implicitly learned memory pattern, it is not easy to undo. Here Cath can simply sit with it and I encourage her to "take her time."

Figure 17.12: she now begins with a small black mark and then uses white crayon to draw a downward rocking movement to settle into the bowl shape. Then she follows this up with rising arched lines, barely visible in white, and releasing them, similar to the movement pattern in figures 17.1 and 17.3, with the only difference that she is now under distinctly less pressure. She feels her heart expand and that she can "spread her wings." When she opens her eyes, she demonstrates this opening of her heart with outstretched arms. She says she feels "like a little girl on top of a mountain in the wind." She compares it to the gesture Kate Winslet famously performs in the movie *Titanic,* standing at the helm of the ocean liner. This is the unharmed little Cath emerging.

FIGURE 17.12. *So nurturing, brought joy to my heart, ability to spread my wings, felt heart space expand. Gentle pattering of energy floating up from my base up to the top of my head. Feeling of the light kicking out the dark, healing everything it touches.*

I slightly correct her not to overstretch her arms, not to "make" the movement, but to allow it to happen. For a moment, she takes it as criticism, but then beautifully catches herself. As she spreads her arms in a relaxed way she begins to notice the "gentle pattering of energy floating up from my base up to the top of my head. Feeling of the light kicking out the dark, healing everything it touches."

This small correction actually allows her involuntary motor division to take over from the voluntary motor impulse. Such a healing impulse cannot be made or manipulated. It is literally a gift from the autonomic nervous system. It does not astonish me that many call such deep repair "spiritual." It emerges from profound relaxation states and an inner surrender. It is about allowing healing to happen. This requires trust and the ability to be sufficiently resourced so that we can be fully open and without fear, receiving whatever our nervous system needs to do in order to heal. I encourage Cath repeatedly to take plenty of time to allow this pattering energy to spread. She looks like she is meditating. She is relaxed and smiling.

Figure 17.13: she asks for yellow paint for the next drawing. I pour it into her hands. She receives it like a prayer. As in the last session, yellow had been

FIGURE 17.13. "I have strength in me! I take up my space!" *Such a strength was found. My base felt so much stronger, like I wasn't sinking, losing everything. Now strong and tall.*

the color of promise, the taste of a new life without the dirty secret to hide. She paints a large yellow bowl shape, initially rocking until the hands move up her spine into the vertical. She is fully embodied here. "I have strength in me. I take up my space." There is no longer a shadow or a wound or a scar. The gentle pattering of energy rising inside her body continues. She knows with deep certainty that she is healed. We take notice of how strong her pelvis looks now and how she has fully restored her boundary; how she has energetically sealed her pelvic floor. After she has written it onto her painting, she makes eye contact with me and says, "I have strength in me." I cannot help thinking of the cockroach that needed to be killed and buried, so it could turn into a lion in her animal story a few months ago. Here is the lion.

Cath writes about her experiences a few days after the session:

> During healing meditation the next morning, I felt a focus on my pelvis releasing some of the dark to create space, a thought of having the belief that "I am unworthy to be a mother" came to me during this process, which I then consciously cleared. This thought feels like a revelation to me, that if I have carried this unconsciously, it makes sense of some of the symptoms I have had in the past. I hope to do more work with this.
>
> Upon arriving home, with the house the state it was in, usually I would have a flood of overwhelm. Instead it just felt doable and it didn't faze me.
>
> Also began having more present and fun moments with my kids. Spontaneously had a bath with my daughter, beautiful time together. My son begun wanting to sit on my lap more and be a bit more cuddly, something he hasn't done for a while.

What I read in this statement is that she feels capable to deal with the chaos at home rather than being flooded by overwhelm. All of a sudden it feels "doable." She is also able to continue her own journey of updating her belief systems, such as that she is an "unworthy mother." Instead she experiences more presence in the relationship with her children involving fun and cuddly contact.

# 18

# Healing

Cath being identified with a cockroach, from associating herself with something disgusting and vermin-like, is not unlike what many survivors of childhood sexual abuse experience. Early childhood shapes our implicit memory, which in turn shapes our unquestioned sense of identity. If abuse makes children feel bad, they will learn that they *are* bad. When we are underage, we translate our felt sense into identity. Our preverbal selves have no capacity to critically view our caregivers and distance ourselves from them. Our mirror neurons learn in the attachment dyad how to adapt to life. If our caregivers are predominantly relaxed and attuned, we will grow up with relaxed and attuned nervous systems and a confident sense of self. If our caregivers are dysregulated, our nervous systems will learn chaos and confusion. In Cath's case the sexual predator was an adult family member. What made it worse for Cath was that when she eventually told her mother, once she was old enough, her mother did not believe her and instead told her she was lying. This is also a common scenario. The "code of silence" has the purpose of preserving the family system; to uncover the abuse would have serious consequences for everyone involved.[1] It is easier to sacrifice one little girl for the common dysfunctional good. However, such a stance seriously messes with a child's identity. Cath feeling bad is considered lying, as not real but made-up. Alice Miller writes that at times prisoners held in concentration camps were better off than some children in their families of origin; at least the prisoners could hate their torturers and name what was happening to them; children instead are expected to love their abusers.[2] What

Cath experienced in her body was considered to be a lie by her family. This literally drove Cath crazy; it made her mentally ill. How could she trust her body and her feelings when her perception was considered to be a crime? The perpetrator was not blamed; she was. Dissociation is often the only way to cope with such stressors. Sexual abuse is bad enough, but Cath's mother also taught her that what she felt was untrue, and that nothing could be done about the abuse. Thus, Cath learned to dissociate herself from her body and her feelings, and that she was helpless.

All this becomes undone in the five sessions I have described above, which were all group sessions, except the last one. Three of these were designed to build resources until Cath was ready for trauma exploration. Her first tangible resource was the self-box as a "Healing Center for her Inner Child," the second one the death and burial of the cockroach and her "resurrection" as a lion. The third group session was learning how to focus on her body, to apply massage movements with Guided Drawing, so she could ease inner tension unassisted and settle hyperarousal states herself.

In the subsequent two Guided Drawing sessions, which I discussed above, she is clearly capable of naturally pendulating between distress states and accessing safety whenever it gets to be too much. She gains strength through encoding the trauma vortex with her resources. This enables her to undo the passive endurance her mother taught her, and instead she finds and expresses her anger with increasing confidence. It seems to me that it was most important for her to be able to speak her truth, to finally tell the story of her abuse, and believe it herself—even if she does so without a conscious narrative. She tells the story of her implicit memories, how the abuse overshadowed her life. She shows the scars that the events have left on her energy body, how they undermined her confidence to be a mother. She is "allowed to be angry" now. As she comes out of dissociation, her anger takes up all the oxygen. It takes up every speck of space inside her. She is all red and on fire. It is as if only the release of her anger is capable of creating sufficient inner space to invite healing in.

This anger is very old. When clients come out of metabolic shutdown—and depression is one version of it—they will be confronted with all the stressors that once catapulted them into dissociation. They have to reenter the inner space they once left. The doorway out is also the way back in. Clients need to be resourced to be able to handle the emotions confronting them now. They need to be able to access these resources under duress. For Cath and for

many others, this is the sorting-the-seeds motor impulse; it allows explosive emotions to be reflected through drawing a corner and then being released sideways rather than uncontrollably surging up through the body. Knowing to remain upright is also important. In this way, the wave of rage does not overwhelm, but the client keeps hold of the reins.

Once we understand in our viscera that we are no longer powerless and under threat, a shift happens in the autonomic nervous system. There is a moment in the second Guided Drawing session when Cath feels viscerally safe; this is a physical sensation while she has the image of standing as a little girl on top of a mountain in the wind with her arms outstretched. There is no longer any need to be defensive and shut down. She feels relaxed and happy; she is safe. This allows healing to happen. Again, it is not something she consciously performs. There is no cognitive insight that prompts change. It is rather a profound understanding within her implicit memory system, informed by her felt sense, a so-called gut feeling of knowing that she is safe now and the abuse is something of the past. Where moments before she experienced intense anger, there are now "waves of healing" rising inside her. These are involuntary motor impulses that give her interoceptors an internal sense of cleansing and deep repair. It is as if the amygdala has pressed the reset button: From now on you will be OK.

Cath's process illustrates in clear steps how the feedback loop between internal sensations and action patterns continuously deepens. It is this sensorimotor process that reveals her truth not so much as a biographical narrative, but as a purging of the layers that overshadowed Cath's core self.

Cath has spent many hours of psychotherapy over the years trying to unravel the story of her past, in particular the pain and confusion around her mother choosing not to believe her. As an adult, she learned that she was not the only victim in her family of origin. Her mother's denial became equivalent to denying her own existence. Yet given the opportunity to listen to her body, the truth unfolds as if there had not been thirty years of oppression to keep it in check. Now she is accountable primarily to herself. The age-old sense of confusion where she felt one thing and was supposed to feel another gives way to a congruent embodied identity. This new body enables her to settle down. Similar to a house she once vacated in panic, she can now move back in. In the last two drawings, she literally gathers her spirit and pulls it down into her body, and thus integrates the once dissociated aspects. She calls her spirit back, her light and her power. This is soul retrieval. Not only

has the lion arisen, but also the magical dragon and the unicorn can now return and find a place inside her world.

Cognitive integration of this bottom-up approach will need to sort the many puzzle pieces into a comprehensive picture. A multitude of aspects emerge as motor impulses, sensory awareness, perception of the shapes and their direction, and the attached emotions. The choice of colors and art materials needs consideration. The physiological responses want to be observed. The events of the clients' past remain in the background; they are like a backdrop. The focus is not on remembering. Instead the attention is set on the here and now and the ever-changing story the body tells. Clients draw what they feel in each and every moment as motor impulses, and they respond to these being fully present. This collaboration with their own libido creates deep trust, because clients *feel* their truth. They find meaning in the healing story their implicit memory tells. Finding such meaning, and consciously acknowledging it, is deeply satisfying. It creates lasting resolutions in the autonomic nervous system.

It is hopefully obvious how self-empowering this approach can be. When I came across Guided Drawing as a nineteen-year-old fine arts student, I adopted the technique just from seeing the images of the shapes on my friend's wall. I drew hundreds of images with closed eyes on my own for five years; only then did I see a therapist for the first time. In those days, it helped me to discharge my chaotic and wildly fluctuating emotionality. I would release anger and grief in what was then called "a catharsis," until I felt settled and at peace within myself. This popular cathartic approach of the 1970s is considered unsafe these days. Rothschild and others have rightfully pointed out that traumatized individuals will easily become overwhelmed again. Because of the high activation of the survival systems in the brain stem, Broca's area in the neocortex is actually shut down and cannot process any cognitive insights. The neurosciences have made the trauma therapies much safer and enabled therapists to accompany clients in a more skilled way.

Once clients like Cath have grasped the "massage" concept, the fact that they can pendulate and thus encode the trauma vortex with a supportive healing vortex, they can proceed widely unassisted. Teaching clients what they can do in distress states is one of the most important trauma interventions. It makes them less dependent on "help" and empowers them to take action. I have known many individuals over time who draw at home on their own, sometimes intensely over several weeks on a daily basis, sometimes

whenever the need arises to "sort myself out." As long as they know how to pendulate, they can safely begin to draw on their own or in large group settings. They will learn to regulate their nervous system, and gain insights into their inner structure; they will begin to listen to their body-mind and gradually trust it more than the self-talk in their heads. *Feeling* better will make them *be* better, even if they do not cognitively understand why they do so. The repetitive motor impulses appeal to our procedural memory. Just like we learned how to walk without cognitive insight, we can realign our triune brain bottom-up through body-focused rhythmic repetition.

The drawings mirror clients' energy body; they mirror the flow of libido on the inside. It is a dyadic attunement process with oneself. I can only guess that it appeals to the mirror neuron systems in our brain. Similar to a mother mirroring every facial expression, every sound of her infant, the movement clients project onto a sheet of paper reflects without any distortion how they feel and who they are. Clients can parent themselves by regulating distress states through comforting movements or through safely discharging tension and emotions.

Van der Kolk describes a successful movement therapy project with impoverished kids where they learned ballroom dancing. This was a client group with complex trauma issues; for most of them, their problems were preverbal, and traditional talking therapies did not work. It was primarily their mirror neuron system that needed to learn dyadic attunement, because these kids had not experienced safe attachment as babies. The fact that in the ballroom dance sessions everybody did the same movements in a structured and rhythmic fashion, that the classes involved fun and a functioning community, was deeply therapeutic. The dual diagnosis clients I describe were all dealing with complex trauma issues, mental illness, and drug and alcohol addiction. Yet all of them were able to discharge distress states with Guided Drawing and then regulating toward feeling better. They could do it themselves; these overwhelmed and disempowered individuals got a taste of how they could access their inner resources to heal.

Modern modes of psychotherapy have been dominated by top-down talking therapies ever since Freud put his first client on the couch. In recent years the arts and bodywork have gained increasing attention. Whenever therapists deal with early childhood issues, with trauma, with clients' sexuality and spirituality, language becomes limited as a therapeutic tool because words cannot access the core of the conflict. The neurosciences can tell us

now why this is so, why we need to address the brain stem in these cases rather than work with the neocortex, yet there are few therapeutic approaches available that can actually reach the nonverbal procedural memory systems in individuals. Such approaches need to be body-focused, rhythmic, and simple in their application because traumatized individuals are not capable of taking in complex instructions. The idea of a self-massage introduces the concept of pendulation; some clients, however, may be so cut off from any sense of well-being that they need active support until they can access a healing vortex within.

I very much hope that Guided Drawing can contribute to the trauma-informed practice of art therapists, expressive therapists, and other mental health professionals. It is an accessible, easily applicable bottom-up tool, once therapists have grasped the underlying trauma concepts. Without a trauma-informed basis, Guided Drawing may veer into acting out or become emotionally overwhelming. Applied with skill, however, it is a formidable healing tool.

As a young art student, at a time when the term *art therapy* did not even exist, I was fortunate to come across this approach, as undeveloped and raw as it was then. I have stuck with it because it helped me heal, and I have witnessed hundreds of clients over the decades benefit lastingly from this sensorimotor approach. Hopefully over time research will give us deeper insights into why it works so well.

# NOTES

## Page viii

1   Daniel Ladinsky, *I Heard God Laughing: Poems of Hope and Joy: Renderings of Hafiz* (New York: Penguin, 1996), 38.

## Foreword

1   Daniel J. Siegel, *Mindsight*: *The New Science of Personal Transformation* (New York: W. W. Norton, 2012).

2   Florence Cane, *The Artist in Each of Us* (London: Thames and Hudson, 1951).

3   Francine Shapiro, *Eye Movement Desensitization and Reprocessing (EMDR) Therapy: Basic Principles, Protocols, and Procedures,* 3rd ed. (New York: Guilford, 2017).

4   Pat Ogden and Janina Fisher, *Sensorimotor Psychotherapy: Interventions for Trauma and Attachment* (New York: W. W. Norton, 2015).

5   Peter A. Levine, *Healing Trauma: A Pioneering Program for Restoring the Wisdom of Your Body* (Louisville, CO: Sounds True, 2008).

6   Cathy A. Malchiodi, "Art Therapy and the Brain," In *Handbook of Art Therapy,* Cathy A. Malchiodi, ed. (New York: Guilford, 2003), 17–26.

## Preface

1   Timothy Leary, *Politics of Ecstasy* (Berkeley, CA: Ronin, 1968).

2   Shunryu Roshi Suzuki, *Zen Mind Beginners Mind,* Trudy Dixon, ed. (Boulder, CO: Shambhala, 2011).

3   A selection of more than twenty of Dürckheim's books published in various languages: Karlfried Graf Dürckheim, *Zen and Us* (New York: Arkana, 1991); *The Way of Transformation: Daily Life as Spiritual Exercise* (London: Allen & Unwin, 1971); *The Call for the Master* (New York: Penguin, 1993); *Hara: The Vital Center of Man* (New York: Mandala, 1980).

4   Transpersonale Leibarbeit.

5   C. G. Jung and Marie-Luise von Franz, *Man and His Symbols* (Garden City, NY: Doubleday, 1964); Jung and Aniela Jaffé, *Memories, Dreams, Reflections* (London: Collins, 1962); Jung, *Mandala Symbolism* (Princeton, NJ: Princeton University Press, 1973); Jung, *Psychology and Alchemy,* 1944 (repr. London: Routledge, 1968); Jung, *Mysterium Coniunctionis: An Inquiry into the Separation and Synthesis of Psychic Opposites in Alchemy,* 1956 (repr. London: Routledge, 1970).

6   Erich Neumann, *Amor and Psyche: The Psychic Development of the Feminine,* 1956, trans. Ralph Manheim (repr. Princeton, NJ: Princeton University Press, 2016); *Art and the Creative Unconscious,* 1959, trans. Ralph Manheim (repr. Princeton, NJ: Princeton University Press, 1971); *The Great Mother: An Analysis of the Archetype,* trans. Martin Liebscher (Princeton, NJ: Princeton University Press, 1955); *The Origins and History of Consciousness,* trans. R. F. C. Hull (Princeton, New Jersey: Princeton University Press, 1954).

7   Peter A. Levine, *Waking the Tiger: Healing Trauma* (Berkeley, CA: North Atlantic Books, 1997); Levine, *Trauma and Memory: Brain and Body in a Search for the Living Past* (Berkeley, CA: North Atlantic Books, 2015); Levine, *In an Unspoken Voice: How the Body Releases Trauma and Restores Goodness* (Berkeley, CA: North Atlantic Books, 2010); Levine, *Healing Trauma* (Boulder, CO: Sounds True, 2005); Babette Rothschild, *The Body Remembers: Casebook, Unifying Methods and Models in the Treatment of Trauma and PTSD* (New York: W. W Norton, 2003); Rothschild, *The Body Remembers: The Psychophysiology of Trauma and Trauma Treatment* (New York: W. W. Norton, 2000); Rothschild, "Applying the Brakes," *Psychotherapy Networker,* September 3, 2014; Bessel A. Van der Kolk, *The Body Keeps the Score: Brain, Mind and Body in the Healing of Trauma* (New York: Viking, 2014).

8   Cornelia Elbrecht, *The Transformation Journey: The Process of Guided Drawing—An Initiatic Art Therapy* (Rütte, Germany: Johanna Nordländer Verlag, 2006).

9   Eugene Gendlin, *Focusing* (New York: Bantam, 1978).

10  Norman Doidge, *The Brain That Changes Itself* (Carlton North, Australia: Scribe, 2007).

11  Van der Kolk, *The Body Keeps the Score;* Sue Gerhardt, *Why Love Matters: How Affection Shapes a Baby's Brain* (Hove, UK: Routledge, 2004).

12  Van der Kolk, *The Body Keeps the Score,* 272.

13  Levine, *Trauma and Memory,* 21.

## Chapter 1

1  Stanley Keleman, *Your Body Speaks Its Mind* (New York: Simon and Schuster, 1975).

## Chapter 2

1  Cornelia Elbrecht, "The Clay Field and Developmental Trauma," In *Creative Interventions with Traumatized Children,* ed. Cathy A. Malchiodi (New York: Guilford, 2015).

2  Cornelia Elbrecht, *Trauma Healing at the Clay Field: A Sensorimotor Approach to Art Therapy* (London: Jessica Kingsley, 2012).

3  Martin Grunwald, ed., *Human Haptic Perception: Basics and Applications* (Boston: Birkhäuser Verlag, 2008); Elbrecht, *Trauma Healing at the Clay Field.*

4  Joan Kellogg, *Mandala: Path of Beauty* (Belleair, FL: ATMA, 1978); Susan Finscher, *Creating Mandalas* (Berkeley, CA: Shambhala, 1991).

5  Johannes Pawlic, *Theorie der Farbe* (Basel, Switzerland: DuMont Verlag, 1976); Pawlic, *Goethe: Farbenlehre* (Basel, Switzerland: DuMont Verlag, 1974).

6  Johannes Itten, *The Art of Color* (Basel, Switzerland: DuMont Verlag, 1961).

7  Ingrid Riedel, *Farben in Religion, Gesellschaft, Kunst und Psychotherapie* (Stuttgart, Germany: Kreuz Verlag, 1999).

## Chapter 3

1  Laurence Heller and Aline LaPierre, *Healing Developmental Trauma: How Early Trauma Affects Self-Regulation, Self-Image, and the Capacity for Relationship* (Berkeley, CA: North Atlantic Books, 2012), 28.

2  C. G. Jung, *The Archetypes and the Collective Unconscious,* Herbert Read, Michael Fordham, and P. F. C. Hull, eds. (Princeton, NJ: Princeton University Press, 1969).

3   Ibid.

4   Suzuki, *Zen Mind.*

5   Diane Waller, *Group Interactive Art Therapy* (New York: Routledge, 1993), 8–21.

6   Clarissa Pinkola Estés, *Women Who Run with the Wolves: Contacting the Power of the Wild Woman* (London: Rider, 1992).

## Chapter 4

1   Jung and Franz, *Man and His Symbols,* 67.

2   Ibid., 67–69.

3   Neumann, *The Great Mother.*

4   Ibid.

5   Joseph Campbell, *The Hero with a Thousand Faces,* 1949 (repr. London: Fontana Press, 1993).

6   Lauren Hansen, "Evaluating a Sensorimotor Intervention in Children Who Have Experienced Complex Trauma: A Pilot Study," Honors Projects, Paper 151, Illinois Wesleyan University, 2011, 16.

## Chapter 5

1   Stephen W. Porges, *The Polyvagal Theory: Neurophysiological Foundations of Emotions, Attachment, Communication, Self-regulation* (New York: W. W. Norton, 2011); Ogden and Fisher, *Sensorimotor Psychotherapy;* Pat Ogden, *Trauma and the Body: A Sensorimotor Approach to Psychotherapy* (New York: W. W. Norton, 2006); Heller and LaPierre, *Healing Developmental Trauma;* Levine, *In an Unspoken Voice;* Bruce Perry, "Applying Principles of Neurodevelopment to Clinical Work with Maltreated and Traumatized Children: The Neurosequential Model of Therapeutics," in *Working with Traumatized Youth in Child Welfare,* ed. N. B. Webb (New York: Guilford, 2006); Robin S. Karr-Morse and Meredith Wiley, *Scared Sick: The Role of Childhood Trauma in Adult Disease* (New York: Basic, 2012); Rothschild, *The Body Remembers: Psychophysiology;* Van der Kolk, *The Body Keeps the Score;* Bruce Perry, "Examining Child Maltreatment through a Neurodevelopmental Lens: Clinical Applications of the Neurosequential Model of Therapeutics," *Journal of Loss and Trauma* 14 (2009), 240–55.

2   Porges, *Polyvagal Theory.*

3   Karr-Morse and Wiley, *Scared Sick,* 58.

4   Ibid., 54–65.

5   Ibid., 65.

6   Van der Kolk, *The Body Keeps the Score,* 113.

7   Alan Chabat and Thomas Balmès, *Babies,* DVD produced by Madman, Studio Canal, 2009.

8   Perry, "Examining Child Maltreatment."

9   Elbrecht, *Trauma Healing.*

10  Perry, "Applying Principles of Neurodevelopment," 41.

11  Daniel Siegel and Tina Payne Bryson, *The Whole-Brain Child: 12 Revolutionary Strategies to Nurture Your Child's Developing Mind* (New York: Bantam, 2012).

12  Van der Kolk, *The Body Keeps the Score;* Gerhardt, *Why Love Matters;* Karr-Morse and Wiley, *Scared Sick;* Perry, "Examining Child Maltreatment"; Perry, "Applying Principles of Neurodevelopment."

13  Perry, "Examining Child Maltreatment"; Perry, "Applying Principles of Neurodevelopment."

14  Heller and LaPierre, *Healing Developmental Trauma.*

15  Dürckheim, *Hara.*

16  Jean Houston, *The Search for the Beloved: Journeys in Mythology and Sacred Psychology* (New York: Penguin Putnam, 1987); Keleman, *Your Body Speaks.*

17  Houston, *Search for the Beloved,* 48.

18  V. S. Ramachandran, "Mirror Neurons, Part 1," 2009, YouTube, http://youtu.be/XzMqPYfeA-s; "Mirror Neurons, Part 2," 2009, YouTube, http://youtu.be/xmEsGQ3JmKg; "The Neurons That Shaped Civilization," TED Talk, 2013, YouTube, http://youtu.be/l80zgw07W4Y.

19  Levine, *Waking the Tiger.*

20  Barbara Brennan, *Hands of Light: A Guide to Healing through the Human Energy Field* (New York: Bantam, 1987).

21  Phyllis Krystal, *Cutting the Ties That Bind: Growing Up and Moving On* (Newburyport, MA: Red Wheel/Weiser, 1995).

## Chapter 6

1   Heller and LaPierre, *Healing Developmental Trauma,* 17.

2   Van der Kolk, *The Body Keeps the Score,* 3.

3   Heller and LaPierre, *Healing Developmental Trauma.*

4   Perry, "Examining Child Maltreatment," 252.

5   Heller and LaPierre, *Healing Developmental Trauma,* 18.

6   Ibid., 270.

7   Suzuki, *Zen Mind.*

8   Levine, *Trauma and Memory.*

9   Hansen, "Evaluating a Sensorimotor Intervention," 17; Perry, "Applying Principles of Neurodevelopment."

10   Shapiro, *Eye Movement Desensitization.*

11   Cathy A. Malchiodi, "Bilateral Drawing: Self-Regulation for Trauma Reparation," *Psychology Today,* September 29, 2015, http://goo.gl/kZfcts.

12   Babette Rothschild, "Trauma Specialist Babette Rothschild: Description of Dual Awareness for Treating PTSD," YouTube, November 16, 2011, http://goo.gl/6v6mVo.

13   Levine, *Waking the Tiger,* 98.

14   Ibid., 21.

15   Rothschild, "Applying the Brakes," 3.

16   Patricia Fenner, "Place, Matter and Meaning: Extending the Relationship in Psychological Therapies," *Health & Place* 17:3 (2011), 851–57.

17   Rothschild, "Applying the Brakes," 1.

18   Based on personal notes from one of Rothschild's seminars.

## Chapter 7

1   Rothschild, *The Body Remembers: Psychophysiology,* 40; Van der Kolk, quoted in Ogden, *Trauma and the Body.*

2   Rothschild, *The Body Remembers: Psychophysiology,* 40–43.

3   Ibid., 44.

4   Rothschild, "Description of Dual Awareness."

5   Based on Rothschild, *The Body Remembers: Psychophysiology.*

6   Heller and LaPierre, *Healing Developmental Trauma,* 96.

7   Malchiodi, "Bilateral Drawing."

8   Paul D. MacLean, *The Triune Brain in Evolution* (New York: Plenum, 1990).

9   Rothschild, *The Body Remembers: Psychophysiology,* 67; Levine, *In an Unspoken Voice,* 133; Ogden, *Sensorimotor Psychotherapy,* 137.

10   Rothschild, *The Body Remembers: Psychophysiology,* 67.

## Chapter 8

1   Levine, *Trauma and Memory,* 17.

2   Ibid., 21.

3   Hansen, "Evaluating a Sensorimotor Intervention," 6.

4   Jean Ayres, *Sensory Integration and the Child: Understanding Hidden Sensory Challenges,* 6th rev. ed. (Los Angeles: Western Psychological Services, 2005), 15.

5   Ibid., 28.

6   Ibid.

7   Gerhardt, *Why Love Matters;* Heller and LaPierre, *Healing Developmental Trauma;* Karr-Morse and Wiley, *Scared Sick.*

8   Heller and LaPierre, *Healing Developmental Trauma,* 17.

9   Ibid., 134.

10  Peter A. Levine and Maggie Kline, *Trauma through a Child's Eyes* (Berkeley, CA: North Atlantic Books, 2007).

11  Van der Kolk, *The Body Keeps the Score,* 160.

12  Gerhardt, *Why Love Matters,* 39.

13  Van der Kolk, *The Body Keeps the Score,* 163.

14  Heller and LaPierre, *Healing Developmental Trauma,* 134.

15  Van der Kolk, *The Body Keeps the Score;* Gerhardt, *Why Love Matters;* Karr-Morse and Wiley, *Scared Sick.*

16  Heller and LaPierre, *Healing Developmental Trauma,* 134.

## Chapter 9

1   Van der Kolk, foreword to Levine, *Trauma and Memory,* xvii.

2   Foundation of Human Enrichment, *Somatic Experiencing: Healing Trauma* training manual (Boulder, CO: Foundation of Human Enrichment, 2007).

3   Porges, *Polyvagal Theory.*

4   Van der Kolk, *The Body Keeps the Score,* 74–86.

5   Ibid., 207.

6   Shapiro, *Eye Movement Desensitization.*

7   Klaus Horlitzka has created a number of useful coloring books with mandala templates: Klaus Horlitzka, *Mandalas of the Celts* (New York: Sterling, 1998); *Native American Mandalas* (New York: Sterling, 2008); *Power Mandalas* (New York: Sterling, 2000). Others can be downloaded from the Internet.

8   Van der Kolk, *The Body Keeps the Score,* 207.

## Chapter 10

1    Perry, "Examining Child Maltreatment," 252.

2    Ogden, *Trauma and the Body*, 199.

3    Ibid., 270.

4    Van der Kolk, quoted in Ogden, *Trauma and the Body*, xxiv.

## Chapter 11

1    Lisa D. Hinz, *Expressive Therapies Continuum: A Framework for Using Art in Therapy* (New York: Routledge, 2009); Vija Lusebrink, "Assessment and Therapeutic Application of the Expressive Therapies Continuum: Implications of Brain Structures and Functions," *Art Therapy: Journal of the American Art Therapy Association* 27:4 (2010), 168–77; Lusebrink, "Art Therapy and the Brain: An Attempt to Understand the Underlying Processes of Art Expression in Therapy," *Art Therapy Journal of the American Art Therapy Association* 21:3 (2004), 125–35.

2    Jean Piaget and Bärbel Inhelder, *The Psychology of the Child* (New York: Basic, 1969).

3    Lusebrink, "Assessment and Therapeutic Application."

4    Perry, "Examining Child Maltreatment."

5    Perry, "Examining Child Maltreatment"; Perry, "Applying Principles of Neurodevelopment."

6    Lusebrink, "Assessment and Therapeutic Application," 172.

## Chapter 12

1    Plenty of studies and research have been done about the line quality in art by psychiatric patients and other special populations: Harriet Wadeson, *Art Psychotherapy* (Hoboken, NJ: John Wiley & Sons, 2010); Linda Gantt and Carmello Tabone, *The Formal Elements Art Therapy Scale: The Rating Manual* (Morgantown, WV: Gargoyle, 1998); Caroline Case and Tessa Dalley, *The Handbook of Art Therapy* (New York: Routledge, 1992); B. Cohen, J. Hammer, and S. Singer, "Diagnostic Drawing Series: A Systematic Approach to Art Therapy Evaluation and Research," *The Arts in Psychotherapy* 12 (1985), 260–83; Cathy A. Malchiodi, *Understanding Children's Drawings* (New York: Guilford, 1998); Lucia Capacchione, *The Creative Journal: The Art of Finding Yourself,* 2nd ed. (Franklin Lakes, NJ: New Page, 2002); Karen Machover, *Personality Projection in the Drawing of the Human Figure: A Method of Personality Investigation* (Springfield, IL: Charles C. Thomas, 1978).

## Chapter 13

1   Levine, *In an Unspoken Voice,* 283.

2   Ibid., 282.

3   Ibid., 78.

4   Siegel and Bryson, *Whole-Brain Child,* 10.

5   Estés, *Women Who Run with the Wolves,* 387.

## Chapter 14

1   Dürckheim, *Hara.*

2   Levine and Kline, *Trauma through a Child's Eyes;* Gerhardt, *Why Love Matters;* Heller and LaPierre, *Healing Developmental Trauma;* Van der Kolk, *The Body Keeps the Score.*

3   Personal communication with the author.

4   Campbell, *The Hero with a Thousand Faces,* 109.

5   Jacob Grimm and Wilhelm Grimm, *The Complete Grimm Fairy Tales* (repr. London: Routledge, 1975), 123.

6   Neumann, *Amor and Psyche;* Pinkola Estés, *Women Who Run with the Wolves.*

7   Karr-Morse and Wiley, *Scared Sick,* 157.

8   Heller and LaPierre, *Healing Developmental Trauma.*

9   Gerhardt, *Why Love Matters;* Levine and Kline, *Trauma through a Child's Eyes;* Heller and LaPierre, *Healing Developmental Trauma.*

10  Van der Kolk, *Body Keeps the Score.*

11  Neumann, *Origins and History of Consciousness,* 8.

12  Neumann, *The Great Mother.*

13  Jung, *Psychology and Alchemy,* 268.

14  Dürckheim, *Hara.*

15  Jung defines *circumambulation* extensively in *Psychology and Alchemy; Mandala Symbolism;* and *Mysterium Coniunctionis.*

16  The creation of mandalas is the source of many books: Finscher, *Creating Mandalas;* Ingrid Riedel, *Formen, Tiefenpsychologische Deutung von Kreis, Kreuz, Dreieck, Quadrat, Spirale und Mandala* (Stuttgart, Germany: Kreuz Verlag, 2002); Elbrecht, *Transformation Journey;* György Doczi, *The Power of Limits: Proportional Harmonies in Nature, Art, and Architecture* (Boulder, CO: Shambhala, 1981); José Argüelles and Miriam Argüelles, *Mandala* (Berkeley, CA: Shambhala,

1972); Jung, *Mandala Symbolism;* Jung and Franz, *Man and His Symbols;* Madhu Khanna, *Yantra: The Tantric Symbol of Cosmic Unity* (London: Thames and Hudson, 1980); Kellogg, *Mandala.*

17    The most fascinating account of the force of the spiral I have found is Doczi, *The Power of Limits.* See Edmark at www.johnedmark.com.

18    Jill Purce, *The Mystic Spiral: Journey of the Soul* (London: Thames and Hudson, 1992), 27.

19    Ibid., 11.

20    Ibid., 110.

21    Neumann, *The Great Mother; Origins and History of Consciousness; Amor and Psyche; Art and the Creative Unconscious.*

22    Neumann, *The Great Mother; Origins and History of Consciousness;* Jung and Franz, *Man and His Symbols;* Jung, *Mandala Symbolism;* Jung, *Mysterium Coniunctionis.*

23    Elbrecht, *Trauma Healing at the Clay Field.*

24    Shapiro, *Eye Movement Desensitization.*

25    Anthony Twig Wheeler, www.liberationispossible.org.

26    Lama Anagarika Govinda, *Foundations of Tibetan Mysticism* (New York: Rider, 1969), 156.

27    Ibid., 159.

## Chapter 15

1    Siegel and Bryson, *Whole-Brain Child.*

2    Jill Bolte Taylor, "My Stroke of Insight," TED Talk, February 2008, http://goo.gl /D8xLGu.

3    Levine, *In an Unspoken Voice.*

4    Hinz, *Expressive Therapies Continuum;* Lusebrink, "Assessment and Therapeutic Application."

5    Grimm and Grimm, *Complete Grimm Fairy Tales;* Jung and Jaffé, *Memories, Dreams, Reflections;* Jung and Franz, *Man and His Symbols;* Robert A. Johnson, *The Psychology of Romantic Love* (London: Arcana, 1987); Johnson, *She: Understanding Feminine Psychology* (New York: Harper and Row, 1989); Estés, *Women Who Run with the Wolves.*

6    Robert A. Johnson, *The Fisher King and the Handless Maiden* (New York: Harper Collins, 1995), 44.

7    Ibid., 30.

8   There is a parallel in this myth to the celebration of the Roman Catholic mass, in which the priest drinks the wine as the "blood of Christ" in order to give life to the community. Jung goes even farther and discusses the transformation of the angry god of the Old Testament into a god of love through the son, the Christ. The god of the Old Testament, depicted as an old man, became rejuvenated in the son. See Jung, *Mysterium Coniunctionis,* 24.

9   Neumann, *Amor and Psyche;* Grimm and Grimm, *Complete Grimm Fairy Tales;* Estés, *Women Who Run with the Wolves.*

10   Alice Miller, *The Drama of the Gifted Child* (New York: Basic, 1981).

11   Frederick S. Perls, *Gestalt Therapy Verbatim,* 1968 (repr. Highland, NY: Gestalt Journal Press, 1992).

12   Rumi, quoted in Houston, *Search for the Beloved,* 206.

13   Alfons Rosenberg, *Kreuzmeditation* (Munich: Koesel, 1976); Rosenberg, *Christliche Bildmeditation* (Munich: Koesel, 1975).

14   The mystery of conjunction is discussed in Jung, *Psychology and Alchemy* and *Mysterium Coniunctionis.*

15   John is symbolized as enlightened man or an angel, relating to Aquarius astrologically and the element air. Mark is associated with a lion and Leo as a fire sign. Matthew is pictured with an eagle, and the heightened image of Scorpio in astrology, representing the element water. Luke appears with the bull, relating to Taurus as an earth sign.

16   Jung, *Mysterium Coniunctionis;* Jung, *Archetypes and the Collective Unconscious.*

17   Rosenberg, *Kreuzmeditation.*

18   Krystal, *Cutting the Ties That Bind.*

19   Khanna, *Yantra.*

20   Susie Orbach, *Bodies* (London: Profile, 2009); Orbach, *Fat is a Feminist Issue: The Anti-Diet Guide to Permanent Weight Loss* (New York: Paddington, 1978).

21   Ogden, *Sensorimotor Psychotherapy,* 391.

22   Van der Kolk, *The Body Keeps the Score,* 136–68.

23   *Quaternio* is Latin for "four-foldedness." See the extensive literature about this subject in Jung, *Mysterium Coniunctionis;* Jung, *Psychology and Alchemy.*

## Chapter 16

1   Joy Schaverien, *The Revealing Image: Analytical Art Psychotherapy in Theory and Practice* (London: Routledge, 1992).

2   Ogden, *Sensorimotor Psychotherapy,* 48.

3    Antonio R. Damasio, "How the Brain Creates the Mind," *Scientific American* 281:6 (1999), 74–79.

4    Ogden, *Sensorimotor Psychotherapy,* 255.

5    Ibid., 515.

6    Ibid., 537.

7    Ibid., 615.

## Chapter 17

1    Hinz, *Expressive Therapies Continuum.*

2    Elbrecht, *Trauma Healing at the Clay Field;* Elbrecht, "Clay Field and Developmental Trauma"; Grunwald, *Human Haptic Perception.*

## Chapter 18

1    Cathy A. Malchiodi, *Breaking the Silence: Art Therapy with Children from Violent Homes* (New York: Brunner/Mazel, 1990).

2    Alice Miller, *For Your Own Good: The Roots of Violence in Child Rearing* (London: Virago, 1983).

# BIBLIOGRAPHY

Argüelles, José, and Miriam Argüelles. *Mandala.* Berkeley, CA: Shambhala, 1972.

Ayres, Jean. *Sensory Integration and the Child: Understanding Hidden Sensory Challenges.* 6th rev. ed. Los Angeles: Western Psychological Services, 2005.

Brennan, Barbara. *Hands of Light: A Guide to Healing through the Human Energy Field.* New York: Bantam, 1987.

Campbell, Joseph. *The Hero with a Thousand Faces.* 1949. Reprinted London: Fontana Press, 1993.

Cane, Florence. *The Artist in Each of Us.* London: Thames and Hudson, 1951.

Capacchione, Lucia. *The Art of Emotional Healing.* 2nd ed. Boulder, CO: Shambhala, 2006.

———. *The Creative Journal: The Art of Finding Yourself.* 2nd ed. Franklin Lakes, NJ: New Page, 2002.

Case, Caroline, and Tessa Dalley. *The Handbook of Art Therapy.* New York: Routledge, 1992.

Chabat, Alan, and Thomas Balmès. *Babies.* DVD. Produced by Madman. Studio Canal. 2009.

Cohen, B., J. Hammer, and S. Singer. "Diagnostic Drawing Series: A Systematic Approach to Art Therapy Evaluation and Research." *The Arts in Psychotherapy* 12 (1985), 260–83.

Cohen, Barry M., Mary-Michola Barnes, and Anita Rankin. *Managing Traumatic Stress through Art.* Baltimore: Sidran, 1995.

Damasio, Antonio R. "How the Brain Creates the Mind." *Scientific American* 281:6 (1999), 74–79.

Doczi, György. *The Power of Limits: Proportional Harmonies in Nature, Art, and Architecture.* Boulder, CO: Shambhala, 1981.

Doidge, Norman. *The Brain That Changes Itself.* Carlton North, Australia: Scribe, 2007.

Dürckheim, Karlfried Graf. *The Call for the Master.* New York: Penguin, 1993.

———. *Hara: The Vital Center of Man.* New York: Mandala, 1980.

———. *The Way of Transformation: Daily Life as Spiritual Exercise.* London: Allen & Unwin, 1971.

————. *Zen and Us.* New York: Arkana, 1991.

Edmark, John. n.d. John Edmark. www.johnedmark.com.

Edwards, J., ed. *Being Alive: Building on the Work of Anne Alvarez.* Philadelphia: Brunner-Routledge, 2001.

Elbrecht, Cornelia. "The Clay Field and Developmental Trauma." In Malchiodi, *Creative Interventions with Traumatized Children*, second edition. New York: Guilford , 2015,191–213.

————. *The Transformation Journey: The Process of Guided Drawing—An Initiatic Art Therapy.* Rütte, Germany: Johanna Nordländer Verlag, 2006.

————. *Trauma Healing at the Clay Field: A Sensorimotor Approach to Art Therapy.* London: Jessica Kingsley, 2012.

Elbrecht, Cornelia, and Liz R. Antcliff. "Being in Touch: Healing Developmental and Attachment Trauma at the Clay Field." *Australian Childhood Foundation Journal* 40:3 (September 2015), 209–20.

————. "Being Touched through Touch: Trauma Treatment through Haptic Perception at the Clay Field: A Sensorimotor Art Therapy." *Inscape, International Journal of Art Therapy* 19:1 (2014), 19–30.

Estés, Clarissa Pinkola. *Women Who Run with the Wolves: Contacting the Power of the Wild Woman.* London: Rider, 1992.

Fenner, Patricia. "Place, Matter and Meaning: Extending the Relationship in Psychological Therapies." *Health & Place* 17:3 (2011), 851–57.

Finscher, Susan. *Creating Mandalas.* Berkeley, CA: Shambhala, 1991.

Foundation of Human Enrichment. *Somatic Experiencing: Healing Trauma.* Training manual. Boulder, CO: Foundation of Human Enrichment, 2007.

Gantt, Linda, and Carmello Tabone. *The Formal Elements Art Therapy Scale: The Rating Manual.* Morgantown, WV: Gargoyle, 1998.

Gendlin, Eugene. *Focusing.* New York: Bantam, 1978.

Gerhardt, Sue. *Why Love Matters: How Affection Shapes a Baby's Brain.* Hove, UK: Routledge, 2004.

Gil, Eliana. "Art and Play Therapy with Sexually Abused Children." In Malchiodi, *Handbook of Art Therapy*. New York: Guilford, 2003, 152–67.

Govinda, Lama Anagarika. *Foundations of Tibetan Mysticism.* New York: Rider, 1969.

Gregory, Richard, John Harris, Priscilla Heard, and David Rose, eds. *The Artful Eye.* Oxford, UK: Oxford University Press, 1995.

Grimm, Jacob, and Wilhelm Grimm. *The Complete Grimm Fairy Tales.* Reprinted London: Routledge, 1975.

Grunwald, Martin, ed. *Human Haptic Perception: Basics and Applications.* Boston: Birkhäuser Verlag, 2008.

Hansen, Lauren. "Evaluating a Sensorimotor Intervention in Children Who Have Experienced Complex Trauma: A Pilot Study." Honors Projects. Paper 151. Illinois Wesleyan University. 2011.

Heller, Laurence, and Aline LaPierre. *Healing Developmental Trauma: How Early Trauma Affects Self-Regulation, Self-Image, and the Capacity for Relationship.* Berkeley, CA: North Atlantic Books, 2012.

Hinz, Lisa D. *Expressive Therapies Continuum: A Framework for Using Art in Therapy.* New York: Routledge, 2009.

Hogan, Susan, ed. *Gender Issues in Art Therapy.* Philadelphia: Jessica Kingsley, 2003.

Horlitzka, Klaus. *Mandalas of the Celts.* New York: Sterling, 1998.

———. *Native American Mandalas.* New York: Sterling, 2008.

———. *Power Mandalas.* New York: Sterling, 2000.

Houston, Jean. *The Search for the Beloved: Journeys in Mythology and Sacred Psychology.* New York: Penguin Putnam, 1987.

Itten, Johannes. *The Art of Color.* Basel, Switzerland: DuMont Verlag, 1961.

Johnson, Robert, A. *The Fisher King and the Handless Maiden.* New York: Harper Collins, 1995.

———. *The Psychology of Romantic Love.* London: Arcana, 1987.

———. *She: Understanding Feminine Psychology.* New York: Harper and Row, 1989.

Jung, C. G. *The Archetypes and the Collective Unconscious.* Edited by Herbert Read, Michael Fordham, and P. F. C. Hull. Princeton, NJ: Princeton University Press, 1969.

———. *Mandala Symbolism.* Princeton, NJ: Princeton University Press, 1973.

———. *Mysterium Coniunctionis: An Inquiry into the Separation and Synthesis of Psychic Opposites in Alchemy.* 1956. Reprinted London: Routledge, 1970.

———. *Psychology and Alchemy.* 1944. Reprinted London: Routledge, 1968.

Jung, C. G., and Marie-Luise von Franz. *Man and His Symbols.* Garden City, NY: Doubleday, 1964.

Jung, C. G., and Aniela Jaffé. *Memories, Dreams, Reflections.* London: Collins, 1962.

Kagin, Sandra, and Vija Lusebrink. "The Expressive Therapies Continuum." *Art Psychotherapy* 5 (1978), 171–80.

Kaplan, Frances F., ed. *Art Therapy and Social Action.* Philadelphia: Jessica Kingsley, 2007.

Karr-Morse, Robin S., and Meredith Wiley. *Scared Sick: The Role of Childhood Trauma in Adult Disease.* New York: Basic, 2012.

Keleman, Stanley. *Your Body Speaks Its Mind.* New York: Simon and Schuster, 1975.

Kellogg, Joan. *Mandala: Path of Beauty.* Belleair, FL: ATMA, 1978.

Khanna, Madhu. *Yantra: The Tantric Symbol of Cosmic Unity.* London: Thames and Hudson, 1980.

Klorer, Gussie P. "Sexually Abused Children: Group Approaches." In Malchiodi, *Handbook of Art Therapy.* New York: Guilford, 2003, 339–51.

Krystal, Phyllis. *Cutting the Ties That Bind: Growing Up and Moving On.* Newburyport, MA: Red Wheel/Weiser, 1995.

Ladinsky, Daniel. *I Heard God Laughing; Poems of Hope and Joy: Renderings of Hafiz.* New York: Penguin, 1996.

Latto, R. "The Brain of the Beholder." In Gregory et al., *The Artful Eye.* Oxford: Oxford University Press, 1995.

Leary, Timothy. *Politics of Ecstasy.* Berkeley, CA: Ronin, 1968.

Levine, Peter A. *Healing Trauma.* Boulder, CO: Sounds True, 2005.

———. *Healing Trauma: A Pioneering Program for Restoring the Wisdom of Your Body.* Louisville, CO: Sounds True, 2008.

———. *In an Unspoken Voice: How the Body Releases Trauma and Restores Goodness.* Berkeley, CA: North Atlantic Books, 2010.

———. "In an Unspoken Voice: How the Body Releases Trauma and Restores Goodness." 5. *Schweizer Bildungsfestival, Weggis, Switzerland.* DVD 1 and 2. Mühlheim, Switzerland. August 23, 2011.

———. *It Won't Hurt Forever.* Boulder, CO: Sounds True, 2001.

———. *Resolving Trauma in Psychotherapy.* DVD. Mill Valley, CA: Psychotherapy.net, 2010.

———. "Rüstzeug für Zeiten von Terror und Aufruhr: Ein körperzentrierter Weg bei traumatischen Erfahrungen." *Video of presentation given at the 4. Internationale Arbeitstagung zu Systemaufstellungen.* Mühlheim, Switzerland. April 30, 2003.

———. *Sexual Healing.* Boulder, CO: Sounds True, 2003.

———. *Trauma and Memory: Brain and Body in a Search for the Living Past.* Berkeley, CA: North Atlantic Books, 2015.

———. *Waking the Tiger: Healing Trauma.* Berkeley, CA: North Atlantic Books, 1997.

Levine, Peter A., and Maggie Kline. *Trauma through a Child's Eyes.* Berkeley, CA: North Atlantic Books, 2007.

Lev-Wiesel, Rachel, and Frances Kaplan. "Art Making as a Response to Terrorism." In Kaplan, *Art Therapy and Social Action.* London: Jessica Kingsley, 2006, 191–213.

Lowe, Richard, and Stefan Laeng-Gilliatt. *Reclaiming Vitality and Presence: Sensory Awareness as a Practice for Life. The Teachings of Charlotte Selver and Charles V. W. Brooks.* Berkeley, CA: North Atlantic Books, 2007.

Lusebrink, Vija. "Art Therapy and the Brain: An Attempt to Understand the Underlying Processes of Art Expression in Therapy." *Art Therapy Journal of the American Art Therapy Association* 21:3 (2004), 125–35.

———. "Assessment and Therapeutic Application of the Expressive Therapies Continuum: Implications of Brain Structures and Functions." *Art Therapy: Journal of the American Art Therapy Association* 27:4 (2010), 168–77.

———. "A Systems Oriented Approach to the Expressive Therapies: The Expressive Therapies Continuum." *The Arts in Psychotherapy* 18 (1992), 395–403.

Machover, Karen. *Personality Projection in the Drawing of the Human Figure: A Method of Personality Investigation.* Springfield, IL: Charles C. Thomas, 1978.

MacLean, Paul D. *The Triune Brain in Evolution.* New York: Plenum, 1990.

Malchiodi, Cathy A. "Art Therapy and the Brain." In Malchiodi, *Handbook of Art Therapy.* New York: Guilford, 2003, 16–25.

———. "Bilateral Drawing: Self-Regulation for Trauma Reparation." *Psychology Today*. September 29, 2015. http://goo.gl/kZfcts.

———. *Breaking the Silence: Art Therapy with Children from Violent Homes*. New York: Brunner/Mazel, 1990.

———, ed. *Creative Interventions with Traumatized Children*. New York: Guilford, 2015.

———. *Handbook of Art Therapy*. New York: Guilford, 2003.

———. *Understanding Children's Drawings*. New York: Guilford, 1998.

McNiff, Shaun. *Art as Medicine: Creating a Therapy of Imagination*. Boston: Shambhala, 1992.

———. *Art-Based Research*. Philadelphia: Jessica Kingsley, 1998.

Miller, Alice. *The Drama of the Gifted Child*. New York: Basic, 1981.

———. *For Your Own Good: The Roots of Violence in Child Rearing*. London: Virago, 1983.

Myss, Caroline. *Anatomy of the Spirit*. New York: Bantam, 1997.

———. *The Energetics of Healing*. Video. Boulder, CO: Sounds True, 1997.

Neumann, Erich. *Amor and Psyche: The Psychic Development of the Feminine*. 1956. Translated by Ralph Manheim. Reprinted Princeton, NJ: Princeton University Press, 2016.

———. *Art and the Creative Unconscious*. 1959. Translated by Ralph Manheim. Reprinted Princeton, NJ: Princeton University Press, 1971.

———. *The Great Mother: An Analysis of the Archetype*. Translated by Martin Liebscher. Princeton, NJ: Princeton University Press, 1955.

———. *The Origins and History of Consciousness*. Translated by R. F. C. Hull. Princeton, New Jersey: Princeton University Press, 1954.

O'Brien, Frances. "The Making of Mess in Art Therapy, Attachment, Trauma and the Brain." *International Journal of Art Therapy* 9:1 (2004), 2–13.

Ogden, Pat. *Trauma and the Body: A Sensorimotor Approach to Psychotherapy*. New York: W. W. Norton, 2006.

Ogden, Pat, and Janina Fisher. *Sensorimotor Psychotherapy: Interventions for Trauma and Attachment*. New York: W. W. Norton, 2015.

Orbach, Susie. *Bodies*. London: Profile, 2009.

———. *Fat Is a Feminist Issue: The Anti-Diet Guide to Permanent Weight Loss*. New York: Paddington, 1978.

Pawlic, Johannes. *Goethe: Farbenlehre*. Basel, Switzerland: DuMont Verlag, 1974.

———. *Theorie der Farbe*. Basel, Switzerland: DuMont Verlag, 1976.

Perls, Frederick S. *Gestalt Therapy Verbatim*. 1968. Reprinted Highland, NY: Gestalt Journal Press, 1992.

Perry, Bruce. "Applying Principles of Neurodevelopment to Clinical Work with Maltreated and Traumatized Children: The Neurosequential Model of Therapeutics." In Webb, *Working with Traumatized Youth in Child Welfare*. New York: Guilford, 2005, 27–53.

———. "Examining Child Maltreatment through a Neurodevelopmental Lens: Clinical Applications of the Neurosequential Model of Therapeutics." *Journal of Loss and Trauma* 14 (2009), 240–55.

Piaget, Jean, and Bärbel Inhelder. *The Psychology of the Child.* New York: Basic, 1969.

Porges, Stephen W. *The Polyvagal Theory: Neurophysiological Foundations of Emotions, Attachment, Communication, Self-regulation.* New York: W. W. Norton, 2011.

Purce, Jill. *The Mystic Spiral: Journey of the Soul.* London: Thames and Hudson, 1992.

Ramachandran, V. S. "Mirror Neurons, Part 1." 2009. YouTube. http://youtu.be/XzMqPYfeA-s.

———. "Mirror Neurons, Part 2." 2009. YouTube. http://youtu.be/xmEsGQ3JmKg.

———. "The Neurons That Shaped Civilization." TED Talk. 2013. YouTube. http://youtu.be/l80zgw07W4Y.

Riedel, Ingrid. *Farben in Religion, Gesellschaft, Kunst und Psychotherapie.* Stuttgart, Germany: Kreuz Verlag, 1999.

———. *Formen, Tiefenpsychologische Deutung von Kreis, Kreuz, Dreieck, Quadrat, Spirale und Mandala.* Stuttgart, Germany: Kreuz Verlag, 2002.

Rosenberg, Alfons. *Christliche Bildmeditation.* Munich: Koesel, 1975.

———. *Kreuzmeditation.* Munich: Koesel, 1976.

Rothschild, Babette. "Applying the Brakes." *Psychotherapy Networker,* September 3, 2014.

———. *The Body Remembers: Casebook, Unifying Methods and Models in the Treatment of Trauma and PTSD.* New York: W. W Norton, 2003.

———. *The Body Remembers: The Psychophysiology of Trauma and Trauma Treatment.* New York: W. W. Norton, 2000.

———. "Trauma Specialist Babette Rothschild: Description of Dual Awareness for Treating PTSD." YouTube. November 16, 2011. http://goo.gl/6v6mVo.

Schaverien, Joy. *The Revealing Image: Analytical Art Psychotherapy in Theory and Practice.* London: Routledge, 1992.

Schore, Allan. *Affect Dysregulation and Disorders of the Self.* New York: W. W. Norton, 2003.

———. *Affect Regulation and Repair of the Self.* New York: W. W. Norton, 2003.

———. *Affect Regulation and the Origin of the Self: The Neurobiology of Emotional Development.* Hillsdale, NJ: Lawrence Erlbaum, 1994.

———. "Early Relational Trauma: Effects on Right Brain Development and the Etiology of Pathological Dissociation." Paper presented at the conference "Attachment, the Developing Brain, and Psychotherapy: Minds in the Making." University College London, 2001.

———. "Neurobiology, Developmental Psychology, and Psychoanalysis: Convergent Findings on the Subject of Projective Identification." In Edwards, *Being Alive.* Oxford: Routledge, 2003.

———. "Regulation of the Right Brain: A Fundamental Mechanism of Attachment Development and Trauma Psychotherapy." Paper presented at the conference

"Attachment, Trauma, and Dissociation: Developmental, Neuropsychological, Clinical, and Forensic Considerations." University College London, 2001.

Shapiro, Francine. *Eye Movement Desensitization and Reprocessing: Basic Principles, Protocols, and Procedures.* New York: Guilford, 2001.

———. *Eye Movement Desensitization and Reprocessing (EMDR) Therapy: Basic Principles, Protocols, and Procedures.* 3rd ed. New York: Guilford, 2017.

Siegel, Daniel, J. *Mind Sight: Change Your Brain and Your Life.* Carlton North, Australia: Scribe, 2009.

———. *Mindsight*: *The New Science of Personal Transformation.* New York: W. W. Norton, 2012.

Siegel, Daniel, and Tina Payne Bryson. *The Whole-Brain Child: 12 Revolutionary Strategies to Nurture Your Child's Developing Mind.* New York: Bantam, 2012.

Slater, Nancy. R. "Revisions on Group Art Therapy with Women Who Have Experienced Domestic and Sexual Violence." In Hogan, *Gender Issues in Art Therapy.* London: Jessica Kingsley, 2002, 173–85.

Suzuki, Shunryu Roshi. *Zen Mind Beginners Mind.* Edited by Trudy Dixon. Boulder, CO: Shambhala, 2011.

Taylor, Jill Bolte. "My Stroke of Insight." TED Talk. February 2008. http://goo.gl/D8xLGu.

Trevarthen, Colwyn. "Mother and Baby—Seeing Artfully Eye to Eye." In Harris, *The Artful Eye.* Oxford: Oxford University Press, 1995.

Van der Kolk, Bessel A. *The Body Keeps the Score: Brain, Mind and Body in the Healing of Trauma.* New York: Viking, 2014.

———. "The Complexity of Adaptation to Trauma: Self-Regulation, Stimulus Discrimination, and Characterological Development." In Van der Kolk and McFarlane, *Traumatic Stress.* New York: Guilford, 2006, 182–214.

———. *The Secret Life of the Brain.* Video. PBS Video Series. 2002.

Van der Kolk, Bessel A., and Weisaeth McFarlane, eds. *Traumatic Stress: The Effects of Overwhelming Experience of Mind, Body and Society.* New York: Guilford, 1996.

Wadeson, Harriet. *Art Psychotherapy.* Hoboken, NJ: John Wiley & Sons, 2010.

Waller, Diane. *Group Interactive Art Therapy.* New York: Routledge, 1993.

Webb, N. B., ed. *Working with Traumatized Youth in Child Welfare.* New York: Guilford, 2006.

Wheeler, Anthony Twig. n.d. LiberationIsPossible.org. www.liberationispossible.org.

Wilson, Frank R. *The Hand.* New York: Vintage, 1998.

# ACKNOWLEDGMENTS

There have been many who have contributed to this book. First and foremost, I wish to thank all my clients and students, from whom I have learned invaluable lessons. You are the reason I am still as passionate about being an art therapist as I was forty-five years ago. In particular I am grateful for the generous contribution of their artwork to Susan Catton, Gabrielle Clark, Elizabeth Kinnane, Tegan Neville, Marie Martin, Sophie Patterson, Helena Ambrosia, Krista Rosewarne, Tess Sketchley, Acacia van Hest, Leilani van Hest, Tobias van Hest, Carolyn West, and many others.

Thank you, Liz Antcliff, my unlikely sister, and Chris Storm, Sally Stower, Sally Tyrell, and Diane Violi, for your friendship, the shared journey, the glasses of wine, the laughs, and for proofreading the first draft. It really helped to entrust friends with the text to begin with after the fragile conception stage, and before the manuscript was released into the great unknown.

Thank you to all the amazing individuals at North Atlantic Books, in particular Ebonie Ledbetter for her patience, which was certainly tested at times; Hisae Matsuda, for being like a gentle rock; and Maureen Forys, who had the monster task of wrestling hundreds of images into place. Working with you has been a pleasure.

Thank you Regula Bühlmann for your generous support for what is in parts a new edition of the first book you published twelve years ago.

And thank you Cathy Malchiodi for your inspiring friendship and support. That snake skin is still working its magic....

# INDEX

# ABOUT THE AUTHOR

**Cornelia Elbrecht,** AThR, SEP, is a leader in groundbreaking art therapy techniques with a particular focus on healing trauma. An art therapist with more than forty years of experience, she is a renowned author, educator, and the founder and director of the Institute for Sensorimotor Art Therapy.

She studied at the School for Initiatic Arts Therapies in the Black Forest in Germany and holds degrees in fine arts and arts education along with extensive postgraduate training in Jungian and Gestalt therapy and bioenergetics and at the Somatic Experiencing Training Institute (SETI).

Best known for her cutting-edge work with Guided Drawing and Clay Field Therapy, she holds regular workshops around the world and at Claerwen Retreat in Apollo Bay, Australia—an internationally respected arts therapy education facility.

The author of numerous books, Elbrecht runs accredited online courses for art therapists, educators, and mental health professionals looking to understand a body-focused art therapy approach to trauma therapy.

For more information on courses and her books, please visit www .sensorimotorarttherapy.com.

# More Information about Guided Drawing

If you wish to learn more about healing trauma with Guided Drawing, there are two main options:

- Cornelia Elbrecht offers workshops in Australia and internationally. Look at her program on the website of the Institute for Sensorimotor Art Therapy, www.sensorimotorarttherapy.com.

- An online training course of seven two-hour sessions can be accessed at the same website. The course is designed for art therapists, educators, and artists to inform about healing trauma with Guided Drawing as a bilateral approach to body mapping.

## *About North Atlantic Books*

North Atlantic Books (NAB) is a 501(c)(3) nonprofit publisher committed to a bold exploration of the relationships between mind, body, spirit, culture, and nature. Founded in 1974, NAB aims to nurture a holistic view of the arts, sciences, humanities, and healing. To make a donation or to learn more about our books, authors, events, and newsletter, please visit www.northatlanticbooks.com.